The Designer as

TO *DAB* AND *ABM* AND *JBM*

B/S

BIS PUBLISHERS
BUILDING HET SIERAAD
POSTJESWEG 1
1057 DT AMSTERDAM
THE NETHERLANDS
T +31 (0)20 515 02 30
F +31 (0)20 515 02 39
BIS@BISPUBLISHERS.NL
WWW.BISPUBLISHERS.NL

ISBN 978 90 6369 292 6

COPYRIGHT © 2013 STEVEN MCCARTHY AND BIS PUBLISHERS

DESIGN: MARTIN VENEZKY'S APPETITE ENGINEERS

ALL RIGHTS RESERVED. NO PART OF THIS PUBLICATION MAY BE REPRODUCED OR TRANSMITTED IN ANY FORM OR BY ANY MEANS, ELECTRONIC OR MECHANICAL, INCLUDING PHOTOCOPY, RECORDING OR ANY INFORMATION STORAGE AND RETRIEVAL SYSTEM, WITHOUT PERMISSION IN WRITING FROM THE COPYRIGHT OWNERS.

front cover image /// **AND SHE TOLD 2 FRIENDS** (CATALOG SPREAD) /// Kali Nikitas (MICHAEL MELDELSON BOOKS) /// 1996
back cover image /// **POSTER WALL FOR THE 21ST CENTURY** (INTERACTIVE INSTALLATION) /// LUST /// 2011 (WALKER ART CENTER, MINNEAPOLIS VERSION)

The Designer as

**Author
Producer
Activist
Entrepreneur
Curator
Collaborator**

&

STEVEN MCCARTHY

: New Models for Communicating

ACKNOWLEDGEMENTS

MANY OF THE IDEAS EXPRESSED IN THIS BOOK BEGAN AS CONVERSATIONS, READINGS AND 'SHOW-N-TELL' SESSIONS THAT MY FORMER COLLEAGUE **Cristina de Almeida** AND I HAD PRIOR TO JOINTLY CURATING THE DESIGNER AS AUTHOR: VOICES AND VISIONS EXHIBITION IN 1995. WE THEN PRESENTED AND PUBLISHED TOGETHER ON THE TOPIC FOR SEVERAL YEARS, HONING OUR CONCEPTS IN PEER-REVIEWED ACADEMIC VENUES. CRISTINA'S EARLY INTELLECTUAL CONTRIBUTIONS DESERVE SPECIAL MENTION HERE.

SEVERAL OF THE BOOK'S SECTIONS ARE EDITED VERSIONS OF ACADEMIC PAPERS THAT HAVE BEEN PRESENTED OR PUBLISHED ELSEWHERE. THEY HAVE BEEN REFINED TO BE AS CURRENT AS POSSIBLE AND TO BE ACCESSIBLE TO A MORE GENERALIZED AUDIENCE. WHERE APPROPRIATE, ACKNOWLEDGEMENT HAS BEEN GIVEN ADJACENT TO THE REPURPOSED TEXT.

I WOULD LIKE TO EMPHATICALLY THANK THE READERS OF DRAFTS OF THE BOOK MANUSCRIPT FOR THEIR PARTICULAR INSIGHTS: **Alice McCarthy** (REPRESENTING THE QUESTIONING NATURE OF UNDERGRADUATE DESIGN STUDENTS), **Jessica Barness** (POSSESSING THE KEEN EYE OF THE GRADUATE STUDENT), **Rob Dewey** (FROM THE VANTAGE POINT OF A CAREER IN DESIGN WRITING AND EDITING), AND **Dominique Bouvier** (MY MOST ASTUTE CRITIC AND YET SYMPATHETIC SUPPORTER). THE FINAL DRAFT WAS BETTER, CLEARER AND MORE READABLE THAN EARLIER EFFORTS, THANKS TO THEIR FEEDBACK.

I WISH TO THANK THE BOOK'S INTERVIEWEES — **Anne Burdick, Noel Douglas, Johanna Drucker, Kenneth FitzGerald, Mieke Gerritzen, Warren Lehrer, Michael Longford, Ellen Lupton, Doug Powell, Rick Poynor, Rick Valicenti** AND **Armin Vit** — WHO GAVE THEIR TIME, EXPERTISE AND OPINIONS FREELY AND FRANKLY. DEAR READER, YOU WILL BE TREATED IN THE PAGES AHEAD!

HEARTY APPRECIATION GOES TO THE MANY CONTRIBUTORS OF THE LARGER COLOR IMAGES THAT ILLUSTRATE THE TEXT. EVERY EFFORT HAS BEEN MADE TO ACCURATELY CREDIT THE IMAGES. THE MANY THUMBNAIL-SIZED GREYSCALE PICTURES THAT RIGOROUSLY POPULATE THE BOOK CONFORM TO THE FAIR USE CLAUSE OF THE US COPYRIGHT ACT, WHEREBY THE NATURE OF THEIR USE, THEIR DEGREE OF TRANSFORMATION, AND THEIR USE FOR COMMENTARY CONSTITUTE PROTECTED SPEECH.

THANKS TO **Martin Venezky** OF APPETITE ENGINEERS, A SELF-AUTHORING DESIGNER WHOSE WORK I'VE ADMIRED FOR A LONG TIME, FOR ARTFULLY SHAPING THE BOOK'S GRAPHIC DESIGN. ALTHOUGH PLENTY BUSY WITH OTHER PROJECTS (INCLUDING AN UNEXPECTED STUDIO RELOCATION!), I BELIEVE THAT MARTIN ACCEPTED THE BOOK DESIGN OPPORTUNITY ON PRINCIPLE, AND FOR THAT I AM GRATEFUL. THE CONCEPT OF PEPPERING THE TEXT WITH IMAGES OF THE MANY PEOPLE, PROJECTS AND PLACES MENTIONED IS MARTIN'S. IT IS AN AUTHORIAL GESTURE THAT IS BOTH PROVOCATIVE AND INFORMATIVE; INSIGHTFUL READERS WILL BE REWARDED WITH HUMOR, JUXTAPOSITION AND SURPRISE.

THANK YOU **Rudolf van Wezel**, DIRECTOR OF BIS PUBLISHING IN AMSTERDAM, FOR COURAGEOUSLY SHARING MY CONVICTION THAT *The Designer As… Author, Producer, Activist, Entrepreneur, Curator and Collaborator: New Models for Communicating* DESERVES A WIDE AUDIENCE OF INQUIRING MINDS.

FINALLY, THANKS TO THE **College of Design at the University of Minnesota** FOR GRANTING ME A SABBATICAL LEAVE SO I COULD FOCUS ON WRITING THE BOOK.

7	Introduction

1 Concept, History

11	**DESIGN AUTHORSHIP EXPLAINED**
15	**DESIGN AUTHORSHIP'S ENABLING TECHNOLOGIES**
31	**TIMELINE OF DESIGN AUTHORSHIP**
43	**INTERVIEW: RICK POYNOR**
47	**INTERVIEW: ELLEN LUPTON**

2 Writing, Type, Text

51	**WRITING NEEDS GRAPHIC DESIGN**
61	**TYPOGRAPHIC DESIGN AUTHORSHIP**
71	**THE VISUAL-VERBAL TEXT**
81	**TYPOGRAPHY AND LIFE: A COMPARISON**
89	**INTERVIEW: KENNETH FITZGERALD**
91	**INTERVIEW: ANNE BURDICK**

3 Advocacy, Social Activism

95	**CULTURAL LEGITIMACY**
99	**DESIGNER AS AUTHOR ACTIVIST**
111	**DESIGN ADVOCACY ACROSS MEDIA**
119	**INTERVIEW: MIEKE GERRITZEN**
121	**INTERVIEW: NOEL DOUGLAS**

4 Design for Art's Sake

125	**CRITICAL DESIGN AND DESIGN FICTION**
139	**THE ART-DESIGN ZONE**
147	**SAMPLING AND REMIXING**
153	**INTERVIEW: WARREN LEHRER**
157	**INTERVIEW: JOHANNA DRUCKER**

5 Entrepreneurism and Economy

161	**DESIGN ENTREPRENEURISM AND ECONOMY**
171	**DESIGNER STORIES THROUGH ENTREPRENEURIAL PUBLISHING**
189	**INTERVIEW: DOUG POWELL**
191	**INTERVIEW: RICK VALICENTI**

6 Community Design Authorship

195	**COMMUNITY DESIGN AUTHORSHIP**
203	**CURATING DESIGN AUTHORSHIP**
217	**INTERVIEW: ARMIN VIT**
219	**INTERVIEW: MICHAEL LONGFORD**
223	Afterword
226	URL index

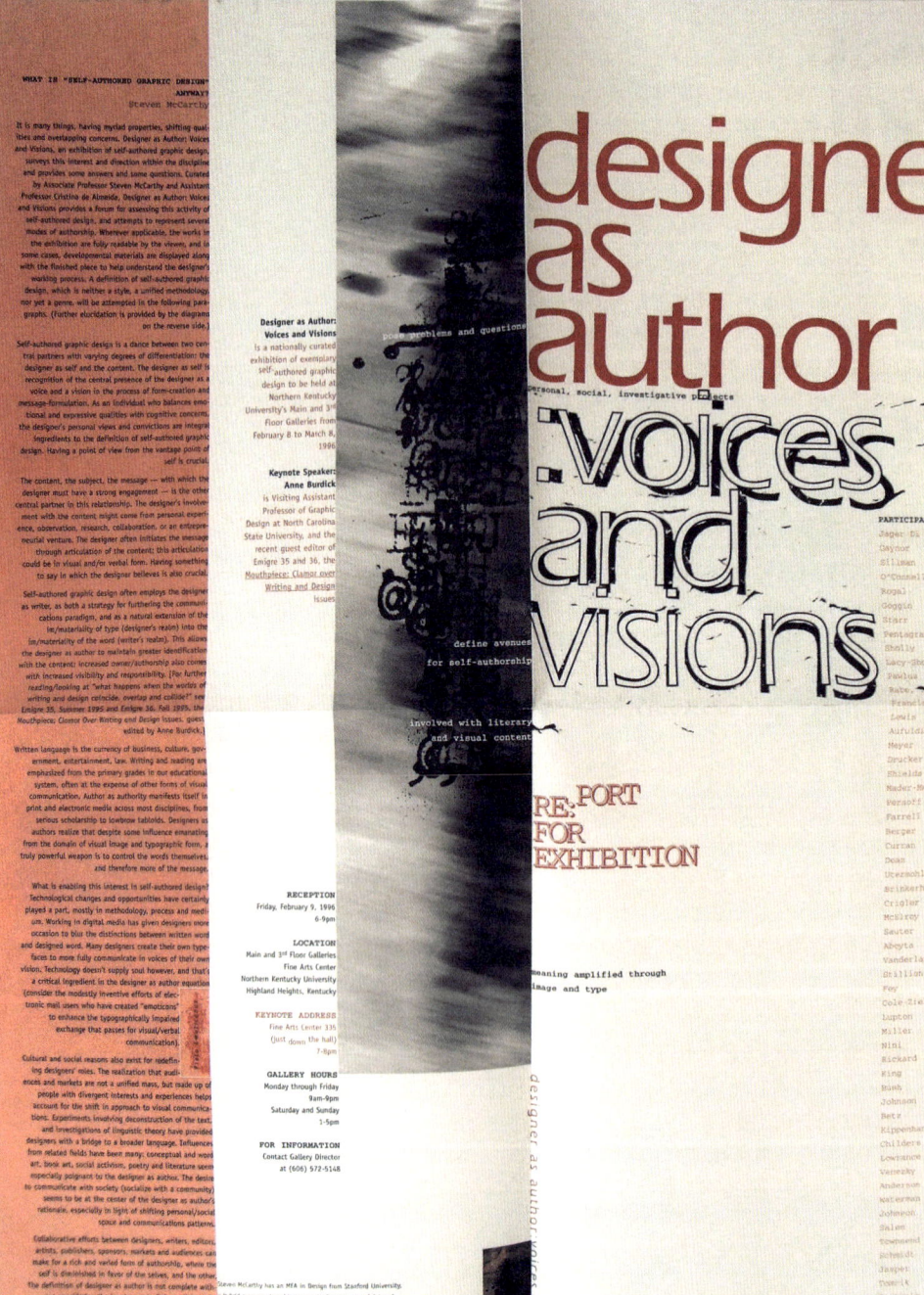

DESIGNER AS AUTHOR: VOICES AND VISIONS (POSTER) /// Steven McCarthy /// 1996

INTRODUCTION

My first notion of design authorship came around 1984 while I was working on a Master of Fine Arts thesis at Stanford University in Palo Alto, California. Because I had worked in graphic and exhibit design prior to graduate school, I had assumed that design only came about by being commissioned by a client (OR IN EDUCATION, ASSIGNED BY AN INSTRUCTOR). *Graphic designers only do their work when given message content and a target market — a reflexive, service-oriented approach — right?*

So when my thesis advisor, Professor Greg Lynch (NOW PARTNER IN THE FIRM STUDIO/LAB), *pushed me to identify a topic and define an area of inquiry, I was somewhat unprepared. 'You mean, I'll frame the questions, write, edit, photograph, illustrate, design, print and self-publish this thing? — by June?' Fortunately, my trepidation was soon replaced with enthusiasm* (HAVING AN UNDERGRADUATE DEGREE STEEPED IN FINE ART MAY HAVE HELPED OPEN ALTERNATIVE CREATIVE PATHWAYS). *I embraced the freedom that choosing a subject allowed me, and dove into my work.*

After weeks of distilling ideas, my thesis question became: 'what are people's oldest possessions, and why do they hang on to them?' My challenge was to find an appropriate and memorable way to communicate the answers.

Experiments with narrative structures combining image and text were created. I explored myriad forms, cutting, tearing and folding paper and other materials. I tested the era's 'state-of-the-art' reproduction technologies (IF ONE PATRONIZED THE LOCAL COPY SHOP AFTER MIDNIGHT, THE LONE EMPLOYEE ON DUTY WOULD TRY ANYTHING; ONCE HE JAMMED THE NEW COLOR COPIER WITH THE QUICKLY MELTING MYLAR I ASKED HIM TO RUN THROUGH — OOPS!). *Prototypes of books and other forms were generated as my content developed. One of my professors, Bill Moggridge* (CO-FOUNDER OF IDEO AND LATE DIRECTOR OF THE COOPER-HEWITT NATIONAL DESIGN MUSEUM), *encouraged me to try digitally recorded voice for the project; I investigated the idea but it didn't seem like the right solution for the 'voice' of my subjects' stories.*

The completed thesis project, a multi-form book about forty-some people in the San Francisco Bay Area and their oldest possessions, was my first work of design authorship. To interview and photograph my demographically diverse subjects and their stuff, I was armed with a large boom-box, cassette tapes and a microphone, and a 35mm camera loaded with black and white film. Back on campus, the tapes were transcribed from voice to text by my young bride, and then the typed and marked-up manuscripts were sent to a photo-typesetting company in Mountain View. Professionally processed photos were sized to fit my layout, galleys of type were pasted into position on 'mechanical boards,' and instructions to the printer were indicated on tissue overlays — the whole process was physically exacting, time consuming and unforgiving of error. 'Command-Z' was not yet a savior.

In spite of this, the integration of message, form and medium was competently orchestrated, and the results were novel, perhaps even radical. Oldest Possessions *was both a book and a table-top exhibit; its graphic vocabulary was a mix of 'punk rock' and 'California new wave' with bookish text. The authoring aspect wasn't merely combining writing with designing — it was in conceiving the topic, and in conceptualizing and realizing its visualization.*

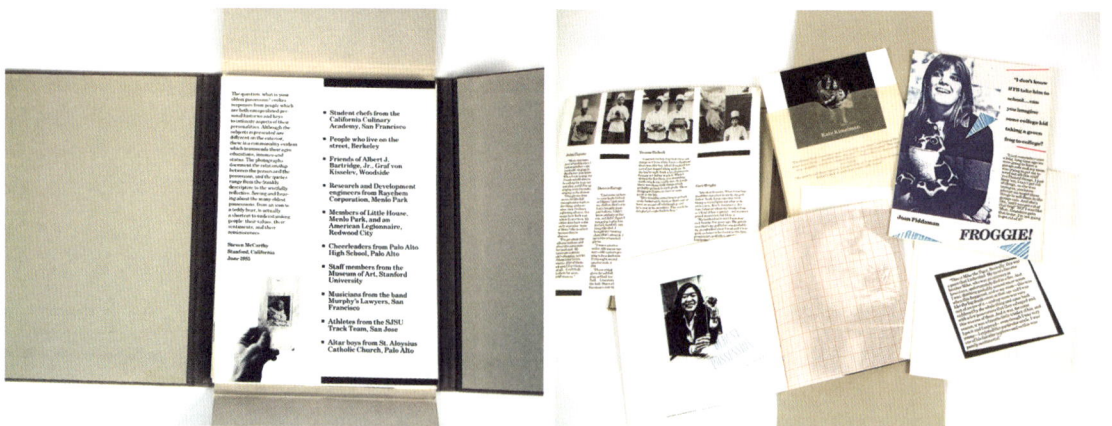

above /// **OLDEST POSSESSIONS** (MULTI-FORM BOOK) /// Steven McCarthy /// 1985
below /// **LET AN ARTIST'S BOOK INSPIRE YOU** (ARTICLE FOR HOW MAGAZINE) /// Steven McCarthy /// 1994

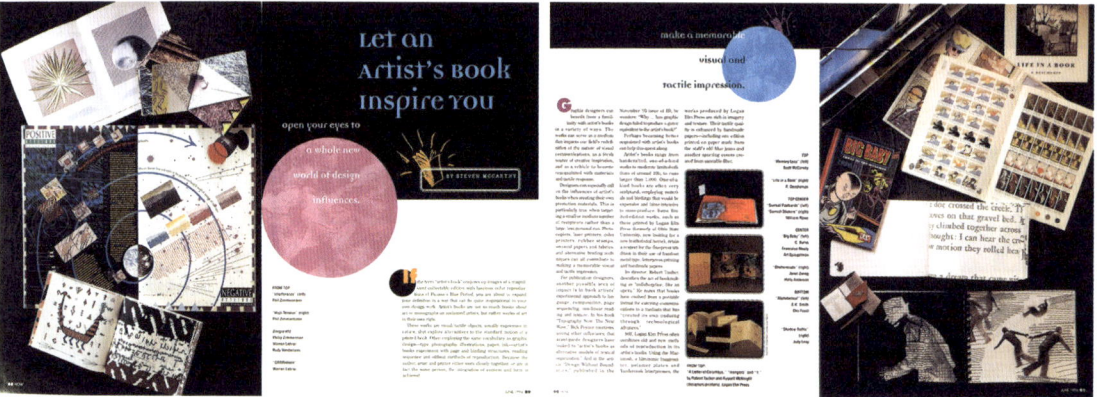

Although I recall seeing an Apple Macintosh at Stanford's graduate student Design Loft studio space in 1984 or '85 (A CURIOSITY THAT SEEMED MORE A TOY THAN A TOOL AT THE TIME), *it wasn't until the late '80s that it was a professional-grade tool for graphic designers. Meanwhile, also in 1984, the very foundation of the graphic design profession was about to be challenged across the Bay in Berkeley as Rudy Vanderlans and Zuzana Licko were using this small personal computer and a bitmap printer to self-publish their writing, graphic and typographic designs in the form of* Emigre *magazine. The Mac's ability to synthetically merge visual and verbal language systems opened up a new way of working with — and thinking about — the integrative possibilities of the designer as author, and of the writer as designer.*

While 1984 might seem a good place to begin a discussion of design authorship, the concept can be found in a chronology of works stretching back over a century. After all, Englishman William Morris wrote, created original type fonts, designed, illustrated and printed his own books in the 1880s. The concept of design authorship can also be found laterally, in graphic design's allied disciplines: industrial design, art, literature, poetry, advertising and architecture.

Another seminal point came in the mid-1990s with the convergence of several key statements about design authorship. Between 1995 and 1996, Emigre *magazine devoted two issues to design authorship, titled* Clamor over Design and Writing, *which were guest-edited by Anne Burdick, then a visiting professor of graphic design at North Carolina State University. A juried exhibition,* Designer as Author: Voices and Visions, *was co-curated by my former colleague Cristina de Almeida and myself at Northern Kentucky University; the call for entries went out in the fall of 1995 and the work was*

exhibited in the winter of 1996. Exhibitors read like a who's who of influential designer-authors: Katie Salen, Ellen Lupton and Abbott Miller, Rudy Vanderlans, Stephen Farrell, David Shields, Johanna Drucker, Maria Rogal, Martin Venezky, Nan Goggin, Thomas Starr, Michael Beirut, Bob Aufuldish and others. In 1996, Ellen Lupton and Abbott Miller published a collection of essays about design theory and history titled Design Writing Research: Writing on Graphic Design. *Finally,* Eye *magazine published an article in the winter of 1996, The Designer as Author by Michael Rock, which fueled the debate.*

The latter, while undoubtedly an important contribution to the discourse, is often taken as the genesis of the topic by those whose research consists of selecting 'the low hanging fruit' (TRY GOOGLE SCHOLAR!). *Rick Poynor's essay Producer as Author, in which he discussed Bruce Mau's content-embracing designs for the journal* Zone, *appeared in* Blueprint *magazine in 1989. In 1991, Blueprint published Poynor's article The Designer as Author. My own article, Let an Artist's Book Inspire You, which I wrote and designed for* How *magazine — supposedly its first ever designer-author combination — was printed in 1994. In it, I asserted: "Because the author, artist and printer either work closely together, or are in fact the same person, the integration of content and form is achieved."*

In 2007, a double issue of the Australian journal Visual Design Scholarship *was devoted to the topic of design authorship, with scholars theorizing aspects of authorship and cultural production that had been previously discussed in the graphic design trade press. Contemporary debates on the blog Design Observer, and in* Print *and* Eye *magazines continue to affirm its vitality. In 2011, the Walker Art Center in Minneapolis launched its first major graphic design exhibit since its influential Graphic Design in America from 1989. Titled Graphic Design: Now In Production, its press release states: "...designers are becoming producers: authors, publishers, instigators, and entrepreneurs employing their creative skills as makers of content and shapers of experiences."*

In the almost two decades since this flurry of activity, design authorship has matured and has been so widely assimilated that its tenets are rarely questioned. Imagine the furor of designers to these propositions: you cannot write the text (ONLY A 'WRITER' CAN DO THAT); *you cannot express yourself* (ONLY AN 'ARTIST' CAN DO THAT); *you cannot publish your work* (ONLY A 'PUBLISHER' CAN DO THAT); *you cannot use your designs for social or political commentary* (ONLY A 'JOURNALIST' OR 'ACTIVIST' CAN DO THAT); *you cannot initiate design work* (ONLY A CLIENT CAN COMMISSION NEW WORK); *you cannot conceive of new products and services* (ONLY A 'BUSINESS PERSON' CAN DO THAT) *— it is absurd to consider!*

Designers as authors, as producers, as entrepreneurs, as activists, as editors, as... ____ are here to stay!

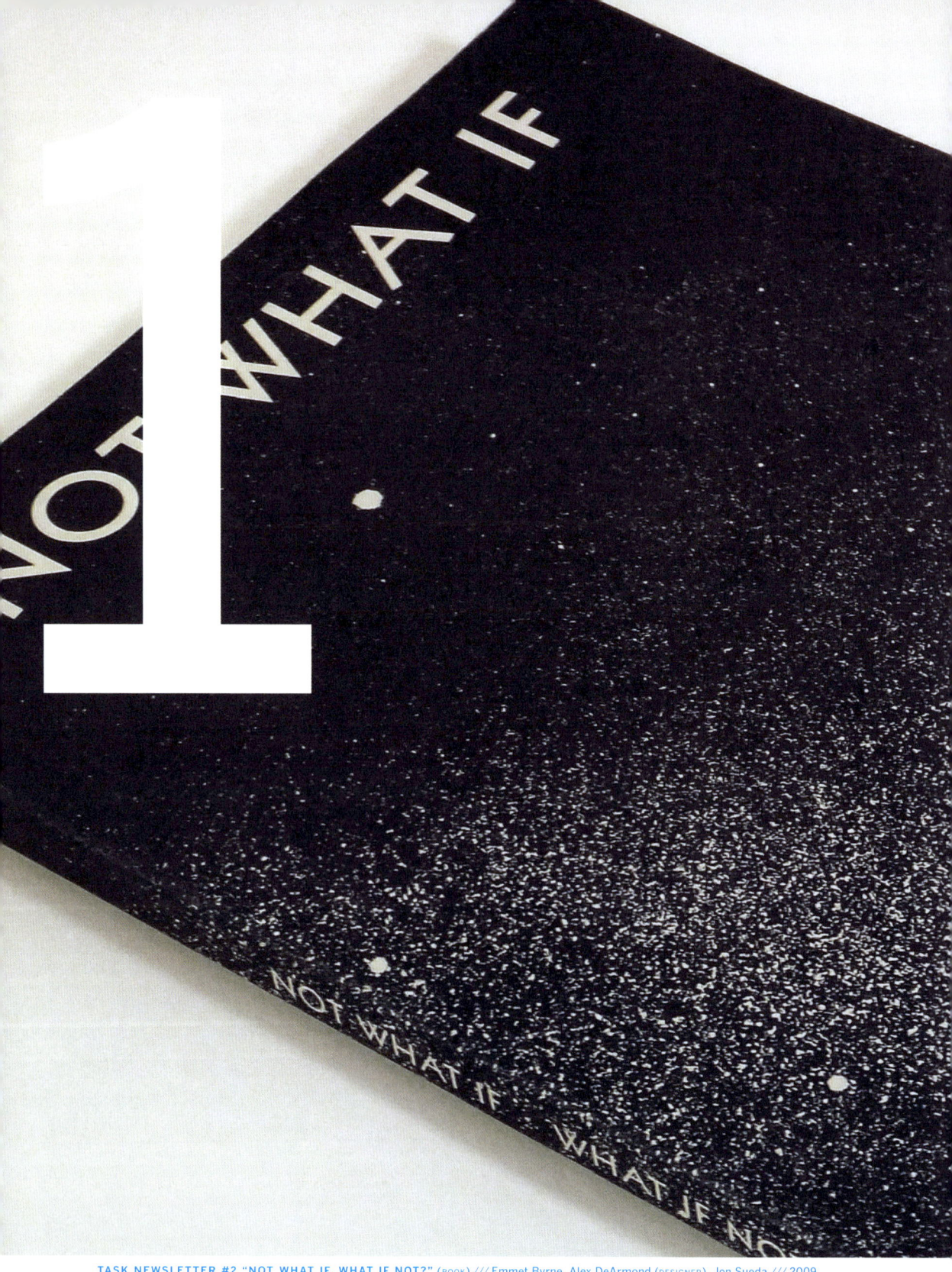

TASK NEWSLETTER #2 "NOT WHAT IF, WHAT IF NOT?" (BOOK) /// Emmet Byrne, Alex DeArmond (DESIGNER), Jon Sueda /// 2009

DESIGN AUTHORSHIP EXPLAINED

What IS DESIGN AUTHORSHIP? How has it been practiced, debated, ignored, theorized, debunked, and championed?

Design authorship might be best defined by what it is not. It is not a style ('GRUNGE' IS A STYLE). It is not a medium ('PRINT' IS A MEDIUM). It is not a technique ('CALLIGRAPHY' REQUIRES TECHNIQUE). It is not a specialization ('PACKAGING DESIGN' IS A SPECIALIZATION). It is not a genre ('PHOTO-MONTAGE' IS A GENRE). It is not a movement ('SWISS MODERNISM' IS A MOVEMENT). It is not a philosophy ('PHENOMENOLOGY' IS A PHILOSOPHY). What, then, is design authorship and how does it differ from conventional design?

01 /// Grunge style
02 /// Stock grunge design elements
03 /// Say it in print
04 /// Calligraphy
05 /// Package design
06 /// David Hockney photo montage
07 /// Swiss modernism
08 /// Mrinal Kanti Bhadra, A Critical Survey of Phenomenology and Existentialism, 1990

The ideas within design authorship include an expanded and more meaningful role for graphic designers through a variety of approaches. Many designers create self-initiated projects without a client commission. Some designers engage in innovative collaborations with diverse sponsors, users, and experts from other fields: musicians, software engineers, actors, scientists, architects, artists, and others. Frequently, designers integrate writing, editing, designing and publishing into an agenda that furthers their messages.

Acknowledging subjective methodologies such as personal expression, ethnographic observation, and literary criticism, for example, enables designer-authors to better empathize with potential users. The recognition of sub-cultural audiences, often through designers' own involvement and interest, helps make designs that are more nuanced and more appropriate. Developing entrepreneurial ventures has been a way for designer-authors to produce innovative new products and services; this is often done to participate in an alternative economy, itself a system to be shaped by design. And finally, designers' desire to affect positive social, cultural, economic and political change through an impassioned engagement is a strong impetus driving design authorship.

Theories of design authorship emerged in the early to mid-1990s as an area of intense debate in the graphic design field. A number of articles, exhibits, design

09 /// Jon Sueda holding Task Newsletter #1
10 /// Michael Bierut
11 /// Paul Rand
12 /// Paul Rand signature
13 /// Yale Bulldog
14 /// Gordon Salchow
15 /// University of Cincinnati Bearcats
16 /// Gordon Salchow, Spring Design Lecture Series, University of Cincinnati, 1979

projects and counter proposals brought the topic into the mainstream. Essentially positioning the designer as a central figure in the visual communications process — contesting notions of neutrality and pure objectivity — designers as authors seek enhanced meaning in their designs.

Some critics question the idea of design authorship, claiming that it's a vehicle for designers to exert their rapidly expanding egos. Rather than working behind the scenes, discretely and anonymously, designer-authors 'forget their place' and strive for glory as cultural producers, as auteurs. Rather than merely focusing on visual form, these designers wish to be involved with content — this is contrary to the conventional wisdom of the profession and how many designers have been trained.

In the publication *Task Newsletter #2*, designer, educator and writer Jon Sueda states: "Although speculative practices have existed throughout the history of design, most notably in architecture, only a small group of graphic designers have positioned themselves in contexts where they are able to pursue explorations built on risk and uncertain ground. This could be the result of numerous unsympathetic conditions deeply rooted in traditional design practice, including the commission structure in which most work is based. According to this model, a client comes to the designer with a brief from which he or she responds by offering viable options for solving the problem. For most clients who want a sellable product, 'what if?' is not the most comfortable starting point. For this reason, speculative projects tend to exist as self-initiated efforts by designers acting as their own clients, proposals within academic contexts, or simply unrealized provocations."

This book explains the machinations of design authorship — its history, how it works, its many manifestations — and is an advocate for the concept. Design authorship has had, and continues to have, a positive impact on the field of graphic design. It has enriched, enabled, expanded and empowered the discipline. It has thrust design from a supporting cast member to a central performer on the world's social, economic and cultural stages. Art, architecture, literature, film, and other expressive, functional and communicative fields have been joined by design's presence.

Authorship also exists in the incremental decisions that designers make. It can be a nudge, an attitude, an approach. Designer and critic Michael Bierut says: "All of the good designers I admire have developed a conviction that the way they serve their clients the best is by bringing a strong point of view to the designer/client relationship. This doesn't always mean simply imposing a strong visual style on everything. It can also mean caring deeply about the meaning of the work, what the messages are, [and] how they're directed."

Artists typically sign their work, as do authors. Attribution is taken for granted — for pride or ownership, or possibly blame. Some designers have a 'signature style' or a 'brand name' that identifies their work, but relatively few designers actively claim credit for their client-oriented designs. American graphic design icon Paul Rand was one exception with his distinctive signature, especially on his illustrative and

17 /// Direct mail
18 /// Direct Marketing Association
19 /// Ohio Environmental Protection Agency
20 /// Tree
21 /// Junk Mail

editorial work. (RAND'S YALE UNIVERSITY GRADUATE STUDENT GORDON SALCHOW, EVENTUALLY A DESIGN PROFESSOR AT THE UNIVERSITY OF CINCINNATI, ONCE CLAIMED "POSTER BY G. S." WITH THIS BEING THE LARGEST TYPE ON A PRINTED POSTER.) Only when one's designs are chosen in an annual competition and published in a trade magazine is attribution known. The payment from a client is usually perceived as credit enough, but what of non-commissioned designs, without a client? Should credit be given to designer-authors, the producers of content?

This is an interesting point, as with increased agency in design authorship comes increased responsibilities — social, economic, ethical, cultural. What about the opposite notion — anonymous design production that's devoid of credit or blame?

Designers typically use their skills and creativity to produce effective visual communications to inform, entertain and persuade viewers. Harnessing the power of verbal and visual languages through text and image, graphic designers give form to the many messages that shape our culture and economy. When they succeed, by creating a symbolically rich and diverse visual culture, the results are an engaged citizenry and a prosperous economy. When they fail (FOR COMPLEX AND SYSTEMIC REASONS AS WELL AS PERSONAL ONES), graphic designers contribute to the waste stream; not just wasted resources like plastic, paper and ink, but wasted consumption as consumers go deep into debt for unnecessary goods. Harder to quantify, but still a concern, is wasted goodwill as the relationships between cultural experiences, civic information, commercial rhetoric and political propaganda become intentionally conflated, to the confusion of the viewer.

For example, a common assumption among direct mail marketers is that a 5% response rate (AN ACTIONABLE RESPONSE FROM MAIL RECIPIENTS) is considered a successful campaign. In 2005, the Direct Marketing Association reported that "the overall average response rate for direct mail, including mailings to both house and prospect files, was 2.77%." Presumably, the remaining 97% goes into the garbage (OR PREFERABLY, THE RECYCLING), at a huge social and environmental cost that is not borne by the sender. The Ohio Environmental Protection Agency claimed that "each year, 100 million trees are used to produce junk mail."

Approached this way, one can see why anonymity is desired; who wishes to be credited with creating waste or ill will — even if the piece is handsomely designed in the conventional sense? Returning to the idea of attribution that is typical in designer-authored works, perhaps a benefit of this is the pressure it will put on typical commercial practice not just to do good work for themselves and their clients, but to do good for all people, for goodness' sake!

Design authorship can then be thought of as a kind of conscience for the wider discipline of graphic design. The integration of content and form means that 'what it says' and 'why it says it' are considered as important as 'how it looks.' This way, the economic activity of professional graphic design is framed by cultural and ethical concerns, thereby elevating its status from a value-neutral service to a social, cultural, economic and political entity that is fully woven into the human condition.

BEFORE THE COMPUTER VIRUS — there was the TERMITE!

✯✯✯✯✯✯✯✯✯✯✯✯✯✯ ✯✯✯✯✯✯✯✯✯✯✯✯✯✯ ✯✯✯✯✯✯✯✯✯✯✯✯✯✯

HAMILTON WOOD TYPE

DESIGN AUTHORSHIP'S ENABLING TECHNOLOGIES

15

Central TO DESIGN AUTHORSHIP has been a heightened engagement with the means of production and distribution. Various technologies, both new and old, have enabled designers to get their messages into the public realm. These have included the personal computer and desktop printer, the letterpress and moveable type, silkscreen, the typewriter, the photocopier, offset printing, the web, and interactive media, among others.

While some of these tools and processes help further the manufacture of designer-authored works, the media that integrate designing and writing deserve special mention. On a single computer with appropriate software, the designer can write and edit text, create a custom typeface to set it in, import and manipulate images, compose page layouts that bring this material together, and print the result to a networked printer. Then, massaging the tone of the prose, correcting a typo, revisiting the type font, swapping one picture for another, adjusting a color, or changing a page layout can happen relatively easily and quickly. Not only are designing and writing infinitely synthetic and malleable in this environment, but it enhances the iterative aspect of the design process.

Letterpress and silkscreen printing have enjoyed a renaissance over the past decade, especially in academic programs and in small studios. While they both offer the particular charms of their medium, they require a knowledge of craft, material and process that differs from computer expertise. In these media, writing is usually done at the level of the slogan, with a broadside or poster as the resulting graphic artifact. Producing a multi-page publication with letterpress or silkscreen is certainly not beyond reach, but due to the time and effort required, many designers opt for posters or simple formats, like an accordion-structure pamphlet. Printing on textured papers, fabric and other diverse substrates is a strong appeal of these technologies. Over-printing and mixing media also produce refreshing results.

01 /// Personal computer and desktop printer
02 /// Letterpress printing press
03 /// Moveable type
04 /// Silkscreen printing
05 /// Underwood typewriter
06 /// Photocopiers
07 /// Offset press
08 /// Accordion folds

 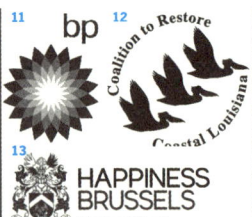

09 /// Anthony Burrill
10 /// Gulf of Mexico
11 /// BP
12 /// Coalition to Restore Coastal Louisiana
13 /// Happiness Brussels
14 /// Hamilton Wood Type Museum, Two Rivers, WI
15 /// Welcome to Two Rivers
16 /// Wisconsin
17 /// Matthew Carter
18 /// Matthew Carter, Carter Latin, 2003
19 /// Matthew Carter (left) and Jim Van Lanen (right)
20 /// Bill Moran
21 /// Polymer plate for letterpress printing
22 /// Stapler
23 /// Spiral binding
24 /// Radar

Designer Anthony Burrill's screen-print "Oil & Water Do Not Mix" is one such example. Using ink literally made from oil-drenched sand captured from the Gulf of Mexico shore after the BP Deepwater Horizon oil spill, the poster makes a powerful graphic — and conceptual — statement. Co-produced with the Happiness Brussels agency in an edition of 200 posters, the proceeds benefitted the non-profit organization Coalition to Restore Coastal Louisiana.

Burrill has also created a series of letterpress broadsides that use large wooden block letters. With slogans like "Clear Your Head," "I Like It, What Is It?" and "Work Hard & Be Nice to People," Burrill's posters celebrate the straight-forward, plain speaking sentiments of yesteryear, with yesterday's hands-on technology. Yet, this technology lives on. The Hamilton Wood Type Museum of Two Rivers, Wisconsin, USA continues to host events, workshops and exhibits related to its 130 year history of manufacturing wooden type. With over 1.5 million pieces of wood type in over a thousand styles, the Hamilton is a vast resource. Typographer Matthew Carter even designed a new triangular-serif chromatic typeface for the Hamilton, in honor of the Museum's founder, Jim Van Lanen. The Hamilton's artistic director Bill Moran designs his own slogan-based posters, including this one printed on thin wood veneer: "Before the Computer Virus – There Was the Termite!"

Setting individual metal letterforms into words, the words into sentences and so on, has empowered many designer-authors to harness letterpress printing's integration of writing, designing and producing graphic works. Because setting volumes of metal type for letterpress printing (THE WAY IT HAS BEEN DONE FOR OVER 500 YEARS) is time-consuming and laborious, many designers output their computer files to polymer plates. This also enables designers to set any digital type and graphics they have access to, as the inventory of all but the most well-equipped letterpress studios will have only limited metal and wooden type choices. Computer output also enables designers to achieve things that are almost impossible to do on the letterpress bed: use contemporary typefaces, curve or angle baselines, overlap characters, control kerning and letter-spacing relationships, and so on.

OIL & WATER DO NOT MIX (PROCESS) /// Anthony Burrill (HAPPINESS BRUSSELS) /// 2010

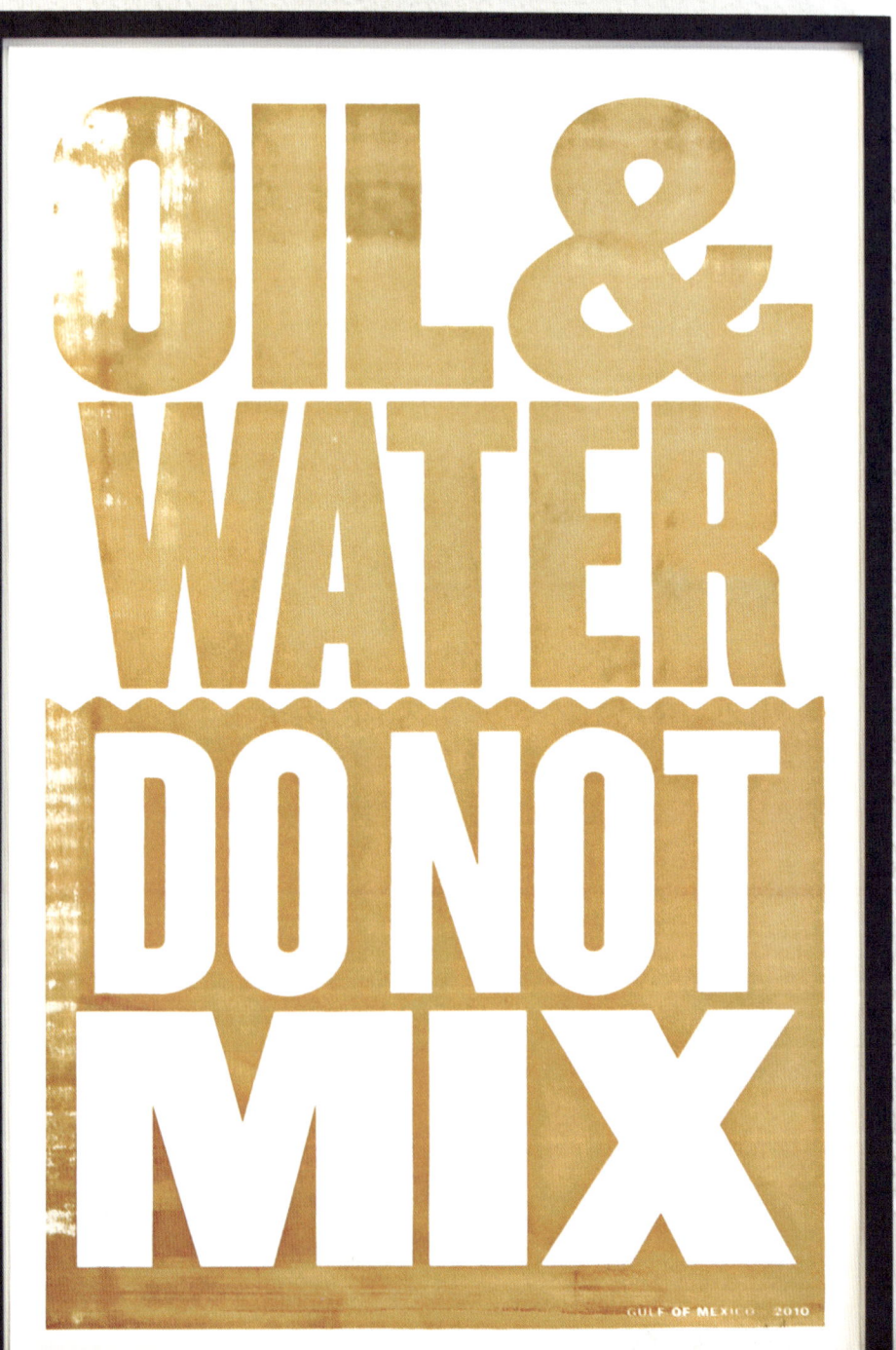

OIL & WATER DO NOT MIX (POSTER) /// Anthony Burrill (HAPPINESS BRUSSELS) /// 2010

Photocopiers have been the inexpensive reproduction technology for writers and designers engaged in creating underground magazines, or 'zines, for many decades. Besides allowing a limited print run (DOZENS OR HUNDREDS, WHILE OFFSET PRINTING REQUIRES EDITIONS IN THE THOUSANDS TO JUSTIFY THE PER UNIT COST), the photocopied look resonates with those desiring a non-mainstream appearance — a gritty, do-it-yourself aesthetic. Collated, hand-folded, stapled or spiral bound, the publications produced by photocopiers have been written, designed and distributed under the radar of the publishing industry, reaching sub-cultural audiences with uncensored content.

The 1990s Riot Grrrl underground scene, associated with punk rock and feminism, was a prolific self-publisher of photocopied 'zines. According to the moma.org web site, "The information disseminated in these cheaply produced, self-published manuscripts became a major tool in the Riot Grrrl movement and prefigured the way blogs and social media would transform the way information is shared today." Their 'zines often featured pink photocopy paper, dry-transfer headline type and collaged imagery. 'Riot Don't Diet' was a recurring slogan, a call to arms.

25 // Riot Grrrl, Riot Grrrl
26 // www.moma.org
27 // Riot Grrrl, Riot Don't Diet
28 // Typewriter ribbon
29 // Typewriter font Pica
30 // Typewriter font Elite
31 // Wite-Out
32 // QWERTY keyboard
33 // Rachel Marsden
34 // Rachel Marsden, Little Book of Fears, 2005

The writing for many of these photocopied publications or other designer-authored works was the typewriter, a technology that reigned supreme for roughly the century spanning the 1870s to the 1980s. The typewriter combined the creative act of writing with a mechanical device that made writing manifest. Metal keys hammered letterforms via an ink-soaked cloth ribbon onto paper, merging the process of writing and printing.

Typewriting was an immediate but rather inflexible technology. Type font choice was extremely limited, character spacing was 'mono-width' (THE LETTERS M AND I BOTH OCCUPIED THE SAME HORIZONTAL SPACE), line length and leading were fixed by the machine's physical structure, and paper size and thickness were largely limited to industry-standard. Nonetheless, some concrete poets exploited the graphic potential of the typewriter to good effect.

A nostalgia for typewriters has emerged over the past several years, as writers and designers desire the sounds and smells associated with clacking keys, ringing carriage returns, evaporating ink and its oft-needed corrective companion: Wite-Out. Contemporary keyboards still use the typewriter's QWERTY layout, so the ghost of this obsolete technology persists in a familiar way. Fortunately, the typewriter's unforgivingly permanent key strike has been rectified by computer software's 'undo' and 'spell check' capabilities!

35 // Piggyback
36 // Make-ready
37 // School of Art & Design t-shirt
38 // SUNY (State University of New York) Purchase
39 // Clifton Meador
40 // Philip Zimmerman
41 // Warren Lehrer
42 // Brad Freeman
43 // Clifton Meador, A Long Walk, 1993
44 // Philip Zimmerman, Sanctus Sonorensis, 2009
45 // Warren Lehrer, A Life in Books: The Rise and Fall of Bleu Mobley, 2012
46 // Brad Freeman, JAB5 (Journal of Artists Books), 1996
47 // Printed Matter, Inc.
48 // New York NY

In spite of typewriting's quirks, some prefer it as a medium and process. Rachel Marsden, an artist, book-binder, writer and scholar of Chinese art, collects old typewriters, which she uses in her creative work. She states on bookartobject.blogspot.com, "…through the use of text, photographic documentation and audience response, I investigate notions of archiving and repetitious actions, such as typing and printing…." For Marsden, the typewriter is a writing tool, but also an object with near-fetish qualities. "I ♥ typewriters!" she exclaims.

Although creating designer-authored works using offset printing is expensive, it is certainly used by large scale collaborative efforts for mass communications with commercial potential. Magazines, books and other graphic designs use offset's high quality, lower per unit cost and manufacturing consistency to increase marketability. Although an entire publication may not necessarily be characterized as a work of design authorship, specific pages, spreads or sections may reveal an enhanced level of meaning between the form and content. Some designer-authors have found ways to 'piggy-back' their projects onto others' press runs, claiming unused paper at the margins, or using trimmings or 'make-ready' sheets.

One facility that combines many of the printing technologies mentioned is the School of Art and Design's Center for Editions at SUNY (STATE UNIVERSITY NEW YORK) Purchase campus. It offers offset, letterpress, a bindery, prepress, digital printing and more in an experimental laboratory environment for teaching and creative research. Clifton Meador, Philip Zimmerman, Warren Lehrer, Brad Freeman and many others have created artists' books there that would have been prohibitively expensive or logistically impossible at a typical commercial printer. Their works are often found at Printed Matter, a shop in New York City that sells designer and artist-authored works. "We are interested in artists' publications that

are 'democratizing' artworks — that is, inexpensive and produced in larger editions or open editions. Generally speaking, we prefer editions of over 100."

A comparable reproduction technology is the Risograph, a high speed digital printer, offering the economies of photocopying with the production pace and volume of offset printing. Unlike photocopying's toner, the Risograph uses ink drums, which can be switched for innovative color experiments, similar to the layering of color with silkscreen. It is well-suited for one, two and three color publications benefitting from a medium-sized press run.

Felix Pfaeffli is a frequent Risograph user. His firm Feixen uses the technology for its creative potential, but also for the production control it offers. The many posters he has designed for Südpol, a multi-purpose cultural center in Switzerland, show the range and appropriateness of this printing process. UK-based Landfill Editions and Ditto Press have leveraged 'Riso' technology in their books, magazines and posters. Referring to Ditto's books, and by extension to Feixen's posters, blog.eyemagazine.com writes: "...these unpretentious, colorful books already display the creative benefits of housing design and production under the same roof."

49 /// Risograph
50 /// Felix Pfaeffli
51 /// Südpol, Lucerne
52 /// Switzerland
53 /// Landfill Editions
54 /// Jiro Bevis, Ditto Press Poster, 2009
55 /// blog.eyemagazine.com
56 /// Occuprint
57 /// Occupy Wall Street

Under a different roof, on-demand digital printing may offer the best of both worlds: the quality and consistency of offset printing and professional-grade binding with the low cost and individuality of computer desktop printing. Several online services now offer the ability to upload digital files and receive a professionally printed and bound book a week later. High resolution imagery, crisp typography, perfect or case-bound binding, and 100 pages on decent paper stock in an edition as low as one is about as expensive as a comparable commercially available book. The idea of mass customization, where the individually customized product enjoys the quality of scale of mass production is realized in on-demand printing, making it a powerful tool for designer-authors.

Web site design is another medium where this occurs. Besides the relatively inexpensive aspect of launching and maintaining a web site that reaches a global audience, designers, writers and

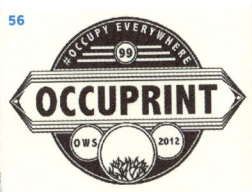

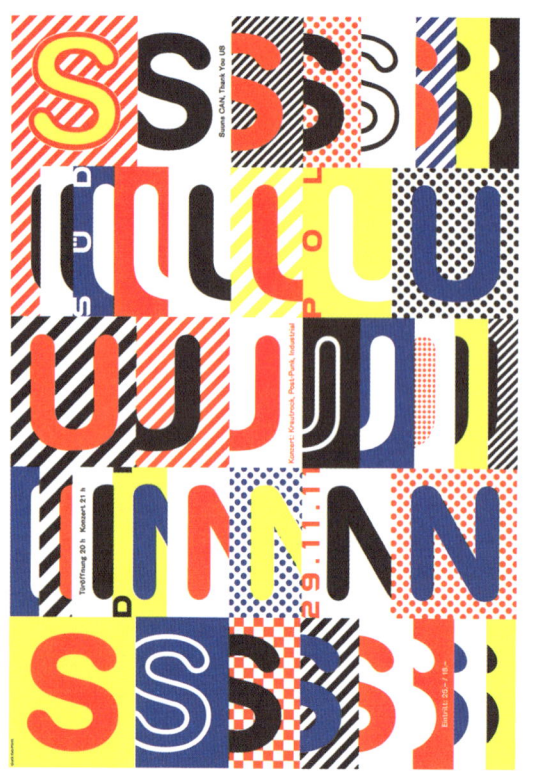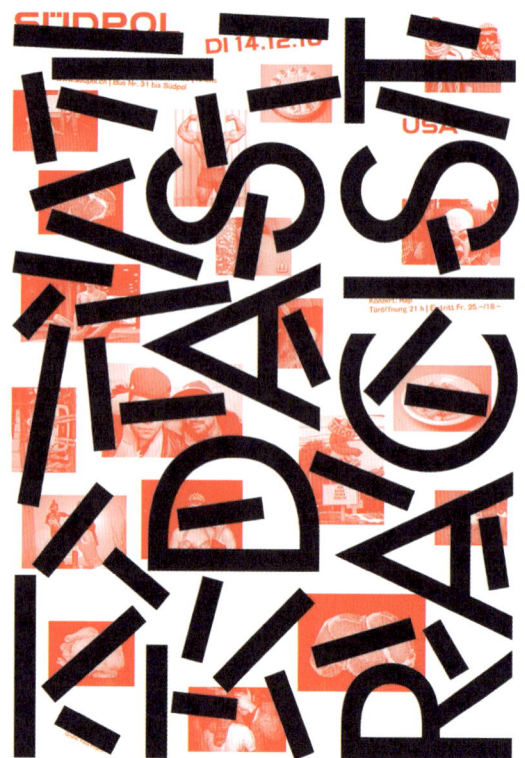

SÜDPOL LUCERNE (POSTERS) /// Felix Pfäffli (FEIXEN) /// 2010–12

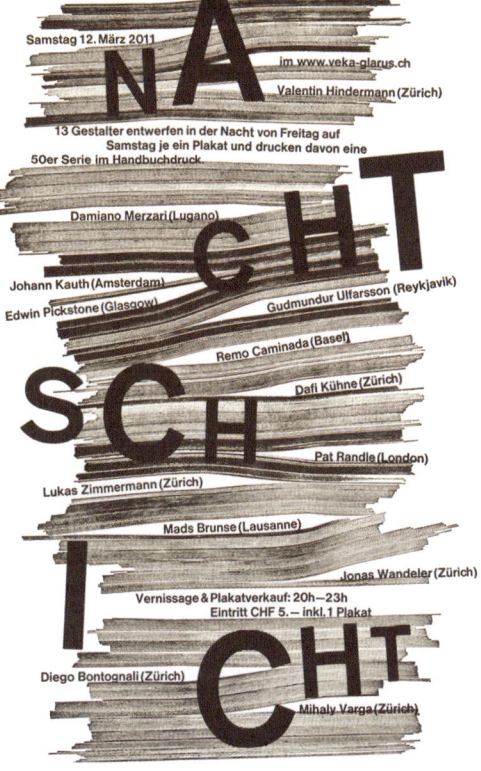

above /// **NACHTSCHICHT** (POSTER) /// Dafi Kühne and Jonas Wandeler (FEIXEN) /// 2011
below /// **LE LUCI DELLA CENTRALE ELETTRICA** (POSTER) /// Dafi Kühne (BABYINKTWICE) /// 2012

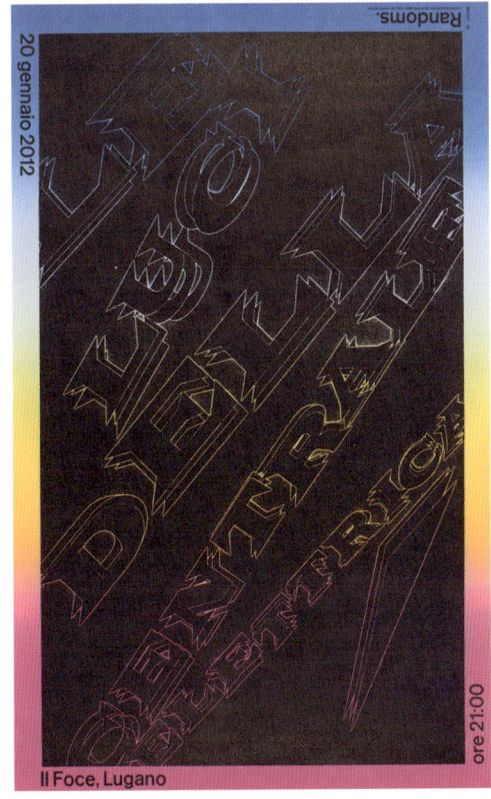

OCCUPY LONDON (POSTER) /// Monika Ciapala (MERDESIGN.CO.UK) /// ca.2011

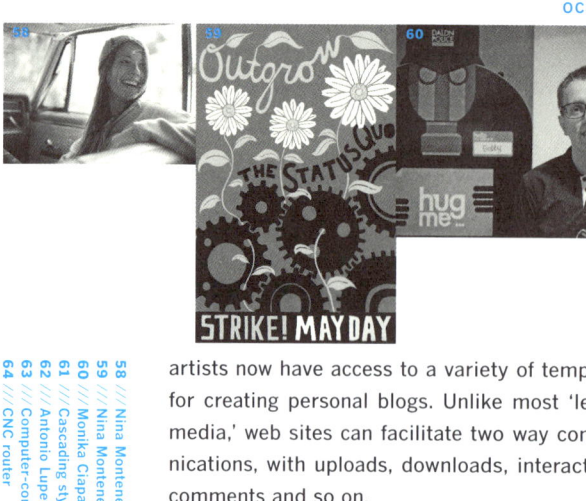

58 /// Nina Montenegro
59 /// Nina Montenegro, Outgrow the Status Quo, 2012
60 /// Monika Ciapala
61 /// Cascading style sheets
62 /// Antonio Lupetti
63 /// Computer-controlled laser cutter
64 /// CNC router

artists now have access to a variety of templates for creating personal blogs. Unlike most 'legacy media,' web sites can facilitate two way communications, with uploads, downloads, interactions, comments and so on.

Occuprint.org displays posters devoted to the causes identified with the Occupy Wall Street movement and its global variants. Freely uploaded and downloaded PDF files, through a Creative Commons license of "Attribution — Non-Commercial — ShareAlike," the posters are varied in style, graphic medium and message. Each designer is named and a web site link provided for most. Nina Montenegro's "Outgrow the Status Quo — Strike! May Day" poster contrasts flowers with gears to make her point. "Occupy London" by Monika Ciapala features a cartoon figure wearing a Guy Fawkes mask who is shackled to a chain and ball inscribed with the word "debt."

Occuprint does have a curatorial aspect to its selection process, accepting posters according to policies (MOSTLY ABOUT CONTENT, NOT STYLE) listed on its web site. Still, the variety is impressive.

For the more ambitious 'digerati,' writing software code furthers the creative control designers have over the content and form of their web communication. Writing software code is its own form of authorship, with considerations of style and format. Besides the building blocks of writing, like words and structure, and designing, like visual elements, web designer-authors must understand the software's particular syntax so that their code is coherent and useable. For example, in writing Cascading Style Sheets (CSS) to better control web typography, Antonio Lupetti advocates taking a "semantic approach instead of a structural approach" that responds to web page content, not just column position.

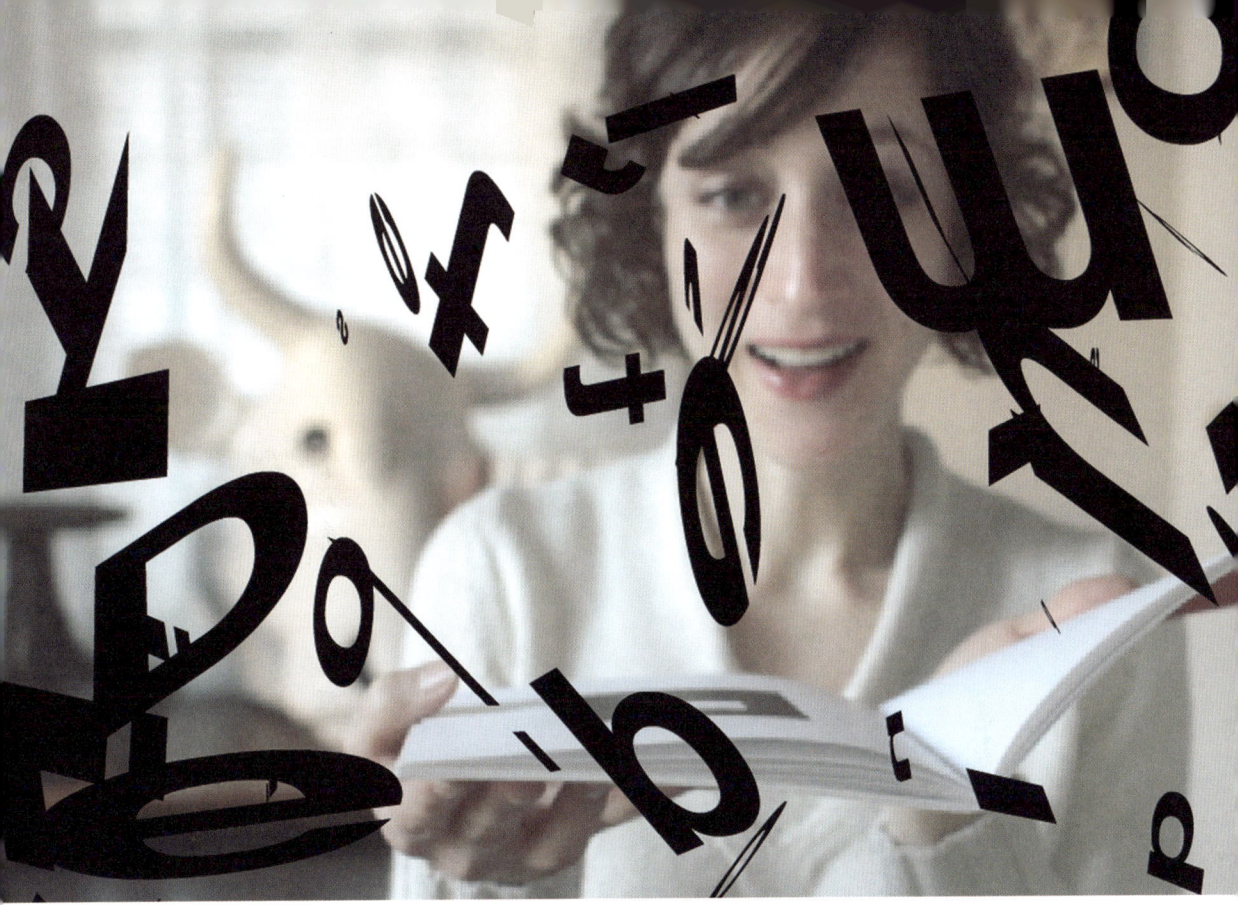

BETWEEN PAGE AND SCREEN (BOOK AND INTERACTIVE EXPERIENCE) /// Amaranth Borsuk and Brad Bouse (SIGLIO PRESS) /// 2012

Dear P,
You give me space to undulate, SCHEREN. My best subject was always division; I like partition. You only get a portion of the stuff that makes me up—or anyone. The rest hides. I own both sword and plowshare, sure. I lied—not idle, I'd sidle up to either side that held me, let slide my I. Oh yes.

—S

65 /// Dafi Kühne
66 /// Zurich, Switzerland
67 /// Dafi Kühne, Voodoo Rhythm Dance Night, 2012
68 /// Dafi Kühne, Zurich Milano, 2011
69 /// Hatch Show Print, Nashville TN
70 /// Nashville
71 /// Nashville (ABC)
72 /// Nashville (Altman, 1975)
73 /// Lovin' Spoonful, Nashville Cats, 1966
74 /// A Nashville Cat

Particular to interactive media (AND THIS INCLUDES NON-ELECTRONIC MEDIA LIKE SOME ARTISTS' BOOKS, EXHIBITS, INSTALLATIONS AND THREE-DIMENSIONAL SPACES) is the consideration of the user as a co-author and co-designer. Navigational choices, non-linear interaction, user input, data-base manipulation and so on, contribute to users constructing their own form and content — the user as participant, as co-designer-author.

An emerging trend is the use of hi- and low-tech together, of blending media and technologies to create hybrid works. Some designers use computer-controlled laser-cutters to etch their Illustrator vector lines into sheets of plastic or rubber for painting stencil art. Others use a CNC (COMPUTER NUMERICAL CONTROL) router to carve wood blocks for letterpress printing. Two examples of merging computer technology with hands-on production follow.

Zurich-based designer Dafi Kühne of Baby Ink Twice, who uses a computer and letterpress to produce posters, states: "I want have the full control over the whole process and make all decisions like choosing the colors and the paper, mixing the ink, setting the amount of pressure ... to fit my design concept." To this end, he uses laser-cut wood type, polymer plates, linoleum blocks and traditional letterpress tools to print his computer designs. Because Kühne did a summer internship at Hatch Show Print in Nashville, USA — a letterpress printing shop since 1879 — he knows the medium's history, and its present.

Duo Amaranth Borsuk and Brad Bouse, by combining strengths in writing poetry and programming software code, have created an offset ink-on-paper book titled *Between Page and Screen* that generates kinetic typography when its abstract pixels are 'read' by a computer's web camera. Furthermore, the book's human reader becomes an on-screen participant in the animation of the text — revealing that the story is a romance! According to imprint.printmag.com, Borsuk's interest in a "distributed idea of authorship" helped create the technologically mediated relationship.

Other designer-authors mix media in unexpected ways: old and new, two-dimensional and three

dimensional, natural and synthetic, hand-crafted and machined. Evelin Kasikov, an Estonian-born designer working in London, creates hand-embroidered images and letterforms sewn onto thick paper. Kasikov sews small Xs onto a low-resolution grid, using the CMYK (CYAN, MAGENTA, YELLOW AND BLACK) color separation common to halftone screening for offset printing. The resulting designs flicker with energy and texture, revealing the process of its production.

Another example is the Fire Basket product designed by Dutch typographer René Knip. Knip's blocky, robust letters are laser-cut into three curved aluminum segments, that when bolted together, create an outdoor receptacle for a patio fire. The type is both structure and message, as a fire within the basket backlights poetic word phrases: "sweet head," "silent tongue," "night egg," and others. Through Knip's imagination, type, metal and fire conspire to initiate the conversations of a night-time party, making design authorship an aspect of social life.

Design authorship is enabled by these technologies that facilitate a strong relationship between the creative act, the craft of its realization, and channels of distribution. The ability to combine writing, designing, producing and disseminating is empowering.

75 /// Amaranth Borsuk
76 /// Brad Bouse
77 /// Amanda Borsuk and Brad Bouse, Between Page and Screen, 2012
78 /// imprint.printmag.com
79 /// Evelin Kasikov
80 /// Estonia
81 /// London UK
82 /// René Knip, Fire Basket, 2007
83 /// Dutch
84 /// René Knip

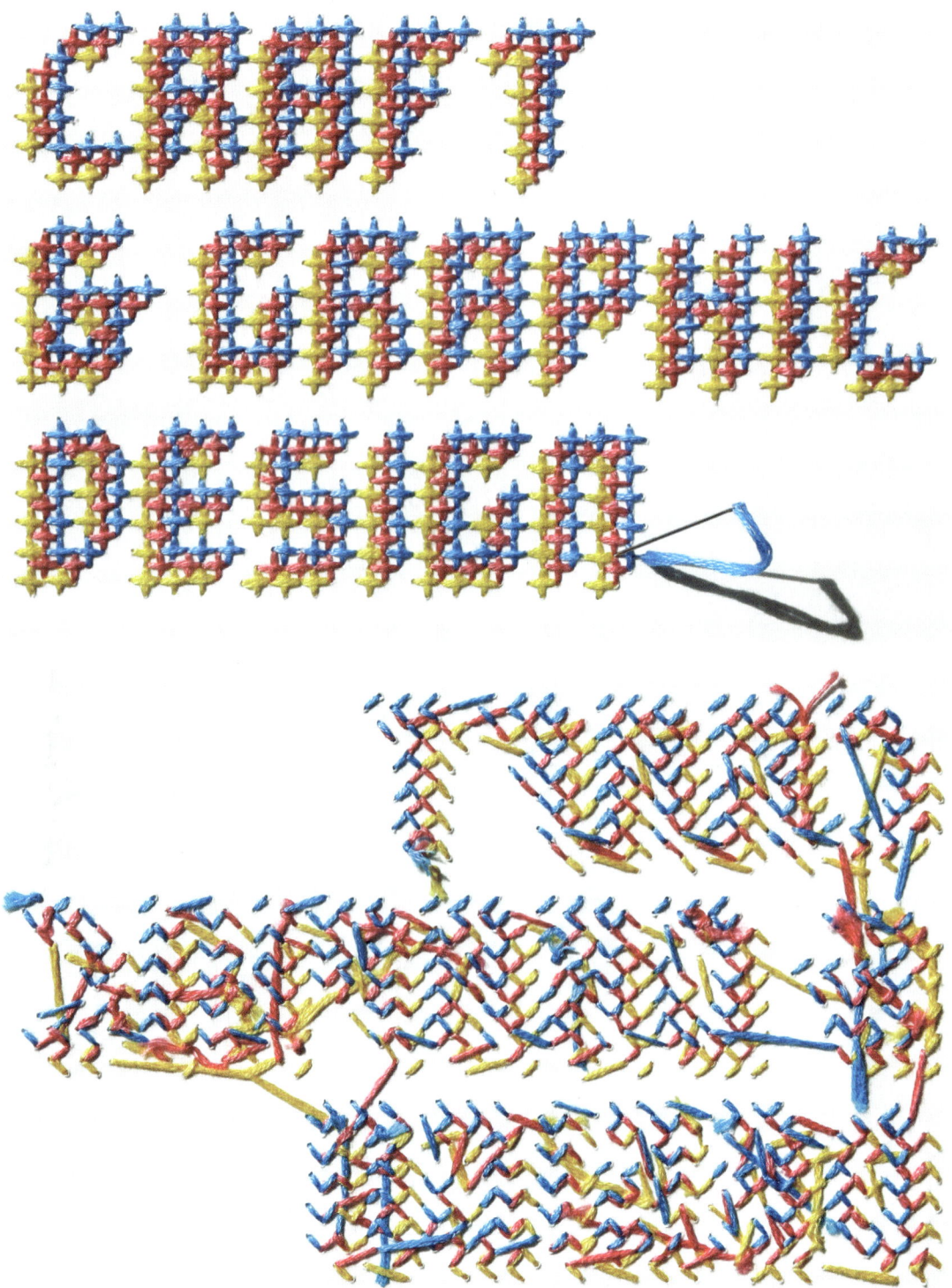

CRAFT AND GRAPHIC DESIGN (EXPERIMENTAL HAND-STITCHED LETTERING) /// Evelin Kasikov /// 2012

TIMELINE OF DESIGN AUTHORSHIP

Design AUTHORSHIP has roots that go back over one hundred and twenty years, to the late nineteenth century. While most of these early works were publications or other print graphics, articles about authorship can be found from the mid-twentieth century forward, and exhibitions of, and about, the designer as author are in evidence from the mid-1990s.

This timeline shows a trajectory of designer-authored works, articles and exhibits — each with date, title, and persons associated with the project. It is not an exhaustive list. Rather, it attempts to show the most influential contributions to the idea of the designer as author over time.

WORKS OF DESIGN AUTHORSHIP

1891 /// **William Morris** /// *The Story of the Glittering Plain* (BOOK)
1892 /// **William Morris** /// *News from Nowhere* (BOOK)
1923-1926 /// **Hendrik N. Werkman** /// *The Next Call* (PUBLICATION)
1923-1931 /// **Kurt Schwitters** /// *Merz* (PUBLICATION)
1928 /// **Jan Tschichlold** /// *The New Typography* (BOOK)
1931 /// **Eric Gill** /// *An Essay on Typography* (BOOK)
1943-1945 /// **Willem Sandberg** /// *Experimenta Typographica* (WORKS)
1949-1967 /// **Herbert Spencer** /// *Typographica* (MAGAZINE)
1950-1951 /// **Alexey Brodovitch** /// *Portfolio* (MAGAZINE)
1957-1980 /// **Push Pin Studio (Milton Glaser, Seymour Chwast, Edward Sorel)** /// *Push Pin Graphic* (PUBLICATION)
1961-1970 /// **Archigram architects, Peter Cook** (EDITOR) /// *Archigram* (MAGAZINE)
1964 /// **Ken Garland** (PLUS 21 OTHER SIGNATORIES) /// **First Things First** (MANIFESTO)
1967 /// **Lorraine Schneider** /// War is Not Healthy for Children and Other Living Things (POSTER)
1967 /// **Marshall McLuhan** (WRITER), **Quentin Fiore** (GRAPHIC DESIGNER) /// *The Medium is the Massage: An Inventory of Effects* (BOOK)
1966-1968 /// **Ralph Eckerstrom** (PUBLISHER), **Massimo Vignelli** (DESIGNER) /// *Dot Zero* (PUBLICATION)
1969-1991 /// **Grapus** /// Socially activist posters
1970 /// **Tom Phillips** /// *A Humument* (ARTIST'S BOOK)
1971-1974 /// **Wolfgang Weingart** /// Typography as (Painting) (POSTER SERIES)
1978-1982 /// **Rick Vermeulen, Hard Werken** /// *Hard Werken* (MAGAZINE)
1984 /// **Tibor Kalman, M&Co.** /// Waste Not a Moment (WRISTWATCH)
1984-2005 /// **Rudy Vanderlans** (DESIGNER AND EDITOR), **Zuzana Licko** (TYPOGRAPHER) /// *Emigre* (MAGAZINE)

01 /// William Morris
02 /// Hendrik Werkman
03 /// Kurt Schwitters
04 /// Jan Tschichold
05 /// Eric Gill
06 /// Willem Sandberg
07 /// Herbert Spencer
08 /// Alexey Brodovitch
09 /// Milton Glaser
10 /// Seymour Chwast
11 /// Edward Sorel
12 /// Peter Cook
13 /// Ken Garland
14 /// Lorraine Schneider
15 /// Marshall McLuhan
16 /// Quentin Fiore (second from left)
17 /// Ralph Eckerstrom
18 /// Massimo Vignelli
19 /// Pierre Bernard (Grapus)
20 /// Tom Phillips
21 /// Wolfgang Weingart
22 /// Rick Vermeulen (left)
23 /// Tibor Kalman
24 /// Zuzana Licko and Rudy Vanderlans
25 /// Guerrilla Girl
26 /// April Greiman
27 /// Simon Johnston
28 /// Mark Holt
29 /// Warren Lehrer
30 /// Michael Burke
31 /// Hamish Muir
32 /// Gran Fury
33 /// Kalle Lassn
34 /// Frank Heine
35 /// David Comberg (Class Action)
36 /// Jonathan Barnbrook
37 /// Anne Burdick
38 /// Art Spiegelman
39 /// Jacqueline Thaw (Class Action)
40 /// Michael Bierut
41 /// Neville Brody
42 /// Jon Wozencroft
43 /// Katie Salen

1985 /// **Guerrilla Girls** /// Women Artists Earn Only 1/3 of What Men Do (POSTER)
1986 /// **April Greiman** /// *Design Quarterly 133:* Does It Make Sense? (PUBLICATION/POSTER)
1986–1992 /// **Simon Johnston, Mark Holt, Michael Burke, Hamish Muir** (DESIGNERS AND EDITORS) /// *Octavo* (PUBLICATION)
1987 /// **Warren Lehrer** /// *GRRRHHHH: A Study of Social Patterns* (ARTIST'S BOOK)
1988 /// **Gran Fury** /// The Government Has Blood on Its Hands (POSTER)
1989–present /// **Kalle Lassn** (EDITOR AND ART DIRECTOR) /// *Adbusters* (MAGAZINE)
1991 /// **Frank Heine** /// Remedy (TYPEFACE)
1991–2000 /// **Jon Wozencroft** (EDITOR), **Neville Brody** (DESIGNER, AMONG OTHERS) /// *FUSE* (PUBLICATION + FONTS)
1992–95 /// **Michael Bierut** (DESIGNER AND EDITOR) /// *ReThinking Design* (PUBLICATION FOR MOHAWK PAPER)
1992 /// **Jonathan Barnbrook** /// Manson (TYPEFACE RELEASED BY EMIGRE AS 'MASON')
1992 /// **Art Spiegelman** /// *Maus: A Survivor's Tale* (GRAPHIC NOVEL)
1994 /// **Class Action** /// Aiding Awareness: Women's Stories (INSTALLATION)
1994–present /// **Anne Burdick** (DESIGN EDITOR SINCE 1996) /// Electronic Book Review (WEBSITE)
1994–2000 /// **Katie Salen** (AND VARIOUS GUEST EDITORS) /// *Zed* (JOURNAL)
1995 /// **Shepard Fairey** /// Obey Giant (VIRAL POSTER CAMPAIGN)
1995 /// **Auriea Harvey** /// entropy8.com (WEBSITE)
1995 /// **Women's Design Research Unit (WD+RU)** /// Pussy Galore (FONT)
1995 /// **Amy Franceschini, Olivier Laude, Michael Macrone** /// atlasmagazine.com (WEBSITE)
1995–1999 /// **Cactus / Tony Credland** /// *Feeding Squirrels to the Nuts* (PUBLICATION)
1997–2004 /// **Kenneth FitzGerald** (EDITOR AND DESIGNER) /// *News of the Whirled* (PUBLICATION)
1997–2004 /// **Jop van Bennekom** (CO-EDITOR AND DESIGNER) /// *Re–Magazine*
1997 /// **James Victore** /// Use a Condom (POSTER)
1998 /// **Bruce Mau** /// Incomplete Manifesto for Growth (WEB PAGE WWW.BRUCEMAUDESIGN.COM)
1998 /// **School of Visual Arts, New York** /// Designer as Author (MFA PROGRAM)
1999 /// First Things First 2000 (MANIFESTO) /// **33 signatories.** *Emigre, Adbusters, Eye,* et al
2000–2011 /// **Stuart Bailey, Peter Bilák, and (later) David Reinfurt** /// *Dot Dot Dot* (MAGAZINE)
2000 /// **Marcia Lausen, Stephen Melamed, Elizabeth (Dori) Tunstall** /// Design for Democracy: Ballot + Election (DESIGN PROJECT)
2001 /// **Josh On** /// They Rule (www.theyrule.net) (WEBSITE)
2001 /// **Tibor Kalman** (TEXT) **Jonathan Barnbrook** (DESIGN) /// Designers, Stay Away from Corporations that Want You to Lie for Them (BILLBOARD AT AIGA CONFERENCE, LAS VEGAS)
2001 /// **Chip Kidd** /// *Cheese Monkeys: a Novel in Two Semesters* (BOOK)
2001–2009 /// **Armin Vit** /// Speak Up/Under Consideration (BLOG)
2002 /// **Kate Bingaman-Burt** /// obsessiveconsumption.com (WEBSITE)
2003–present /// **Michael Bierut, William Drenttel, Jessica Helfand, Rick Poynor** /// (FOUNDING EDITORS) Design Observer (BLOG)

44 /// Shepard Fairey
45 /// Auriea Harvey
46 /// Sian Cook (WD+RU)
47 /// Amy Franceschini
48 /// Olivier Laude
49 /// Tony Credland
50 /// Jop van Bennekom
51 /// Bruce Mau
52 /// Steven Heller (co-founder SVA MFA in Design Writing)
53 /// Michael Macrone
54 /// Kenneth FitzGerald
55 /// James Victore
56 /// Stuart Bailey
57 /// Peter Bilák
58 /// Marcia Lausen
59 /// Dori Tunstall
60 /// David Reinfurt
61 /// Stephen Melamed
62 /// Josh On
63 /// Tibor Kalman
64 /// Chip Kidd
65 /// Armin Vit
66 /// Kate Bingaman-Burt
67 /// William Drenttel and Jessica Helfand
68 /// Nicholas Blechman
69 /// Rick Poynor
70 /// Rick Valicenti
71 /// Peter Lunenfeld
72 /// Metahaven
73 /// Abake
74 /// Cristina de Almeida
75 /// Steven McCarthy
76 /// Kali Nikitas
77 /// Johanna Drucker
78 /// Maya Drozdz (right)
79 /// Chris Corneal
80 /// Zak Kyes
81 /// Daniel Jasper
82 /// Tom Starr
83 /// Walter Benjamin
84 /// Roland Barthes
85 /// Michel Foucault
86 /// Mark Owens
87 /// Elizabeth Sacartoff
88 /// Gunnar Swanson
89 /// Katherine and Michael McCoy
90 /// Will Novosedlik
91 /// Michael Rock
92 /// Ellen Lupton
93 /// Renée Riese Hubert
94 /// Denise Gonzalez Crisp
95 /// Mike Sharples
96 /// Abbott Miller

34

2003 /// **Winterhouse Editions** /// *The National Security Strategy of the United States of America* (BOOK)

2003 /// **Rick Valicenti** /// *Suburban Maul* (PUBLICATION)

2004 /// **Nicholas Blechman** (EDITOR) /// *Empire* (Nozone IX) (BOOK)

2001–2005 /// **Peter Lunenfeld** (EDITOR) /// MIT Mediawork (PROJECT)

2008 /// **Chip Kidd** /// *The Learners* (BOOK)

2008 /// **Shepard Fairey** /// Obama Hope (POSTER)

2011 /// **Åbäke** /// I am still alive #21 in *Graphic Design: Now in Production* (CATALOGUE FOR WALKER ART CENTER)

2011 /// **Metahaven** /// Facestate (PROJECT)

EXHIBITIONS

1996 /// *Designer as Author: Voices and Visions* /// **Cristina de Almeida, Steven McCarthy** (CURATORS) /// NORTHERN KENTUCY UNIVERSITY, HIGHLAND HEIGHTS KY

1996 /// *And She Told 2 Friends: An International Exhibit of Graphic Design by Women* /// **Kali Nikitas** (CURATOR) /// WOMAN MADE GALLERY, CHICAGO IL

1998 /// *The Next Word: Text and/as Image and/as Design and/as Meaning* /// **Johanna Drucker** (CURATOR) /// THE NEUBERGER MUSEUM OF ART, SUNY PURCHASE NY

1999 /// *Soul Design* /// **Kali Nikitas** (CURATOR) /// MINNEAPOLIS COLLEGE OF ART AND DESIGN, MINNEAPOLIS MN; GRAFILL GALLERY, OSLO, NORWAY

2001 /// *Adversary: an Exhibition (of) Contesting Graphic Design* /// **Kenneth FitzGerald** (COLLATOR) /// TRAVELED TO SEVEN VENUES

2004 /// *Outside In* /// **Maya Drozdz** (CURATOR) /// TRAVELED TO FOUR VENUES

2004 /// *I Profess: The Graphic Design Manifesto* /// **Maya Drozdz and Chris Corneal** (CURATORS) /// TRAVELED TO EIGHT VENUES

2006 /// *Trigger: Projects Initiated by Graphic Designers* /// **Jacqueline Thaw** (CURATOR) /// FORDHAM UNIVERSITY AT LINCOLN CENTER, NEW YORK NY

2007 /// *Forms of Inquiry: The Architecture of Critical Graphic Design* /// **Mark Owens, Zak Kyes,** (CURATORS) /// TRAVELED TO FOUR VENUES

2007 /// *Products of our Time* /// **Daniel Jasper** (CURATOR) /// GOLDSTEIN MUSEUM OF DESIGN, UNIVERSITY OF MINNESOTA, ST. PAUL MN

2011 /// *We The Designers invitational exhibition* /// **Tom Starr** (CURATOR) /// NORTHEASTERN UNIVERSITY, BOSTON MA; NATIONAL PRESS CLUB, WASHINGTON DC; AIGA GALLERY, NEW YORK NY; TRAVELED TO FOUR VENUES

WRITINGS AND PRESENTATIONS

1934 /// **Walter Benjamin** /// The Author as Producer (REFLECTIONS: ESSAYS, APHORISMS, AUTOBIOGRAPHICAL WRITINGS)(NEW YORK: HARCOURT BRACE JOVANOVICH, 1978)

1940 /// **Elizabeth Sacartoff** /// Artist as Reporter (A-D, SEPTEMBER–AUGUST 1940) (NEW YORK: A-D PUBLISHING CO.)

1967 /// **Roland Barthes** /// The Death of the Author (ASPEN JOURNAL, NEW YORK: ROARING FORK PRESS)

97 /// Monika Parrinder
98 /// Anthony Dunne
99 /// Fiona Raby
100 /// Cheryl Towler Weese
101 /// Gérard Mermoz
102 /// Katherine Moline
103 /// Kate Sweetapple
104 /// Tara Winters
105 /// Maria Rogal
106 /// Dmitri Siegel
107 /// Kate Bowden
108 /// Rebecca Targ
109 /// William Morris, The Story of the Glittering Plain or the Land of Living Men, 1891
110 /// William Morris, The News from Nowhere, 1892
111 /// Hendrik N. Werkman, The Next Call, 1923
112 /// Kurt Schwitters, Merz 11, 1924
113 /// Jan Tschichold, The New Typography, 1928
114 /// Eric Gill, An Essay On Typography, 1931
115 /// Willem Sandberg, Experimenta Typographica, 1956
116 /// Herbert Spencer, Typographica 7, 1953
117 /// Alexi Brodovitch, Portfolio, 1951
118 /// Push Pin Studios, Push Pin Graphic 76, 1978
119 /// Archigram Architects, Archigram 4, 1964
120 /// Ken Garland, First Things First, 1964
121 /// Lorraine Schneider, War Is Not Healthy for Children and Other Living Things, 1967
122 /// Marshall McLuhan and Quentin Fiore, The Medium is the Massage: An Inventory of Effects, 1967

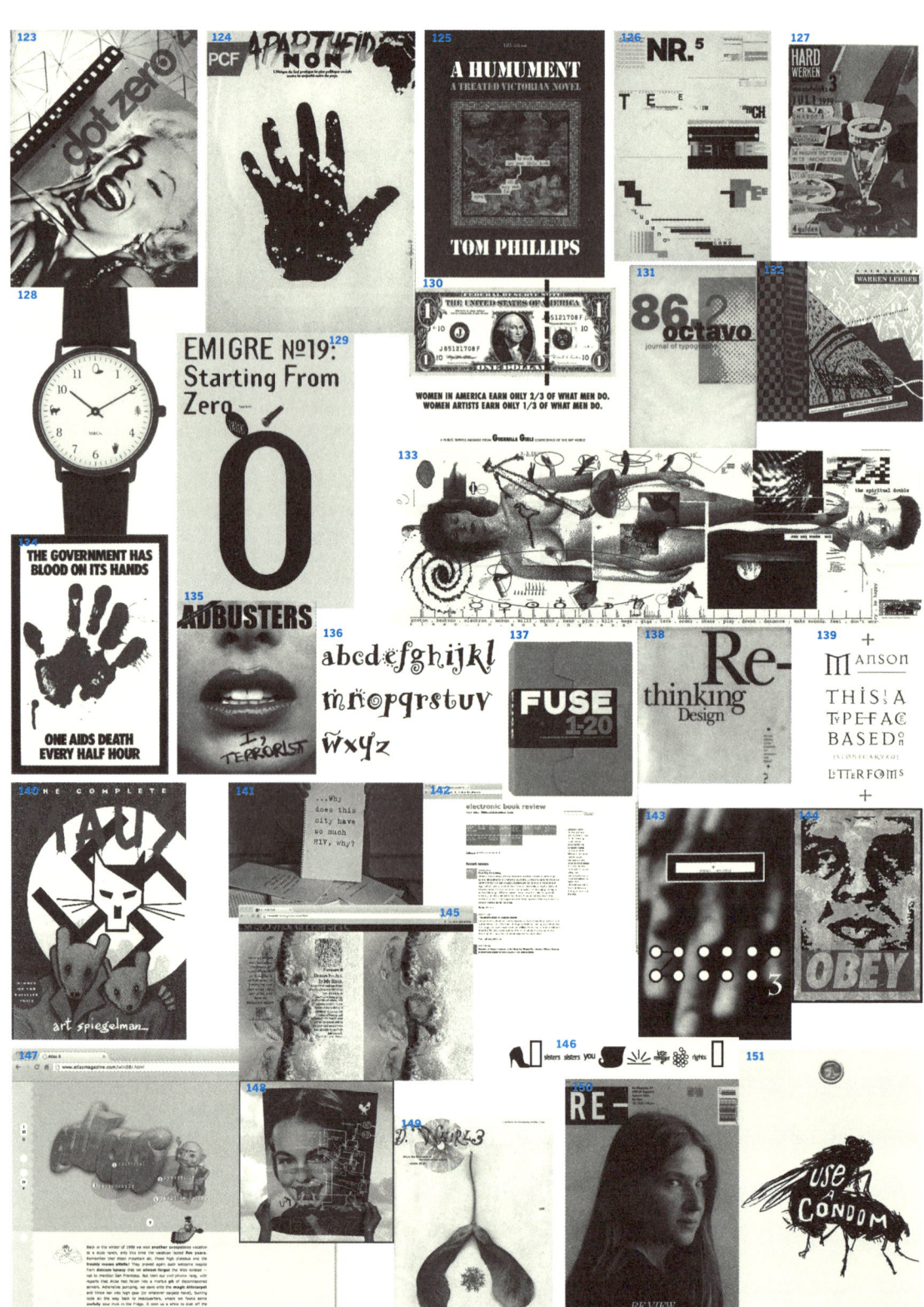

1969 /// Michel Foucault /// What Is an Author? (BULLETIN DE LA SOCIÉTÉ FRANÇAISE DE PHILOSOPHIE)(REPRINTED IN LANGUAGE, COUNTERMEMORY, RRACTICE: SELECTED ESSAYS AND INTERVIEWS) (ITHACA: CORNELL UNIVERSITY PRESS, 1977)

1989 /// Rick Poynor /// Producer as Author (BLUEPRINT)

1991 /// Renée Riese Hubert, guest editor /// The Artist's Book: the Text and Its Rivals (VISIBLE LANGUAGE VOL. 25 2/3)

1991 /// Rick Poynor /// The Designer as Author (BLUEPRINT)

1991 /// Pierre Bernard /// The Social Role of the Graphic Designer (LECTURE AT CORE OF UNDERSTANDING CONFERENCE)(REPRINTED IN ESSAYS ON DESIGN: AGI'S DESIGNERS OF INFLUENCE)(LONDON: BOOTH-CLIBBORN, 1997)

1992 /// Anne Burdick /// Parameters and Perimeters (EMIGRE 21)

1992 /// Katherine McCoy /// *Fourteenth Annual 100 Show Design Year in Review* (CHAIRMAN'S ADDRESS)(AMERICAN CENTER FOR DESIGN, CHICAGO)

1993 /// Anne Burdick /// What has Writing Got to Do with Design? (EYE 3)

1994 /// Will Novosedlik /// The Producer as Author (EYE 15)

1994 /// Gunnar Swanson /// Graphic Design Education as a Liberal Art: Design and Knowledge in the University and the Real World (DESIGN ISSUES 10.1, MIT PRESS)

1995 /// Cristina de Almeida & Steven McCarthy /// Call for Entries: Designer as Author: Voices and Visions (SUBMISSION CALL)(HIGHLAND HEIGHTS, KY: NKU)

1995–1996 /// Anne Burdick, ed. ///Clamor over Design and Writing (EMIGRE 35 AND 36)

1996 /// Cristina de Almeida /// Voices and/or Visions (DESIGNER AS AUTHOR: VOICES AND VISIONS) (CATALOG/POSTER)(HIGHLAND HEIGHTS, KY: NKU)

1996 /// Steven McCarthy ///What is 'self-authored graphic design' anyway? (DESIGNER AS AUTHOR: VOICES AND VISIONS) (CATALOG/POSTER)(HIGHLAND HEIGHTS, KY: NKU)

1996 /// Anne Burdick /// Who the Hell is Anne Burdick? (KEYNOTE ADDRESS)(DESIGNER AS AUTHOR: VOICES AND VISIONS EXHIBITION)(NORTHERN KENTUCKY UNIVERSITY)

1996 /// Michael Rock /// The Designer as Author (EYE 20)

1996 /// Ellen Lupton & Abbott Miller /// *Design, Writing, Research: Writing on Graphic Design* (LONDON: PHAIDON)

1996 /// Kali Nikitas /// *And She Told 2 Friends: An International Exhibit of Graphic Design by Women* (INTRODUCTION)(CHICAGO: MICHAEL MENDELSON BOOKS)

1996 /// Rudy Vanderlans /// Graphic Design and the Next Big Thing (EMIGRE 39)

1997 /// Denise Gonzales Crisp /// Out of context: designists slash entrepreneurs and other slash utopians (EMIGRE 43)

1998 /// Ellen Lupton /// The Designer as Producer (THE EDUCATION OF A GRAPHIC DESIGNER) (NEW YORK: ALLWORTH PRESS)

1998 /// Steven Heller ///The Attack of the Designer Authorpreneur (AIGA JOURNAL OF GRAPHIC DESIGN 16)(NEW YORK: AMERICAN INSTITUTE OF GRAPHIC ARTS)

1999 /// Mike Sharples ///*How We Write: Writing as Creative Design* (LONDON: ROUTLEDGE)

2000 /// Rick Poynor ///*Vaughan Oliver: Visceral Pleasures* (BOOTH-CLIBBORN EDITIONS)

2000 /// Monika Parrinder /// The Myth of Genius (EYE 38).

2000 /// Michael Bierut /// A Manifesto with Ten Footnotes (I.D. VOL 47, NO.2)

2000 /// Cristina de Almeida & Steven McCarthy /// Self-authored Graphic Design and Enabling Technologies (PRESENTATION AT METAMORPHOSES 2000: EXPRESSIVE ART, TECHNOLOGY AND HUMANITIES)(SCHOOL OF VISUAL ARTS, NEW YORK)

2001 /// Anthony Dunne & Fiona Raby /// Designer as Author (DESIGN NOIR: THE SECRET LIFE OF ELECTRONIC OBJECTS)(BASEL, BOSTON, BERLIN: BIRKHÄUSER)

123 /// Ralph Eckerstrom and Massimo Vignelli, Dot Zero 4, 1967
124 /// Grapus Studio, Against Apartheid, 1984
125 /// Tom Philips, A Humument, 1970
126 /// Wolfgang Weingart, Typographic Process Nr. 5: Typography as Painting, 1971–74
127 /// Rick Vermeulen, Hard Werken, Hard Werken 3, 1979
128 /// Tibor Kalman, M&Co, Waste Not A Moment, 1984
129 /// Rudy Vanderlans, Emigre 19, 1990
130 /// Guerilla Girls, Women Artists Earn Only 1/3 of What Men Do, 1985
131 /// Simon Johnston, Mark Holt, Michael Burke, Hamish Muir, Octavo 86.2, 1987
132 /// Warren Lehrer, GRRRHHHH: A Study of Social Patterns, 1987
133 /// April Greiman, Design Quarterly 133, 1986
134 /// Gran Fury, The Government Has Blood on Its Hands, 1988
135 /// Kalle Lasn, Adbusters 4, 2006
136 /// Frank Heine, Remedy, 1991
137 /// Jon Wozencroft, Neville Brody, FUSE, 1991-2000
138 /// Michael Bierut, ReThinking Design, 1992-1995
139 /// Jonathan Barnbrook, Manson, 1992
140 /// Art Spiegelman, Maus: A Survivor's Tale, 1992
141 /// Class Action, Aiding Awareness: Women's Stories, 1994
142 /// Anne Burdick, Electronic Book Review, 1994–present
143 /// Katie Salen, et al, Zed , 1994-2000
144 /// Shepard Fairey, Obey Giant, 1995
145 /// Auriea Harvey, Entropy8, 1995
146 /// Women's Design Research Unit (WD+RU), Pussy Galore, 1995
147 /// Amy Franceschini, Olivier Laude, Michael Macrone, Atlasmagazine.com, 1995
148 /// Cactus/Tony Credland, Feeding Squirrels to the Nuts 2, 1995-1999
149 /// Kenneth FitzGerald, News of the Whirled #3, 2002
150 /// Jop van Bennekom, Re-Magazine #7, Autumn 2001
151 /// James Victore, Use a Condom, 1997

37

152 /// Bruce Mau, Incomplete Manifesto for Growth, 1998
153 /// First Things First 2000
154 /// Stuart Bailey, Peter Bilák, David Reinfurt, Dot Dot Dot #4, 2002
155 /// Jonathan Barnbrook, Designers, Stay Away from Corporations that Want You to Lie for Them, 2001
156 /// Josh On, Theyrule.net, 2001
157 /// Chip Kidd, Cheese Monkeys: A Novel in Two Semesters, 2001
158 /// Armin Vit, Speak Up/Under Consideration, 2001–09
159 /// Marcia Lausen, Stephen Melamed, Elizabeth (Dori) Turnstall, Design for Democracy, 2000
160 /// Kate Bingaman-Burt, obsessive-consumption.com, 2002
161 /// Michael Bierut, William Drenttel, Jessica Helfand, Rick Poynor, Design Observer, 2003–present
162 /// Nicholas Blechman, Empire (Nozone IX), 2004
163 /// Winterhouse Editions, The National Security Strategy of the United States of America, 2003
164 /// Rick Valicenti, Suburban Maul, 2003
165 /// Abake, I Am Still Alive #21, 2011
166 /// Shepard Fairey, Obama Hope, 2008
167 /// Chip Kidd, The Learners, 2008
168 /// Peter Lunenfeld (editor), Utopian Entrepreneur (MIT Mediaworks Pamphlet), 2001
169 /// Kali Nikitas, curator, Soul Design, 1999
170 /// Kenneth FitzGerald, collator, Adversary: an Exhibition (of) Contesting Graphic Design, 2001
171 /// Metahaven, Facestate, 2011
172 /// Cristina de Almeida & Steven McCarthy, curators; Designer as Author: Voices and Visions, 1996
173 /// Kali Nikitas, curator; And She Told 2 Friends: An International Exhibit of Graphic Design by Women, 1996
174 /// Johanna Drucker, curator, The Next Word: Text and/as Image and/as Design and/as Meaning, 1998
175 /// Maya Drozdz, curator, Outside In, 2004
176 /// Maya Drozdz & Chris Corneal, curators, I Profess: The Graphic Design Manifesto, 2004
177 /// Jacqueline Thaw, curator, Trigger: Projects Initiated by Graphic Designers, 2006
178 /// Mark Owens & Zak Kyes, curators, Forms of Inquiry: The Architecture of Critical Graphic Design, 2007
179 /// Walter Benjamin, Reflections, 1978
180 /// PM Magazine, August–September 1940
181 /// Roland Barthes, The Death of the Author, 1967 (as it appeared in Aspen 5+6)
182 /// Daniel Jasper, curator, Products of our Time, 2007
183 /// Tom Starr, curator, We The Designers, 2007
184 /// Michel Foucault, Language, Countermomory, Practice, 1977

2001 /// **Rick Poynor** /// Auteur theory (PRINT 55)

2001 /// **Steven McCarthy** /// Tinker Tailor Designer Author (EYE 41)

2001 /// **Cristina de Almeida & Steven McCarthy** /// Designer as Author: Diffusion or Differentiation? (DECLARATIONS OF [INTER]DEPENDENCE AND THE IM[MEDIA]CY OF DESIGN SYMPOSIUM) (CONCORDIA UNIVERSITY, MONTRÉAL)

2002 /// **Cheryl Towler Weese** (MODERATOR) **featuring Jonathan Barnbrook, COMA and J. Abbott Miller** (DESIGN AUTHORSHIP AND CONTEMPORARY BOOK DESIGN)(AIGA VOICE 2)

2002 /// **Steven McCarthy & Cristina de Almeida** /// Self-authored Graphic Design: a Strategy for Integrative Studies (JOURNAL FOR AESTHETIC EDUCATION)(URBANA-CHAMPAIGN, IL: UNIVERSITY OF ILLINOIS PRESS)

2003 /// **Rick Poynor** /// Authorship (NO MORE RULES: GRAPHIC DESIGN AND POSTMODERNISM) (NEW HAVEN, CT: YALE UNIVERSITY PRESS)

2005 /// **Michael Rock** /// Fuck Content (HTTP://2X4.ORG/IDEAS/2/FUCK+CONTENT/)

2006 /// **Gérard Mermoz** /// The Designer as Author: Reading the City of Signs— Istanbul: Revealed or Mystified? (DESIGN ISSUES 22.2)(MIT PRESS)

2007 /// **Katherine Moline** /// Authorship, Entrepreneurialism and Experimental Design (VISUAL:DESIGN:SCHOLARSHIP VOL. 2, NO. 2)

2007 /// **Steven McCarthy** ///Curating as Meta Design-authorship /// (VISUAL:DESIGN:SCHOLARSHIP VOL. 2, NO. 2)

2007 /// **Kate Sweetapple** /// Power Dressing: a Critique of Design Authorship (VISUAL:DESIGN:SCHOLARSHIP VOL. 3, NO. 1)

2007 /// **Tara Winters** /// Using Concepts of Authorship in Graphic Design to Facilitate Deep, Tranformative Learning (VISUAL:DESIGN:SCHOLARSHIP VOL. 3, NO. 1)

2007 /// **Dmitri Siegel** /// Designers and Dilettantes (DESIGN OBSERVER) (HTTP://OBSERVATORY.DESIGNOBSERVER.COM/ENTRY.HTML?ENTRY=5947)

2007 /// **Kate Bowden** /// How Should We Critique 'Critical Design'? (HTTP://WWW.MONOMO.CO.UK/BLOG)

2008 /// **Steven McCarthy** /// From Graphics to Products: Critical Design as Design Authorship (NEW VIEWS 2: CONVERSATIONS AND DIALOGS IN GRAPHIC DESIGN) (LONDON COLLEGE OF COMMUNICATION)

2008 /// **Rick Poynor** /// Critical Omissions (PRINT 62).

2009 /// **Teal Triggs** /// Designing Graphic Design History /// (JOURNAL OF DESIGN HISTORY VOL. 22, NO. 24).

2009 /// **Maria Rogal** /// Designer as Author: Writing in the Visual Environment (HTTP://WWW.MARIAROGAL.COM/TEACHING/?PAGE_ID=173)

2009 /// **Rebecca Targ** /// Writing as strategy: Transforming authorship in the design classroom (PRESENTATION AT WRITING DESIGN; OBJECT, PROCESS, DISCOURSE, TRANSLATION: THE DESIGN HISTORY SOCIETY ANNUAL CONFERENCE)

2010 /// **Steven McCarthy** /// Designer-authored Histories: Graphic Design at the Goldstein Museum of Design (DESIGN ISSUES 27.1)(MIT PRESS)

185 /// Blueprint, 1989
186 /// Blueprint, 1989
187 /// Katherine McCoy, chair, Fourteenth Annual 100 Show Design Year in Review, 1992
188 /// Eye Vol.3 No.9, 1993
189 /// Eye Vol.4 No.15, 1994
190 /// Renée Riese Hubert, guest editor, Visible Language vol.25 2/3, 1991
191 /// Essays on Design: AGI's Designers of Influence, 1997
192 /// Emigre 21, 1992
193 /// Anne Burdick, editor, Emigre 35, 1995
194 /// Anne Burdick, editor, Emigre 36, 1995
195 /// Eye No.20, 1996
196 /// Design Issues 10.2, 1994
197 /// Emigre 43, 1997
198 /// Steven Heller, editor, The Education of a Graphic Designer, 1998
199 /// Ellen Lupton & Abbott Miller, Design, Writing, Research: Writing on Graphic Design, 1996
200 /// Mike Sharples, How We Write: Writing as Creative Design, 1999
201 /// Rudy Vanderlans, editor, Emigre 39, 1996
202 /// I.D. Vol.47 No.2, 2000
203 /// AIGA Journal of Graphic Design, vol.16 no.2, 1998
204 /// Rick Poynor, Vaughan Oliver: Visceral Pleasures, 2000
205 /// Eye No.38, 2000
206 /// Journal of Aesthetic Education, 2002
207 /// Rick Poynor, No More Rules: Graphic Design and Postmodernism, 2003
208 /// Anthony Dunne & Fiona Raby, Design Noir: The Scret Life of Electronic Objects, 2001
209 /// Print Vol. 55 No.1, January/February, 2001
210 /// Eye No.41, 2001
211 /// Design Issues 22.2, 2006
212 /// Michael Rock, 2x4.org: Fuck Content, 2005
213 /// Visual:Design:Scholarship Vol.2 No.2, 2007
214 /// Visual:Design:Scholarship Vol.2 No.2, 2007
215 /// Visual:Design:Scholarship Vol.3 No.1, 2007
216 /// Visual:Design:Scholarship Vol.3 No.1, 2007
217 /// Maria Rogal, Designer as Author, 2009
218 /// Dmitri Siegel, Design Observer: Designers and Dilettantes, 2007
219 /// Kate Bowden, How Should We Critique 'Critical Design'?, 2007
220 /// Print, October, 2008
221 /// Journal of Design History Vol.22 No.4, 2009
222 /// Design Issues 27.1, 2010

INTERVIEW: RICK POYNOR

43

Rick Poynor is a writer, curator, educator and critic who expounds on design topics ranging from graphics to architecture, and media to visual culture. He founded Eye magazine in 1990, which he edited for seven years, and co-founded the blog Design Observer. Poynor is currently a contributing editor and columnist of Print magazine, and research fellow at the Royal College of Art in London. His books include Typography Now, No More Rules and Obey the Giant.

MCCARTHY Design authorship has been an interest of yours for over twenty years — you've written about it extensively and published the opinions of others on the topic. To what extent were you, or other design critics, describing an emerging phenomenon or providing the profession with a roadmap to greater intellectual and creative autonomy?

POYNOR It was both things at the same time. I studied the history of art before I became interested in design. The first designer I interviewed as a journalist, the product designer Daniel Weil (NOW AT PENTAGRAM), conducted his experimental design practice much like an artist. I felt immediately at home with this kind of work. The graphic designers I began to write about for Blueprint magazine, in the late 1980s, were individuals whose work took self-direction and some degree of autonomy for granted. Again, the personal, artistic and authorial dimension of their designs seemed natural to me; if I had been a graphic designer that's what I would have been doing too. I was further encouraged to write about this work by the fact that, in Britain, at that point, no one seemed to be exploring it in any depth, while many older designers were extremely dismissive of approaches that they saw as unacceptably self-indulgent and a denial of design's 'problem-solving' purpose. As a journalist, I felt that this was a significant new tendency and that it was visually and conceptually exciting material to investigate, but I had no idea, when I put together Typography Now: The Next Wave (1991), that it would prove to be an international hit. On the contrary, the project felt like an eccentric and risky undertaking for its publisher. The book clearly arrived at some kind of turning point

01 /// Rick Poynor
02 /// Eye No.1, 1990
03 /// Design Observer
04 /// Print, 2011
05 /// Royal College of Art, London
06 /// London, England
07 /// Rick Poynor, Typography Now: The Next Wave, 1992
08 /// Rick Poynor, Transgression: Graphisme et Post Modernisme (No More Rules, French translation), 2003
09 /// Rick Poynor, Obey the Giant, 2007
10 /// Daniel Weil
11 /// Pentagram
12 /// Blueprint

13 /// Typographica No.8, December 1963
14 /// Herbert Spencer
15 /// Rudy Vanderlans
16 /// Emigre 10, 1988
17 /// The Penrose Annual, 1964
18 /// Herbert Spencer, Pioneers of Modern Typography, 1969
19 /// Vaughan Oliver
20 /// New York NY
21 /// Rick Poynor, Vaughan Oliver: Visceral Pleasures, 2000

and it was reprinted many times over the next few years. Having found my ideal territory as a writer and as editor of *Eye* magazine, where I published a lot of this new graphic design, I just kept on going with it.

What were the primary conditions that enabled the field of graphic design to expand its domain from neutral service provision to being more engaged with content?

We have to be careful when talking about the development of graphic design in such schematic terms. When are we saying that this transition occurred? It might be convenient to see this as a phenomenon of the past 25 years, but there are plenty of examples of designers from earlier decades who saw their role in more expansive terms and who engaged with content. In the 1990s, I conducted research into *Typographica* magazine, published in London from 1949 to 1967. The project was instigated by a designer, Herbert Spencer, who acted as editor, writer and designer — much like Rudy VanderLans did 20 years later with *Emigre* magazine. Spencer was certainly concerned, as a successful typographer and design consultant, with providing a service to his clients. Nevertheless, much of his time was given over to self-initiated research and to providing platforms for the analysis and discussion of graphic design. He was also editor of the influential *Penrose Annual* and he authored books such as *Pioneers of Modern Typography* (1969). He is not a unique case.

...

I don't see a rupture in the postmodern 1980s and 1990s with graphic design's earlier phases so much as a continuum. Smart designers have always had the vision, capacity and inclination to bring something more to their practice than 'neutral service provision.' However, it is certainly the case that there was an intensification of interest in the notion of authorship through design in the late 1980s and early 1990s. Earlier designers tended not to theorize about their extracurricular activities — they just got on with them. Now, as a way of asserting and enhancing their role, graphic designers began to speak more self-consciously about their aims, intentions and relationship to content. This was the period when the image and idea of the 'graphic designer as author' emerged. In 1994, I gave a lecture about the British record sleeve designer Vaughan Oliver at the 'Modernism and Eclecticism' conference in New

York in which I interpreted his graphic work in terms of the auteur theory used in cinema. I later developed this approach in a monograph about Oliver. I was interested in what we could mean by authorship in a collaborative activity such as design, and how we could demonstrate that some deeper than usual form of authorship is actually present in a graphic work — a critical problem that still hasn't received enough attention in my view.

...and following that question, how has this content engagement impacted the discipline? And if I may be so bold, impacted the world?

We have reached the point where it's simply taken for granted by many graphic designers that they could or should be engaged with content. This is a direct legacy of the authorship debates of the 1990s. Many mid-career designers and design teachers were educated in those years and they absorbed these powerful ideas as a matter of course. The irony today is that 'design authorship' is an unloved and even unfashionable concept identified with the excessive, David Carson-esque design styles and attitudes of the 1990s. This is a simplistic reading and reduction of the idea, but the extreme individualism that authorship seems, at this distance, to suggest to today's generation is no longer tenable. Design styles have been much quieter in the past decade, with modernism a resurgent influence, and graphic designers prefer to see themselves as sensitive collaborators and enablers rather than as ego-driven soloists. Nevertheless, more graphic designers than ever are engaged in self-initiated activities entirely congruent with earlier concepts of authorship. Self-publishing is flourishing and the 'designer as producer' gleefully seizes the means of production.

The current concepts 'critical design,' 'entrepreneurial design' and 'design fiction' seem to have roots in design authorship. Any thoughts?

These concepts all have their roots in design authorship. The critical designer is fully engaged in reflecting on the potential of the discipline through self-initiated research projects and speculative proposals. The entrepreneurial designer takes authorial thinking to the logical next stage and brings ideas to production in the world. The creator of design fictions applies personal vision to imagining new objects that have yet to be designed. It's entirely fitting that each new refinement of design authorship should generate its own terminology.

Thank you!

22 /// David Carson
23 /// David Carson design
24 /// David Carson-esque design
25 /// Thank you

OBEY THE GIANT: LIFE IN THE IMAGE WORLD (BOOK) /// Rick Poynor (BIRKHÄUSER), Stephen Coates (COVER DESIGN), Kam Tang (ILLUSTRATION) /// 2001, 2007
JAN VAN TOORN: CRITICAL PRACTICE (BOOK) /// Rick Poynor (010 PUBLISHERS) /// Simon Davies (COVER DESIGN, BASED ON A CALENDAR DESIGN BY JAN VAN TOORN) /// 2008
THINKING WITH TYPE (BOOK) /// Ellen Lupton, Ellen Lupton and Jennifer Tobias (COVER DESIGNERS) /// 2004, 2010
DESIGN YOUR LIFE (ILLUSTRATION FROM BOOK) /// Ellen Lupton and Julia Lupton /// 2009

INTERVIEW: ELLEN LUPTON

47

Ellen Lupton is a graphic designer, writer, educator and is the curator of design at Cooper-Hewitt National Design Museum in New York. She also directs the graduate program in graphic design at the Maryland Institute College of Art (MICA) in Baltimore. Lupton has written the books Design Writing Research *(with Abbott Miller),* Thinking with Type, *and* The ABC's of the Bauhaus, *among others. She recently co-curated the exhibition* Graphic Design: Now in Production.

MCCARTHY Your contributions over twenty years to the concept of design authorship are legendary — exhibits, books, essays, critiques, presentations and more. To what degree have theories of design authorship changed mainstream graphic design?

LUPTON Design authorship means so many things. It can mean developing a signature approach to visual design — the designer as auteur, as Michael Rock has argued. It can mean engaging the tools of design to produce, disseminate, and embody content from other fields, as writers such as Dave Eggers and Jonathan Safran Foer have done. It can mean becoming a writer or commentator about design, as I have done in my career. Bruce Mau has done all these things — generating his own content by way of a signature visual approach.

...

All these methods were taking place in the early '90s, but they are more prevalent today and have changed in key ways. Networked communication has allowed more voices to take part and build communities and followings. There may be less interest in the auteur approach and more interest in collaboration, community-building, and tool-making. Designers are developing ideas that other people can use. In the area of web design and interactive media, a practical and critical discourse is bubbling up from designers who are actively engaged in the field. Craig Mod, for example, is a powerful voice in the area of electronic books and publishing. He not only writes and lectures extensively on this subject but is actively authoring and publishing his own material in these new media. The List Apart group and Information Architects are doing similar work in web design. The conversation has shifted from how things look and what they mean to

01 /// Ellen Lupton
02 /// Cooper-Hewitt National Design Museum, New York NY
03 /// New York NY
04 /// Maryland Institute College of Art, Baltimore MD
05 /// Baltimore MD
06 /// Ellen Lupton and Abbott Miller, Design Writing Research, 1999
07 /// Abbott Miller
08 /// Ellen Lupton and Abbott Miller, The ABC's of Bauhaus, The Bauhaus and Design Theory, 2000
09 /// Graphic Design: Now in Production
10 /// Michael Rock

11 /// Baltimore MD (continued)
12 /// Dave Eggers
13 /// Jonathan Safran Foer
14 /// Bruce Mau
15 /// Craig Mod
16 /// A List Apart
17 /// Information Architects
18 /// Switzerland

how they work and how people use them. If the '90s was all about design as interpretation, the focus now is on function and pragmatics. The new generation of design authors is building the knowledge base of their evolving field — as did the Swiss designers of the '50s and '60s and the Bauhaus Constructivists before them. The new generation is doing it largely outside the framework of educational institutions. They are making their own institutions via conferences, web sites, and seminars.

In recent years your book publishing has increased in quality and quantity, and now includes the input of your graduate students at MICA (Maryland Institute College of Art). Why have you integrated this classic medium — the ink on paper book — into an agenda that merges education, entrepreneurism, opinion, research and expression?

My own work has followed in the direction of tool-making as well. My work has become less about history, critique, and analysis and more about ideas and methods that people can use. Many of my books from the last decade are tool-based, from *Thinking with Type* (2004) to *Graphic Design Thinking* (2011). There's no accident that this shift coincides with my decision to become an educator. I've been teaching full-time at MICA since 1997, after fifteen years of working full-time as a curator. (CURATING IS STILL A KEY PART OF MY PRACTICE, BUT I AM A FULLY VESTED GRADUATE AND UNDERGRADUATE EDUCATOR.) I decided to publish *Thinking with Type* because I saw the need for a different kind of pedagogical publishing: smart, informative, accessible, and, above all, useful. I wanted to create a book that designers could use.

...

As a museum curator, one speaks as an aesthetic or cultural authority. One is celebrating the higher cultural value or significance of certain objects and practices. But as an educator, one is trying to help people create their own work. The emphasis is never on what you have to say but on what they will be able to do with it. The emphasis shifts from the sender to receiver.

...

I learned an enormous amount about typography in the process of writing *Thinking with Type*, discovering that teaching is its own form of learning. What if I could engage our graduate students in explaining their own thought processes to other people, and along the way learn to create better work and stronger processes for

themselves? And thus began a series of publications co-authored with students and faculty at MICA. In books like *D.I.Y.: Design It Yourself* (2006) or *Graphic Design: The New Basics* (2008), our graduate students have delved deep into various methods and concepts, creating original visual work that demonstrates broader concepts. Voilà, teaching and learning becomes research and authorship.

...

The printed book remains a wonderfully economical and accessible way to share information. MICA's publishing partner, Princeton Architectural Press, is committed to keeping our books low-cost and well-produced. It's been a great marriage of interests.

Over a decade ago, a colleague and I gave a presentation at the Declarations conference in Montréal supporting the 'diffusion' rather than the 'differentiation' model of design authorship. Diffusion supports the notion of broadly integrating the tenets of design authorship throughout a designer's practice (engagement with content, consideration of social, cultural and economic consequences, acknowledgement of subjective voice, etc.), while differentiation suggests a 'separate but equal' approach (conventional, neutral design practice is augmented by projects offering enhanced meaning — think 'day job' versus 'night gig'). Where are we today with this idea?

There are so many ways to be a designer. I have no interest in declaring that one model is better than the other. If you embrace the 'designer as auteur' definition of design authorship, then everything a designer does has the potential to bear the signature of its maker. What is a "conventional, neutral design practice"? If we dismiss conventional work, then we are dismissing design's fundamental character as a mediating practice, a frame, a go-between. Most design is collaborative, not the work of a single author. Most projects have many authors — not least among them the client. All of us have done work that signals our fondest values and aspirations, but our "day jobs" help us feel our way through what this practice is all about. To insist that every part of a designer's work must fit a single mold or standard doesn't mesh with design's fundamental character as a tool for getting things done and a membrane between form and content.

As a museum curator, can you put that role in 'authorial' context?

Curating is 5% authorship, 95% email. Indeed, curating is a lot like graphic design. Most of the work we do involves explaining, organizing, asking, documenting, planning, negotiating, meeting, and following up. The ideas and the writing are the tiny slice that keeps it interesting.

Thank you!

19 /// Bauhaus
20 /// Bauhaus
21 /// Ellen Lupton, Graphic Design Thinking, 2011
22 /// Ellen Lupton, D.I.Y.: Design It Yourself, 2006
23 /// Princeton Architectural Press
24 /// Ellen Lupton, Graphic Design: The New Basics, 2008
25 /// Montreal, Canada
26 /// Thank you

2

MEDIAWORK PAMPHLETS (BOOK SERIES) /// Peter Lunenfeld (EDITORIAL DIRECTOR)(MIT PRESS) /// 2001 – 2005

WRITING NEEDS GRAPHIC DESIGN

Writing DOES NOT exist without graphic design.

Letterforms consist of discrete graphic shapes; these marks or 'glyphs,' correspond to sounds linking oral and literal language. The conventions of writing require a type of formal organization that can only be called a graphic design. Lines, spaces, indentations, columns, formats, margins — all contribute to a text being readable, and the author's intentions being understood by a reader. These material features are often built into a word processing program's defaults rather than determined from scratch with every document, and therefore pre-exist as requirements of coherent writing.

UCLA professor N. Katherine Hayles says it this way: "…it is impossible not to create meaning through a work's materiality. Even when the interface is rendered as transparent as possible, this very immediacy is itself an act of meaning-making that positions the reader in a specific material relationship with the imaginative world evoked by the text." So it seems that even the transparency of Beatrice Warde's 'crystal goblet' — her analogy to clear, functional type devoid of decoration or personality — is not without meaning!

In English, the 26 letters of the roman alphabet, numerals, punctuation, diacritical marks and occasional flourishes and dingbats, comprise the writer's basic toolkit, the font of type. Spelled with these basic characters, words are written — actually 'selected,' as they already exist; Robert Venturi echoes this idea for design: "The architect selects as much as creates." Sentences and paragraphs are constructed from words, and writing happens — but not before using, or choosing, a typeface to write in. Even one's personal hand-writing is a graphic interpretation of the alphabet.

Writing typically goes from the author through the designer to the reader through typographic designs of letterforms and graphic designs of text. Grammatically correct composition is rendered legible through font choice, and readable through competent text setting and page layout. Semantics (THE MEANING OF WORDS, PHRASES AND SENTENCES) is related not just to literal meaning, but to the expressive and functional aspect of typography — setting 'pro wrestler' in a flowery wedding script changes its meaning. Syntax (THE ORDERING AND ARRANGING OF WORDS INTO SENTENCES) is also impacted by graphic choices: font, color, size, placement and so on determine emphasis and can allow the reader to have multiple pathways through a text. Semiotics (THE SYSTEMATIC STUDY OF SYMBOLS AND SIGNS) considers the complex inter-relationships between meaning and form in language.

01 /// N. Katherine Hayles
02 /// Beatrice Warde
03 /// Crystal goblet
04 /// Roman alphabet
05 /// Robert Venturi
06 /// Pro wrestler
07 /// Pro wrestler, ITC Edwardian Script

Legibility is the ability of each specific alphabet character to be recognized for what it is. Each letter has defined characteristics that make it unique: shapes, angles, number of strokes and so on. As example, the capital B should consist of a straight vertical stroke on its left side, with two semi-circular strokes on its right, their diameters roughly half of the straight stroke and meeting in the center. To deviate too much from this formula could potentially confuse the reader (PERHAPS THE BOTTOM BOWL IS UNHINGED — A LETTER R? IS THE LOWER COUNTER SPACE IS SQUEEZED SHUT — A P?). Typefaces that experiment with legibility, and these experiments are welcome investigations into the parameters of visual language, are probably best suited for display purposes, like magazine headlines or for posters.

08 /// B
09 /// Hrant Papazian
10 /// Hrant Papazian, Mas Lucida, 1998
11 /// Saccades
12 /// Zuzana Licko
13 /// Gerard Unger
14 /// Gerard Unger, While You're Reading, 2007
15 /// MIT Press
16 /// Bruce Sterling
17 /// Bruce Sterling, Shaping Things, 2005
17 /// Lorraine Wild

An exception to the purely aesthetic approach many type designers bring to letterform design might be typographer Hrant Papazian's novel design for a 'reformed' alphabet. Aspiring to achieve a more functional design without straying too far from recognizable forms, Papazian based his letter shapes on research into legibility and readability. He radically tweaked the shapes of lowercase letters to 'improve the tool' that writers use.

Legibility is determined by the original typeface designer, as the shapes of the letters are fixed in the design of the font. (DESIGNERS CAN OPTICALLY DISTORT LETTERFORM SHAPES, BUT UNLESS THIS IS DONE WITH AN EXPERT'S TOUCH, LEGIBILITY IS OFTEN COMPROMISED.) Typeface attributes like bold, condensed, light, italic and so on, must still conform to the tenets of conventional letterform design to maintain their legibility. As readers recognize words by their distinctive exterior and interior shapes, adhering to the structural similarity and rhythmic difference of letterform design is crucial for words being correctly interpreted.

Readability, however, is determined by the choices made by the graphic designer. Type size, letter and word spacing, line length, leading, column format and page layout have an impact on how readable the text will be. When successful, the reader's eyes jump in quick movements (CALLED 'SACCADES') of three, four, five words at a time in effortless reading. But as typographer Zuzana Licko famously stated regarding legibility and reading, "You read best what you read most."

Using all caps for text adversely affects readability. Making the font too small might make the type unreadable to those without the most acute vision. Extremely long lines with inadequate leading challenge the reader to maintain a linear flow. Forcing type into narrow columns set in a justified format often makes for awkward and unreadable text because of flooded 'rivers' of word space. Color and contrast matter too: red type on a blue background lacks value differentiation, while light gray type on a white background lacks contrast.

Writing and design share concerns — and responsibilities — in typography. Writers who do not know better than to use two spaces after a period, double hyphens instead of an en- or em-dash, primes for apostrophes and double primes for quotation marks would do well to work with a designer who can implement typographic best practices. Knowing which option key puts an umlaut over a ü, an accent circonflexe over an â and a ¼ or ⅔ sign when one is called for, are helpful skills too.

As reading is the visual perception and decoding of graphic marks in a language system to communicate meaning, it is best enabled by coherent writing, legible typefaces and readable graphic design. If any one of the three is done poorly, the act of reading is labored — or worse, avoided. Done well, literal content and visual form are symbiotically linked in a transference of meaning from writer, via designer, to reader. Context matters too, as Gerard Unger put it in his book *While You're Reading:* "The mix of curiosity for change and desire for the familiar means that many people will happily accept out-of-the-ordinary typography on a T-shirt, but in the columns of their daily paper or the pages of a novel what they want is conventional fonts and layout."

A creative project that successfully bridges the worlds of design and writing, and expression and function, is exemplified in the MIT Press Mediaworks Pamphlet series. Collaboratively pairing a writer and graphic designer, the books transgress the typical border between literal and visual communication. Both writer and designer are given equal billing. Bruce Sterling's *Shaping Things* was designed by Lorraine Wild, N. Katherine Hayles' *Writing Machines* by Anne Burdick, Brenda Laurel's *Utopian Entrepreneur* by Denise Gonzales Crisp, Paul D. Miller's (AKA DJ SPOOKY THAT

MEDIAWORK PAMPHLETS (BOOK SERIES) /// Peter Lunenfeld (EDITORIAL DIRECTOR)(MIT PRESS) /// USER/INFOTECHNODEMO ///
Peter Lunenfeld, Meike Gerritzen (DESIGN) /// 2005
RHYTHM SCIENCE ///
Paul D. Miller, COMA (DESIGN) /// 2004
SHAPING THINGS ///
Bruce Sterling, Lorraine Wild (DESIGN) /// 2005
UTOPIAN ENTREPRENEUR ///
Brenda Laurel, Denise Gonzales Crisp (DESIGN) /// 2001
WRITING MACHINES ///
N. Katherine Hayles, Anne Burdick (DESIGN) /// 2002

The "pointed reminder" sharpens when we discover that the Last Interview is missing, so that we see the complex chain of mediation only through Zampanò's written remediation of it, remediated in turn by Johnny and the editors.

So intricate are the layers of mediation that unmediated moments are glaring in their incongruity once we notice them. Commenting upon how obsessed Navidson is with the house prior to his final exploration, Zampanò delivers the following account meant to show that Navidson has become deadened to stimuli that ordinarily would arouse intense emotions. The scene begins

> the tape of Wax kissing Karen back in October when Navidson first came across context. The point in Zampanò's re-telling of the scene is that Navidson twice, once at regular speed, hardly responded. He viewed the scene moved on to the rest of the footage without saying a word. (p. 397). If we have our wits about us we may ask, how can Zampanò possibly know how Navidson viewed this scene? There is no possibility he was actually in the room, so he could know only if Navidson recounted his reaction in the missing Last Interview, about which nothing is said in the text, or made a tape of himself editing the tape. But the tape of Navidson watching would itself have been subject to editing, cuts, and othe... it could not function as a naive record but on... Moreover, Zampanò's comments com... but from his analysis of the U... HST, Navidson's la... because it h...

above /// **WRITING MACHINES** (MIT MEDIAWORKS PAMPHLET) /// Anne Burdick /// 2002
below /// **UTOPIAN ENTREPRENEUR** (MIT MEDIAWORKS PAMPHLET) /// Denise Gonzales Crisp /// 2001

...raising enough cash to see ...e business through to an IPO or acquisition. But a real business plan is not just about money; it's about value. Everything has an economy—even non-profit services and charities. To whom does your product or service have value? Who is willing to pay for that value, and how? Remember that the user may not be the buyer, and that people are less willing than ever to pay for things with their time and attention—a serious weakness of advertising-based business plans.

Be a realist. Resist the temptation to create an unrealistic business ...lan in order to attract investment or to please your Board. Be clear ...ut how long your business will take to be profitable and secure ...ng-term commitment of your investors. If you don't make your ...s, it's probably better to dial down your burn rate than to ...ney. Every debt your company incurs makes it less ...future investors or buyers.

...rial relationship between Marketing and Product ...utionalized conflict between marketing and ...established team sport in Silicon Valley, and ...ductive. Everyone who works for a company ...de. Using the same research to inform both ...onism and increase cooperation. ...ased decision-making empowers ...ore likely true. Over-reliance on

90

SUBLIMINAL KID) *Rhythm Science* by COMA, and series editor Peter Lunenfeld's *User: InfoTechnoDemo* by Mieke Gerritzen. The mitpress.mit.edu web site describes the publications: "Mediawork Pamphlets are 'zines for grown-ups, commingling word and image, enabling text to thrive in an increasing visual culture." Because the writers were encouraged to speak in the first person, weaving their lives into the narratives about design, culture and technology, the role of author is amplified.

Burdick's and Crisp's graphic interpretations — or enhancements — to their authors' words merit special mention. Images of words, and words as images, blur the distinctions between reading and looking in these examples. Burdick weaves images of documentary text into Hayles' prose, allowing for a coherent syntactic flow while distinguishing between subject and object. She also 'bulges' passages of text for emphasis; this effect questions the page as a material surface for writing and activates the gap between writer and reader. Crisp created photo-illustrations of words — set on a computer screen, and zoomed to almost architectural scale, their grayscale pixels reference the modular, grid-oriented construction of writing. Author Laurel's voice varies through typography, as multiple typefaces and formats communicate tone, nuance and emphasis. To refer back to Unger's comment, Burdick and Crisp have made a successful hybrid of a T-shirt and a daily paper through their Mediaworks Pamphlet designs.

19 /// N. Katherine Hayles
20 /// N. Katherine Hayles, Writing Machines, 2002
21 /// Anne Burdick
22 /// Brenda Laurel
23 /// Brenda Laurel, Utopian Entrepreneur, 2001
24 /// Denise Gonzalez Crisp
25 /// Paul D. Miller (aka DJ Spooky)
26 /// Paul D. Miller, Rhythm Science, 2004
27 /// COMA (Cornelia Blatter)
28 /// COMA (Marcel Hermans)
29 /// Peter Lunenfeld holding User:InfoTechnoDemo, 2001
30 /// Mieke Gerritzen
31 /// T-shirt
32 /// Daily paper
33 /// Les Brown & his Orchestra with Doris Day, Sentimental Journey, 1944
34 /// Kris Sowersby
35 /// Sarah Maxey
36 /// Kate Camp
37 /// New Zealand

Another project involving collaborative writing, typography and design is the Sentimental Journey series of postcards. But rather than the textual orientation of the Mediaworks Pamphlets, Sentimental Journey operates at the level of the two word phrase. It is a shared effort by typographer Kris Sowersby, graphic designer Sarah Maxey and poet Kate Camp, all of New Zealand. Camp selected the phrases — "freshly squeezed," "land ahoy," "lucky charm," "new leaf," and others — sending Maxey and Sowersby each half of the phrase, who give their word an expressive, sometimes calligraphic, visualization (WITHOUT KNOWING THE OTHER'S WORD). Once united, the pair is a lively interpretation of the original phrase. Although they are joined by proximity and clichéd usage on the postcard, the graphic individuality of each word animates the difference, a contrast in meaning and form.

38 /// Katherine McCoy
39 /// Cranbrook Academy of Art, Bloomfield Hills MI
40 /// Colorado
41 /// High Ground
42 /// Stevie Wonder, Higher Ground, 1973
43 /// Katherine McCoy, See Read Image Text, 1989
44 /// Jonathan Safran Foer, Extremely Loud & Incredibly Close, 2005
45 /// Jonathan Safran Foer
46 /// Anne Chalmers
47 /// Miklós Tótfalusi Kis, Janson, 1685
48 /// Oskar Schell (as played on screen by Thomas Horn)
49 /// Steven Hall
50 /// Steven Hall, The Raw Shark Texts, 2007
51 /// An oncoming shark
52 /// Zenon Fajfer

Designer-authors are fully fluent in writing, designing and reading, and are able to meld form, function and expression into a communicative whole. This idea is visualized in a poster by Katherine McCoy, former chair of two-dimensional design at the Cranbrook Academy of Art, and now of the High Ground workshop and studio in Colorado, USA. The verbs 'see' and 'read' are positioned above the nouns 'image' and 'text' and are connected with a straight line, reinforcing the accepted wisdom of how people perceive. But a thinner line crosses the composition, linking see to text and read to image; in the center of this X is a rich stew of overlapping pictures and words, articulating the many fluid possibilities for visual communication.

Signaling a wide-spread acceptance of text that communicates visually as well as literally, several recently published mainstream books push the conventions of type and book page layout. *Extremely Loud and Incredibly Close*, written by Jonathan Safran Foer and designed by Anne Chalmers, uses negative space, word and letter spacing, leading (WHICH GRADUALLY DECREASES AND FORCES THE TYPE TO OVERLAP INTO A DENSE BLACK TEXTURE ON SEVERAL PAGES), strike-throughs, italics and caps to powerful graphic effect. The book also uses color and images conceptually and illustratively. Within the context of traditionally set Janson Text typeface for most of the novel, the story is propelled by these devices as it also makes the reader pause and reflect. By seeing text and reading images, the reader occupies narrator Oskar Schell's nine year old mind, made real by the combination of words and graphic design.

Steven Hall's novel *The Raw Shark Texts* employs other typographic devices: repetition (A SINGLE LINE OF TYPE ACTS AS THE WATER'S SURFACE AND REPEATS EIGHT TIMES OVER FIVE PAGES), concrete poetry (THE FIGURE OF AN ONCOMING SHARK IS BUILT OF WORDS AND WORD FRAGMENTS), and custom letterform design (THE WORD 'EVERYTHING' IS CONSTRUCTED OF ARROWS). Hall is credited with doing the type treatments himself, an example of the author as designer. Although some of Hall's choices might

SENTIMENTAL JOURNEY (POSTCARDS) /// Sarah Maxey (GRAPHIC ARTIST), Kris Sowersby (TYPEFACE DESIGNER), Kate Camp (POET) /// 2011

ing and closing, what was he looking for, why was he always looking? He came to my door, "Grandma?" I didn't want to betray her, I turned off the lights, what was I so afraid of? "Grandma?" He started crying, my grandson was crying. "Please. I really need help. If you're in there, please come out." I turned on the light, why wasn't I more afraid? "Please." I opened the door and we faced each other, I faced myself, "Are you the renter?" I went back into the room and got this daybook from the closet, this book that is nearly out of pages, I brought it to him and wrote, "I don't speak. I'm sorry." I was so grateful to have him looking at me, he asked me who I was, I didn't know what to tell him, I invited him into the room, he asked me if I was a stranger, I didn't know what to tell him, he was still crying, I didn't know how to hold him, I'm running out of room. I brought him over to the bed, he sat down, I didn't ask him any questions or tell him what I already knew, we didn't talk about unimportant things, we didn't become friends, I could have been anyone, he began at the beginning, the vase, the key, Brooklyn, Queens, I knew the lines by heart. Poor child, telling everything to a stranger, I wanted to build walls around him, I wanted to separate inside from outside, I wanted to give him an infinitely long blank book and the rest of time, he told me how he'd just gone up to the top of the Empire State Building, how his friend had told him he was finished, it wasn't what I'd wanted, but if it was necessary to bring my grandson face to face with me, it was worth it, anything would have been. I wanted to touch him, to tell him that even if everyone left everyone, I would never leave him, he talked and talked, his words fell through him, trying to find the floor of his sadness, "My dad," he said, "My dad," he ran across the street and came back with a phone, "These are his last words."

MESSAGE FIVE.
10:04 A.M. IT'S DA S DAD. HEL S DAD. KNOW IF
 EAR ANY THIS I'M
HELLO? YOU HEAR ME? WE TO THE SOON
ROOF EVERYTHING OK FINE MUCH
SORRY HEAR ME
 HAPPENS, REMEMBER—

above /// **EXTREMELY LOUD AND INCREDIBLY CLOSE** (BOOK) /// Jonathan Safran Foer (HOUGHTON MIFFLIN), Anne Chalmers (DESIGNER) /// 2005
below and opposite /// **VAS: AN OPERA IN FLATLAND** (BOOK) /// Steve Tomasula, Stephen Farrell (ART AND DESIGN) /// 2002

seem typographically awkward in the conventional sense, it is conceivable that an unschooled approach enabled him to achieve an unorthodox solution.

The books of Foer and Hall, and some of the Mediaworks books, fit into a hybrid image-text form called 'liberature,' coined by Polish writer Zenon Fajfer in 1999. Fajfer describes liberature as "a type or genre of literature in which the text is integrated with the physical space of the book into a meaningful whole and in which all elements — from the graphic ones to the kinds of paper (OR OTHER MATERIAL) and the physical shape of the book — may contribute to its meaning." The author, liberated from conventional structures, uses graphic design to enhance the text.

What these examples show, whether collaborative or solo-authored, is that experimentation, research and theory in design authorship can inform contemporary practices. While McCoy's communications-theory poster of 1989 employed deconstruction to illustrate 'see text' and 'read image,' the designer-authors of the books mentioned have applied these ideas in practical formats, demonstrating that, indeed, writing needs graphic design. London-based publisher Visual Editions sums it up well: "We think that books should be as visually interesting as the stories they tell; with the visual feeding into and adding to the storytelling as much as the words on the page. We call it visual writing."

53 /// London, England
54 /// Visual Editions typeface

Aad van Dommelen (Proforma), Rotterdam,

Emigre: Apple Computer is g
Macintosh by making everyb
lieve they can produce profe
looking graphic design quic
cheaply. Do you feel this en
your profession in any way
Aad: Everybody can produc
n the computer, but that
ke them graphic designe

above /// **MATRIX** (TYPEFACE) /// Zuzana Licko (EMIGRE) /// 1986 below /// **MRS. EAVES** (TYPEFACE) /// Zuzana Licko (EMIGRE) /// 1996

Deconstructivist theorists

Typi non habent claritatem insitam; est usus legentis in iis qui facit eorum claritatem. Investigationes demonstraverunt lectores legere melius quod ii legunt saepius. Claritas est etiam processus dynamicus, qui sequitur mutationem consuetudinum lectorum. Mirum est notare quam littera gothica, quam nunc putamus parum claram, anteposuerit litterarum formas humanitatis per saecula quarta decima et quinta decima.

THE AMBIENT LAVA LAMP

Typi non habent claritatem insitam; est usus legentis in iis qui facit eorum claritatem. Investigationes demonstraverunt lectores legere melius quod ii legunt saepius. Claritas est etiam processus dynamicus, qui sequitur mutationem consuetudinum lectorum. Mirum est notare quam littera gothica, quam nunc putamus parum claram, anteposuerit litterarum formas humanitatis per saecula quarta decima et quinta.

BELOW: MRS EAVES SMART LIGATURES ITALIC

Affinity with gifts

TYPOGRAPHIC DESIGN AUTHORSHIP 61

Typography OCCUPIES a unique position in the world of design.

It is both an artifact, with fixed visual properties, and a medium, through which words are formed into messages. Another duality is that the craft of its inception is furthered by the craft of its usage. Meaning-making becomes a shared enterprise between the writer, the type designer, the graphic designer, the printer, and ultimately, the reader.

Type designs also communicate through their visual properties, their personalities. This aspect of type design is typically tied to personal expression, aesthetics, historical reference, technological advances, cultural qualities or national identity. The writer's words become transformed through typographic tone of voice. From Arial to Zapfino, type choice communicates something about the writer and the words written.

In design authorship, designers typically initiate their own messages and often write, design and publish their own works to support their ideas. Add to this the design of letterforms, and the act of visual communication becomes holistic as the typography further bridges the words to the publication.

The first influential integration of typographic design, craft and publishing was William Morris and his Kelmscott Press in the final decades of the nineteenth century. The imprint's first book was *The Story of the Glittering Plain*, a fictional work of his own writing, type design and printing. *News from Nowhere*, Morris' book about a Marxist-influenced utopia that reflected his own views, was printed at Kelmscott Press in 1892, after it ran as a series in Commonweal, a Socialist magazine, in 1890. Though his family fortunes helped subsidize his creative practice, Morris was not a dilettante writer. "Morris was offered the Chair of Poetry at Oxford University in 1877; he declined," according to a statement on the University of Maryland's online William Morris Collection. Morris essentially used his writing, designing and printing to advance his ideology.

01 /// Robin Nicholas and Patricia Saunders, Arial, 1982
02 /// Hermann Zapf, Zapfino Extra X Pro Regular, 1998
03 /// William Morris
04 /// Kelmscott Press
05 /// William Morris, The Story of the Glittering Plain, 1891
06 /// William Morris, The Story of the Glittering Plain, ebook edition 2011
07 /// William Morris, News From Nowhere, 1892
08 /// William Morris, News From Nowhere, CreateSpace Independent Publishing Platform, 2008
09 /// Commonweal, 1890
10 /// University of Oxford, Oxford UK
11 /// University of Maryland Terrapins

12
THE ARTS AND CRAFTS OF TODAY. BEING AN ADDRESS DELIVERED IN EDINBURGH IN OCTOBER, 1889. BY WILLIAM MORRIS.
'Applied Art' is the title which the Society has chosen for that portion of the arts which I have to speak to you about. What are we to understand by that title? I should answer that what the Society means by applied art is the ornamental quality which men choose to add to articles of utility. Theoretically this ornament can be done without, and art would then cease to be 'applied'... would exist as a kind of abstraction, I suppose. But though this ornament to articles of utility may be done without, man up to the present time has never done without it, and perhaps never will; at any rate he does not propose to do so at present, although, as we shall

Using both medieval and Venetian typographic influences, and their ideal of enlightened handicraft, Morris endeavored to bring about social progress. His typeface Golden was based on Nicholas Jenson's fifteenth century Humanist forms, while typefaces Troy and Chaucer were derived from Gothic shapes. Design historian Philip Meggs wrote, "The paradox of William Morris is that as he sought refuge in the handicraft of the past, he developed design attitudes that charted the future." These attitudes were manifest in his creative practice — from wallpaper designs celebrating nature to religion-themed book ornamentation — but because he integrated philosophy, writing, typography, book designing and printing, Morris paved the way for the designer-authors of the twentieth century.

The heir apparent to William Morris is arguably Eric Gill. Recognized widely for the typeface that bears his name, Gill also wrote, drew, engraved, sculpted, and printed his own books. Because Gill Sans is based primarily on humanist forms dating to typography's Old Style, rather than on nineteenth century Grotesks or Bauhaus-era geometry (CONSIDER ITS CONTEMPORARY, THE TYPEFACE FUTURA), it is obvious that Gill also looked to history for influence. However Gill Sans' historical reference owes much to Gill's former teacher — and designer of the typeface for the London Underground — Edward Johnston, who created his own humanist sans in 1916. He did this with Gill's assistance, for which he paid Gill 10% of the fee, as explained in Simon Loxley's book *Type: the Secret History of Letters*.

Gill used his type designs, such as Perpetua, a classically proportioned serif typeface that shows its influence from Roman capitals, and Joanna, a delicate slab serif face created for his own printing company, Hague & Gill, to publish his own words. Proclaiming his ideologies through writing, designing letterforms and creating illustrations, Gill integrated his lifestyle into his design and craft.

12 // William Morris, Golden, 1890
13 // Nicholas Jenson
14 // William Morris, Troy, 1892
15 // William Morris, Chaucer, 1893
16 // Philip Meggs
17 // Eric Gill
18 // Eric Gill, Gill Sans, 1926
19 // Paul Renner, Futura, 1927
20 // London Underground
21 // Edward Johnston
22 // Edward Johnston, Johnston Sans, 1919
23 // Simon Loxley
24 // Simon Loxley, Type: The Secret History of Letters, 2004
25 // Eric Gill, Perpetua, 1929
26 // Eric Gill, Joanna, 1937
27 // Kool & the Gang, Joanna, 1983
28 // Hague & Gill

As Morris and Gill demonstrate, the idea of typographic design authorship emerges from this critical juncture:

/// designers write to advance social, political or aesthetic philosophies
/// they create typographic forms and graphic designs to visualize their writing
/// they print and publish these works for distribution, aiming to further their ideas and influence society.

Gill designed type and book illustrations for the Golden Cockerel Press, which also published some of his writing prior the Hague & Gill enterprise. Gill wrote a number of books, with *An Essay on Typography* best known among publication designers for its formal and literal advocating of ragged right text formatting. The book was typeset in Gill's Joanna font which was named after his daughter, and eventual wife of Gill's business partner René Hague.

29 /// The Golden Cockerel Press
30 /// Eric Gill, An Essay on Typography, 1931
31 /// Eric Gill, Portrait of René Hague, 1925
32 /// Jan Tschichold
33 /// Jan Tschichold, "Die Neue Typographie" lecture invitation, 1927
34 /// Herbert Bayer, Universal Alphabet, 1925
35 /// Herbert Bayer
36 /// Theo Van Doesburg
37 /// Theo Van Doesburg, Alphabet, 1919
38 /// Paul Renner
39 /// Paul Renner, Futura original drawings
40 /// Apple Macintosh, 1984
41 /// Apple LaserWriter, 1985
42 /// Vector versus bitmap

An Essay on Typography combines the features of immersive design authorship: writing, typography, designing and printing. It demonstrates Gill's connection to the fine press movement, and to Morris' influence. However, a modernist typographic sensibility was well under way during this time in continental Europe. Tschichold's *Die Neue Typographie* was published in 1928, and Bayer, Van Doesburg and Renner, among others, all produced modernist sans serif typefaces prior to *An Essay on Typography*'s publication.

The design and craft convergences employed by Morris and Gill required technical expertise and the mastery of different media developed after years of practice. The environment of the digital desktop in the 1980s brought writing, type designing, illustration, imaging, page layout and printing into a single integrated system. In the way that printing with moveable type democratized literacy, readily accessible computing hardware and software made visual communications a more populist pursuit.

Apple released the Macintosh computer in 1984, with its 'WYSIWYG' (WHAT YOU SEE IS WHAT YOU GET) graphical user interface. The next year its LaserWriter printer with Postscript page definition software came out, which used algorithms to create vector-based type — a qualitative improvement over low

43 /// Emigre
44 /// Berkeley CA
45 /// Rudy Vanderlans, Emigre 1, 1984
46 /// Zuzana Licko and Rudy Vanderlans
47 /// Zuzana Licko, Lo Res Cyrillic, 1985
48 /// Zuzana Licko, Matrix Italic, 1991, 2007
49 /// The Matrix, 1999
50 /// Zuzana Licko, Narly, 1993
51 /// Gnarly
52 /// Zuzana Licko, Totally Gothic, 1990
53 /// Zuzana Licko, Filosofia, 1996
54 /// Zuzana Licko, Base Nine, 1995
55 /// Zuzana Licko, Mrs. Eaves, 1996
56 /// John Baskerville
57 /// Zuzana Licko, Mrs. Eaves Just Ligatures, 1996
58 /// Zuzana Licko, Mr. Eaves, 2009

resolution bitmapped type. In this digital environment, word processing, letterform design, page layout, image manipulation and pre-press production were brought together in a transformative way.

It was at this juncture that *Emigre*, a pioneering graphic design magazine and digital type foundry was founded in Berkeley, USA. The collaborative project of designer and editor Rudy Vanderlans and typographer Zuzana Licko, *Emigre* magazine was the voice of a new generation of graphic designers: post-modern, deconstructed, experimental. *Emigre* promoted the type designs of emerging typographers and published interviews and articles by and about graphic design's avant-garde. In doing so, it shifted the landscape of contemporary design practice and theory.

Licko's earliest fonts harnessed the crude bitmaps of the low resolution pixel, which garnered criticism from typography's purists. By focusing on the letterforms' aesthetics, those critics missed the point: that new messages demand new forms, and that designing type for one's own text was completely within the traditions of Morris and Gill. It was pure design authorship.

Eventually, Licko's typefaces were crafted with the highest digital standards. The first typeface she designed for optimal Postscript output was Matrix, in 1986, as explained on the Emigre web site: "…Matrix was based on a few simple ratios, and the points required to define the letter forms were limited to the essentials. This is how Matrix acquired its geometric shapes and its distinctive triangular serifs which require fewer points than traditional square or curved serifs. Also, the 45 degree diagonals were the smoothest diagonal that digital printers could generate. Matrix thus consumed relatively little memory space to store in the printer and facilitated fast printing."

Licko's letterforms ranged from eclectic (Narly) to historicist (Totally Gothic and Filosophia) to functional (Base Nine). Mrs. Eaves, her interpretation of Baskerville — with less contrast, smaller x-height and a wider set width than John Baskerville's 1750s original — is named after Sarah Eaves, Baskerville's housekeeper and lover. Licko created over two hundred ligatures for the Mrs.

BARNBROOK BIBLE (BOOK) /// Jonathan Barnbrook (BARNBROOK DESIGN) /// 2007

II. Design's Absurd Hero

by Alice Twemlow

In his 1942 essay THE MYTH OF SISYPHUS, Albert Camus conducts a philosophical exploration of the absurd using the analogy of Sisyphus who, in Greek mythology, was condemned to forever repeat the same meaningless task of pushing a rock up a mountain, only to see it roll down again. Camus is interested in whether or not Sisyphus knows and understands his fate, leading the reader to extrapolate that consciousness of the futility of our actions, in a world devoid of meaning and God, inevitably requires suicide. Camus concludes his essay, however, with an image of Sisyphus at the foot of his underworld mountain that is unmistakably hopeful. "This universe henceforth without a master seems to him neither sterile nor futile," Camus writes. "Each atom of that stone, each mineral flake of that night-filled mountain, in itself forms a world. The struggle itself toward the heights is enough to fill a man's heart. One must imagine Sisyphus happy."

VII. bastard font

Bastard is an experimental Blackletter font created in 1988 when the computer had finally made it possible for designers to easily construct typefaces. It acknowledged a strong typographic form but reinterpreted it using this new technological aesthetic.

The thing that fascinated me about Blackletter forms was the similarity of shapes: the characters would only differ very slightly, yet they would make up all of the meanings, tones and variations in language. It was amazing that out of this morass of vertical lines you could read meaningful text.

I was really interested in the history of Blackletters, a neutral style of letterform that had been hijacked by the Nazis, but was so central to the development and history of typography. I felt that it was important not to ignore their five hundred years of influence while acknowledging their twentieth century fascist associations.

BARNBROOK BIBLE (BOOK) /// Jonathan Barnbrook (BARNBROOK DESIGN) /// 2007

Eaves font, which gives the face a distinctive character when set as text, and says something about the idea of connectivity and relationships — linguistic, historical, personal. The redesign and naming strategy give voice to what was once history's marginalia.

Mrs. Eaves builds on a tradition of re-designing established typefaces. While typeface names can be offered trademark protection, and the software code copyrighted, the physical properties of letterforms are considered in the public domain. This opens letterform design to constant re-interpretation. In a sans serif remix of her own Mrs. Eaves, Licko has recently released Mr. Eaves. Gill's Sans and Perpetua and others' typefaces were remixed in Prototype by Jonathan Barnbrook.

While serving to promote Emigre's own typefaces, and those of other designers its foundry released, the magazine's pages were often a visual playground. In referring to graphic designers being more experimental than traditional typographers with their type designs, Vanderlans wrote: "Graphic designers, on the other hand, have something else in mind when they design typefaces. Their type is usually filled with connotations, quotes, questions, contradictions, critiques, and idiosyncrasies. ... One of the reasons for a graphic designer to draw typefaces is to control every element on the page. While Barnbrook was able to create very intricate designs with the display fonts that he had drawn over the years, none were practical for setting texts in a book. Priori was to be his first text type design that would make it possible to finally control all elements on the page, including lengthy texts."

Barnbrook's Priori Sans of 2003 shows structural influence from Gill Sans, as did his Mason Sans (formerly Manson) from 1992. Both faces also have stylistic elements from vernacular sign-painting, religious symbolism and stone-carving, tying Barnbrook to Gill's bohemian spiritualism and Morris' medievalist idealism. In an *Eye* magazine interview with Rick Poynor, Barnbrook once sympathized, "I still agree with the socialist side of modernism."

Barnbrook's design authorship is manifest in the portfolio of provocative type and graphic designs he has created over two decades, but also in the socially and politically activist position he embraces. His designs have appeared in *Adbusters*, the anti-consumerist magazine, and in 1999 he designed a Las Vegas billboard that visualized designer Tibor Kalman's quote: "Designers, stay away from corporations that want you to lie for them." Using type to provoke in a social context has been a hallmark of Barnbrook's — additionally, his type tools faciltate this for those who use his fonts to author their own works.

59 /// Jonathan Barnbrook, Prototype, 1995
60 /// Jonathan Barnbrook
61 /// Jonathan Barnbrook, Priori, 2003
62 /// Jonathan Barnbrook, Priori Sans, 2006
63 /// Jonathan Barnbrook, Mason Sans Bold OT, 1992
64 /// Sign painting
65 /// Stone carving
66 /// Eye, Winter 1994
67 /// Rick Poynor
68 /// Adbusters
69 /// Fabulous Las Vegas

70 /// Tibor Kalman
71 /// Jonathan Barnbrook, Stay Away from Corporations That Want You to Lie for Them, 1999
72 /// Tate Modern, London

The art world's Relational Aesthetics theory describes typographic design authorship, according to this definition from the Tate Museum glossary: "The French curator Nicholas Bourriaud published a book called *Relational Aesthetics* in 1998 in which he described the term as meaning 'a set of artistic practices which take as their theoretical and practical point of departure the whole of human relations and their social context, rather than an independent and private space.' He saw artists as facilitators rather than makers and regarded art as information exchanged between the artist and the viewers. The artist, in this sense, gives audiences access to power and the means to change the world."

In this regard, type design participates in a form of relational aesthetics. The intentions of the original typeface designer — 'neutrality' is also an intention — are met with the literary considerations of the writer, as interpreted by the rhetorical motivations of the graphic designer, as interpreted by society. But what might make its opposite — dissonance, for example — a desired outcome? As magazine art director David Carson once asserted, "Don't mistake legibility for communication."

This idea is visually manifest in the book *Helvetica: Homage to a Typeface*. Every page spread depicts examples of work by those whom Lars Müller terms "superb designers" (THE PROFESSIONALS) using Helvetica on posters, books and packages. Every other spread — hidden initially by a perforation that the reader must tear — documents the quotidian use of Helvetica in everyday contexts (BY AMATEURS). This device segregates and establishes hierarchy, but it still posits the monochromatic voice of Helvetica as a constant element in global visual communications: generic, ubiquitous, authoritarian, timeless, infinite. In other words, Helvetica, originally 'Neue Haas Grotesk' designed by Max Miedinger in 1958, represents the antithesis of typographic design authorship — it is ostensibly legible, but it doesn't communicate the full range of the human condition.

While Helvetica connotes order, structure and rationality — a kind of modernist absolutism — the relative possibilities of relational aesthetics are inherent in the integrated activity of thinking, writing, designing, publishing and reading, followed by action. As the historical examples have shown, typographic design authorship is the result of several relational factors:

/// transformative integration of established craft with new technology
/// knowledge of, and sampling from typographic history
/// personal vision informed by philosophy and ideology
/// creation of innovative forms
/// desire to bring about positive social change

Thus, typography is a product, a process, and a tool — sometimes separately, sometimes concurrently. As a product, it is marketed and sold; if the type designer is entrepreneurial in her approach, the economic act becomes empowering, and a form of authorship. As a process, type has a role in the whole of humanity's continuously evolving written communications; when type's visual forms meet language's linguistic ones, a complex semiotic system results. As a tool, type exists to make authors and their 'tone of voice' — expression, function, persuasion — accessible to readers, or when appropriate, challenging to them.

When the idea inspires the writing, and the type enables the writing, and the graphic design structures the type, and the printing produces the edition, and the book (OR WEB SITE OR POSTER...) engages the reader, and the reader acts to change society, the act of typographic design authorship is complete.

73 /// Nicholas Bourriaud
74 /// Nicholas Bourriaud, Relational Aesthetics, 1998
75 /// David Carson
76 /// Lars Müller, Helvetica: Homage to a Typeface, 2002
77 /// Lars Müller
78 /// Helvetica
79 /// Christian Schwartz, Neue Haas Grotesk (revival), 2011
80 /// Max Miedinger

HELVETICA: HOMAGE TO A TYPEFACE (BOOK) /// Lars Müller (INTEGRAL LARS MÜLLER, DESIGNER) /// 2005

CARNIVAL, THE FIRST PANEL (DETAIL) /// Steve McCaffery /// (1967–1970)

THE VISUAL-VERBAL TEXT 71

"Autonomous works of total authorship must be considered a valuable contribution to graphic design."
ANNE BURDICK, "WHAT HAS WRITING GOT TO DO WITH DESIGN?", EYE, 1993

For **MANY** decades the skills of writing, designing, printing and publishing existed as separate fields, with their own methodologies, tools, techniques and trade practices. While this specialization created deeper knowledge and craft within these discrete disciplines, segregated domains were established that made hybrid forms the exception. In turn, this limited the kinds of messages that were communicated.

Countering this notion, Ellen Lupton's redefinition of "graphic design as a writing activity, not just an after-the-fact activity of polishing and presenting" positions the designer as novelist and poet, and as the examples will show, the writer as designer, typographer and artist. As graphic designers use typography, page composition, space and book structures to influence reading and pacing, visually-minded authors know that their narrative can be enhanced by graphic interventions.

The field of concrete poetry is a convenient starting point, especially French poet Stéphane Mallarmé's seminal work *Un Coup de Dés Jamais N'Abolira Le Hasard* from 1897, which helped establish the possibilities for texts that were both verbal and visual. Canonical works of concrete poetry by the Dadaists and the Futurists are familiar to students of graphic design and art history. However, an expanded interpretation of concrete poetry is best exemplified in this contemporary definition of the Ruth and Marvin Sackner Archive of Visual and Concrete Poetry:

"The Sackners collected their [mid-twentieth century concrete poets'] works as well as those of subsequent poets and over the years expanded the scope of the Archive to include unique or small edition artist's books that integrated text and image or consisted of experimental typography. They added examples of typewriter art and poetry, experimental calligraphy, correspondence art, stamp art, sound poetry, performance poetry, micrography, assembling periodicals, 'zines,' and graphic design as well as conventional poetry and prose written by concrete/visual poets and artists in the collection. Further, they collected experimental typographic, text and image works from such contemporary art movements as Fluxus, Transfuturism, and Inism."

In the nineteen-teens and -twenties writers such as Tristan Tzara and Guillaume Apollinaire explored the symbolic potential of image, texture, form and space in their

01 /// Anne Burdick
02 /// Eye, Summer 1993
03 /// Ellen Lupton
04 /// Stéphane Mallarmé
05 /// Stéphane Mallarmé, Un Coup de Dés Jamais N'Abolira Le Hasard, 1897
06 /// Ruth and Marvin Sackner
07 /// The Sackner Archive, entrance to publications storage

poems. Visual artists and designers such as Piet Zwart and Kurt Schwitters built transgressionary compositions from letters, words and texts. Both approaches attempted to bridge the visual/verbal divide while reconfiguring established domains of communication. Meaning was simultaneously unmoored and enhanced in an emerging integrated and symbiotic language system.

08 // Fluxus typography
09 // Inism typography
10 // Tristan Tzara
11 // Tristan Tzara, Calligramme, 1917
12 // Guillaume Apollinaire
13 // Guillaume Apollinaire, Calligramme, 1914
14 // Piet Zwart
15 // Piet Zwart, Wij Nu Experimenteel Toneel, 1925
16 // Steve McCaffery
17 // Typewriter

Design authorship, like art and literature, cannot be reduced to simple formula without criticism. There are many legitimate approaches, and they co-exist on sliding scales. These scales range from visual to literal, from functional to expressive, from personal to public, from commercial to altruistic, from implicit to explicit, and so on. A series of case studies of design authorship involving the text — in which art, design, typography, writing and publishing combine in surprising ways — follows.

Steve McCaffery is a poet who has pushed the literal into the visual realm in his works since the late 1960s. Using a typewriter to create 'typestracts,' he applies letters to paper in the way an abstract expressionist painter applies paint: energetically and freely, but not without purpose. Besides existing as visual works, McCaffery also performed his typestracts live, transforming them from the visual to the oral.

Tom Phillips is an artist who's best known for his work *A Humument*, his reworking of a 1892 Victorian novel. By selectively painting and drawing over the original text, he extracts a new story by simultaneously concealing and revealing. Phillips' acts of editing and image-making contrive to create a form of free verse squirming through fields of color and texture.

Chip Kidd is best known as a prolific and celebrated book jacket designer, giving visual form to the outer package of others' texts. His cover designs serve to summarize and market the stories within to potential bookshop customers. (BOOK TEXTS ARE TYPICALLY DESIGNED BY ANOTHER GRAPHIC DESIGNER ALTOGETHER.) Kidd's own novel *The Cheese Monkeys* reveals his talent for writing. As its designer, he also interpreted his own words graphically, with innovative results.

While the definition of 'typestract' refers to the creation of abstract forms with a conventional typewriter, McCaffery must have enjoyed the double entendre of 'type's tract' — with type referring to categories of things in common and tract referring to an area of indefinite extent. This is conceptually and graphically evident in his works *Carnival*, *Panel One* created in 1967–1970 and

A HUMUMENT (SINGLE PAGES) /// Tom Phillips /// (1973–2012)

Carnival, Panel Two from 1970–1975. According to McCaffery, "Carnival is planned as a multi-panel language environment, constructed largely on the typewriter and designed ultimately to put the reader, as perceptual participant, within the center of his language." *Panel One* was imprinted with red and black ink solely from the typewriter's ribbons, while *Panel Two* added larger rubber-stamped letterforms. Both used masks to create — in their negative shapes — amorphous white space that delineates the curvilinear fields of type. The Panel series exist as perforated book pages that can be torn from their bindings and assembled into 16-panel grids, with the result a "visual performance of type" says critic Fiona McMahon, akin to a painting or print.

McCaffery describes his Carnival project with arcane terms in an interview with Ryan Cox: "acoustic paragramatism," "textual cartography," "psychogeographic wandering," "post-bop jazz," and a "phonetic semantic allegory." McCaffery is referred to by Marjorie Perloff as a "'post-concrete' poet" because of his emphasis on the page and book rather the poem. One could also use this term to recognize his exploitation of the visual over the literal, and the letter, as micro element, over the word and text as macro elements. Scholar Johanna Drucker claims that "he uses visuality as an integral element of textuality, not as a decorative surplus or afterthought." The next example might be the opposite: the use of text as an integral element of visual imagery.

18 /// Tom Philips, Humument Self-Portrait at Fifty, 1987
19 /// Tom Philips, A Humument, 1980
20 /// A Humument App
21 /// Chip Kidd
22 /// Chip Kidd, The Cheese Monkeys, 2001

23 /// Carnival
24 /// Carnaval
25 /// Rubber Stamp
26 /// Fiona McMahon
27 /// Ryan Cox
28 /// Marjorie Perloff
29 /// Johanna Drucker
30 /// W.H. Mallock, A Human Document, 1892
31 /// W.H. Mallock
32 /// Abstract color field painting (Morris Louis, Where, 1960)
33 /// Pictorial symbolism (Salvador Dali, Flight of a Bumblebee, 1944)

Tom Phillips took the book *A Human Document* by W.H. Mallock and made it his canvas, while allowing a new story to emerge. Phillips states: "… his book is a feast. I have never come across its equal in later and more conscious searchings. Its vocabulary is rich and lush and its range of reference and allusion large. I have so far extracted from it over one thousand texts, and have yet to find a situation, statement or thought which its words cannot be adapted to cover."

While McCaffery's *Carnival* is visually explosive and literally abstract, Phillips' *A Humument* fuses found narrative with visual devices ranging from abstract color field painting to pictorial symbolism to comic book panels. The grid of the original page layout is often a guide: line measure, leading, word space and margins become edges and borders. The text itself contributes to graphic texture on some pages. He uses the white space — the 'rivers' — that flows through the text as a tether between words and phrases, creating syntax.

Semantically, *A Humument* offers options and limitations. While the original word order of *A Human Document* is fixed, Phillips carves out unexpected relationships, building on the convention, at least in English and other languages using the roman alphabet, of reading from top to bottom and from left to right. Still, these word-shape bubbles take on their own life as characters in the story, as a close reading reveals elements of Phillips' autobiography. "Because of the extreme intertextual nature of this work, which breaks boundaries between the textual and visual, whereby the text itself becomes worked into 'image,' Phillips is able to turn the leaves of the Mallock pretext into a folio of allusion to the artist's own previous works," writes Jennifer Wagnor-Lawler.

While McCaffery 'writes' by placing letters on page, his reader is left to derive meaning from an abstract text field, or reacting to *Carnival*'s exuberant colors, textures and shapes, simply enjoy the picture. Phillips' strategy is editorial: he conceals much and reveals more. His images seem to be largely decorative foils — 'eye candy' — for the subtext. By subverting the negative (WHITE RIVERS OF WORD AND LINE SPACE) into positive conjunctions that help create new meaning, Phillips anticipates digital hyperlinking and tag clouds. Both McCaffery and Phillips enable, maybe even demand, non-linear reading. Perhaps *A Humument* offers a more coherent story, achieved through Phillips' editorial choices enacted upon Mallock's original codex-bound text.

Referring to his editing and layering approach as "treatment," "translation," and "revision," critic James Maynard emphasizes the performative aspect of Phillips' art, as the

CARNIVAL, THE SECOND PANEL /// Steve McCaffery /// (1970–75)

crowd laugh gesture. and kalei t ; we want ing
She sat w throughout that scene, " abundant her large eye
, we want we want— "

father's face "Can you understand," asked my father, "the
splendid uch , only to wilt and perish.
"We are not g of that ," he said, " . My father okes of wl .

fel long-term beings. u understa ? not ca heroes of

above /// TREE OF CODES (BOOK) /// Jonathan Safran Foer (VISUAL EDITIONS) /// 2010
below /// THE CHEESE MONKEYS: A NOVEL IN TWO SEMESTERS (BOOK) /// Chip Kidd (SIMON AND SCHUSTER) /// 2001

Humument project has lasted over four decades with ongoing editions involving many 'originals.' Performance — not quite comparable to McCaffery's public reading of *Carnival* — exists in Phillips' iterative process and in the consequent decoding by his readers.

Decoding, and to a degree, performance, is also asked of contemporary readers in Jonathan Safran Foer's *Tree of Codes* (2010), a book that owes a debt of gratitude to *A Humument*. Using a similar strategy — "erasure" is Foer's term — *Tree of Codes* employs die-cutting to slice text passages from Bruno Schulz' 1934 book *The Street of Crocodiles*. Although editing by subtraction as opposed to Phillips' additions of color and image, Foer also extracts a new narrative from Schulz' original. Foer's die-cutting has another analogy in McCaffery's paper masks that 'cut' typed letters from his poems. Where *Tree of Codes* differs from *Carnival* and *A Humument*, and adds a fresh approach, is that subsequest pages are partially visible through the rectangular windows, making non-linear reading inevitable and suggestive of hyperlinking. This device enables phrases to appear out of syntax and foreshadow their upcoming position in the story, while also contributing to the 'book as sculpture' effect. The performance aspect is the reader's — while *Carnival* and *A Humument* are flat graphics, *Tree of Codes* invites a tactile and kinetic engagement.

In spite of, or possibly because of, McCaffery's and Phillips' radically interdisciplinary works of several decades ago, it is claimed by Drucker that "the attitude of contemporary poets and editors toward typographically manipulated works... has been one of suspicion bordering on hostility." Is it more subversive, then, to blur distinctions between design, typography and writing in a mass-produced novel, as Chip Kidd has done — acting as "archivist, editor, art director and writer" as Véronique Vienne has termed?

The Cheese Monkeys: A Novel in Two Semesters is about two graphic design students and their tyrannical professor, set in the late 1950s and published in 2001. Kidd's writing style is chatty, and his characters are animated, as if the author is writing from personal experience; indeed, Kidd attended an American state university not unlike the one he describes. Vienne describes it as: "A thinly veiled autobiographical account of his college days, *The Cheese Monkeys* lies somewhere between adolescent derision and design manifesto — *Catcher in the Rye* meets First Things First."

The book counters publication design conventions with devices that surely express Kidd's desire to break the traditional rules of his professional work: printing on the fore-edges of the text block, running the front matter across nine pages (INCLUDING THROUGH THE GUTTERS), splitting the title

34 /// Comic book panel
35 /// Jennifer Wagner-Lawler
36 /// James Maynard
37 /// Jonathan Safran Foer
38 /// Automatic Die Cutting machine
39 /// Bruno Schulz
40 /// Bruno Schulz, The Street of Crocodiles, 1934
41 /// Crocodile

page across two spreads, printing small text on the edges of the cover boards, printing narrative text on the end papers, and so on.

42 /// J.D. Salinger, The Catcher in the Rye, 1951
43 /// Veronique Vienne
44 /// Ken Garland, First Things First, 1964
45 /// Adrian Frutiger, Apollo, 1962
46 /// Giambattista Bodoni, Bodoni, 1798

The text changes typefaces from semester one to two, from Apollo to Bodoni, and has liberal use of italics and caps for conversational emphasis. At the end, black text becomes screened to light gray to 'fade' the speaker's voice. Generous margins, smallish font and justified text give the book a classical appearance. Rick Poynor refers to Kidd's book as "a distinctive object [that has]... appeal for the visually minded, though it's good enough not to need these extras."

Kidd's desire to merge the visual with the textual is accomplished in two ways. The front matter discloses that he wrote the book in Quark 3.2, a page layout software program. This enabled him to simultaneously write, edit and design; typographic concerns about font size, widows, orphans, word spacing, and so on, could be directly addressed in the writing process. Kidd's own 'type's tract' was the virtual space of the computer desktop environment, where writing, editing, design and publishing are integrated.

The second aspect of intertextuality is that the book is self-exemplifying. The stories about graphic design as a higher calling than commercial art are demonstrated through Kidd's own publication design concepts. *The Cheese Monkeys*' story reinforces this. "Usually, with Kidd designs, the big ideas are visible on the cover. Here the big ideas — about growing, working, loving — are all inside," wrote Thomas Hine in *The New York Times*. In the protagonist's final design assignment brief, on the book's last page, he's ordered by Kidd to "design a moment in time. ...It could be a word, a picture, a poster, a combination of these, hell... maybe even a book — you get the idea."

Kidd's book is the most accessible of the three projects illustrated here. It is commercially available, has achieved mainstream critical and popular success, has been optioned for a film, and has a sequel, *The Learners: The Book After "The Cheese Monkeys"*. While *The Cheese Monkeys* lacks the exuberant abstraction of *Carnival* and the innovative density of *A Humument*, it also succeeds as a comprehensive work of design authorship. The author is no less involved than McCaffery or Phillips, just less visible, honoring the reader over the viewer. Furthermore, in *The Cheese Monkeys*, the qualities of concrete poetry are acted out at the level of the entire book, from cover design to typeface choice. That the book text changes font from the 'art' semester — Apollo — to the 'graphic design' semester — Bodoni — is an intentional concretizing of the chronology, and of the characters' maturation process.

A HUMUMENT (SINGLE PAGE) /// Tom Phillips /// (1973–2012)

Although the three examples — poetry made overtly visual, a story born from text edited by art, and a novel holistically written, typeset and designed — differ in process and product, all contribute to the concept of the designer as author as interdisciplinary hybrid. Not designer or writer or artist or editor — but both/and. Two of these creative examples largely define the margins of practice, while *The Cheese Monkeys* has opened the door to a new genre of designer-authored, and author-designed, mainstream novels such as *Tree of Codes*. By doing so, they all redefine 'type's tract.'

47 /// Rick Poynor
48 /// Quark Xpress
49 /// Thomas Hine
50 /// The New York Times
51 /// Chip Kidd, The Learners, 2008

79

above left /// **GILL SANS** (SPECIMEN DRAWING) /// St. Brides Library, London /// 2010
above right /// **AN ESSAY ON TYPOGRAPHY** (BOOK) /// Eric Gill (DAVID R. GODING PUBLISHER, 1988 REPRINT) /// 1931
below /// **MANSON** (RELEASED BY EMIGRE AS "MASON") (TYPEFACE) /// Jonathan Barnbrook /// 1992

TYPOGRAPHY AND LIFE: A COMPARISON

Eric GILL and Jonathan Barnbrook

are recognized in the graphic design canon as accomplished and inventive typographers, sharing a country of origin and similar influences, though they are separated by generations. Yet they both advanced their personal ideologies through the strategy of design authorship, and might be best remembered because of this.

This section examines the confluence in thought and action between the two designers in both their creative production, and in their world views — views on religion, society, economics and morality expounded on through numerous self-published books, essays, interviews, web sites, and of course, their graphic designs.

Does the phrase "feeling of spontaneous religious ecstasy" describe the life's work of artist, typographer, designer and stone mason Eric Gill? After all, he was a man of dichotomies: iconoclastic and spiritual, erotic and intellectual, modernist and medievalist. Perhaps it does. Yet, it was written by another Englishman, contemporary typographer and designer Jonathan Barnbrook, and originally published on his Virus web site in 1999. Ostensibly, the quote had nothing to do with Eric Gill, and yet many parallels can be drawn between the two men. In the same provocative, self-aware, and occasionally awkward manner towards using self-authored works to advance his ideologies about life and design, Jonathan Barnbrook has much in common with Eric Gill.

Both Eric Gill and Jonathan Barnbrook are designers-as-authors, in varying degrees, in varying contexts, and at opposite ends of the twentieth century. They engaged their graphic works with not only a personal vocabulary — their style — but also used their designs, prints, drawings, typefaces, sculptures, films, lectures, books and interviews to put forth their views and philosophies. In this they are not alone during the century: think of the design, writing and self-initiated ventures of Jan Tschichold, Alexi Brodovitch, Paul Rand, Push Pin Studio, Octavo, Emigre, Ellen Lupton, Stuart Bailey and others.

Eric Gill, a multi-talented artist, designer and writer whose working life spanned the first four decades of the twentieth century, is best known today by most graphic designers for his humanist sans serif typeface Gill Sans. It was commissioned by Stanley Morison for the Monotype Company in 1927, and developed over several years with the addition of various weights and widths. According to scholar Gérard Mermoz, attribution of Gill Sans to Gill alone, indicative of the intellectual

01 /// Eric Gill
02 /// Jonathan Barnbrook
03 /// Jan Tschichold
04 /// Alexi Brodovitch
05 /// Paul Rand
06 /// Push Pin Graphic
07 /// Octavo
08 /// Emigre
09 /// Ellen Lupton
10 /// Stuart Bailey

property assumption tied to the typeface name, is misleading. His design evolved throughout the process with the involvement of Monotype's draftsmen, from a face that was more idiosyncratic to the popular Gill Sans we recognize today. Its success can partly be attributed to the widely quoted 'crystal goblet' author Beatrice Warde, Monotype's publicity person and one of Gill's many female companions, who championed the type as having "dignity and clarity."

Trained originally as an architect, Gill also studied stone carving at the Chichester Technical and Art School, and eventually calligraphy and lettering under Edward Johnston at Central School of Art and Design in London. It was Johnston's iconic sans serif typeface that he designed for the London Underground Railway in 1916 that inspired Gill to create his own sans, which was eventually used by the London and North Eastern Railway.

11 /// Eric Gill, Gill Sans, 1926
12 /// Stanley Morison
13 /// Gill Sans Monotype Sample
14 /// Gerard Mermoz (left)
15 /// Beatrice Warde
16 /// Chichester, England
17 /// Edward Johnston
18 /// Central School of Art and Design, High Holborn, London
19 /// London, England
20 /// London Underground
21 /// London and North Eastern Railway timetable
22 /// Brighton, England
23 /// Canterbury Cathedral, Church of England
24 /// Roman Catholic Church
25 /// Eric Gill, The Four Gospels, Golden Cockerel Press, 1931
26 /// Golden Cockerel Press

Born in 1882 in Brighton, England, Gill was an eclectic fellow by all accounts. He lived a modest, Bohemian lifestyle, moving his family and entourage (inclusive of dogs, cats, goats and geese) from bourgeois town to monastic commune to rural studio. Gill converted to Catholicism — on his thirty-first birthday — having been disillusioned with his father's vicarage at the Church of England. "I invented the Roman Catholic Church," he stated; yet as audacious as this remark seems, it gave Gill license to arrive at a personal reconciliation between his spiritual devotion and his frequent transgressions into behavior that the Church deems as sinful, and society unacceptable. Gill has been documented as indulging in adultery, bestiality and incest.

The commissions Gill received during his life include creating woodblock illustrations for *The Four Gospels* published by the Golden Cockerel Press, carving the Stations of the Cross for Westminster Cathedral, designing and carving a huge relief panel for the League of Nations building in Geneva, and creating various works for his patron, Count Harry Kessler. Gill also kept detailed journals, wrote and published extensively, and drew the figure endlessly: his family members, his mistresses, his friends, himself.

Books that Gill wrote include: *Art-Nonsense* (1929), *An Essay on Typography* (1931), *Money and Morals* (1934), *Trousers and the Most Precious Ornament* (1937) and at least a dozen others, with his *Autobiography* published a month after his death in 1940. Numerous books have been written about Gill, and his works and papers are in major world-wide collections. Recent interest in the works of Eric Gill is in evidence: an exhibition, *Primitive Types: The Sans Serif Alphabet from John Soane to Eric Gill* held at the St. Bride Printing Library in London, and a conference titled *Eric Gill & the Guild of St. Dominic* (GILL'S PRINTING IMPRINT) held at the University of Notre Dame. Numerous works of Gill are exhibited frequently in museums and libraries.

Jonathan Barnbrook is regarded today as a leading graphic designer and typographer, and through interviews and personal projects, as a provocateur and design critic. He was born in 1966, near London, attended Central St. Martins and then earned a master's degree at the Royal College of Art. Barnbrook's current design practice is a mixture of commissioned work, entrepreneurial projects, and collaborations — most notably with British artist Damien Hirst.

His primary recognition comes from the design of several typefaces that have achieved both popular usage and critical acclaim, and the ensuing debate about his typeface-naming strategies. Besides typography, Barnbrook designs books, posters, and corporate television advertising, although he has expressed ambivalence about the inherent contradiction of the latter in respect to his current anti-corporate position. His design practice has designed the books *Staging a Revolution: The Art of Persuasion in the Islamic Republic of Iran*, *I am Iman* (ABOUT THE SUPERMODEL), and Hirst's infamous *I Want to Spend the Rest of My Life Everywhere, with Everyone, One to One, Always, Forever, Now*. Barnbrook's work has been in numerous exhibitions, published in

27 /// Eric Gill, The Stations of the Cross (The Entombment), 1918
28 /// Eric Gill, The Creation of Man, League of Nations, Geneva, 1938
29 /// Count Harry Kessler
30 /// Eric Gill, Art Nonsense and Other Essays, 1929
31 /// Eric Gill, An Essay on Life and Works in the England of 1931, & Particularly Typography, 1931
32 /// Eric Gill, An Essay on Typography, 1988
33 /// Eric Gill, Money and Morals, 1934
34 /// Eric Gill, Trousers and the Most Precious Ornament, 1937
35 /// Eric Gill, Autobiography, 1940
36 /// St. Bride Printing Library, London
37 /// Primitive Types, 1999
38 /// Eric Gill and the Guild of Saint Joseph & Saint Dominic, conference poster
39 /// University of Notre Dame, Notre Dame IN
40 /// Central Saint Martins College of Art & Design, London
41 /// Royal College of Art, London
42 /// Damien Hirst

highly competitive graphic design annuals, and in critical venues such as *Emigre, Eye* and *Typography Now*. Barnbrook has been a vocal advocate of contemporary typography and design for the past two decades, lecturing world-wide: the American Institute of Graphic Arts Voice 2 conference, the Icograda conference, ATypI annual conference and many others. He is a signatory to the hotly debated First Things First 2000 manifesto, and has been a contributor to *Adbusters* magazine.

43 /// Peter Chelkowski & Hamid Dabashi, Staging a Revolution: The Art of Persuasion in the Islamic Republic of Iran, 1999
44 /// Iman, I Am Iman, 2001
45 /// Damien Hirst, I Want to Spend the Rest of My Life Everywhere With Everyone One to One Always Forever Now, 1997
46 /// Eye, Winter 2000
47 /// Rick Poynor, Typography Now Two, 1996
48 /// AIGA, Voice 2 conference website
49 /// ICOGRADA: International Council of Graphic Design Associations; A Partner of the International Design Alliance
50 /// ATypI: Association Typographique Internationale
51 /// First Things First 2000
52 /// Jonathan Barnbrook, Adbusters "Design Anarchy" issue, 2001
53 /// Jonathan Barnbrook, Barnbrook Bible, 2007
54 /// VirusFonts
55 /// Adrian Shaughnessy
56 /// Clerical collar
57 /// London Soho
58 /// Seedy sex shop
59 /// Jonathan Barnbrook with Margaret Richardson

Barnbrook's own *The Barnbrook Bible*, published in 2007, is a magnum opus of his designs, type fonts and progressive ideas. According to Adrian Shaughnessy, "The spectre of religion hangs over this book. It begins with the odd-sounding note of the title and continues inside with Barnbrook's extensive use of religious symbolism and typographic conventions associated with English religious texts; Eric Gill's stark red-and-black typographic creed lives on in Barnbrook's design."

Barnbrook has been widely written about, interviewed, and through his VirusFonts.com web site, has published his thoughts on issues ranging from graphic design to capitalism to society. Barnbrook says that he is not supportive of organized religion, yet his approach to spiritual issues is intentionally enigmatic: he once spoke at a typography conference wearing a priest's clerical collar. Barnbrook's studio in London's Soho is "complete with seedy sex shops viewed from the window" according to critic M. Richardson, but there is no evidence that Barnbrook shares Gill's prodigious libido.

The confluences in thought and action between Eric Gill and Jonathan Barnbrook, albeit almost a century apart, are striking. Although manifest in different ways, the tension between spiritual issues and carnal appeal creates an obvious departure

point. Gill's conflicts in his personal life and work, and his resolution or justification of those conflicts, are quintessentially linked to early twentieth century modernity and its industrial, economic and social structure on the heels of Victorian England. Barnbrook is of his milieu: post-modern, deconstructed, technological, and yet as Gill, concerned with craft, creative and economic independence of the artisan, and historic references and their contemporary interpretation.

In the way that Gill was attracted to the flesh — recording his myriad sexual affairs, drawing his own genitals, and interpreting the spirit and body as one — Barnbrook's themes of bodily fluids and bodily functions are constant in his work. The typeface Manson, named after the mass murderer Charles Manson and later changed to Mason for distribution by Emigre, caused much debate about the relationship between the name of a typeface and its meaning. It is ironic here in its reference to stone-masonry, and yet stone-cut letters were very much part of Barnbrook's typographic influence. Spindly Bastard (AN EXTREMELY CONDENSED NEO-TEXTURA FACE, AND ITS COMPANION FAT BASTARD), Prozac, Exocet (NAMED AFTER THE FRENCH-MADE MISSILE), Coma, Expletive, Apocalypso, Drone — images of blood, flesh, nerves, medicine, chemicals and weapons infuse Barnbrook's type with a charged rhetorical position. Typeface names Tourette, Nixon and Regime suggest a relationship to the idea of control — lack of, and abuse of. In an interview with Michelle Trudo, he states: "naming a typeface is incredibly important because it is a chance to link the poetry of letterforms with the poetry of abstract shapes with the poetry of language."

60 /// Charles Manson
61 /// Freemasonry
62 /// Jonathan Barnbrook, Mason, 1992
63 /// Jonathan Barnbrook, Spindly Bastard, 1995
64 /// Jonathan Barnbrook, Fat Bastard, 1995
65 /// Mike Myers as Fat Bastard
66 /// Jonathan Barnbrook, Prozac Life, 1995
67 /// Prozac
68 /// Jonathan Barnbrook, Exocet, 1992
69 /// Exocet missile
70 /// Jonathan Barnbrook and Marcus Leis Allion, Coma, 2001
71 /// Coma, 1978
72 /// Jonathan Barnbrook and Marcus Leis Allion, Expletive, 2000
73 /// Jonathan Barnbrook and Marcus Leis Allion, Apocalypso, 1997
74 /// Jonathan Barnbrook, Drone, 1995
75 /// Drone

76 /// Jonathan Barnbrook, Tourette Extreme, 2005
77 /// Georges Gilles de la Tourette
78 /// Jonathan Barnbrook, Nixon Script, 1997
79 /// Richard Nixon
80 /// Jonathan Barnbrook, Regime, 2010
81 /// Michelle Trudo
82 /// Religious cult
83 /// David Earls
84 /// Malcolm Yorke
85 /// Teutonic iron cross for iphone
86 /// Plus sign
87 /// Chi rho
88 /// The Letter X
89 /// Crosshairs
90 /// Eric Gill, Crucifix, Chalice and Host, 1917
91 /// Ragged-right versus justified text
92 /// Jonathan Barnbrook, Mason Sans, 1992

Barnbrook's VirusFonts.com web site — a commercial venture for marketing his own typefaces similar to Gill's self-published efforts — is styled "like a religious cult" claims David Earls, adding a tongue-in-cheek pop spirituality to his uneasiness with selling his work. In one section of the site, viewers are invited to donate money; for $10,000 donors: "A special sin allowance voucher — redeemable when you want to do something such as commit adultery or embezzle your business funds."

Analogous to Gill's central positioning of Catholicism as his reason to sculpt, draw, write, and create letterforms that were "absolutely legible-to-the-last degree" quoting Malcolm Yorke, Barnbrook literally positions Christianity's strongest symbol, the cross, as central to his type and graphic designs. Not necessarily a crucifix, the cross shape is evident in Barnbrook's page compositions, and by his own admission, he begins many of his type font designs by creating the T first. Sometimes resembling a Teutonic iron cross, sometimes a plus sign, sometimes a Chi-Rho symbol, and sometimes angled like the letter X, Barnbrook seems to use the cross much like crosshairs on a gun-sight, often within a circle. Gill also vacillated between using the T alphabetically and figuratively. In some carvings and illustrations, he would cut off the top of the crucifix and have Christ nailed to a large T; elsewhere, a T would serve as an initial cap and a cross simultaneously.

Gill's advocacy of ragged-right text to avoid compromising his typography's readability, and his despise for machine-made ornament, mirrors Barnbrook's contempt for computer distortion and blind reliance on software's typographic defaults.

As with Gill, one of Barnbrook's typographic influences was Edward Johnston, and Manson Sans bears an especially strong structural resemblance to Johnston's London Underground Railway face, and of course to Gill Sans. Gill criticized Johnston's letters' details, saying that they weren't quite "patient of dialectical exposition," whereas Gill wanted Gill Sans to be machine-reproducible. This comes full circle in Barnbrook's disappointment that his Manson, due perhaps to cultural association with its name as well as its aesthetic properties, was embraced by the so-called Gothic musical and fashion subculture.

Both Gill and Barnbrook seem to enjoy the titillation of provocative written and oral language, as they also revel in the power of visual imagery to shock viewers. Gill bemoans "a bastard aesthetic... employed by men of commerce," while Barnbrook laments "the fact that too many designers are constantly kissing corporate ass." Gill referred to his ultra-bold weight of Gill Sans as Double Elefans, with one critic interpreting this a criticism against well-fed bankers. Barnbrook adopts a more direct assault, using a promotional poster for his Fat and Spindly Bastard typefaces to exclaim, "to be used by corporate fascists everywhere."

In 1910 Gill worked on the lettering of Oscar Wilde's monumental gravestone; in 2000 Barnbrook designed posters and other materials for an exhibition titled *Oscar Wilde and the Art of His Time* held at London's Barbican Centre. This appears to be a coincidence, or maybe it is another connective thread between the works of Gill and Barnbrook.

The many similarities between the work of Eric Gill and Jonathan Barnbrook have been made apparent. The obvious similarities are in the typographic designs; the less obvious, and worthy of additional study, are their world views and how they both used the strategy of design authorship to advance their philosophies. In Gill, the aspect of design authorship, coupled with his unorthodox lifestyle, differentiated him from his peers to the point of being a freakish iconoclast. Barnbrook embodies the spirit of his times, and represents the diffusive nature of self-authored graphic design in contemporary practice, whereby increased agency comes with increased responsibility.

93 /// Goth fashion
94 /// Goth music
95 /// Eric Gill, Gill Sans Ultra Bold, 1928
96 /// Fat banker (before and after)
97 /// Oscar Wilde
98 /// Oscar Wilde gravestone
99 /// Jonathan Barnbrook, The Wilde Years: Oscar Wilde and the Art of his Time, 2000
100 /// Barbican Centre, London

INTERVIEW: KENNETH FITZGERALD

Kenneth FitzGerald is a designer, artist, writer and a professor at Old Dominion University in Norfolk, Virginia. FitzGerald recently wrote the book Volume: Writings on Graphic Design, Music, Art, and Culture, *and formerly self-published the periodical series* News of the Whirled. *In 2001, FitzGerald 'collated' the traveling exhibition* Adversary: an Exhibition (of) Contesting Graphic Design.

MCCARTHY You've brought many gifts to graphic design education: iconoclasm, emphasis on cultural and intellectual aspects of design, elevation of critical writing as a worthwhile endeavor, chipping away at the art/design/literature divide, and more. How do you teach design authorship to your students?

FITZGERALD Primarily by introducing and critiquing the concept at different levels. Simply introducing the idea of a graphic authorship is a substantive move. And then by having different projects that require students to provide or uniquely shape the content.

In a discipline whose primary identity is as 'professional' (an activity done for money), why do you require your students to consider things that are not 'career-oriented' but about life in general?

For me, that's what any humanities study at the college level is about. I would be committing academic malpractice if I weren't addressing broader concerns. And then, as your question frames it, I regard design as a discipline where the profession is a component and not the entirety of the activity. So once again, to be true to design's nature, I must open out what we engage in class. Ultimately, I think that it's the profession that demands an expansive education. The profession at its highest levels consistently calls for students with a wide-ranging intellect, historical knowledge, and conceptual acuity. Those virtues only come from looking beyond crafting speculative design artifacts.

Graphic design and writing are both symbol systems that communicate visually and carry abstract meaning. How should educators teach fluency in these systems while having students embrace content in their work?

Short of providing a curriculum, it's difficult to address fluency in any meaningful way here. But I first always make the challenge to my students that there's no conflict between graphic design, writing, and embracing of content. That's no small thing, and tough to do, as you have prominent and self-aggrandizing contemporary voices reanimating a value- and content-free conception of design. I suppose I can only refer back to my first answer, which, I admit, doesn't give (m)any specifics.

Any final thoughts on the notion that design authorship has transformed graphic design?

While I'm supportive of investigating ideas and actions of graphic authorship, I don't think a substantial claim can be made that it's transformed graphic design. The concept and practice simply hasn't been embraced by enough practitioners to have had a meaningful effect.

90

And, as previously mentioned, you have figures suppressing the idea for their own reasons. But it has opened possibilities and engendered distinctively engaging work. Who knows what will come of keeping the idea in play?

Thank you!

clockwise from top left /// **NEWS OF THE WHIRLED** (MAGAZINE) /// Kenneth FitzGerald /// 1997–2004
VOLUME: WRITINGS ON GRAPHIC DESIGN, MUSIC, ART, AND CULTURE (BOOK) /// Kenneth FitzGerald (PRINCETON ARCHITECTURAL PRESS), Jiwon Lee (COVER DESIGNER) /// 2010
CLAMOR OVER DESIGN AND WRITING (EMIGRE ISSUES 35 AND 36) /// Anne Burdick (EDITOR) /// 1995–96
DIGITAL_HUMANITIES (BOOK COVER) /// Anne Burdick (with Peter Lunenfeld, Johanna Drucker, Todd Presner and Jeffrey Schnapp) /// 2012

INTERVIEW: ANNE BURDICK

Anne Burdick is a designer, educator, writer and editor. Her work bridges theory and practice, and manifests itself in academic presentations, electronic texts, and printed books. She has been widely recognized for her creative work, including receiving "The Most Beautiful Book in the World" award at the Leipzig, Germany book fair in 2001. She is a faculty member and chair of the Graduate Media Design Program at the Art Center College of Design in Pasadena, California.

MCCARTHY You were an early and important voice in theorizing design authorship. Your 1993 Eye article "What has Writing Got to Do with Design?" and your guest editing of Emigre's "Mouthpiece" issues two years later are major and influential contributions. Approaching twenty years on, to what degree has design authorship transformed graphic design?

BURDICK First, thank you for asking me. I can't say that I have seen any kind of "transformation" in commercial graphic design, in the main. But ideas from design authorship flourish in different pockets of design, though it's not clear if design authorship is the cause. I do see a change in undergraduate student postures and projects — more zines, more "personal" or self-initiated work. And graduate education has grown considerably since the early '90s creating a generation of designers who incorporate critical reflection as "authors" of their own practices.

...

Blogs and social media have turned many designers into writers crafting a public identity. There are — as there have always been — a small group of designers who are professional or academic writers themselves; they are joined by a growing number of journalists and scholars specializing in design criticism and theory. Some of the designer/writers whose work I appreciate are Stuart Bailey, Metahaven, Mieke Gerritzen, Denise Gonzales Crisp, Brian Roettinger, and Project Projects.

...

Designers who operate at an instrumental or strategic level may have been influenced by the enlarged role of the designer as conceived in

01 /// Anne Burdick
02 /// Leipzig, Germany
03 /// Leipzig Book Fair
04 /// Art Center College of Design, Pasadena CA
05 /// Pasadena CA
06 /// Anne Burdick, What has writing got to do with design?, Eye No.9, Summer 1993
07 /// Eye No.9, Summer 1993
08 /// Stuart Bailey
09 /// Metahaven

design authorship, but I believe they are more likely to have come out of service and business design. And recently I've seen the designer as author used in the context of critical design, where the emphasis is on the ideological aspect of design, drawing on the idea of the author as an individual with a distinct point of view and the ability to author a critique through design. Perhaps the most enduring transformation is that many graphic designers nowadays would consider themselves to be makers of meaning — rather than a neutral conduit — which wasn't always the case.

How do you think earlier debates about 'voice' and 'attribution' in design authorship are being played out with today's emphasis on community, 'co-design,' and so on?

That's an interesting connection! Voice and attribution are all about power, agency, authority, and responsibility — legally and culturally. Foucault's analysis of the author function is definitely relevant to issues regarding who speaks and with what authority. So the aspect of design authorship that is concerned with a critique of intellectual property, regulation of speech, and the production of knowledge, is utterly relevant to community-based design centered on social justice.

...

There is another, perhaps more cynical answer. The interest in community and co-design is generally motivated by good intentions and a search for relevance. An initial draw to design authorship was to gain greater recognition for the designer, to enjoy the cultural status of an "author," which would be a good fit for someone drawn to pro-social design in order to be a hero or savior. But like I said, that's perhaps a bit too cynical. Co-design is different; it requires an erasure of the individual as creative genius and therefore is a decidedly different position for a designer to assume, one in which the historical concept of the author is destroyed completely.

...

I think that a lot of the early excitement about the model of the author was self-recognition on the part of designers, and rightfully so. For me it was a response to the context in which I became a designer, a time when international design had morphed into corporate design. My early education and work experience taught me that graphic designers should be chameleons, should erase themselves and be good service providers with no politics, no point-of-view. Authorship provided a model for participation and a way to think about design as the production of meaning. The idea that you should be responsible for what you produce in the world — that each utterance has an ideology and is part of the cultural connective tissue — fundamentally changed my thinking about design. It isn't like there is a separate category for design that is "social". Design is always already social and political. The post-structuralist critique of the author provided me that.

As design editor for the Electronic Book Review, you've been immersed in thinking about how visual

and literal language co-exist in this interactive environment. How has new media affected notions of design authorship?

There is one significant change that alters everything: In print, designers don't make writing tools. In digital media they do.

...

In my practice I have shifted from creating individual static works to creating systems, situations and conditions for both reading and writing. With Electronic Book Review, where we conceived of the interface as a tool for reading and writing, my role in the construction of texts became both subtler (YOU COULDN'T "SEE" IT) and more integrated. In collaboration with the programmer and editor, we built the infrastructure that defines what can be written, by whom, and how. Lengths of texts, visible display and juxtaposition, modes of navigation — these are fundamental components in the composition of a visual and/or verbal argument. We were building community relationships and conditions for participation by writers and readers.

...

My experience in digital media, and in particular my work in the digital humanities, has revealed the extent to which designing tools and environments for discourse and exchange is about constructing knowledge and communities of practice. It doesn't get more "authorial" than that!

'Design fiction' is an emerging topic, as evident by the Art Center's recent Made Up exhibition. Does it have intellectual roots in design authorship?

To the extent that design authorship as a concept is derived from literature and literary theory, YES!

...

Design is pure fiction — until it gets made, of course. Even design based on the most extensive research or the strictest rationale is essentially a proposition cast into an imaginary world of someone's creation, whether that future is five minutes or fifty years away. And that future is populated by imaginary people. And the best cultural form we have for imagining the inner life of people who don't exist is literature. That's why I believe that reading fiction is essential for all designers!

...

To some extent, design fiction is not a separate category; it's a way of conceptualizing design that brings literature and the humanities back into the equation — it wrangles design out of the problem-solving mindset of engineering and science. For as designers "author" imaginary worlds through the act of designing, they are in fact creating fictions every day.

Thank you!

14 /// Michel Foucault
15 /// Chameleon
16 /// Electronic Book Review
17 /// Made Up: Design's Fictions
18 /// Thank You

3

WE WILL FIGHT WE WILL KISS

LONDON CAIRO ROME TUNIS

FREELY DOWNLOADABLE POSTER /// Deterritorial Support Group /// ca. 2010–12

CULTURAL LEGITIMACY

It is TAKEN FOR GRANTED in many Western societies that artists and writers use their imagination, vision, skill and craft to express themselves to the world, and in doing so, enjoy an elevated cultural status. Their ideas are directly linked to the means of their creative production: paintings, poems, films, sculptures and novels, and many other forms. Whatever the medium or format, it is rare for artists or writers to be questioned as to the legitimacy of their work — it is assumed to have cultural value, even if it languishes unsold or unknown.

Because the discipline of graphic design emerged from the printing trade, designers have often been valued because of their technical expertise, whether with hardware or software. The perception that designers merely add some decorative aspect to the functional business of communicating leaves the notion that conceptual thinking is best left to the producers of content. Even while maturation of the graphic design field over the past decades has enabled designers to be involved with strategic planning and conceptualizing, much mainstream thinking holds that designers have a neutral position in the production of visual communication.

Inspiration for increased capital could come from outside of design, as Rick Poynor states: "It is highly visible authorship in the adjacent fields that designers envy and aspire to enter (ART, WRITING, FILM, FASHION, ARCHITECTURE) that gives these fields their social, professional and cultural capital."

Besides using image and text in both content and form to communicate, designer-authors are empowered to initiate. While most graphic design continues to be commissioned work within the typical client-designer-market service model, designers as authors produce original content and give it appropriate form. Design authorship may be self-initiated, lacking a conventional client, but that does not mean it lacks an audience. Instead of being reactive, it is proactive.

Some voices in mainstream graphic design, however, cannot conceive of design authorship's intellectual reach, and how it might challenge, or peacefully co-exist, with conventional practice. Dmitri Siegel, in critiquing a film by artist, designer and educator Elliot Earls, wrote: "It no longer seems quite as audacious for a designer to make a movie. Instead it raises questions like: Has the dominance of the 'designer as author' model transformed graphic design into a vague form of cultural production?; and, is the allure of the legitimacy of authorship pulling design away from the defining characteristic of the profession — the designer/client relationship?" The assumption that design needs a client is a common fallacy. Design needs content, and design needs users (READERS, A MARKET, AN AUDIENCE, ETC.), but the message content, including entrepreneurial ventures, can equally come from the designer.

01 /// Rick Poynor
02 /// Dmitri Siegel
03 /// Elliott Earls

Several factors have enabled this shift in the communications paradigm. Designers know how to read and write, skills learned by most people in a literate society. This is coupled with knowledge of typography, mastery of the elements and principles of design, image-making ability and immersion in mass media dissemination. The typical designer is well-versed in the functional, representational and symbolic aspects of written and pictorial language — a powerful combination.

As the field of graphic design grew more professional over the latter decades of the twentieth century, as denoted by technological advances, professional organizations, publications, education programs and popular awareness, designers themselves evolved into a target market. Numerous conferences, competitions, paper specimen brochures, digital fonts and clip art, and other specialized products and services sought this growing market. Students were recruited for the increasing number of education programs, ensuring a steady influx of future designers.

At the same time, many designers identified with distinct sub-cultures and niche markets: punk rock, gender equity, gay rights, peace movements, and social and environmental justice, among many others (EVANGELICAL RELIGIOUS GROUPS AND THE COLLEGE REPUBLICANS HAVE USED DESIGN TO ADVANCE THEIR IDEAS). Being involved with, or at least interested in, these causes gave designers an additional reason to use their visual communications abilities — they were motivated by content that mattered to them personally.

By being targeted as a market themselves, and by empathizing with other groups, designers realized that they could advance their convictions by employing their talents to communicate with, and for, others — client commission or not. New collaborative relationships developed between designers, writers, editors, publishers and their publics. New messages demanded new forms, and the designer as author — with a newfound voice — happily obliged.

In a *Print* magazine interview with Metahaven, the Deterritorial Support Group goes further: "With the advent of post-Fordist, neoliberal form of capitalism, design has become too critical to be trusted to designers..." In an inversion of this book's title *The Designer As...*, the DGS comment seems to advocate for The ... As Designer, harnessing design's power for social, political and economic change. Political activists, government officials, public policy makers and citizen designers alike might be awaking to design's capacity for imagining the future, joining artists and writers in the act of legitimizing design authorship.

THE POST-POLITICAL = THE MOST POLITICAL

egypt! liberals across the western hemisphere join us in applauding your unflinching pacifism and respect for due process in achieving your goals! xoxo

above /// FREELY DOWNLOADABLE POSTERS /// Deterritorial Support Group /// ca. 2010–12
below /// MARCUS AURELIUS 00:52:12:11 (FROM THE SARANAY HOTEL SUITE) (LAMBDA PHOTO PRINT) /// Elliott Earls /// 2007

CORPORATE AMERICAN FLAG (VERSION 2) /// Shi-Zhe Yung (DESIGNED ORIGINAL)(ADBUSTERS) /// 2000

DESIGNER AS AUTHOR ACTIVIST

99

"What is the relationship between form and content, particularly in political poetry?"
WALTER BENJAMIN, THE AUTHOR AS PRODUCER, 1934

This QUESTION, asked in 1934 of writers, can be applied to graphic designers who author their own messages — verbally and visually — in the service of political change and social justice. Besides the relationship of form and content in designer-authored work, this section will examine designers' motivations and intentions — why do they engage the public with their designs, and what outcomes do they desire?

To examine the intentions and motivations of designers who initiate their own messages, rhetorical aspects of communication must also be considered. Cristina de Almeida states: "the degree of authorship in graphic design is expanded when designers have the ability to negotiate discursive functions into carefully re-examined expressive patterns and graphic mediums."

Acknowledging the shifting creative and intellectual territory of graphic design, with its attendant economic, professional and cultural implications, one can view politically engaged work as a natural outcome of the increasingly wide reach of design in everyday life. It is understandable that progressive designers want to merge form and content into a more holistic message of their own authorship, thus becoming architects of their future.

Iconic examples of protest graphics abound, such as the Corporate American Flag, sold online by Adbusters.org, the "magazine concerned about the erosion of our physical and cultural environments by commercial forces." With corporate logos standing in for the fifty stars, Adbuster.org states: "This flag is a beautiful, edgy work of art. Hang it in your office or wave it at a protest — it absolutely captures the spirit of the omnipotent control of corporate America."

Designed by Shi-Zhe Yung, the flag has been a 'social actor' in many anti-globalization protests, and is explicit in its content. It is an advocate for an equitable economic future where democratic interests aren't overpowered by corporate powers and their lobbyists. But beyond serving as a symbol for the anti-globalization movement, has the flag affected real social or political change?

The book *Empire* (Nozone IX), edited by Nicholas Blechman, is devoted to designers and illustrators expressing their reactions to the US invasion of Iraq and other aspects of American military and cor-

01 /// Walter Benjamin
02 /// Christina de Almeida
03 /// Adbusters corporate flag for sale
04 /// Nicholas Blechman, Empire, 2007
05 /// Nicholas Blechman
06 /// Iraq

EMPIRE (NOZONE IX) (BOOK) /// Nicholas Blechman, editor /// 2004

porate imperialism, but its political impact is unknown. Individual contributions vary in their rhetorical intent. Peter Buchanan-Smith and Amy Gray's "The Great Villains of World History" series compellingly implicates the Pope as 'emperor of Catholicism' with facts about abuses of power over two millenia. Prem Krishnamurthy's spread, with an essay, photo and line illustration of a floor plan, reveals that it was created entirely for free at an Apple store — a cleverly parasitic act or subtle product endorsement? In Charles S. Anderson's five page series, it is hard to tell if his quotes and collages are ironic or jingoistic.

The other aspect to *Empire*'s questionable influence is its manifestation as a commercial product, a widely available paperback book that's probably most attractive to fellow designers. Perhaps 'the revolution will not be televised,' but will it be commodified? Thomas Frank and Matt Weiland's book *Commodify Your Dissent* articulates this concern.

Design authorship can be a reaction to a perceived problem, or the proactive stance of identifying an opportunity. *Empire* seems to be doing both, with good intentions, but limited impact toward true social change.

To present examples of designs with proven politically activist results, two case studies are used — the first as an example preceding awareness of design authorship, the second, post-awareness. One embodies a linear, asynchronous communications trajectory, the other a lateral, synchronous quality; one serves primarily as monologue, the other dialog; one espouses idealism, the other realism.

Lorraine Schneider's 1967 print Primer (POPULARLY REFERRED TO BY ITS TEXT "WAR IS NOT HEALTHY FOR CHILDREN AND OTHER LIVING THINGS") and Shepard Fairey's 2008 Obama Hope poster will illustrate the two approaches. They represent two different eras of political activism, and employ different strategies of rhetoric, media, process and dissemination. Both are iconic works of design authorship — for different, perhaps even opposite, reasons.

Each artifact can be identified with its designer, its author. But by applying Walter Benjamin's 'the author as producer' and Roland Barthes' 'death of the author' models, as well as contemporary research into design authorship, one can see how the posters acquired their own cultural identities separate from that of their creators, while also allowing for intellectual attribution beyond the designer-authors.

07 /// Peter Buchanan-Smith
08 /// Amy Gray
09 /// Pope
10 /// Pope
11 /// Prem Krishnamurthy
12 /// Apple Store
13 /// Charles S. Anderson
14 /// Thomas Frank
15 /// Matt Weiland
16 /// Thomas Frank and Matt Weiland, Commodify Your Dissent, 1997
17 /// Lorraine Schneider
18 /// Shepard Fairey

PRIMER (POSTER) /// Lorraine Art Schneider /// 1968

19 /// Roland Barthes
20 /// Pratt Institute: Brooklyn NY
21 /// North Vietnam
22 /// South Vietnam
23 /// Another Mother for Peace
24 /// Mothers Day card
25 /// United States Congress
26 /// League of Nations, Geneva, Switzerland

Benjamin asserted that authors aligning their production with proletariat class struggle would lose their autonomy, but gain a politically correct position. Barthes went further by arguing that the consumption of a text by a reader signifies the demise of the author, and stated that as a scriptor, the writer merely channels language that is interpreted by readers. Substitute designer or artist for author and graphic image for text, and the principles still apply.

Lorraine Schneider's Primer, originally a four square-inch (10 X 10 CM) etching created for an art exhibit at the Pratt Institute in New York, was produced in response to the Vietnam war. The image features a coarsely rendered black flower illustration with an ochre-colored inner disk on a yellow background. The words "war is not healthy for children and other living things" are crudely, yet planfully, squeezed between the stem, leaves and the poster's edge. More lettering than typography, the hand-drawn lowercase letters seem familiar and non-threatening. This naïve graphic approach makes the image appear intentionally child-like and innocent, while the high contrast color palette suggests urgency.

Exclusive rights of reproduction were given to the Los Angeles-based Another Mother for Peace organization, founded in 1967, which used it for a variety of graphic purposes: cards, buttons, stickers and posters. A Mother's Day card campaign to members of the US Congress helped establish Primer as an icon of the anti-war movement and led to world-wide recognition. Primer's message was eventually translated into twenty languages and royalties from sales earned hundreds of thousands of dollars for Another Mother for Peace.

A mother of four herself, as well as an accomplished printmaker, Schneider was motivated by her own history of supporting progressive causes and by the growing distaste Americans had for the war claiming their sons, brothers and fathers. Due to the success of Primer, Schneider was invited to speak at the League of Nations in Geneva, Switzerland in 1972: "This is a very rewarding moment for me. I never dreamed that my modest little etching would turn into a huge banner. It is also an unusual position for me to be in because, as you know, most artists work in contemplation and solitude. ... It is very hard to talk about art, how one creates something, where do I begin – with my anger, my pain, my concern for the children of Vietnam, for my own children, for all children. What could I do, what could one person do?"

OBEY GIANT (STICKERS) /// Shepard Fairey /// 1989–present

This passage reveals Schneider's temperament as an artist — personal expression, subjectivity and inner motivation were mobilized by her emotional response to the Vietnam war. The amplification of her authorial voice is acknowledged: small to large, personal to public, yearning to fulfillment, and private anguish to a politically engaged catharsis.

The success of Primer in achieving global recognition and mobilizing women against the war was more serendipitous than planned. It was the right image at the right time in the right place, created by someone inexperienced with large-scale graphic endeavors. The campaign promoting it may have been as important to its success as the icon itself. "War is not healthy for children and other living things" was a sentiment that many could empathize with, and because it was designed by a woman and promoted by Another Mother for Peace in an era of women's political and social ascendency, it also contributed to the feminist movement.

Shepard Fairey created the Obama Hope poster in 2008, an American election year; it depicts a stylized illustration of Democratic presidential candidate Barack Obama's face with the word "hope" set beneath it in a bold sans serif font, all caps. (THE FIRST VERSION SAID "PROGRESS.") The poster's palette is a bright red with dark and light blues on a tan background, a twist on the typical American flag tri-color — patriotic but not simplistic. While favorably received by the Obama campaign, Fairey was not commissioned or paid to design the original poster.

Prior to the Hope poster, Fairey had already established a reputation as a street artist and designer of niche cultural graphics — his Obey Giant graphic campaign is ubiquitous world-wide through a viral distribution system, where local supporters reproduce, occasionally alter, and post the design. Showing a close-cropped stylized image of pro-wrestler Andre the Giant's face, with the word "obey," the graphic campaign mocked governmental, institutional and corporate control while employing the same strategies of global

27 /// Andre the Giant
28 /// obeygiant.com
29 /// Jim Fitzpatrick

PHOTO: HANA COHEN/FLICKR CC LICENSE

CHE (T-SHIRT) /// Unknown /// Undated

PRIMER (POSTER) /// Lorraine Art Schneider /// 1968

above /// **OBAMA HOPE** (POSTER) /// Shepard Fairey /// 2008 below /// **OBAMA NOËL** (SIC)(POSTER) /// Unknown /// Undated

30 /// Che Guevara
31 /// T-shirt
32 /// Karl Marx
33 /// Alberto Korda, Guerrillero Heroico, 1960
34 /// Alberto Korda photographed by Paal Audestad
35 /// Paal Audestad, Self Portrait
36 /// Fidel Castro
37 /// Associated Press office
38 /// Mannie Garcia
39 /// Mannie Garcia, Sen. Barack Obama, 2006
40 /// Lisa Cartwright
41 /// Stephen Mandiberg

branding schemes. That most of its posting was done illegally, freely and without central planning, is its own political statement.

When Fairey designed the Hope poster, he was already adept at manipulating the environment graphically, at harnessing the modes and media of visual communication, and at eliciting public responses — both positive and negative. Fairey's obeygiant.com web site has this tagline: "Manufacturing Quality Dissent Since 1989." He was also highly polished at his craft as an illustrator and graphic designer, with numerous industry awards, museum and gallery exhibitions, and speaking engagements.

The Hope poster builds on an iconographic vocabulary in art and graphic design — and in journalism and advertising — of the heroic figure gazing towards a promising future. The origins of this propagandistic look can be traced to various roots, but an oft-referenced work is the 1967 Che Guevara poster by Irish illustrator Jim Fitzpatrick, created the same year as Primer. An image that has transcended culture, geography, epoch and its original meaning, the Che portrait is now a commodity of t-shirt shops around the world. Once identified with Marxist revolutionary ideals, the icon now represents vague notions of an assimilated counter-culture. It was based on the famous Guerrillero Heroico photograph by Alberto Korda, official photographer of Fidel Castro.

Fairey's Hope poster does not hide this influence — rather, it harnesses it. The use of flat colors, graphic shapes translated from photographs of the subjects, similar compositions and figure/ground proportions, and the faces' solemn, upward-focussed expressions contribute to an obvious comparison.

The photograph that Fairey used as the basis for his image of then-candidate Obama was made by Associated Press photographer Mannie Garcia in 2006. While the tonal qualities of the photo have been flattened and contours of the face simplified, Obama's likeness is faithful to the original picture. For this reason, and the fact that Fairey did not request permission or pay a usage fee, AP threatened to, and eventually did, sue Fairey for copyright violation. Fairey countered the threat with his own lawsuit, claiming that his appropriation of the image was legitimate under statutes of the Fair Use clause of the US Copyright Act.

As the Fair Use clause is meant to protect works of commentary, criticism and parody, one must ask to what degree the Hope poster comments on, criticizes or parodies the original photograph, or its content. Because criticism and parody connote a negative approach, a conceptual degradation of the original, commentary seems the obvious choice: Fairey's motive was to support the election of Barack Obama as president of the United States of America, and an enhanced, more heroic rendering of the image would help achieve this goal. Fairey stated: "I

believe with great conviction that Barack Obama should be the next President."

Walter Benjamin wrote: "What we require of the photographer is the ability to give his picture the caption that wretches it from modish commerce and gives it a revolutionary useful value. But we shall make this demand most emphatically when we — the writers — take up photography." Fairey figuratively 'took up photography' when he appropriated Garcia's picture. The 'caption' is the word "hope," but also Fairey's creative process and the poster's larger political, economic and cultural context. "The work [Hope poster] pays stylistic homage to past technologies of political art, pointedly emphasizing the craft of the screened reproduction in a current state of affairs in which the dream of technological and economic progress is no longer politically tenable," wrote Lisa Cartwright and Stephen Mandiberg.

Another interpretation to the notion of Fair Use 'commentary' can be offered. Because of emergent issues in intellectual property, ownership, copyright, patent law, and so on — much of it furthered by globalism, digitization and dissemination on the World Wide Web — Fairey's appropriation itself may be considered an act of graphic activism, as it takes a critical stance. He committed a small crime for the sake of the greater good; he 'took from the rich and gave to the poor.' This assertion is, of course, debatable on many levels, but it is relevant to the role of the designer as author in political discourse and public engagement.

The case between Fairey and the Associated Press has been settled out of court, with each side asserting its claim of righteousness. From

42 /// Sarah Palin
43 /// Sarah Palin Nope
44 /// Sarah Palin Nope
45 /// Sarah Palin Nope
46 /// Bill Clinton
47 /// Bill Clinton Grope
48 /// Bill Clinton Grope
49 /// Bill Clinton Grope
50 /// Pope
51 /// Pope
52 /// Pope
53 /// Obama Dope
54 /// Obama Dope
55 /// Obama Dope
56 /// Obama Viva
57 /// Obama Che
58 /// Obama Rope
59 /// Obama Rope
60 /// Occupy Hope
61 /// James Montgomery Flagg, I Want You for the U.S. Army, 1917
62 /// Okwui Enwezor
63 /// Obama Hope at the National Portrait Gallery

64 /// National Portrait Gallery, Washington DC
65 /// Martin Sullivan
66 /// Michael Rock
67 /// Barbara Avedon (far right)

a statement on obeygiant.com: "The two sides have also agreed to work together going forward with the Hope image and share the rights to make the posters and merchandise bearing the Hope image and to collaborate on a series of images that Fairey will create based on AP photographs. The parties have agreed to additional financial terms that will remain confidential." (NOTE: IN A FEBRUARY 2012 HEARING, FAIREY PLEADED GUILTY TO A COUNT OF CRIMINAL CONTEMPT REGARDING THE MANIPULATION OF EVIDENCE STEMMING FROM THE AP LAWSUIT.)

While Fairey's authorial role was less pure, and possibly more sophisticated — or at least more complicated — than Schneider's, the role of the audience complicates Hope even further. As a work of propaganda, even if relatively benign and aspirational, Hope has inspired its own appropriation. Numerous parodies countered the pro-Obama sentiment of the Hope poster: Republican Sarah Palin with 'nope,' former president Bill Clinton with 'grope,' the Catholic Pope with 'pope,' Obama smoking with 'dope,' a montage of Obama and Che with 'viva!' and the most offensive remix, a lynched Obama with 'rope.' Fairey even repurposed his Hope poster for the Occupy Wall Street movement, using the Guy Fawkes facemask common to street protesters.

The Hope poster has become a dialectical device, copied by admirers and ridiculed by critics. It has entered the national consciousness; it is memetic. James Montgomery Flagg's I Want You for the U.S. Army poster of 1917 might be America's most frequently spoofed poster, but Hope is a close second.

The appropriation and reappropriation of Hope can be seen as a collective act of activist authorship. According to Okwui Enwezor: "If we look back historically collectives tend to emerge during periods of crisis, in moments of social upheaval and political uncertainty within society. Such [a] crisis often forces reappraisals of conditions of production, reevaluation of the nature of artistic work, and reconfiguration of the position of the artist in relation to economic, social, and political institutions."

A commissioned version of Hope, remixed with collage elements and configured large-scale, has been acquired by the Smithsonian Museum's National Portrait Gallery in Washington, the institutionalization of an image born in the street. In a nod to Hope's political, rather than its artistic merit, the director of the National Portrait Gallery Martin Sullivan said, "Shepard Fairey's instantly recognizable image was integral to the Obama campaign."

Fairey's Hope poster is collectable high art and populist street graphic, worshipped in some camps and reviled in others, concurrently signified and signifier. In his essay The Death of the Author (as Producer), John Stopford writes, "In the age of commodity aesthetics, nothing is more urgent than a political conception that can also appeal to and hence organize the anonymous alienation of the modern sensibility." Whether or not Hope surpasses this and acquires the distorted meaning and commodity status of the Che icon remains to be seen.

Unanticipated in Benjamin's 'author as producer' and Barthes' 'death of the author' is the multiplicity of authorship made possible by digital media and contemporary discursive practices.

While Schneider's Primer was linear, monologic and embraced idealism, Fairey's Hope is lateral, dialogic and engaged in — some might argue embroiled in — in 'realpolitik.' Both posters are products of their times, and both employ design authorship; Hope, however, is emblematic of the complexity of the now-porous relationship between author (ARTIST, DESIGNER, PHOTOGRAPHER), idea, image, message and audience.

Schneider and Fairey made their political convictions public through activist design authorship. Their graphic forms gave voice to content that shaped popular opinion and behavior. Critic Michael Rock's position that design needs to be liberated "from under the thumb of content" adheres to conventional disciplinary segregation and hierarchy. It is amoral in a world where politics, design, ethics and morality collide.

Referring to the desired outcome of the 1967 Mother's Day card campaign featuring Primer, Barbara Avedon wrote in 1974: "We intended to be answered to by those men in Washington whom we paid with our tax dollars and whom we were convinced would respond the very moment they learned of our displeasure." The Vietnam war eventually ended in 1975. One can infer that Primer's role in the peace movement helped galvanize the political support that brought it to its end, especially among women. In 2003, at the onset of the US–Iraq war, Another Mother for Peace was revived and once again Primer is its emblem.

The outcome of the 2008 American election is known: Barack Obama was elected president. Referring to the impact of Fairey's poster, Max Friedman wrote: "Once representations of the candidate were no longer left exclusively to the corporate media, the Obama brand took on its own momentum. It was a self-reinforcing dynamic of cool: no one made a pop-art poster for Clinton or McCain."

The Primer and Hope posters demonstrate, convincingly and over separate eras, that designers as authors have brought about change through what Liz McQuiston calls "a personal concern for world problems, and an active interest in issues that have an impact on the individual, society and the planet as a whole. Protest and personal expression, particularly in graphic or visual form, ...[continue] to be a vibrant aspect of the new personal politics and its global perspective."

Activist design authorship is greater than the sum of its parts — graphic design, writing, image-making and self-publishing — when it is engaged in social and political change.

CHARLES DARWIN CHANGE (STICKER) /// Unknown /// 2011

LOGORAMA (DIGITAL VIDEO) /// François Alaux, Hervé de Crécy and Ludovic Houplain (DIRECTORS)(H5) /// 2009

DESIGN ADVOCACY ACROSS MEDIA

111

Advocacy IN DESIGN AUTHORSHIP can mean at least three things. Designers can advocate for specific causes they wish to support, designers can be advocates for certain people such as a disenfranchised population or targeted user group, and of course designers can be advocates for the concept of design authorship itself. This section explores the first two directions, and adds various media — digital video, computer animation, information databases, proximity sensors and smart phones — as expressions of authorship.

The Story of Stuff, an online video written by Annie Leonard and animated by Ruben DeLuna, is about the harmful effects of over-consumption. It is a twenty minute animation with charmingly simple black and white line drawings that squirm gently behind the video's human narrator. According to the storyofstuff.org web site, "*The Story of Stuff* exposes the connections between a huge number of environmental and social issues, and calls us together to create a more sustainable and just world. It'll teach you something, it'll make you laugh, and it just may change the way you look at all the stuff in your life forever."

01 /// Annie Leonard
02 /// Ruben DeLuna
03 /// The Story of Stuff Project
04 /// François Alaux
05 /// Hervé de Crécy
06 /// Ludovic Houplain

While fact-based, straight-forward, and seemingly aimed towards school children, there's little doubt as to *The Story of Stuff* project's political orientation. Annie Leonard brings the concerns of labor, social justice, environmentalism, economic equity and grass-roots organizing to compete with the concerns and interests of global corporate commerce and complicit politicians. That her video has been seen over 15 million times and translated into over a dozen languages is testimony to the power of design authorship to create awareness and affect awareness.

Logorama is also an animated short film that critiques global consumption, but with a very different approach. Created over a six year span by members of the Paris-based design group H5 — directors François Alaux, Hervé de Crécy and Ludovic Houplain — *Logorama* uses thousands of brand icons as the people, buildings and landscape of a dystopian and surreal Los Angeles. Characters and props spawned from the brands McDonald's, Michelin, Pringles, Esso, Mr. Clean, Pizza Hut, Chevrolet, Apple and many others populate this fast-moving and humorous drama — or based on the ending, tragedy.

While accepting an Academy Award for the best animated short film of 2010, *Logorama* producer Nicolas Schmerkin said, "Good evening. It doesn't look like [it], but it's a French film. ... I'm the

07 /// Los Angeles CA
08 /// Ronald McDonald
09 /// McDonald's
10 /// Michelin Man
11 /// Mr. Pringles
12 /// Mr. Pringles (new)
13 /// Esso
14 /// Mr. Clean
15 /// Pizza Hut
16 /// Chevrolet
17 /// Apples
18 /// Nicholas Schmirkin with Academy Award
19 /// Naomi Klein
20 /// Naomi Klein, No Logo: Taking Aim at the Brand Bullies, 1999
21 /// Kalle Lasn
22 /// Steven Johnson
23 /// Janet Murray
24 /// Steven Johnson, Interface Culture, 1999
25 /// Janet Murray, Hamlet on the Holodeck, 1998

producer of the film, so I have to thank the three thousand non-official sponsors that appeared in the film. And I have to assure them that no logos were harmed during the making of the project." Surely, this last comment is tongue-in-cheek, as the film portrays a culture run amok with branded images. Humor aside, author and journalist Naomi Klein discloses all manner of corporate-branded dirty laundry in her book *No Logo: Taking Aim at the Brand Bullies* by pointing out actual environmental, social and economic harm.

Both of these projects, available freely on the web, are critical of what *Adbusters* founder Kalle Lasn refers to as the "polluted mental environment." Both use humor and unconventional media to contest dominant economic and cultural models. While *The Story of Stuff* explains by simplifying, Logorama weaves a rich, convoluted tapestry of branded corporate inter-connectedness. Both demonstrate that when creativity is harnessed to marginalized voices, powerful visual communication can be the result, advocating for heart-felt causes.

However, as videos, these stories are presented as linear narratives; the viewer passively watches. How might interactive media enable users to participate as co-authors in a designed experience?

Steven Johnson and Janet Murray have written about technology's potential with literal and visual language, and the way the electronic environment mediates communication. Johnson states in his book *Interface Culture*, "The [hypertext] link is the first significant form of punctuation to emerge in centuries, but it is only a hint of things to come." He continues, implying the magic of digital interaction between both designer/author and audience/participant, "...the novelists and site designers and digital artists are busy conjuring up the new grammar and syntax of linking."

above /// **THE STORY OF STUFF** (DIGITAL VIDEO) /// Annie Leonard (WRITER, NARRATOR) and Ruben DeLuna (ANIMATOR) /// 2007
below /// **WORD COUNT** (WEBSITE) /// Jonathan Harris /// 2003

POSTER WALL FOR THE 21ST CENTURY (INTERACTIVE INSTALLATION) /// LUST /// 2011 (WALKER ART CENTER, MINNEAPOLIS VERSION)

26 /// Dreamweaver CS6
27 /// Gary Wright, Dream Weaver, 1976
28 /// Flash
29 /// The Flash
30 /// Processing
31 /// Processor
32 /// Jonathan Harris
33 /// Query Count

In *Hamlet on the Holodeck*, Janet Murray's definition of digital environments as, "procedural, participatory, spatial and encyclopedic" seems to reinforce different cognitive modes. Her "multiform story" examples, (OPEN-ENDED, TIME-INDEPENDENT, MORPHING, AND SO ON) show how the integration of these qualities puts the reader/viewer in the center of the interaction, immersed simultaneously in the reading and the creating.

Design authorship becomes not just the broadcasting of content, but the establishment of open-ended scenarios for interaction and participation. This might require knowledge of software coding and mastery of programs like Dreamweaver and Flash, as well as more specialized programs like Processing. It will also require knowledge of behavioral sciences like psychology and sociology, and some familiarity with cognition and perception, to enable designers to consider how and why people make decisions about content and navigation.

In the way that print-oriented designers need to consider issues of legibility and readability (ISSUES THAT ALSO APPLY TO SCREEN-BASED MEDIA), design authorship for interaction must acknowledge the user's participation in assembling their own unique experience. Clicking, rolling over, dragging, dropping, scrolling, changing, selecting, moving, inputting, uploading, triggering proximity sensors — are all added to the role of simply looking, even if the looking is directed at a sophisticated image or narrative, such as *The Story of Stuff* or *Logorama*. Add to this the inclusion of a dynamic database, and the role of the designer-author becomes akin to a film director trying to coordinate a script, actors, a set, camera and sound staff, special effects, editing and more.

One example of user-empowered authorship is Jonathan Harris' Word Count, a web site that enables users to search over 85,000 English words by their prevalence in ranked order. Word Count is a functional tool for learning about common and arcane word rankings, but it is also fun, like a word game. Users type in a word and Word Count shows that word in numerical order, adjacent to the words before and after it. The site also communicates the ranking graphically, with size diminishing with less frequent occurrence. According to wordcount.org, "The goal is for the user to feel embedded in the language, sifting through words like an archaeologist through sand, awaiting the unexpected find."

In this regard, Word Count is like an automatic poetry-generating machine. The word 'author' (NUMBER 2323) is followed by 'bedroom, republic, links, agent' and preceded by 'sixty.' While this syntax is completely random, one can see the opportunities for free association. In the site's partner, Query

Count, Harris uses the all words entered by users as another database. 'Sex, the, love, libertarian, shit, fuck, god' are the top seven. Number 297 is 'design' followed by 'job.'

Harris conceived the idea and designed the interface. Categorized as information design, the site is elegant and the information transparent. Harris uses a 'long tail' graphic, a statistical vector caused by a high number of relatively few units offset by a low number of many units to represent the word order. As a designer-author, he created the space for writer/readers to revel in word play, to observe numerical order of usage (AS OPPOSED TO THE MORE COMMON ALPHABETICAL ORDER), and to contemplate the resulting unorthodox syntax.

A different approach to usability and interaction is the dynamic digital poster wall of Dutch firm LUST, created initially for the Graphic Design Museum in Breda, The Netherlands in 2008, and subsequently displayed as version 3.0 at the Walker Art Center in Minneapolis, USA in 2011. In their Poster Wall for the Twenty-first Century, they use computer code — Kinect sensors and n-Track software — to pull data from the internet and subject it to a variety of morphing visual effects. With an ever-changing projection, the wall responds dynamically to the proximity of viewers. When close enough, a QR (QUICK RESPONSE) code is generated, enabling viewers to extend their experience by scanning with a smart phone and linking to additional content. According to the cooperhewitt.org web site, "The resulting pieces are raw rather than polished, using default fonts and randomly assembled components to comment on the ubiquitous texture of digital media."

The Poster Wall for the Twenty-first Century combines seemingly arbitrary content, mined from news sources and blogs, with the physical intentions of the viewer. Authorship is at the level of the code and the staging of public interactions — the posters are really supporting cast to the ideas of data, dynamism and proximity. One imagines that the Heraclitus quote 'change is the only constant' was the guiding concept for this project. But to put it in their own words: "LUSTlab researches, generates hypotheses and makes unstable media stable again."

The posters of the Poster Wall for the Twenty-first Century aren't printed on paper and posted on a public wall as tangible artifacts. They are instances in time: moving, changing, delivering random messages. The project is not even about the poster, one could argue, but about experiencing data flow, flux and human interaction with information.

These digital projects demonstrate the range of design authorship in electronic media. Both videos are content-driven — the intentions of the designer-author are delivered intact to the viewer, who is receptive and passive, but hopefully well-entertained. Word Count and the Poster Wall for the Twenty-first Century require user participation to be fully 'read.' While a viewer might reflect on the subjects of *The Story of Stuff* and *Logorama*, the viewer is partially the advocate of the interactive works. The designer-author's work is co-authored and its meaning collaboratively out-sourced.

34 /// The Netherlands
35 /// LUST Lab
36 /// Graphic Design Museum, Breda
37 /// Walker Art Center, Minneapolis MN
38 /// Kinect sensor
39 /// QR code
40 /// Cooper Hewitt National Design Museum, New York NY
41 /// Heraclitus

INTERVIEW: MIEKE GERRITZEN

119

Mieke Gerritzen is a graphic designer who works across public events, electronic and print media. She is currently the director of the Museum of the Image in Breda, The Netherlands. As an educator, Gerritzen has led the graduate design department of the Sandberg Institute in Amsterdam. Her books include: Mobile Minded, Style First *and* Everyone is a Designer in the Age of Social Media.

MCCARTHY You've written about, exhibited, and practiced through your many designs, your distinctive 'style' (an exuberant approach to color, strong graphic shapes, generous use of symbols and icons, and adherence to bold sans serif type) — is style important to creating works of design authorship?

GERRITZEN Well, I think style is authorship. And my style gives me lots of freedom to communicate the information that belongs to me. Also the style helps me think.

Because of these consistent, yet varying, stylistic features, one could say that your graphic 'voice' is unmistakable. How does that affect the message of your communication?

As a designer you always look for a balance between the message, form and style. My 'style of content' is already merged strongly. I'm old enough to know where and what I want to communicate. I'm not working for clients — my work has become very autonomous.

Why do you predominantly use the limited typographic palette of **bold sans serif, OFTEN IN CAPS?**

Caps create nice lines so that you can use them as stripes. Type is image for me. Of course I wish I was the type of person that uses very classic chic fonts like Garamond, and I sometimes do… The bold character does not have a specific reason. It feels good and fits me better.

Now that you're directing the Museum of the Image in Breda, you can act 'authorially' at the level of exhibitions and events, by curating shows and creating related programming. In which cultural direction will you take MOTI?

MOTI is a museum about image culture and tries to control, research and present the explosive visual culture that surrounds us these days. The influence of style and form to our society is something I've been interested in for years already. I'm also very interested in merging art disciplines. I have never believed in fences around material and media. I will try to bring back some Dadaism in this century.

Thank you!

01 // Mieke Gerritzen
02 // Museum of the Image, Breda
03 // Breda, The Netherlands
04 // Sandberg Institute, Amsterdam
05 // Mieke Gerritzen, Mobile Minded, 2002
06 // Mieke Gerritzen, Style First, 2003
07 // Mieke Gerritzen, Everyone is a Designer in the Age of Social Media, 2010
08 // Tony Stan, ITC Garamond, 1977
09 // Tristan Tzara, Dadaphone No.7, 1920
10 // Thank you

above /// **MOBILE MINDED** (BOOK) /// Mieke Gerritzen /// 2002
below /// **HIDDEN FIST** (LEFT)(POSTER), **UNFUCK THE WORLD** (TOP RIGHT)(POSTER DETAIL), **SOMETHING FOR NOTHING** (BOTTOM RIGHT)(POSTER) ///
Noel Douglas (noel@noeldouglas.net) /// 2009

INTERVIEW: NOEL DOUGLAS

Noel Douglas is an artist, designer, activist, educator and musician. Douglas' designs for social economic and political change have appeared in street interventions, the design press, online and in exhibitions world-wide. He leads the communication design degree program at University of Bedfordshire in Great Britain.

MCCARTHY You're heavily engaged with graphic activism, not just by designing compelling graphics about pressing social and political issues, but by participating in the street, through direct action. How does your design authorship critique poorly behaved multi-national corporations while also considering the designers who further their public images through branding and advertising?

We can have only collective answers to the life-threatening problems being caused the failure of the market and the nearing onset of out-of-control climate change. As individuals we can sometimes make choices in our work — and we should if we can. A number of studios and designers do indeed try to work ethically doing non-corporate design work or furthering the role of green design. But for many designers, as with many other workers, the market determines the priorities of production, which is of course why design has become so overrun with branding and advertising in the last 20 years — because globalization has brought with it a huge expansion of capitalism that has required all that branding and marketing.

So for me this is less about attacking an individual's moral or ethical failure as a designer because they did some work for some corporation, and instead focus on building up an alternative current of design with broadly anti-capitalist values, so when people say 'well, what can I do?' we can say 'this!' In the UK we are trying to do this currently by setting up Occupy Design (occupydesign.org.uk) to work with the Occupy movement here to help it with its needs but also using the group as a way to intervene in the design world, spreading the Occupy 'meme' through society in our particular bit of it where we can hope to make a difference.

Given the visual message saturation of the modern environment, what strategies exist for effective discourse in the public sphere?

Obviously we cannot compete with multi-million pound ad campaigns in terms of their coverage of the urban environment but we can use our two strengths, our numbers and being strategic about when and where we do something. This is also where the importance of being an activist and being part of networks matter, I know my work has got to tens of thousands of people because of the use of these networks to distribute work, and the response I get. But alongside this face-to-face organizing and involvement, social media is helping us to fund large-scale operations. Occuprint, an offshoot from Occupy Wall Street in the US, managed just last month to raise $24,000 on Kickstarter to print propaganda for the second wave of Occupy events

06 /// Occupy Wall Street
07 /// Kickstarter
08 /// 99%
09 /// Paris Metro
10 /// Superstudio, Megastructure, 1969
11 /// Yakov Chernikhov, Constructivist Architectural Fantasy
12 /// Stephen Duncombe
13 /// Stephen Duncombe, Dream: Re-imagining Progressive Politics in an Age of Fantasy, 2007)
14 /// Hippie
15 /// Indignados occupy Prato della Valle Square, Padua, Italy

in May 2012. That's an interesting aspect — we're beginning to realize our power and use our numbers as the 99% to get things done independent of corporate interests. Being strategic means choosing the right moment to do something and organizing for it. In 2003 I witnessed the results of about 300 anti-advertising activists who attacked, defaced and replaced all the ads on the Paris Metro as part of a campaign to help media workers fighting against precarity, which was an extraordinarily powerful action that no one could ignore. That action was part of a larger campaign and that's important because of course we can't necessarily know when a 'right moment' might be and so we need to think less of one poster or graphic or campaign being the be all and end all, and rather it being an ongoing struggle with the key task being to draw more people into action, thereby increasing the chances of success.

How does the graphic vocabulary of a 'way forward' (toward positive social change) differ from conventional protest graphics that are 'against' various institutions and practices?

Often the visual language of the positive future is banal and twee compared with the more well-ploughed furrow of 'resistance type' graphics but this doesn't mean design cannot be used to call the future in its graphic visualizations. Groups from the late '60s, like architects Superstudio, used images and montage to re-imagine the world in ways that avoided clichéd ideas of utopia and still managed to open up an imaginative space in the viewer's mind that wasn't didactic and closed off. Of course this was a strong aspect of early Constructivist work too as they lacked funds to make many of their proposals.

Stephen Duncombe, in his book *Dream: Re-imagining Progressive Politics in an Age of Fantasy*, describes the concept of the 'ethical spectacle' as another possible answer to this question. The ethical spectacle as he describes it "is a dream self-consciously enacted, a dream put on display." It is a dream that we can watch, think about, act within, try on for size, yet necessarily never realize. It is a means to imagine new ends. As such the ethical spectacle has the possibility of creating an outside,

as an illusion. To be clear, this is not about 'outside' as in the '60s hippie idea of dropping out — there is no 'outside' of capitalism — this is about taking seriously the need for imaginative space, for rituals, for icons, for culture that may give people the direction and motivation to get the change we need. I would argue that this is what the Occupy/Indignados encampments are doing, and it's certainly what happened in Tahrir Square! Furthermore, this need for new ideas to take visual form is an essential and often neglected part of revolutionary political change. What visual form this takes is up for debate and is a 'live' issue. Two elements that are crucial for me are: it's important that the visual forms are contemporary and popular and don't just replicate aesthetics from past moments of struggle, and that they are part of the architecture of the protest and not separate from it.

To what degree do you believe your work has helped bring about change, or at least an awareness of important social, political, cultural and economic issues?

Networked culture makes it relatively easy at a quantitative level to see how many people are reached with a message, as does being an active participant in movements because one sees first-hand the reaction to work and the use of the work by others. But I'm just one part of a whole, it's not enough! We need more: more people, more ideas, more creativity, more images, more agitation and imagination, we have to convince all those people who currently don't see the need to act, that this is no longer a matter of whether someone believes a better future is possible but that if we don't come together in large enough numbers and work to replace capitalism with a system more humane, more democratic and sustainable there will be no future worth living for.

Thank you!

16 /// Tahrir Square, Cairo, Egypt
17 /// Awwwww thank you!

4

FORAGERS 1 (FROM BETWEEN REALITY AND THE IMPOSSIBLE SERIES) /// Fiona Dunne & Anthony Raby /// 2010

CRITICAL DESIGN AND DESIGN FICTION 125

TWO RECENT theoretical design movements have roots in design authorship. "Critical design" and "design fiction," simply by their names, seem to take the idea of authoring in general into the specializations of opinionated critical writing and imaginative fiction writing, as if design authorship is limited to objectivity, fact and reality. Perhaps it is a differentiation, or simply the growth of disciplinary progeny.

Design criticism is generally thought of as critical and editorial writing about design. The critical act is not just commentary on, or criticism about, but the translation of the visual and material into the verbal. The relationship is inherently reactionary — first comes the design, followed by the criticism.

The emergent field of critical design, however, uses the medium of design to make statements about social, political, economic and cultural issues, or about the discipline itself. Primarily associated with contemporary product design (SEE EXPLANATION IN DUNNE AND RABY'S 2001 BOOK DESIGN NOIR), critical design's posture bears strong resemblance to graphic design authorship, which often takes a critical stance. The other parallel is in critical design's communicative nature — the objects may function in the traditional sense, but their main goal is to contribute to the field's discourse as polemical actors.

Critical design, according to the gallery Z33 web site referring to the exhibited work of Martí Guixé, Jurgen Bey, Fiona Raby & Anthony Dunne, is a current movement consisting of: "...designers who are ... known for their critical attitude towards mainstream product design. Although they have distanced themselves from today's commercial design world, they sometimes use its mechanisms to pose questions about technological, social and ethical questions. Their ambivalent, critical position towards design and the spirited, playful form language used to express this is a constant theme..."

01 /// Fiona Raby and Tony Dunne
02 /// Dunn and Raby, Design Noir, 2001
03 /// Gallery Z33: Hasselt, Belgium
04 /// Martí Guixé
05 /// Martí Guixé, Food Bank Bench, 2001
06 /// Jurgen Bey
07 /// Jurgen Bey, Linen Closet, 2002
08 /// Fiona Raby & Anthony Dunne, Evidence Doll, 2005

Diverse themes of consumption, privacy, waste, sexuality, debt, technology, genetics, media and globalism are raised in critical design's broad agenda. Critical design is often manifest in objects: the quirky furniture and domestic products of Dutch firm Droog, Kate Bingaman-Burt's *Obsessive Consumption* project (CREDIT CARD

09 /// Droog Design, Chest of Drawers
10 /// Kate Bingaman-Burt, Hand-Drawn Credit Card Statement, 2004
11 /// Kate Bingaman-Burt
12 /// Tobias Wong
13 /// Tobias Wong, Coke Spoon 2, 2005
14 /// Daniel Jasper
15 /// Martí Guixé, Fill-In-The-Blank Wall Clock, 2010
16 /// Tibor Kalman
17 /// Tibor Kalman, M&Co, Wristwatch, 1984
18 /// Woman soldier
19 /// Woman soldier
20 /// U.S.-Iraq war
21 /// Gerrard O'Carroll
22 /// Don't Panic
23 /// Products of Our Time
24 /// Connections: Experimental Design
25 /// Katherine Moline
26 /// Designing Critical Design
27 /// Jan Boelen
28 /// Forms of Inquiry
29 /// Zak Kyes

STATEMENT BED SHEETS, DOLLAR SIGN PILLOWS, HAND-DRAWN PURCHASES, AND MORE), Tobias Wong's chrome-plated box cutter and gold-plated McDonald's stirrer spoon, Daniel Jasper's quilts depicting American women soldiers killed in the Iraqi war, self-defined 'ex-designer' Martí Guixé's 'fill in the blank' wall clock, and many more. Graphic designer Tibor Kalman of M&Co may have been the proto-critical designer with his whimsical watches and office products in the 1980s.

Critically designed artifacts carry meaning beyond the function of the object. Jasper's Casualties of War Series quilts can certainly warm one's bed at night, but they are really about war, feminism, and domesticity. Because the quilt's basic unit, the square of colored cloth, is a single pixel in a low-resolution image spanning a 'queen-size' quilt, the designs also confront the viewer through the use of scale. In close proximity to the quilt, one is simply impressed by color, pattern and texture — but from a distance, a dead woman soldier stares back. Jasper's critical point is that 'things are not what they seem,' or a disconnect between perception and reality, a commentary on the geo-politics of terrorism and the US-Iraq war.

Recent exhibitions of critical design demonstrate worldwide interest: *Don't Panic* (LONDON) curated by Gerrard O'Carroll; *Products of Our Time* (MINNEAPOLIS-ST. PAUL) curated by Daniel Jasper; *Connections: Experimental Design* (SYDNEY) curated by Katherine Moline; *Designing Critical Design* (BELGIUM) curated by Jan Boelen; and *Forms of Inquiry: The Architecture of Critical Graphic Design* (LONDON) curated by Zak Kyes.

CASUALTIES OF WAR SERIES: TYANNA AVERY-FELDER (QUEEN-SIZE QUILT) /// Daniel Jasper /// 2005

30 /// Jonathan Barnbrook
31 /// Jonathan Barnbrook, Mason Sans, 1992
32 /// Gran Fury, Read My Lips, 1988
33 /// 1986 Plymouth Gran Fury Salon
34 /// Shepard Fairey
35 /// Shepard Fairey, Obey Giant, 1990
36 /// Benetton
37 /// Colors Magazine, Issue 4, 1993
38 /// Adbusters, Issue 100, March/April 2012
39 /// Superstudio
40 /// Archigram, Plug-in City, 1964
41 /// Archizoom, No Stop City, 1969
42 /// Rem Koolhaas
43 /// Rem Koolhaas, Seattle Public Library, 2004
44 /// Alessandro Mendini
45 /// The Design Museum, London

Critical design deserves to be cast into the wider context of design authorship. By considering historical precedents and examining similarities, the activism and entrepreneurialism of critical design will be shown to have their roots in theories of graphic design authorship. Specific examples that are more strongly associated with graphic design include: Jonathan Barnbrook's rhetorically charged typeface designs and naming provocations, Gran Fury's confrontational posters for gender and sexual awareness issues, Shepard Fairey's globally viral *Obey Giant* campaign, Benetton's *Colors* — a "magazine about the rest of the world" — that covers global social issues, and Adbusters magazine as a forum for anti-consumerist designs.

There are two primary parallels between critical design and design authorship. The first is the act of self-initiation — acting without client commissions — whereby designers frame the topic, aesthetics, process, medium, materials, and users of their designs. The second is the politicized viewpoints of the designers; their designs stake out intentional positions that range from social, cultural, economic and geo-political to personal concerns. Both design authorship and critical design, whether self-referential, 'art'-like, populist or idealistic, pose questions as readily as they offer alternative solutions.

Architecture's influence on concepts of critical design should be acknowledged — experimental firms Superstudio, Archigram and Archizoom from the 1960s and '70s are appropriate models, as are the works of contemporary architect Rem Koolhaas and designer-architect Alessandro Mendini. Referring to Superstudio, the Design Museum stated, "Rather than blithely regarding architecture as a benevolent force, the members of Superstudio blamed it for having aggravated the world's social and environmental problems. Equally pessimistic about politics, the group developed visionary scenarios in the form of photo-montages, sketches, collages and storyboards of a new 'Anti-Design' culture in which everyone is given a sparse, but functional space to live in free from superfluous objects."

TRANSPARENCY SUIT (GARMENT) /// Studio Smack /// 2010

Many of critical design's objects might be considered superfluous in the conventional functional sense, but as carriers of meaning they assert their presence. Mendini's Designer's Suit (CO-CREATED WITH KEAN ETRO) is a classically cut men's business suit covered with corporate logos, not unlike the uniforms of many race car drivers. It identifies the companies' brands while commenting on the wearer's identity as beholden to corporate interests.

The theoretical projects, exhibits and publications about graphic design authorship since the 1990s have also had a direct bearing on the discourse surrounding critical design. The field of product design does not own the concepts behind critical design any more than design authorship is the exclusive intellectual domain of graphic design. Both terms overlap and converge. Both enlarge the activist presence of the discipline of design in general, and both require society to engage in design meaning-making beyond the passive role of consumer.

The term design fiction is largely associated with the confluence of science fact and science fiction — the latter primarily through sci-fi novels and films — as advocated by the writings of futurists Bruce Sterling and Julian Bleecker. Design fiction posits that the future can be imagined through narrative devices, and that indeed, this is already related to the way designers work: brainstorming, speculating, creating and prototyping. While its disciplinary roots seem most firmly established in computer science, engineering and by experimental product designers like Anthony Dunne and Fiona Raby, its theoretical underpinnings are linked to the wider design world.

Theories of design authorship suggest that design fiction has been around for longer than some realize, and that design fiction reaches well beyond science

46 /// Kean Etro
47 /// Race car driver
48 /// Bruce Sterling
49 /// Bruce Sterling, Islands in the Net, 1988
50 /// Julian Bleecker
51 /// Julian Bleecker and Nicholas Nova, A Synchronicity: Design Fictions for Asynchronous Urban Computing, 2009
52 /// Art Center College of Design, Made Up
53 /// Art Center College of Design, Pasadena CA
54 /// Tim Durfee
55 /// Denise Gonzales-Crisp
56 /// William Morris, News From Nowhere, 1892

130

DESIRE MANAGEMENT (FILM STILLS, FILM SHOT ON 16MM AND HD) /// Noam Toran /// 2005

to employ the arts and humanities. This section will demonstrate, through three case studies, that the definitions of design authorship have included design fiction — in practice and theory — for many years.

The goal here is not to pit the arts and humanities against science, in philosophy or method, but to expand the definition and range of design fiction so that more design disciplines can benefit from its intellectual reach. This notion of using non-scientific methods is broached in the description of *Made Up*, a 2011 exhibit and symposium about design fiction at the Art Center College of Design. Organizer Tim Durfee states: "Worthwhile [design fiction] work requires occasional liberation from the strictly rational. Many of the most valued contributions to both high and popular culture originated from fevered, non-rational processes."

In her essay "Discourse This! Designers and Alternative Critical Writing", scholar Denise Gonzales Crisp has coined the term 'designwrights' to mean "writers [who] use the rhetorical position of fiction to capture facets of the design world not readily expressed in expository prose." That she uses as one example William Morris' 1892 book *News From Nowhere*, about a utopian socialist society in the twenty-first century, which he wrote, illustrated, designed and printed, establishes one genesis to design fiction's trajectory.

57 /// Noam Toran
58 /// Mad Men
59 /// Design Within Reach
60 /// Amy Francheschini
61 /// Twitter
62 /// Trojan horse

THE MACGUFFIN LIBRARY (OBJECT SERIES) /// Noam Toran, Onkar Kular, Keith R. Jones (CO-AUTHORS OF THE WORK) /// 2008

THIS IS NOT A TROJAN HORSE (PROJECT) /// Amy Franceschini (FUTUREFARMERS) /// 2010

63 /// David Mack, Kabuki: Skin Deep, 1999
64 /// David Mack, Kabuki: Reflections, 1998
65 /// David Mack
66 /// Asian martial arts
67 /// Stefan Hall
68 /// Jim Casey

Three cases will be used to demonstrate design authorship's relationship to, and influence on, design fiction. Each case represents the engagement of designed fictions with non-scientific methods — the humanities, art, history, the social sciences and literature.

The short films of Noam Toran, which feature his speculative product designs as actors in complex social and emotional scenarios, will most closely resemble design fiction's definition of combining science fact and fiction in film. While Toran's product designs might best be categorized as part of the discourse of critical design, the films are a narrative all their own — part *Mad Men*, part Design Within Reach advertisement, part unsettling psychological thriller. Toran describes his approach as: "*Desire Management* is a film comprising five sequences in which objects are used as vehicles for dissident behavior. In the film, the domestic space is defined as the last private frontier, a place where bespoke appliances provide unorthodox experiences for alienated people…."

Amy Franceschini's practice ranges from applied graphic designs (THE TWITTER LOGO) to large-scale installations and performances using designed objects. While her firm Futurefarmers was at the forefront of the digital revolution, especially with interactive media, Franceschini now stages public interventions that leverage low tech materials and high technology with ideas about an environmentally and culturally sustainable future. Preferring to meld event, process, product and system, Franceschini's *This is not a Trojan Horse* people-powered vehicle is one example of her approach to design authorship. Issues of bio-diversity and sustainable agriculture are raised by this "vehicle for social and material exchange," as Franceschini refers to her wooden contraption that travels the Italian countryside.

Kabuki, a sophisticated comic series, is written, illustrated and designed by David Mack. The main character, a Japanese woman superhero with a very mortal past, has a rich inner life, as visualized by Mack's rendered images, collage elements and thoughtful dialog. The protagonist exists in the "cyberpunk tradition in which Asian martial arts skill is often combined with technological enhancement," claim critics Jim Casey and Stefan Hall.

These three designers' works, in addition to employing non-scientific knowledge realms, also occupy three different points along a spectrum of 'the real' — the degree to which reality can be said to be necessary for fiction to be plausible. In this regard, considerations of reality include speculation of what might be, largely a philosophical endeavor. When one considers that philosophy is a subset of the humanities, and that disciplinary border transgression is generally a mutually beneficial act, the case for design (SCIENCE) fiction being informed by design (ARTS AND HUMANITIES) authorship is furthered.

Toran's films, and the objects and people within, have a hyper-realistic, high-definition quality. They are clean, sharp and precise; they are planfully scripted and art-directed. He says, "The works attempt to evoke memories and sensations related to cinema and cinema watching, and to

135

KABUKI: THE ALCHEMY (BOOK) /// David Mack (MARVEL COMICS) /// 2009

69 /// Amy Franceschini, Kosovo Elf 1999
70 /// The Jetsons
71 /// Brazil, 1985
72 /// Brazil
73 /// Brazil
74 /// Chuck Palahniuk

examine the implications of cinema's influence on the collective consciousness, be it as collective fantasy, myth or memory forming." Toran's design fiction future is shiny and orderly, but oddly awry.

Franceschini's early screen-based work was cutesy-cartoony, even as her interactive computer games like Kosovo Elf opposed the war-time atrocities by the Serbians and subsequent NATO bombing. Her large-headed characters frequently float through the screen-space to chirpy music, often in Jetson-like vehicles. Franceschini's recent work more closely resembles the machines and architecture in the science-fiction film *Brazil* — not expressly dystopian, but rather 'steampunk' — but whose function is benign social interactions through design. In the spirit of relational aesthetics, Franceschini's users collaborate earnestly and endeavor to create meaning with the environment and their place in it. Reality is built upon actual, and virtual, social networks and interactions. Ideally, the future is ethically constructed through people-design-people relationships.

Mack's *Kabuki* is illustrated with a style that blends the representational with the expressive. The integration of image and text (COMPUTER SET, FOUND AND HAND-WRITTEN), and ink and paint rendering with collage, creates a communicative flow — not unlike film — akin to thoughts, memories and dreams. Even depictions of violence are less disturbing for their reality than for their psychological impact.

In the introduction to Mack's *Kabuki: The Alchemy* graphic novel, novelist Chuck Palahniuk wrote, "Art is the lie that tells the truth better than the truth. And in Kabuki, David Mack ...[uses] his past instead of being used by it." If 'art is the lie that tells the truth,' then Mack's design fiction vision of the future is extruded through Kabuki's imagined past. Perhaps that's why *The Alchemy* book ends with this line: "It begins like this... Once upon a time..."

Besides the expanded cognitive, expressive and experiential toolkit that the arts and humanities provide design fiction, considerations of authorship — whether employed for fiction, fact or something in between — alter perceptions of the future by engaging the present and past. Across design disciplines and in different media, the design fiction works of Toran, Franceschini and Mack show that when designers author their own — and their users' — narratives, objects or systems that employ methods beyond science, a fuller future can be imagined.

Taking the expansive view, design criticism and design fiction are part of the design authorship family. They expand the discipline into what might appear to be foreign territory, but really tread on familiar and accessible grounds once the roots are exposed. Because of this, these new directions offer strong potential for enriching the design discipline while being inherently interdisciplinary.

137

KABUKI: THE ALCHEMY (BOOK) /// David Mack (MARVEL COMICS) /// 2009

INTOLERABLE BEAUTY: PORTRAITS OF AMERICAN MASS CONSUMPTION (PHOTOGRAPHY SERIES) /// Chris Jordan
above /// **CRUSHED CARS #2, TACOMA** /// 2004 below /// **CIRCUIT BOARDS #2, NEW ORLEANS** /// 2005

THE ART–DESIGN ZONE

139

"All art is quite useless."
OSCAR WILDE, THE PICTURE OF DORIAN GRAY, 1890

On THE SURFACE, this quote suggests two primary things. One, that art has no function; it cannot house people, provide transportation, inform patients, direct citizens to vote, sell widgets, extend human capabilities or any number of practical things. Two, that if art has value in the face of not being useful might mean that it is superfluous — a luxury, a trifle enjoyed by a leisure class or a cultural elite. The paradox lies in the tension between these ideas.

On the other hand, it is accepted that design is useful. It functions, and through that function it gives value to the user. When designs work well, when there is a perfect symbiosis between form and function, the value increases as the user's needs go beyond satisfaction to having emotionally rewarding experiences with the design. However, in the hyper-consumerism of the global economy, the notion of 'needs' that are met through designed artifacts, environments and services has become consumer desires that are anticipated, manipulated, cultivated and consummated.

Design then, seems to address fewer needs but more wants and more desires, at least in the developed world — often with accompanying consumer debt. The function of much design now is to lubricate the exchange of currency, not to provide affordable housing, healthy foods, efficient transportation, accessible information, a cultured citizenry and more. The success of much design is cemented the moment it leaves the store, not over the lifespan of its use, or its reuse, or in its discarded state.

Photographic artist Chris Jordan has addressed this in his series *Intolerable Beauty: Portraits of American Mass Consumption.* Seen from a distance, Jordan's photographs have a slightly undulating surface and an even, largely monochromatic color palette — perhaps at an aesthetic level, they are beautiful. Closer inspection reveals thousands of discarded products, grouped by type and often bleeding off all sides of the image: cell phones, chargers, circuit boards, cars, cigarette butts, glass bottles, wooden palettes, oil drums and more. The photos appear visually seductive while

01 /// Oscar Wilde
02 /// Oscar Wilde, The Picture of Dorian Gray, 1890
03 /// The Picture of Dorian Gray, 1945
04 /// Chris Jordan
05 /// Cell phone
06 /// Charger
07 /// Circuit board
08 /// Car
09 /// Cigarette butt
10 /// Glass bottles
11 /// Wooden palettes
12 /// Oil drum

13 /// Design for the Other 90% exhibition
14 /// Worldbike
15 /// Worldbike in action
16 /// LifeStraw
17 /// LifeStraw in action
18 /// Tomato
19 /// John Warwicker, Tomato member
20 /// Tomato, Mmm...Skyscraper I Love You, 1994
21 /// Franz Kline, Untitled, 1957

shocking the viewer with a disturbing portrait of consumption and waste. Through personal expression the images are art; through communication of environmental issues the images are designed to create awareness and inspire change.

Does this emphasis on desire over need, and consumption over function mean that design is less useful than it should be? If so, does this creeping quality of 'uselessness' mean that design is becoming unmoored from its original mission, that of improving the human condition? Does this mean that design is becoming more like art?

Design for the Other 90%, an exhibition about designs created for populations that do not enjoy the standard of living taken for granted in the Western World, is a welcome exception to the notion of 'uselessness.' "Designers, engineers, students and professors, architects, and social entrepreneurs from all over the globe are devising cost-effective ways to increase access to food and water, energy, education, healthcare, revenue-generating activities, and affordable transportation for those who most need them," according to cooperhewitt.org. "These designers' voices are passionate…" as they endeavor to create functional things of value. The Worldbike, with its 'long-tail' design for hauling people and cargo, and the LifeStraw, a drinking tube that filters water-borne bacteria, are two notable examples.

As some forms of design authorship straddle both art and design, through its emphasis on expression, initiation and speculation, a comparison is required. With any two ideas being compared, a 'black and white' polarization often results — here, a sliding scale is preferred, as context determines varying shades of gray.

Artists' books, or 'book arts,' an art genre that uses the book form, is an obvious point of comparison. Varying between one-of-a-kind sculptural books to large editions using commercial production techniques, artists' books employ the tools of graphic design (TYPE, IMAGES, SYMBOLS, COMPOSITION, PAPER, INK, BINDING STRUCTURES) and writing (POETRY, WORD PLAY, METAPHOR, NARRATIVE, SEQUENCE) with art's emphasis on expression, aesthetics and 'uselessness.' Artists' books are emblematic of this gray zone: some works are quite functional, with an emphasis on communication and readability; others might be impractical for the mass market but inspire designers with novel ideas, use of materials and innovative forms.

Art is concerned with personal expression in material form. It is about the creative use of wood, paint, metal, plastic, cloth, software, ink, stone, clay,

MASK II (SCULPTURE) /// Ron Mueck /// 2001–02

light, space, sound and so on. Experimentation is core to art-making; it shares this with science, engineering and the design disciplines — they address the timeless question: what if…? Art and design also share a language of form. The vocabularies of elements (LIKE LINE, SHAPE, COLOR AND SPACE) and principles (SUCH AS UNITY, HIERARCHY, BALANCE AND RHYTHM) provide a common discourse, even as they lead to different outcomes.

British design firm Tomato's print work of the 1990s, in particular, bears strong resemblance to the painted black on white Abstract Expressionist canvases of Franz Kline that were created in the 1950s. Abstract, aggressive, energetic and complex, Tomato's work uses a fine art vocabulary to communicate for its clients in the music and culture fields. Even their current work, the animated identity for Tokyo Rocks for example, draws upon Kline's painterly influence.

Art is conceptual. Ideas about seeing, feeling, observing, documenting, communicating, parodying and satirizing give art its social and psychological impact. Art gives voice to fundamental human emotions. Concepts of visual and spatial syntax, semantics and semiotics relate art to design. Even the notion of art being therapeutic for its creators is valid to designers as they are called upon to emphathize with their users.

The hyper-realist sculptures of Ron Mueck are an example of contemporary conceptual art that is also representational. He creates startlingly real depictions of faces and bodies, often nude, with actual hair, glistening mucus membranes, textural skin, and other realistic cues. By changing one single relationship — human scale — Mueck succeeds in recasting our humanity. When staring at *Dead Dad*, a two-thirds reduction of the artist's own father, viewers are awkwardly over-sized voyeurs. Next to *Mask II*, a decapitated head nearly 4 feet (120 cm) from chin to top of head, viewers shrink in comparison, and perhaps from complicity.

Art has social, cultural and political influence. Art's roles include both reflecting back at society and speculating as to society's future. Like design, art imagines scenarios — not just applied,

ROCKS TOKYO (VIDEO STILLS) /// Simon Taylor (TYPOGRAPHY AND ART DIRECTION), Jan Urbanoski (CGI)(TOMATO) /// 2010

ROCKS
TOKYO

problem-solving scenarios, but imagining for imagining's sake, an act of pure speculation. Art also serves as critical commentary — it gives voice to the marginalized, the outsiders, it speaks truth to power.

Do these criteria — personal expression, emotional concepts, and cultural influence — also apply, to some degree, to design? Returning to the idea of usefulness versus uselessness, it seems that context and intention matter. Is art mysterious and ambiguous while only design is clear and explicit? When zooming one's car down the highway on a rainy night while searching for a specific exit, which solution is preferred: a highly legible and readable sign on reflective material resulting from user testing, or a typographically expressive and experimental message with vague, yet poetic inferences about the destination? Now apply these vocabularies to a counter-cultural magazine on one's lap — which is desirable in which situation?

Ryan McGinness has taken the imagery of graphic design — symbols, letters, pictograms, graphic illustrations — and uses it to build an expressive fine art vocabulary. Like Andy Warhol, Robert Rauschenberg, Jasper Johns, Barbara Kruger and others, McGinness appropriates the material of commercial graphics, street signage and symbolic communication to make art. (MCGINNESS ALSO SERVED AS A CURATORIAL ASSISTANT AT THE WARHOL MUSEUM – POSSIBLY AN EARLY INFLUENCE.) He layers brightly colored vector-based shapes into dense compositions. The effect seems primarily visual and aesthetic, although some meaning is connoted by viewers' associations with the images from other contexts.

Context itself became the emphasis of one exhibit, according to colab-projects.com: "In 2003, Ryan McGinness produced an exhibition at BLK/MRKT Gallery in Los Angeles that consisted of nothing more than corporate sponsors' logos sized on the gallery walls according to their level of sponsorship for the exhibition. McGinness explains, 'My hope was that a content-deprived exhibition comprised of only sponsorship logos would create enough pause for us to consider both the fine art of corporate sponsorship and the corporate sponsorship of fine art.'" This is an unquestionable embracing of socio-cultural-economic content that communicates his position, as McGinness continues to mine the vernacular of commercial design for his inspiration.

One long-held assumption is that art comes about from an internal, personal motivation while design requires an external, public impetus. Another is that design

23 /// Andy Warhol
24 /// Andy Warhol, Campbell's Soup Can, 1964
25 /// Robert Rauschenberg
26 /// Robert Rauschenberg, Retroactive II, 1963
27 /// Jasper Johns
28 /// Jasper Johns, Three Flags, 1958
29 /// Barbara Kruger
30 /// Barbara Kruger, Untitled (We Don't Need Another Hero), 1987
31 /// Ryan McGinness
32 /// BLK/MRKT Gallery, Los Angeles CA
33 /// Sponsorship Redux, private reception invitation, 2011
34 /// Sponsorship Redux, poster, 2011

ROB REACT/FLICKR CC LICENSE

33 WOMEN (PAINTED MURAL) /// Ryan McGinness /// 2010

results from a client commission, thereby casting the activity as primarily an economic trade, while art might eventually sell in the marketplace but this should not taint its creative production. Both assumptions carry truths as well as myths, and polarize creative activities that design authorship strives to bridge.

Paula Scher is best known as a partner in the New York office of Pentagram. Her maps, however, are self-initiated illustrations that depict continents, countries, cities and oceans with dense, hand-lettered words. Painted on large canvasses, Scher's maps are not merely geographic information designs — they are geo-political, with commentary about global climate change, trade relationships and the history of colonialism. "Obsessive, opinionated and more than a little personal, the maps provide an exuberant portrait of contemporary information in all its complexity and subjectivity," says pentagram.com.

Although sold in commercial galleries, Scher also creates her maps for client commissions, to serve as commercial and editorial illustrations in a mass communication context. In an interview with Steven Heller on theatlantic.com web site, she concludes, "Design has a purpose. Art has no purpose. I can't imagine one without the other."

This reinforces the idea of usefulness as the sole measurement distinguishing art from design. But because 'usefulness' itself is open to interpretation, it does not seem to fit an either/or model. A more appropriate definition might be that art and design have an ever-shifting and contextual relationship. Lacking a firm border, they share a gray zone of indeterminate boundaries, awaiting creative exploration.

35 /// Andy Warhol Museum, Pittsburgh PA
36 /// Paula Scher
37 /// Pentagram
38 /// Pentagram
39 /// Pentagram.com
40 /// Steven Heller
41 /// Atlantic.com

CHINA (MAP)(DETAIL) /// Paula Scher /// 2008

Page 278

delicious and refreshing.
But there wasn't any.

Renie PRICE had already been over, blabbing about seeing the tall girl in the red coat again, but by then, her gossipy tell-tales were old news to Mary. Luckily, Mrs. P had only seen me going out, not coming back.

Roy stepped up with an explanation, telling her that his 'cousin' had gone to live in Dundee. Permanently. "She's going to join a convent, as a matter of fact," he said. It was all he could think of on the spur of the moment. Mary shot him a glance to let him know he had gone too far. "Yes," she said, with a light dusting of icing sugar, "so we won't be seeing her again."

"A convent?" said Renie. "Fancy that. She didn't look the convent type."

Mary smiled awkwardly. Roy looked at the wall.

"She's a big girl, isn't she, Mary?" said Renie, seeking confirmation.

Roy stepped in. "She's not that big."

Renie wasn't having it. "Ooh, she is. She's taller than you, Roy."

"That's just high heels," he said.

"And she likes her bright colours, doesn't she?" The tone was mocking.

Mrs. PRICE was beginning to get on Roy's nerves. He said: "Not always. She wears subtler hues as well. Anyway, there's no law against bright colours, is there?"

Page 279

This was not strictly true.
IN 1960, AMENDMENTS TO THE 1938 FOOD, DRUG AND COSMETIC ACT outlawed THE USE OF THE STRAWBERRY-TONED RED No.3A COLOUR ADDITIVE USED IN MARASCHINO CHERRIES, BUBBLE GUM AND CERTAIN LIPSTICKS BECAUSE TESTS SHOWED THAT LARGE AMOUNTS CAUSED THYROID TUMOURS IN MALE RATS.

They finally got rid of her, and Mary went out to the garden. When she came back in, Roy was adjusting his tie in the hall mirror.

"Where do you think you're going?" she demanded.

"Out. I've arranged to meet EVE."

"You can't. We've got to get a bonfire going and get rid of all those clothes. Or have you forgotten?"

"No need. I went out last night."

"Last night?"

"Yes, I couldn't sleep for worrying, so I DROVE OUT TO THE COUNTRY and buried them in a field."

"I didn't hear you get up. What time was that?"

"AROUND TWO."

Mary shook her head. "You should have told me what you were doing. I thought we were going to BURN them down the garden." She sounded almost disappointed, as if she'd been looking forward to it.

"I know, but it's done now."
"Did anybody see you?"

WOMAN'S WORLD (BOOK) /// Graham Rawle (ATLANTIC BOOKS) /// 2005

Page 246

than a short skirt, you know. They're not bothered who's wearing it. They're animals, most of them, and their morals are disgusting. It's not even safe for decent girls to go out alone after dark, never mind you."

"It was awful."
"What did he do?"
"I can't say."
"Where was this, ON THE STREET?"
"No." Roy's hands were still covering his face, unable to bear the shame.
"Where then?" she demanded, impatiently.
Slowly, he answered. "At his flat."
Mary WAS INCENSED. "You went to a man's flat? Dressed as NORMA? ROY, what the devil were you thinking? That's just asking for trouble."
"I know."
"Did he think you were a WOMAN?" ROY squirmed. "Yes . . . I think so . . . I don't know. He might have known."

THESE ARE THE DIFFICULT QUESTIONS. delicate as daffodils in the snow.

"And he soon found out for sure, I suppose."
Roy didn't want to think about what she might be imagining.
"THERE WAS A FIGHT," said ROY, unsteadily.
"Then she hit him."
"Who did?"
"NORMA. She hit him really hard."
"Well, it's what he deserved, I expect, but it's your own stupid fault for going there in the first place."

Page 247

"No, it's worse than that. He's dead."
"What the devil are you on about?

TALK PROPERLY. Dead?

He can't be." She stared at him, astonished and perturbed. Roy said nothing. There in the silence, Roy heard Mary's heart plummet to THE BATHROOM FLOOR like a weight on a cut rope.

Mary perched on the edge of the bath next to Roy. She was hunched over, resting her elbows on her knees with her palms pressed to her eyes as the terrible truth sank in.
"I knew something like this would happen. What have I done to make you do these terrible things? LOVED you too much, I expect. I should have been firmer with you when you were young."

There was nothing to say.

IT was a long time before she spoke again, but when she did she wanted to know all the ins and outs. After the obvious WHO WAS HE? HOW DID IT HAPPEN? her questions became more practical. Who had seen me? Who knew I was there? Was any evidence left at the scene of the crime? Fingerprints?

SAMPLING AND REMIXING

147

01 /// Copyright
02 /// Kurt Schwitters
03 /// Kurt Schwitters, A Ramaat, 1942
04 /// Hannah Höch
05 /// Hannah Höch, The Art Critic, 1919-20
06 /// John Heartfield
07 /// John Heartfield, Der Sinn Des Hitlergrusses (The Meaning of the Hitler Salute), 1932
08 /// Richard Hamilton
09 /// Richard Hamilton, Just what is it that makes today's homes so appealing, so different?, 1956
10 /// Richard Prince
11 /// Richard Prince, Untitled (Cowboy), 1993
12 /// Don Joyce and Mark Hosler of Negativland
13 /// Negativland, U2, 1991

Authorship IN GRAPHIC DESIGN is typically

thought of as the designer-author's original voice, of one's authentic creative production. But what about authorship through sampling, appropriating, parodying, copying — is this a legitimate method of designing?

Perhaps scale, scope and context can be used to determine this. If one copies a paragraph or more of text without permission, compensation or attribution, this is considered plagiarism. One could even apply this to sentences, but what about phrases? Is taking a phrase plagiarism, or acceptable — could it even be a coincidence? Words and letters are recognized as being in the public domain, the building blocks of all writing, so it is not plagiarism to use specific words (IF THE WORD IS A REGISTERED TRADEMARK, THEN IT IS A DIFFERENT ISSUE DEPENDING ON CONTEXT). Clearly, the order that the words are in and the number of words that are borrowed help to determine if plagiarism occurs.

Beyond the ethical issues of copying someone else's work, there are legal considerations. Copyright law protects against unauthorized copying, but in the United States, the Fair Use clause of the Copyright Act allows for exceptions. Using four criteria, Fair Use considers if the work in question is for commercial or nonprofit purposes, including education; the nature of the work (materials and medium); the relationship of the portion used to the whole work; and the potential effect of the copy on the marketability of the original. Fair Use is meant to protect works of commentary, criticism and parody as 'free speech.'

Another way to consider sampling is through the lenses or music, literature or art. Collage, montage and assemblage have been recognized art methods for the past century. Remixing, layering, juxtaposing, mash-ups and referencing are seen historically in the works of many artists: Kurt Schwitters, Hannah Höch, John Heartfield, Richard Hamilton, Richard Prince, Negativland and

14 // Girl Talk (Greg Gillis)
15 // Girl Talk, Feed the Animals, 2008
16 // Kenneth Goldsmith
17 // Graham Rawle, Woman's World, 2008
18 // Graham Rawle
19 // DJ Spooky (Paul D. Miller)

Girl Talk among others. The 'commonplace books' dating to the Middle Ages were essentially hand-written compilations of text passages, quotes, recipes, poems, prayers and more from other sources — they can be considered the proto-mix tape! For today's writers engaged in digital copy and paste 'patchwriting,' Kenneth Goldsmith says that "the act of writing is literally moving language from one place to another, proclaiming that context is the new content."

Patchwriting has long been possible in the analog world. *Women's World*, a novel entirely cobbled together from collaged words found in 1960s British women's magazines, was written and designed by Graham Rawle. Availability of certain words and phrases determine the story's syntax, characters and plot. Graphically and literally, *Women's World* has a bumpy, humorous flow from its 40,000 snippets of text and image, which is its charm. Although the book's text is graphically active with varying fonts, sizes and formats — all in the half-toned grayscale of photographic scanning — the story is equally propelled by coherent patchwriting.

Paul D. Miller, also know as DJ Spooky that Subliminal Kid, is renown for innovative musical mixing and sound sampling. Even his original styles of 'illbient' and 'trip hop' can be considered portmanteau word collages, as word meaning is transported into new contexts and alternative meanings. In his book *Rhythm Science*, Miller said: "The Dj 'mix' is another form of text and its involutions, [as] elliptical recursive qualities and repetitions are helping transform an 'analog' literature into one that is increasingly digitized. Dj-ing let's you take the best of what's out there and give your own take on it." The rhythms, patterns and vectors of music have direct parallels in both writing and design, making the DJ an author who mixes existing work into new work. Or as Luna van Loon put it in the Dutch design journal *Morf 6*, "Copying and cutting-and-pasting are well-considered strategies instead of arbitrary ones."

Today's technology-savvy users create original content (DIGITAL ART, MUSIC AND VIDEO) and mix it with mass media works in new, ever-evolving forms of interactive authorship. Artists and designers, actors, musicians and authors' individual roles have permanently shifted as curators, directors, producers and editors have blurred traditional boundaries, and vice versa. For example, the Apple iPhone application Mixel enables users to create and share collages of digital images from on- or offline sources. Using one's fingers on a touch-screen instead of scissors and paper, images can be combined, sent to others and then remixed in infinite ways.

Enrique Radigales' idealword.org site is a virtual gallery of HTML-based illustrations that uses collage images, pixelated drawings, text and software code. By manipulating image file types and layers, Radigales' screens appear in successive scans, creating a crude animation. As the images are bit-mapped GIF files, they can be scaled up and down, another innovative form of animation. Many images also have screen-grabbed photographic content pasted into pixelated contour shapes, thereby mixing media. An interview with Radigales on furtherfield.org discloses that: "…IdealWord's beauty is not merely surface deep. Each drawing contains texts that have been visually camouflaged within the image. These hidden texts — in a variety of styles, and from often surprising sources — are visible by selecting and copy-pasting the piece into a blank text document, or by

viewing the HTML source code." By engaging the viewer in the deconstruction of the image and word collages, Radigales extends the notion of sampling into performance.

Digital media have erased the distinctions between original and copy. In analog technologies, like film, mimeography, photocopying, and tape recording, each successive copy loses quality. With the binary code of computer software, each copy is an exact duplicate of the original, assuming consistent file types and lack of compression. Whether with a JPG image or an MP3 music file, distribution and sharing in the digital environment has become fast, cheap and wide-reaching. This has caused both content creators and consumers to reconsider issues of ownership, access and originality. New categories of attribution and distribution have emerged, such as 'Copyleft' and 'Creative Commons' licenses.

IDEALWORD.ORG (WEBSITE) /// Enrique Radigales /// 2003–10

25 /// William Mitchell
26 /// Massachusetts Institute of Technology (MIT), Cambridge MA
27 /// William Mitchell, The Reconfigured Eye, 1992
28 /// Convergence
29 /// Satromizer effect (portrait of Jon Satrom, creator)

William Mitchell, former dean of the school of architecture at MIT, uses the terms 'allographic' and 'autographic' in his book *The Reconfigured Eye*. The terms are also explained in the article The Art Portrait, the Pixel and the Gene in the journal Convergence: "Autographic refers to artforms that are unique, created in a single instance, and difficult to reproduce without degradation, like a painting. Allographic refers to artforms that are notational and performative, like sheet music or a theatrical script, original both in their conception and in their subsequent performance. Digital images, by Mitchell's definition, fit the allographic description. For example, an artist might create an image which could then be performed by other artists through manipulation of color, contrast, composition, cropping, applying special effect filters, adding collage elements, etc."

'Glitching,' the corruption (OR ENHANCEMENT) of digital files through code manipulation, is one method of creating mashed-up content. By intentionally introducing one file's binary or ASCII code into another, unexpected results are possible. Although 'breaking' a file might be undesirable in most contexts, some glitch artists enjoy the aesthetic of random results. Even crossing media is possible: using text to alter a JPG image, image data to alter an Mp3 sound file, or sound data to alter text — digitization is the common ingredient, and distortion the common outcome.

Responding to the glitch trend is Satromizer, "the world's first multi-touch glitch tool," a new app for the Apple iPhone and iPad devices. Because it allows the user to glitch images directly on the screen by touching, it lacks the creative input that directly manipulating digital file codes provides. Although inverting an image's 'signal to noise' ratio, Satromizer masks glitching's penchant for randomness and happy accidents.

Sampling and remixing strategies like collage and montage are often additive, but subtractive methods can be equally compelling. Taking parts away through editing, deleting, covering and revising can be an effective way to mash-up the original. Instead of literally, or figuratively, cutting and pasting, some designers, artists, writers and musicians create derivative works by simply cutting. Goldsmith, author of the book *Uncreative Writing*, elaborates, "Success lies in knowing what to include and — more important — what to leave out. If all language can be transformed into poetry by merely reframing — an exciting possibility — then she who reframes words in the most charged and convincing way will be judged the best."

The appropriate way to look at sampling in design authorship is as a matter of degree, not easily polarized into right and wrong. The Stanford University Libraries' Copyright and Fair Use web site offers a fifth factor to Fair Use: "Are You Good or Bad?" This considers ethical and moral issues along with legal ones — in cases of borrowing or altering copyrighted works, context and intention seem to matter.

'Subvertising,' a neologism formed from the words subvert and advertising, involves the altering of billboards, corporate identities, branding and other forms of advertising as graphic activism. Some types of graffiti are considered subvertising; the stencil art of Banksy is an example. To contest the

UNTITLED (SUBVERTISED POSTER) /// 2011

one-way communication of much advertising in the public realm, subvertising — or 'culture jamming,' another common term for this approach — uses additive and subtractive methods to create new layers of meaning. Commercial messages then take on an urgent social, political, economic and cultural relevancy. While this activity is typically illegal by standard definitions of ownership and access, it is worth asking if the larger issues around wealth, consumption, debt and power can be legitimately addressed through this type of design authorship.

Sampling and remixing can be performed in various media, with various techniques, with a variety of outcomes. Some collages are laden with social or political meaning, and are meant to serve as commentary. Others are purely aesthetic, or contain images and words juxtaposed for humor. Regardless, the designer channels the authorship of others into new creative works.

30 /// Kenneth Goldsmith, Uncreative Writing, 2011
31 /// Stanford University Libraries & Academic Information Resources
32 /// Bansky (unmasked)
33 /// Bansky, Napalm, 2004

PHOTO COURTESY THE AUTHOR

PURRFLUX (GLITCH SERIES) /// jon.satrom (HTTP://JONSATROM.COM) /// 2010

INTERVIEW: WARREN LEHRER

153

Warren Lehrer is a multi-media artist, writer, educator and designer. He is a partner in the studio EarSay, a "nonprofit arts organization dedicated to uncovering and portraying stories of the uncelebrated." Lehrer's artist's books and media projects are in numerous collections, including the Museum of Modern Art, the Getty Center, the Georges Pompidou Centre and the Tate Gallery. He is a professor at Purchase College of the State University of New York.

MCCARTHY I've been a fan of yours since picking up a copy of your artist's book GRRRHHHH: a Study of Social Patterns at the Stanford University Library in the late '80s (LET IT BE SAID THAT AT 464 PAGES, IT SET THE BAR FOR BRUCE MAU'S AND IRMA BOOM'S SUBSEQUENT TOMES!). Your practice includes books, performances, digital films, sound works and mixed media — where are you on the art-design continuum?

LEHRER Doing my wobbly-dance on the edges between the two, I guess; generally ignoring the distinctions while embracing the continuum. My undergraduate training was in painting and printmaking, though I was always writing on the side. While still in college, the writing and the image making started oozing into each other, much to the dismay of one of my painting professors who warned me that words and images exist in completely different realms and should always remain separate. Inspired by his admonition (AND THE ENCOURAGEMENT OF ANOTHER PROFESSOR), I went to graduate school for graphic design so I could learn the tools and methodologies needed to produce my own books and multi-media projects. And that's pretty much how I function to this day — as a writer/designer working on self-authored and collaborative projects that somehow combine writing and image making, and sometimes music and theater.

Though most of your works seem self-authored or collaborative with other artists, the works are not without content or a message. How do you conceive of the best forms or media for these stories?

I'll give you a few examples. From early on, I've been interested in blurring the line between life and art, and somehow translating/creating experience through my work — particularly

01 /// Warren Lehrer
02 /// EarSay, Inc.
03 /// Museum of Modern Art, New York NY
04 /// The Getty Center, Los Angeles CA
05 /// The Georges Pompidou Centre, Paris
06 /// The Tate Modern, London
07 /// State University of New York Purchase College Panthers
08 /// Warren Lehrer, Grrrhhhh: A Study of Social Patterns, 1988
09 /// Stanford University, Palo Alto CA
10 /// Bruce Mau
11 /// Rem Koolhaas and Bruce Mau, S, M, L, XL, 1996 (1376 pages)
12 /// Irma Boom
13 /// Irma Boom, SHV Thinkbook, 1996 (2136 pages)

14 /// Roller Boogie, 1979 (Venice Beach)
15 /// Warren Lehrer, Versations, 1980
16 /// AIGA
17 /// Judith Sloan
18 /// Queens NY
19 /// Warren Lehrer and Judith Sloan, Crossing the BLVD, 2003

the experience of character, relationships, and place. My graduate thesis was a performance score/book inspired by people I had met on Venice Beach in the summer of 1979. Versations was a setting of eight conversations, arranged and scored for the page and the stage as a kind of structuralist, music/spoken word composition. Each character was cast in their own typeface and typographic configuration. Instead of using punctuation or set column widths, line breaks were determined by breath or thought pauses. Silences equaled space on the page; ink equaled sound; typographic notation tracked the rhythm and emphasis of speech, the shape of thought, the nature and densities of interactions. Printed on all rag, translucent paper, readers could see echoes of voices coming and going. At my graduate thesis presentation, I leafed through the pages of the oversized playbook as actors and musicians performed excerpts. The faculty and visiting critics were divided as to whether what I had done was graphic design, genius or garbage. One of them recommended I submit the book for an AIGA award. It was selected as one of the 50 books of the year in 1981. At the opening of the exhibit in New York, one of the other awardees asked me how I got away with designing the book the way I did. I thought it was funny question, and though I wasn't working in the traditional sense as a graphic designer, it made me think that the field was an open one.
...
My life and my art lost almost all boundaries after I met, married, and partnered with actor, oral historian, and audio artist, Judith Sloan. We formed EarSay, a non-profit arts organization, and after writing two documentary plays together, we took on a large project documenting the migration stories of our neighbors in polyglot Queens — the most ethnically diverse locality in the United States. *Crossing the BLVD: Strangers, Neighbors, Aliens in a New America* ended up being a book (W.W. NORTON), a series of public radio documentaries, a performance, animations, a website and traveling exhibition which includes a mobile photo-story booth. In each branch of the project, our goal was to transport the reader/listener/viewer to the streets of Queens, and have them feel as if they're sitting in front of each person, looking into their eyes, listening to their stories, their humor, their living history.
...
My most recent book project, which I've just finished writing and designing, is an illuminated novel containing 101 books within it, all written by my protagonist, a controversial, bestselling author who finds himself in prison looking back on his life and career. *A Life In Books: the Rise and Fall of Bleu Mobley* is my first novel, and part of what it portrays is the creative process you asked about. How does an artist find the right form for particular stories? ... My own process writing and designing this book was kind of peculiar and mysterious. First I designed the covers of all 101 Bleu Mobley's books. Then I wrote excerpts that read like short stories.

left /// **CROSSING THE BLVD** (BOOK PAGE SPREAD) /// Warren Lehrer and Judith Sloan (AUTHORS), Warren Lehrer (DESIGNER AND PHOTOGRAPHER) /// 2003
right /// **FRENCH FRIES** (BOOK PAGE SPREAD) /// Warren Lehrer and Dennis Bernstein (AUTHORS), Warren Lehrer (DESIGNER) /// 1984

Fleshing out Mobley's creations enabled me to chart out events in his life, and write his (faux) memoir — the primary narrative in *A Life In Books*. Paired together, the confessional autobiography and the retrospective monograph paint a portrait of a complex, well meaning, if flawed artist. Like my protagonist, who grapples with the decline of the physical book as a primary vehicle for storytelling and the changing nature of how people read, I am currently working on an iPad edition of the novel that will include animations, video performances of Mobley book excerpts, breakout galleries, annotations, and other interactive components.

As an educator with an innovative research agenda, how do you teach the typical graphic design student who might spend his/her career in the more quotidian aspects of the profession?

I don't see much of a dichotomy there. When students come to me with quotidian aspirations — to get a good job, to make hip-looking design, and live nice comfortable lives — that's perfectly fine. It's my job, not only to prepare them to be professionals in the field, but to help them discover a path to a life's work filled with meaning, exploration, even purpose. I don't flaunt authorship or my way of working onto students. But I do want them to see the awesome power graphic design has shaping culture, and the responsibility, the opportunity, and the gift that can be.
...
The traditional model for design education evolves from the notion of the artisan/craftsman who serves the needs of the client, generally assumed to be a corporation. It's a disservice to teach design with that singular assumption today. Design educators tend to function as stand-ins for clients, supplying the project/problem to the student throughout their entire undergraduate and graduate careers. Credits and grades stand-in for salaries and awards. When it comes to senior or graduate thesis projects, design educators (ESPECIALLY IN THE UNITED STATES) often find themselves frustrated by the design student's inability to define their own project. It's no wonder! Design students have, in the main, not been encouraged to develop their own ideas and vision. Thankfully, this is starting to change.
...
In today's globalized, digitalized, post-post modern, information age — design is everywhere, images and icons are currency, text is oral again, music is bound to images, people are watching more than reading, and everything from politics to personal identity is branded. For better and for worse, graphic designers deliver much of this cultural landscape. They need to be informed, conscious mediators, able to listen, research, write, communicate, manage, orchestrate, understand the historical and cultural significance of the shapes, colors, even typefaces they're putting out there. Most importantly, they need to be able to think for themselves, to redefine the problem if necessary, especially today when entrepreneurism, collaboration, even self-authorship is a very real part of the design

A LIFE IN BOOKS: THE RISE AND FALL OF BLEU MOBLEY (COVER) /// Warren Lehrer and Jonathon Rosen /// 2013

GRRRHHHH: A STUDY OF SOCIAL PATTERNS (BOOK) /// Warren Lehrer /// 1988

field. Even if a majority of design students don't grow up to be authors or producers of their own projects — what they design and who they design for is ultimately an expression of their values, their approach to working, and the kind of education they received.

Any final thoughts on the notion that design authorship has transformed graphic design?

'Graphic Design' began in the early part of the twentieth century out of revolutionary art, literary, cultural, scientific, and political movements. It developed as a professional art practice imbued with the ideals of making a better world. While proudly proclaiming the heady pioneering days of graphic design (PRACTICED BY POET/PAINTERS, RADICAL LANGUAGE ARTISTS, UTOPIANS AND REVOLUTIONARIES) as its history — its contemporary practitioners, awarders, curators, and educators increasingly defined contemporary graphic design as a servant of industry, the state, and large cultural institutions. That didn't stop artists and writers and other creative people on the fringes from using the means of design to do their thing, be they Fluxus artists, Book Artists, Concrete Poets, Letterists, Situationists, Guerrilla Activists, or any number of iconoclasts who don't fit neatly into any ist, ism or guild. What has changed, it seems to me, is the discourse within the mainstream of the field.

...

There is no question that the model of the designer as functionary of a client is waning. Design authorship exists today as an alternative, potentially viable (IF NOT LUCRATIVE) path for designers to pursue, even in its less purist manifestations (DESIGNER AS COLLABORATOR, AS PARTNER, AS A PERSON INVOLVED IN THE FORMATION OF AN INTERDISCIPLINARY PROJECT). It's not only design that has changed — so has technology, the speed of change, global economics, and the nature of the workplace. We're currently in an extended recession, and the days of strong unions, and companies having fidelity to their employees seem to be a thing of the past. If I were a young designer today with a proclivity toward design as innovation, I'd say what the heck! Why not take a crack at pursuing my own dreams, become a citizen designer, entrepreneur, author, — (FILL IN THE BLANK).

Thank you!

INTERVIEW: JOHANNA DRUCKER

Johanna Drucker is a writer, critic, artist and visual theorist. She is a professor in the Department of Information Studies at the University of California–Los Angeles. Her artist's books have been widely exhibited and are numerous collections nation-wide. Scholarly works have included the books The Visible Word, The Alphabetic Labyrinth, Graphic Design History: A Critical Guide *(with Emily McVarish), and many journal articles.*

MCCARTHY Your life's work has been at the confluence of three systems for making ideas manifest: writing, designing and art-making. How do you move so fluidly within a personal practice that combines historical research, analysis, criticism, scholarship, communication, expression, creativity, craft and self-publishing?

DRUCKER I think of myself as an artist and a writer who makes books. I think in format. I'm not sure why, but graphical forms of expression have always informed my writing — in the literal sense of making and giving form to its expression. I find the mining of the archive and the experience of daily exposure to graphical forms are both ways of enriching the ways I think about what I do. The study of materials produced before the age of mass media is particularly rewarding because people had to figure out innovative solutions without the templates and conventions that circulate so broadly in our culture. Scholarly work stimulates my imagination, provides inspiration and provocation. Making is thinking, and critical analysis is part of the cycle of elaborating tools for thought. All seems to fit together, except for the time pressures, of course, and that is a matter of sequencing one's tasks.

Not only are you a prolific maker of artist's books, you've written the scholarly book *The Century of Artists' Books,* **and for years were involved with publishing JAB (JOURNAL OF ARTISTS' BOOKS). Why are certain forms, and media, more appropriate than others for your thoughts, and actions, as a maker and thinker?**

Oh, I can't take any credit for JAB, that is all Brad Freeman's doing. He initiated that project, did all the work, layout, publishing, printing, shipping, editing, everything. All I did was fill up empty space in the columns! Whenever he needed something to complete an issue he would just ask me to scribble a bit. He's done an enormous service to the artists' books community. Brad [book artist] and Steve Clay [publisher of Granary Books] were both major influences in writing *The Century of Artists' Books,* as was Tony Zwicker [artists' book dealer], now long gone. She taught us about the limits of our own knowledge, showed us what we

01 /// Johanna Drucker
02 /// UCLA, Los Angeles CA
03 /// Johanna Drucker, The Visible Word, 2003
04 /// Johanna Drucker, The Alphabetic Labyrinth, 1999
05 /// Johanna Drucker and Emily McVarish, Graphic Design History: A Critical Guide, 2008
06 /// Emily McVarish
07 /// Johanna Drucker, The Century of Artists' Books, 2004
08 /// Journal of Artists' Books
09 /// Brad Freeman
10 /// Steve Clay
11 /// Granary Books

12 /// First Assembling for Tony Zwicker
13 /// Nicholas Negraponte, Being Digital, 1996
14 /// Nicholas Negraponte
15 /// Ubuweb
16 /// Pennsound
17 /// Buffalo
18 /// Electronic Poetry Center

didn't know. She was wonderful in her combination of enthusiasm, endorsement, and direct confrontation with us as artists. Any medium has aesthetic qualities and characteristics. But I want to write in a multi-dimensional way. I think we all do. We write, we have thoughts, we have thoughts about where those thoughts might go, and then we have to edit to make the printed page or digital display conform to very limited conventions. Possibilities for thinking differently about writing can be recovered from the study of older forms of inscription and also projected forward to newer possibilities of digital writing spaces. Right now, for instance, I'm doing a little bit of analysis on the ways graphical features of the digital conventions in blogs, tweets, wikis, and so on structure the shape of argument online.

Concrete poetry is something you've written about and practiced through the experimental text in your book-works. Is this the essential 'touch point' between words and pictures (INCLUSIVE OF LETTER-FORMS, TYPOGRAPHY AND PAGE COMPOSITIONS AS IMAGES) — the poet as designer?

Except for sound and performance work, all poetry is visual. The graphical features of writing and text are part of the semantic field. Paying attention to that fact has been at the center of my work as an artist, critic, and scholar. I'm working right now on a small book on visual epistemology, graphesis, in the context of digital humanities. So I think my emphasis is more on graphical organization — the schematic disposition of elements — than on strictly iconographic characters or qualities. So, yes, that is the touch point. Pictorial organization and its conventions are of course of interest, as are the wonders of the visual world, but format features are essentially diagrammatic rather than iconic.

Your most recent research is concerned with digitization and visual culture. How has 'being digital' (TO BORROW NICHOLAS NEGRAPONTE'S BOOK TITLE) impacted the concept of the designer as author?

More people know how to think more innovatively with fonts, color, animation, and hybrid forms than ever before. When I began to make printed work, forty years ago (SHOCKING, BUT TRUE), the task of learning basic production skills was the price of entry to graphic design. We made lines with ruling pens (PARALLEL BLADES THAT HELD A WELL OF INK AND DELIVERED IT FOR DRAFTING PURPOSES AS MECHANICALLY PERFECT LINES), and had to know how to 'spec' type to get proofs from a service bureau that produced proofs of hot type or of phototype, and it was all very expensive. If you got your specifications wrong, you paid to have the type reset. The magic of being able to transform a text from one font to another blew our minds when the first desk top computers appeared. Now everyone knows what a font is and what point sizes mean. This is a great time for the long 'hidden' tradition to become visible and for the creative energies of poets who made use of graphical forms to become better known. The online resources that have been put together by ubuweb, PennSound, Buffalo's epc [Electronic Poetry Center], Rui Torres' PO.EX

[Digital Archive of Portuguese Experimental Literature], Scott Rettberg's ELMCIP [Electronic Literature as a Model of Creativity and Innovation in Practice] and the ELO's online archive (ELECTRONIC LITERATURE ORGANIZATION), are all great resources for this kind of study. The accessibility of all this cultural material, poetic imagination, is fantastic. But we should remember that it all takes enormous amounts of work and effort, much of it a labor of love and dedication, as, indeed, were the original projects... We still need even more flexible tools for writing diagrammatically, taking full advantage of the computational environment, its analytic and synthetic properties, as well as its graphical platforms. We will read differently ahead, and across distributed fields of discourse that organize themselves in constellationary configurations according to the rhetoric and poetics of flexible, mutable, mobile forms. And that will seem as natural as the writing and reading we have been schooled in the past, that regulated our thoughts to a careful march across the page.

Thank you!

19 /// Rui Torres
20 /// Poesia Experimental
21 /// Scott Rettberg
22 /// ELMCIP (Electronic Literature as a Model of Creativity and Innovation in Practice)
23 /// ELO (Electronic Literature Organization)
24 /// ELO (Electric Light Orchestra), Telephone Line, 1977
25 /// ELO (Electric Light Orchestra), Can't Get It Out of My Head, 1974
26 /// Thank you

STOCHASTIC POETICS (LETTERPRESS PRINTS) /// Johanna Drucker /// 2010–12

SEWARD CO-OP INTERIOR (ENVIRONMENTAL GRAPHICS) /// Jeff Johnson (CREATIVE DIRECTOR), Lucas Richards (ILLUSTRATION AND DESIGN)(SPUNK) /// 2010

DESIGN ENTREPRENEURISM AND ECONOMY

161

01 /// Company boardroom
02 /// Jessica Barness
03 /// Gourmet coffee
04 /// Spunk Design Machine
05 /// Jeff Johnson
06 /// Minneapolis MN

The DOMINANT economic model for designers has typically been: a client commissions the designer to do a project, design work is performed, the designer gets paid. Repeat as needed. While this model is still the most prevalent for the profession, alternative approaches have emerged.

Some designers position themselves as entrepreneurs, developing new products and services. Besides simply designing a product or service, design entrepreneurs want to be comprehensively involved: concept, design, naming, production, branding, packaging, advertising, marketing, and sales. Others innovate as initiators of new business relationships, taking a proactive, rather than a reactive stance. Occasionally, designers have enlarged their presence in decision-making and strategy by getting a seat in the company boardroom. A few designers even eschew the conventional wisdom of the market and seek 'off the grid' solutions, such as bartering, peer-to-peer trade, sponsorships, grant-funding, crowd-sourcing, licensing and embracing fair trade principles.

Designer Jessica Barness has created a prototype for a web site that proposes a new model. "Interdesign: connection for social innovation," is an online tool that uses social networking to share opportunities between designers, researchers and organizations. Participants can select the compensation they wish to receive, from volunteering to being funded by a grant to trading goods or services — "five pounds of gourmet coffee" — to currency. Besides those seeking design help, designers can seek services they need: business consulting, legal advice, and so on. The model suggests a system of trade that facilitates ideologically informed sharing and swapping, a marketplace of 'the visible hand.'

A good example of ideologically influenced authorship combined with design entrepreneurism is the work of Spunk Design Machine. Led by founder Jeff Johnson, they have created branding, advertising, packaging, signage and architectural elements for two co-operative food stores because of a belief in the agricultural, nutritional and economic practices of each. The Seward Co-op in Minneapolis, Minnesota and the Davis Food Co-op of Davis, California have both benefitted from Spunk's comprehensive involvement. Because of Spunk's interest in the concept of the stores' integration into the urban fabric and issues of sustainability, value-added designs were also created, like the Davis Food Co-op's bicycle-mounted 'flying tomato' grocery hauler and Seward's playfully shaped bicycle racks.

Screen 1

LOGIN

THE BASICS | DESIGNERS | RESEARCHERS | ORGANIZATIONS

ABOUT
CONNECT
POST

Design shapes messages, causes and ideas toward positive change and the greater good.

Society is changing, and designers are leading the way. Through experience and the build up of knowledge across a broad range of disciplines, designers communicate to narrower audiences, deal with more complex issues and tackle sustainability in interaction. An informed audience leads to informed decision making, awareness, larger conversations and ultimately social innovation for the greater good.

interdesign

DESIGNERS + RESEARCHERS + ORGANIZATIONS
connecting for social innovation

Screen 2

LOGIN

ABOUT
CONNECT
POST

Make a connection.

SEEKING design | research | organization
COMPENSATION volunteer | trade | grant funding
KEYWORD

HEART DISEASE PREVENTION SEEKING DESIGN
CONTACT David Javajoe
AFFILIATION Center for Health Studies (post-doc)
EMAIL javajoe@umn.edu
COMPENSATION Trade (5 lb. gourmet coffee = total project)
TIMEFRAME Deadline June 1
I'm looking for a designer to develop a research poster based on my recent work in coffee and its benefits in heart disease prevention (funded by a major coffee corporation in Colombia). The poster will be presented at an academic conference in mid-June.

ANIMAL SHELTER AWARENESS CAMPAIGN SEEKING RESEARCH
CONTACT Amy Likescitters
AFFILIATION Graphic Design (graduate student)
EMAIL likescr863@umn.edu
COMPENSATION None
TIMEFRAME Any
I'm interested in creating a team to launch a campaign for animal shelter awareness in the Twin Cities. My skills are in both print and web; ideally searching for people in mass communications, law, and business. Thanks!

KEEP THE MISSISSIPPI GARBAGE-FREE! SEEKING DESIGN
CONTACT Pat Keepitgreen
AFFILIATION Department of Urban and Regional Development (faculty)
EMAIL keepitgreen@umn.edu
COMPENSATION Grant funding

INTERDESIGN (WEBSITE) /// Jessica S. Barness /// 2010

P6 WELCOME KIT (BROCHURE) AND STYLE GUIDE (BOOK) /// Jeff Johnson (CREATIVE DIRECTOR), Lucas Richards (ILLUSTRATION AND DESIGN)(SPUNK) /// 2010

Spunk has also taken its entrepreneurship to the next level by designing identity and collateral materials for the Principle Six Cooperative Trade Movement (P6). According to cooperativegrocer. coop, "Principle Six is a pilot initiative created by Equal Exchange, a worker-owned fair-trade cooperative, and six consumer co-ops… to leverage the power of cooperatives to build a sustainable, alternative economy in greater alignment with our shared values." P6 advocates the patronage of small farmers who produce co-operatively and who live locally. By creating designs for businesses and economic philosophies that Spunk supports, authorship is acted out through its choice of clients.

As design authorship gained traction with more designers creating original content, finding channels of economic empowerment became a logical step. Digital media and rapid prototyping technologies enable designers to produce work without the typical 'bricks and mortar' overhead or layers of 'middlemen' of many established practices. Creating, marketing and selling original typefaces, illustrations, graphic designs and photography through a web site is relatively inexpensive. On-demand publishing allows designer-authors to sell work as orders come in, by-passing the need to print a large edition up front. Concurrently, some do-it-yourself designers revel in the craft of older technology, using letterpress, silkscreen, stencils, handmade papers and other methods to manufacture their works of design authorship.

Design entrepreneur Richelle Huff has identified an overlooked market: pre-teen boys. Observing that the toys serving this age group are mostly hard (METAL, WOOD AND PLASTIC SPORTS EQUIPMENT, ELECTRONIC DEVICES AND SO ON), Huff noticed that wild play potentially causes injuries. Still, she found that as pre-pubescent 'tweens,' her ten year old son and his friends enjoyed rough physical play. By combining the softness of pillows and recycled fabric with cartoon-face features, Huff's solution was born: Kreechers. The designs are impish and irreverent with crossed eyes, extended tongues and vibrant colors, promoting interaction and engaged play — without risk of pain. Because of the product's graphic vocabulary, Kreechers are also a socially and culturally accepted companion for boys to hug while watching TV or to use as a pillow while reading.

07 /// Davis, California
08 /// Davis Food Co-op Flying Tomato Grocery Getter
09 /// Seward Co-op Bicycle Rack
10 /// Bricks and mortar
11 /// Richelle Huff

12 /// Pre-teen boys
13 /// Sports equipment
14 /// Pillow
15 /// TV
16 /// Rabbit
17 /// Mexico
18 /// Kidrobot.com

Kreechers are now sold through two American specialty toy companies, and may have helped define a new market segment: soft toys for wild boys.

An example of entrepreneurism as cultural opportunity is found in a series of trendy collectable figures. The Dunny character, a plastic doll loosely modeled on a rabbit, is purchased and traded for its innovative surface graphic designs and has achieved wide-spread subculture cachet. Occupying both cultural and commercial territory, Dunny is coveted, collected and displayed — not unlike a museum object. Azteca, a new line of fifteen figures, credits individual designers and a curator. "Curated by Headquarter in Mexico City, the Azteca Dunny series showcases some of the hottest names in Mexican art, fashion, graphic design, music, and industrial design. The brightly colored series captures the creative passion of Mexico's artistic community. The objective of the series was to bring to the surface the very essence of Mexican street arts, underground culture, and diverse history," says the Kidrobot web site. In the case of Azteca, the entrepreneurial marketing was more about where the designs were from, than where they were selling.

KIDROBOT AZTECA (TOY) /// featuring art by the Beast Brothers /// 2007

FLOYD, EUGENE AND MILDRED, KREECHERS™ (TOYS) /// Richelle Huff /// 2007

One of the most established tools of design entrepreneurism is the self-promotion piece. Ambitious designers turn their talents — long used to support the promotional efforts of their clients — towards the designers' own aspirations. Conceiving the message, writing copy, designing a memorable graphic package for distribution, works of self-promotion are design authorship with an eye for attracting business. Furthering the direct impact of self-promotional designs, several design magazines publish issues devoted to self-promotion, providing a wider audience for recognition, reputation and potential clients. A select few designers have achieved 'starchitect' status, using their signature style and name recognition to generate bountiful new business.

19 /// Bruce Mau
20 /// Bruce Mau, Life Style, 2005
21 /// Bill Cahan
22 /// Bill Cahan, I Am Almost Always Hungry, 1999
23 /// Marian Bantjes
24 /// Marian Bantjes, I Wonder, 2010
25 /// Stefan Sagmeister
26 /// Peter Hall
27 /// Stefan Sagmeister and Peter Hall, Sagmeister: Made You Look, 2001
28 /// David Carson
29 /// Lewis Blackwell
30 /// David Carson and Lewis Blackwell, The End of Print: The Grafik Design of David Carson, 1995
31 /// Jonathan Barnbrook
32 /// Jonathan Barnbrook, The Barnbrook Bible, 2007
33 /// John Maeda
34 /// John Maeda, Maeda On Media, 2000
35 /// Jon Wozencroft
36 /// Jon Wozencroft, The Graphic Language of Neville Brody
37 /// Neville Brody

The king of entrepreneurial self-promotion must surely be the designer monograph. When some designers achieve a certain level of recognition through awards, high profile clients, lectures, exhibits and so on, an illustrated book often follows, further cementing their reputation. Bruce Mau's *Life Style*, Bill Cahan's *I Am Almost Always Hungry*, Marian Bantjes' *I Wonder*, Stefan Sagmeister and Peter Hall's *Sagmeister: Made You Look*, David Carson and Lewis Blackwell's *The End of Print: The Grafik Design of David Carson*, Jonathan Barnbrook's *The Barnbrook Bible*, John Maeda's *Maeda @ Media* and Jon Wozencroft's *The Graphic Language of Neville Brody* are but a few examples.

These tomes are entrepreneurial in two ways. They are products sold to consumers, generating income for their designer-authors. They are also promotional towards the designers' future aspirations of more and better business — 'better' might be defined as commissions from desired industries, high profile 'blue chip' clients and enhanced reputations.

OBSESSIVE CONSUMPTION: WHAT DID YOU BUY TODAY? (PROJECT) /// Kate Bingaman-Burt /// 2010

Taking a different tack, William Drenttel and Kevin Smith of Winterhouse Editions designed *The National Security Strategy of the United States of America*. The text was freely available through the U.S. government; Winterhouse added value by creating a typographically pleasing paperback book, which it sells. While seemingly politically neutral and not overtly self-promotional, that the book makes the information accessible and readable to the public is its own designer-authored statement. This could be considered an example of what Simon Kavanagh of Danish school and design consultancy Kaospilot terms the user-focused "listen louder" approach. By contrast, much marketing and advertising rhetoric seems to only 'yell louder,' which is perhaps why many tune it out. Many government and corporate documents worthy of reading seem to be rendered in an unapproachable manner, discouraging public interpretation. Winterhouse addresses this challenge.

Economic empowerment, creative independence and enhanced reputations through design authorship may be driven only partially by the desire for compensation. Some designers have reacted to the way that their client work, according to the First Things First 2000 manifesto, was "helping draft a reductive and immeasurably harmful code of public discourse." Commercial success in design is no longer the sole measurement of accomplishment — ethical, moral and environmental concerns are also important. No matter the fees generated, the accolades received or awards won, many ethically minded designers cannot reconcile the disconnect between corporate image and corporate behavior.

Kate Bingaman-Burt is a designer, illustrator and educator whose creative inquiry bridges economic concerns and entrepreneurial ventures. Her original obsessiveconsumption.com web site stated that it served to: "showcase her love/hate relationship with money, shopping, branding, credit cards, celebrity, advertising and marketing. The work is inspired by the ever ubiquitous, generic, delicate, sometimes stomachache inducing credit card statement, craft as activism, and general consumerism. She created Obsessive Consumption in 2002 when she decided that she was going to not only document all of her purchases, but to also create a brand out of the process to package and promote." Although Bingaman-Burt is both "repulsed and grossly fascinated by the branding of consumer culture," her initial creative agenda took a critical stance.

38 /// William Drenttel
39 /// Kevin Smith
40 /// Winterhouse Editions, The National Security Strategy of the United States of America, 2003
41 /// Simon Kavanagh
42 /// Danish
43 /// Danish
44 /// Kaospilot
45 /// First Things First 2000
46 /// Kate Bingaman-Burt
47 /// Credit card statement
48 /// Etsy
49 /// Kate Bingham-Burt, Obsessive Consumption: What Did You Buy Today?, 2010

50 /// Bruce Sterling
51 /// Bruce Sterling, Shaping Things, 2005
52 /// Kitten
53 /// Cat litter
54 /// Torn Curtain, 1966
55 /// Marcel Proust, In Search of Lost Time, Volume 1: Swann's Way, 1913
56 /// Roger Martin
57 /// Rotman School of Management, Toronto
58 /// Jon Kolko
59 /// Medea Malmö University
60 /// Sweden
61 /// Frog, Project M (Project Masiluleke), website

Since then, Bingaman-Burt has found opportunities to market and sell products that poke fun at the marketing, selling and buying of products. Now online as katebingamanburt.com, the web site offers opportunities to "shop & consume." Viewers are redirected to the online shop Etsy where they can buy Bingaman-Burt's line drawings of products. Her drawn documentation of purchases — from food to sunglasses to clothes to electronics — is now released as the book *Obsessive Consumption: What Did You Buy Today?*

An interest in 'true cost economics' has some designers questioning their part in capitalism, and wondering if design activity is part of a sustainable future, or part of its demise. True cost economics considers a product's complete lifecycle and ancillary impact, starting with design: from raw material acquisition to manufacturing, from packaging to distribution, from purchasing to usage, from consumption to waste and recycling, from regulations to laws. Environmental and social cost are part of true cost. In his book *Shaping Things*, Bruce Sterling put it this way: "A price as low as literally free can mean the economic equivalent of a free kitten — I may get a free kitten, but then I have to deal with the consequences, with no exit strategy." Besides cat food, litter and veterinary costs, Sterling might also be referring to torn curtains, scratched furniture and lost time.

Roger Martin, dean of the School of Management at the University of Toronto, has coined the term 'design economy' to describe the emerging corporate leveraging of design thinking and action. Surpassing past economies — agrarian, manufacturing, service, information — the design economy will harness the imagination, 'right brain' lateral thinking, problem-solving, the iterative process, and project-oriented efforts. As design itself demands a seat at the table of corporate decision-making, it makes sense that the business world wishes to think like designers.

Interaction designer and educator Jon Kolko is a progressive representative of the triad of business, design and education. Kolko served as entrepreneur-in-residence at MEDEA, a design-oriented research center for collaborative media at Malmö University in Sweden, where he addressed

issues of design synthesis and design's ability to solve 'wicked problems.' A leading proponent of 'social entrepreneurism' to tackle these problems, such as poverty, disease, low income housing, education and more, Kolko acknowledges the challenges of using conventional business models to do so. Regarding the AIDS prevention work done in South Africa by frog design's Project M, he states: "...despite the well-intentions of nearly everyone at the company, and despite the large-scale positive evidence that the work was actually doing what it was supposed to, and despite the massive and positive PR the company received, it was a simple question of economics. Frog — owned by a company named Aricent, which in turn is owned by a 'leading global investment firm with deep roots in private equity,' is expected to produce a certain amount of money every quarter. Project M wasn't making money, and while it wasn't losing money either, it simply didn't compare to the profitability of a large corporate engagement."

Because of the inter-relatedness of design with the economy, culture, society and politics, it is nearly impossible to recommend a comprehensive solution. But at least designers as authors — as producers, as entrepreneurs, as ... — are able to participate critically in the economy that uses their skills and creativity. Salvador Zepeda, a fellow with IDEO.org (THE NON-PROFIT SPIN-OFF OF THE GLOBAL PRODUCT DESIGN COMPANY IDEO) says, "Social entrepreneurs repurpose their professions to serve their lives, instead of repurposing their lives to serve their professions." Computer game developer and technology theorist Brenda Laurel takes this idea further with her 'utopian entrepreneur' concept, while acknowledging its challenges: "I'm not unaware that combining 'utopian' with 'entrepreneur' creates something of an oxymoron."

While entrepreneurial designers are initiating, producing and selling wonderful things that they have created for new markets, they are encouraged to consider the wider implications, or at least embrace the words taught to all medical doctors: 'First, do no harm.'

62 /// South Africa
63 /// Frog
64 /// Aricent
65 /// Salvador Zepeda
66 /// IDEO.org
67 /// Brenda Laurel

PORTFOLIO 2 (MAGAZINE) /// Alexey Brodovitch (ART DIRECTOR) /// 1950

DESIGNER STORIES THROUGH ENTREPRENEURIAL PUBLISHING

The idea THAT GRAPHIC DESIGNERS could, and would, tell their
own stories through their writing, designing, and publishing can be found throughout the twentieth century. Whether documentary, reflective, expressive, critical, self-promotional, comparative, or visionary, designers have harnessed the means of production to state their views in print — a concept and a practice that parallels most of the discipline's growth and maturity. Jan Tschichold's influential *New Typography*, published in 1928, Eric Gill's polemical book, *An Essay on Typography*, from 1931, and Willem Sandberg's *Experimenta Typografica* books, begun in the 1940s, are just a few early examples that illustrate how graphic designers and typographers have advanced their ideas through self-authorship.

On the intellectual heels of deconstruction, semiotics, conceptual art, and postmodernism, and enabled by new technologies for the creation, production, and distribution of designed artifacts, more graphic designers began to produce self-initiated work in the century's latter decades. A decade into the new century, designer-authored works are widely produced, at least by those with an enlarged sense of agency. In particular, graphic designers as entrepreneurs have published magazines and journals that advance their ideas to niche markets.

The publications being discussed have both macro and micro qualities, as discrete works show particular examples of design authorship, while an entire run of a publication or several publications together reflect how the larger themes of design authorship have evolved over time. All works position the graphic designer as subject (BY DESIGNERS) and object (ABOUT DESIGNERS), while the graphic designs that give their ideas tangible form are as integral to their messages as the literal words. After all, as scholar Gérard Mermoz asserts more generally in a Design Issues essay, "It would be far more productive if the subject of graphic authorship, superficially debated in/by the profession, were addressed in terms of its specifics — highlighting how specific designs work, at the levels of their graphical, semiotic, and ideological dimensions."

The works mentioned include the publications *PM* (later *A-D*), *Portfolio*, *Push Pin Graphic*, *Dot Zero*, *Octavo*, *Emigre*, *FUSE*, *Zed*, and *News of the Whirled*. Contemporary publications *Dot Dot Dot* and *Task Newsletter* are also germane to this chronology and are briefly analyzed too. Each publication is discussed with particular emphasis on its contribution to the concept of graphic designers'

01 /// Jan Tschichold
02 /// Jan Tschichold, Die Neue Typographie, 1928
03 /// Eric Gill
04 /// Eric Gill, An Essay on Typography, 1931
05 /// Willem Sandberg
06 /// Willem Sandberg, Experimenta Typographica #11, 1931

07 /// Gerard Mermoz
08 /// Design Issues, Spring 2006
09 /// Alice Twemlow
10 /// Rick Poynor
11 /// PM, No. 19, 1936
12 /// New York 1934
13 /// Dr. Robert L. Leslie
14 /// Herbert Bayer
15 /// Herbert Bayer, Alfabet, 1925
16 /// Gene Federico
17 /// Gene Federico, She's Got to Go Out, 1954
18 /// E. McKnight Kauffer
19 /// E. McKnight Kauffer, Soaring to Success, 1919

writing and designing of their own stories, their own histories. Names of major contributors have been cited because doing so expands the connections between design authorship and the designer's involvement with the broader discipline of graphic design practice, and because according to Alice Twemlow quoting Rick Poynor, it is a legitimate historical approach to credit "exceptional individuals."

Each work discussed below signals a shift in the ways graphic design is thought of, both in terms of documenting professional practice and in how culture, new technologies, and socio-political issues have informed the history of the discipline. Because ideas about graphic design authorship were emerging in the mid-1990s, and were being debated in *Emigre* and *Zed* in particular, the selection acquires an aspect of being self-aware from that point forward. That the earlier publications hadn't yet been labeled as works of design authorship does not diminish their contributions; rather, they establish a foundation for shaping subsequent discourse. The works have this in common: They all contribute to the historical narrative, in designers' voices, of how authorial practice has enlarged the discipline of graphic design.

PM, which stood for Production Manager, was first published in 1934 in New York City and defined itself as an "intimate journal" and a "non-profit, cooperative graphic arts magazine." Edited by Robert L. Leslie, *PM* published articles, reviews, and visual essays and also ran advertising. Its topics were primarily typography, printing, paper stock, art direction, illustration, and photography, which were aimed at an audience within the graphic arts trade, as evident in its title.

However, *PM* did change its name to *A-D* — Art Direction and/or Advertising Design — in 1940, to reflect the field's growing professionalism. *PM/A-D* published industry and professional news six times per year, until 1942.

The list of contributors to *PM/A-D* reads like a 'who's who' of mid-century American and European émigré graphic designers: Herbert Bayer, Gene Federico, E. McKnight Kauffer, William Golden, William Dwiggins, Cipe Pineles, Herbert Matter, and others. Editor Leslie is credited by Erin Malone with "spreading the ideals of European modernism to a generation of designers and art directors," and doing so with a "missionary zeal" according to Steven Heller in Baseline.

In *PM/A-D*, one encounters several elements of authorship beyond the typical neutrality of many graphic design trade magazines. The June-July 1939 issue advocated a boycott of "Nazi-made type

above /// **PM/A-D** (magazine) /// Robert L. Leslie (editor) /// 1934–1942
below /// **PORTFOLIO** (magazine) /// Alexey Brodovitch (art director) /// 1950–1951

above /// **PUSH PIN GRAPHIC** (MAGAZINE) /// Push Pin Studios /// 1957–1980
below /// **DOT ZERO** (PUBLICATION) /// Robert Malone (EDITOR), Ralph Eckerstrom (PUBLISHER), and Massimo Vignelli (DESIGNER) /// 1966–1968

EMIGRE (MAGAZINE) /// Rudy Vanderlans (EDITOR AND DESIGNER) and Zuzana Licko (TYPOGRAPHER) /// 1984–2009

faces" through the publication of a proclamation opposing "international fascism and all the barbarism and oppression inseparably identified with it...." From the August–September 1940 issue, critic Elizabeth Sacartoff titled her essay "Artist as Reporter," bringing to mind terms from the late 1990s like Ellen Lupton's "designer as producer," Steven Heller's "authorpreneur," and Denise Gonzales Crisp's "designist," which were proposed in the aftermath of the 'designer as author' term.

20 /// William Golden, CBS, 1951
21 /// William A. Dwiggins
22 /// W. A. Dwiggins, Layout in Advertising, 1948
23 /// Cipe Pineles
24 /// Cipe Pineles
25 /// Cipe Pineles, Seventeen, 1949
26 /// Herbert Matter
27 /// Herbert Matter, Swiss Travel Poster, 1936
28 /// Erin Malone
29 /// Steven Heller
30 /// Baseline Magazine, before and after
31 /// PM Magazine, August–September 1940
32 /// Ellen Lupton
33 /// Denise Gonzales Crisp
34 /// Alexey Brodovitch
35 /// Harper's Bazaar, February 1952
36 /// Frank Zachary
36 /// Napoleon

PM/A-D began as a trade magazine, but by showcasing progressive design and speaking out on political issues, it set the stage for subsequent publications. *Portfolio* was one such magazine.

Portfolio, art directed by Alexey Brodovitch (DURING WHICH TIME HE ALSO ART DIRECTED THE WOMEN'S FASHION MAGAZINE, HARPER'S BAZAAR), was published only three times between 1950 and 1951. Frank Zachary was its editor and is credited with corralling the magazine's writers, artists, and photographers. Primarily visual, and formally experimental with elaborate production values, *Portfolio* featured portfolios of design, illustration, photography, and calligraphy from established and emerging artists. Some articles covered historical topics, such as Napoleon's patronage of typographer Giambattista Bodoni, while others portrayed the work of contemporary artists and designers, such as Alexander Calder, Jackson Pollock, Charles and Ray Eames, Richard Avedon, Paul Rand, and Ben Shahn.

Portfolio's engagement with design authorship was through the process of commissioning, inviting, editing, and then exposing the content to Brodovitch's dramatic sense of space and structure. Its filmic pages provided an inventive format for others' works to interact with a master art director in a purely aesthetic context. "They demanded nothing from the reader but admiration," stated Richard Hollis in *Graphic Design: A Concise History*.

Portfolio has become coveted as a collectable design artifact. As a work of design authorship, it exudes a celebratory quality: virtuosity meets optimism, a form of design for design's sake. That it was published just three times signals its ideological success at the expense of commercial failure, as *Portfolio* did not accept advertising.

Taking the opposite approach, *Push Pin Graphic* did accept advertising and ran for 23 years. Published 86 times by Push Pin Studios (MILTON GLASER, SEYMOUR CHWAST, AND EDWARD SOREL) from 1957 to 1980, the bi-monthly *Push Pin Graphic* influenced a generation of American graphic designers through its humor and wit. Ostensibly published to promote the illustration, design, and photography of Push Pin Studios, the brochure-sized publication took on its own cultural life over time. Seymour Chwast was the editor and art director for many of the early years, eventually swapping the editor title for publisher. Paula Scher served as contributing editor for many issues and Ken Robbins edited a number of later issues.

37 /// Napoleon
38 /// Napoleon
39 /// Giambattista Bodoni
40 /// Alexander Calder
41 /// Alexander Calder, Yellow Sail, 1950
42 /// Jackson Pollock
43 /// Charles & Ray Eames
44 /// Charles & Ray Eames, Eames Lounge & Ottoman, 1956
45 /// Richard Avedon
46 /// Paul Rand
47 /// Paul Rand, UPS, 1961
48 /// Ben Shahn
49 /// Richard Hollis
50 /// Richard Hollis, Graphic Design: A Concise History (2nd Revised Edition), 2001
51 /// Seymour Chwast & Milton Glaser
52 /// Edward Sorel
53 /// Push Pin Studio
54 /// Paula Scher
55 /// Ken Robbins

Moving beyond its own promotional aspirations, *Push Pin Graphic* eventually began showcasing other artists, designers, and photographers. Colorful and idiosyncratic in an era of type and stripe Swiss modernity, the accessible *Push Pin Graphic* was a flag-bearer for pop culture. Recognizing *Push Pin Graphic*'s popularity in the New York-centric graphic design community, ads by printers, service bureaus, and type houses regularly appeared in the publication.

Theme-oriented issues during the 1970s — "Mothers," "Your Body and You," "New York at Night" — were vaguely topical, but the era's contentious debates about feminism, sexual politics, and marginalized subcultures were primarily referenced for their comic value. Later issues ventured further from typical graphic design concerns, with literary reprints such as "The Lottery in Babylon" by Jorge Luis Borges and "The Masque of the Red Death" by Edgar Allen Poe, which lent themselves as backdrops for Push Pin Studio's illustrations.

56 // Push Pin Graphic 64, "Mothers", 1976
57 // Push Pin Graphic 67, "Your Body and You", 1977
58 // Push Pin Graphic 68, "New York At Night", 1977
59 // Jorge Luis Borges, Ficciones, 1941
60 // Jorge Luis Borges
61 // Masque of the Red Death, 1964
62 // Edgar Allan Poe
63 // Seymour Chwast, The Push Pin Graphic, 2004
64 // The Push Pin Graphic, AIGA Exhibition, 2005
65 // New York New York, Las Vegas NV
66 // Ralph Eckerstrom
67 // Massimo Vignelli
68 // Jan Conradi, Unimark: The Design of Business and the Business of Design, 2009
69 // Robert Malone

Blending the promotional with the personal is possibly *Push Pin Graphic*'s main contribution to the ideas of designer-authored stories and histories. A newly published monograph, *Push Pin Graphic: A Quarter Century of Innovative Design and Illustration*, by Seymour Chwast, and a Spring 2005 exhibition of *Push Pin Graphic* at the American Institute of Graphic Arts gallery in New York attest to the magazine's continuing popularity. "A precursor to the self-published design zines and promotions that followed its lead, its historical significance is undeniable," states the AIGA web site.

Appearing almost anecdotal to *Push Pin Graphic*, *Dot Zero* was a quarterly publication out of New York City that was produced from April 1966 to Fall 1968 and that lasted only five issues. Published by Ralph Eckerstrom, and designed by Massimo Vignelli (THE TWO WERE CO-FOUNDERS OF THE DESIGN CONSULTANCY UNIMARK INTERNATIONAL), *Dot Zero* was interdisciplinary, modernist, intellectual, and analytical. Austere in its black and white reproduction, *Dot Zero*'s graphic vocabulary implied a high-browed seriousness and objectivity.

In *Dot Zero 1*, editor Robert Malone promised that the publication "...will deal with the theory and practice of visual communication from varied points of reference, breaking down constantly what used to be thought of as barriers, and are now seen to be points of contact." Making good on its claim, its pages were stages for the ideas of media theorist Marshall McLuhan, designer-artist Bruno Munari, economist John Kenneth Galbraith, design strategist Jay Doblin, and author Umberto Eco, among others.

In an introductory statement in *Dot Zero 1*, Herbert Bayer wrote, "*Dot Zero*... plans to assume an unattached attitude by starting from naught and freeing itself from the impediments of taking sides." Perhaps *Dot Zero*'s strict grids and uniform sans serif typography were intended to support this philosophy, while relying on the literal content of articles to express opinions and stake out intellectual territory. However, the graphic designer's role as neutral participant in the

above /// **OCTAVO: INTERNATIONAL JOURNAL OF TYPOGRAPHY** (PUBLICATION) /// Simon Johnston, Mark Holt, Michael Burke, and Hamish Muir (8vo) /// 1986–1992
below /// **FUSE** (PUBLICATION AND TYPEFACES) /// Neville Brody and Jon Wozencroft (EDITOR AND DESIGNER) /// 1991–2000 (ORIGINAL ISSUES 1–18)

70 // Marshall McLuhan
71 // Bruno Munari
72 // John Kenneth Galbraith
73 // Jay Doblin
74 // Umberto Eco
75 // Herbert Bayer
76 // Helvetica
77 // Dot Zero 1, 1966
78 // Dot Zero 2, 1966
79 // Dot Zero 3, 1967
80 // Dot Zero 4, 1967
81 // Dot Zero 5, 1968
82 // Octavo 86.1, 1986
83 // Octavo 86.2, 1986
84 // Octavo 87.3, 1987
85 // Octavo 87.4, 1987
86 // Octavo 88.5, 1988
87 // Octavo 89.6, 1989
88 // Octavo 90.7, 1990
89 // Octavo 92.8, package, 1992

process of shaping meaning through visual form has since been thoroughly contested. In *Dot Zero*, design authorship is evident less from what is said, and more from how it was said through its selection of typeface: Helvetica.

Octavo: International Journal of Typography elevated the modernist aesthetic of *Dot Zero* to high modernism. *Octavo* was published eight times by the British graphic design firm 8vO, Eight Five Zero, beginning in 1986 and ending in 1992. 8vO partners Simon Johnston, Mark Holt, Michael Burke, and Hamish Muir edited and designed the journal, which featured written essays and displays of visual materials. The editors stated: "…we take an international, modernist stance." A philosophy of typographic excellence, high quality production values, and a modernist typographic orthodoxy — small sans serif type, asymmetrical layouts, rectilinear grids, left justification — were the journal's signature. To quote one observer, a London College of Communication student, "Octavo had object quality; it informed and acted as a didactic model in itself."

Some issues explored a broad range of typographic topics, such as signs and information, and the history of lowercase letterforms. *Octavo 87.4*, however, is completely devoted to Wolfgang Weingart's 1972 lecture, How Can One Make Swiss Typography? This choice seems appropriate within the context of design-authorship, as Weingart's signature methodology extended beyond his own graphic works to the legions of designers he taught and influenced.

In the final issue of *Octavo* in 1992, a CD-ROM, its editors challenged: "Multi-media or multi-mediocrity and the baggage of the past?" The accompanying poster featured the pixelated type common to digital devices, perhaps as an acknowledgement to typography's shifting territory. Ironically, this shift was forecast by digital imaging pioneer April Greiman's poster and essay from *Octavo 86.1*.

As the primary influence that shifted typography's territory, *Emigre* magazine needs little introduction to the discipline's practitioners and scholars of the past two decades. An avant-garde publication that ushered in the era of digital design and typography, *Emigre* has been a forum for experimental designer-authored work from its first issue. Evolving over time from an eclectic and personal publication in the mid-1980s to one that defined the discipline's major debates about typographic legibility, deconstruction theory, semiotics and linguistics, aesthetics, and contemporary practice, *Emigre* influenced a generation of graphic designers.

Editor and designer Rudy Vanderlans and typographer Zuzana Licko were both designer-authors in the narrow sense, while the magazine and typefaces they created enabled their peers to have a voice in articulating a new vision for the field. In *Emigre 11*, devoted to graphic designers using the Apple Macintosh computer, a fundamental aspect of technology's influence on design-authorship is stated in the editorial: "Text, image, and layout all exist as manifestations of the same medium and the capability of simultaneously editing text and composing the layout will influence both design and writing styles."

Designing and using original Postscript type fonts was another opportunity for designers' messages to take on added meaning and personality. In this regard, Emigre was a pioneering digital type foundry, releasing numerous faces by the prolific typographer Zuzana Licko, as well as by many others, including Jonathan Barnbrook, Scott Makela, Barry Deck, and Sibylle Hagmann. This creative production allowed new messages to be given new forms — an early modernist credo now recontextualized, reconfigured, and remixed.

In *Emigre 35* and *36*, the "Mouthpiece, Clamor over Writing Design" issues, guest editor Anne Burdick expressed her interest "in the operations and uses of the material word — voice, presence, authorship,

90 // Simon Johnston
91 // Mark Holt
92 // Michael Burke
93 // Hamish Muir
94 // Student
95 // London College of Communication
96 // Wolfgang Weingart
97 // CD-ROM
98 // April Greiman
99 // Zuzana Licko and Rudy Vanderlans
100 // Apple Macintosh 1984
101 // Postscript v. Bitmap
102 // Sibylle Hagmann, Cholla, 1999
103 // Jonathan Barnbrook, Priori Acute, 2009
104 // P. Scott Makela, Dead History, 1990
105 // Barry Deck, Template Gothic, 1990
106 // Sibylle Hagmann
107 // P. Scott Makela
108 // Barry Deck
109 // Emigre 35, 1995
110 // Emigre 36, 1995
111 // Anne Burdick

ZED: A JOURNAL OF DESIGN (PUBLICATION) /// Katie Salen (EDITOR)(CENTER FOR DESIGN STUDIES AT VIRGINIA COMMONWEALTH UNIVERSITY, PUBLISHER) /// 1994–2000

above /// **NEWS OF THE WHIRLED** (MAGAZINE) /// Kenneth FitzGerald (EDITOR AND DESIGNER) /// 1997–2004
below top /// **DOT DOT DOT** (MAGAZINE) /// Stuart Bailey and Peter Biľak, and later David Reinfurt (EDITORS) /// 2000–11
below bottom /// **BULLETINS OF THE SERVING LIBRARY** (PUBLICATION) /// Stuart Bailey, Angie Keefer, David Reinfurt (EDITORS) /// 2011–present

112 /// Font Shop
113 /// Jon Wozencroft
114 /// Neville Brody
115 /// Floppy disk
116 /// Matthew Carter
117 /// Peter Saville
118 /// Phil Baines
119 /// Malcolm Garret
120 /// Tibor Kalman, Perverse Optimist, 2000
121 /// Rick Valicenti
122 /// Teal Triggs, member, WD+RU
123 /// Paul Elliman

ownership, agency...." Rudy Vanderlans' editorial from *Emigre 39* seems to cement the importance of the designer as author concept: "The only significant contribution introduced to graphic design in the last 10 years or so ... might have less to do with anything visual than with how design is produced and who it is produced by." *Emigre* has been central to the idea of graphic designers writing and designing their own histories through its provocatively inseparable form and content.

FUSE was first released in 1991 as an experiment in interactive digital typography. Whereas *Emigre* served to present and market its own typographic offerings through expressively functional use, *FUSE* pushed its type into the realm of pure aesthetics. Published by FontShop International, edited by Jon Wozencroft, and designed by Neville Brody, *FUSE* featured type designs by leading British and international typographers. Each issue consisted of a 3.5-inch floppy disk with digital fonts, four A2-sized posters showing the creative potential of the type designs, and an additional A2 sheet with an essay.

Occupying the territory between form and function, legibility and expression, and art and communication, *FUSE* investigated the borders of typographic expression and "[provided] a framework for a new way of looking at language..." stated Jon Wozencroft. Contributors of essays and type designs included Matthew Carter, Peter Saville, Bruce Mau, Phil Baines, Malcolm Garret, Tibor Kalman, Rick Valicenti, and WD+RU (Women's Design + Research Unit), among others, within the 18 issues of *FUSE*.

Summing up *FUSE*'s innovative approach to letterform design and its contentious role in rendering language visible, Paul Elliman wrote in a *FUSE* essay: "The problem remains that typography not only supports the artificial structuring of language, it exists for it." While many of the typefaces released by *FUSE* were examples of typographic innovation, they functioned less as useable alphabets and more as polemical statements on the nature of visual language. Its typographers' marks were designer-authored signatures, personal and abstract, and yet perhaps existing as the runes, cuneiforms, and hieroglyphics to the anthropologists and archaeologists of the future.

Zed: a Journal of Design that bridged the gap between education and design practice, was published seven times from 1994 to 2000 by the Center for Design Studies at Virginia Commonwealth University. Edited by Katie Salen, as well as various guest editors, *Zed* structured its content around themes such as Politics of Design, Design and Morality, and Public + Private in its quest "to identify and embrace the margins; to question, debate, and question again; to weigh the alternatives and consider the possibilities," said Salen.

In this regard it was intellectually wide-reaching, with written and visual essays by, among others, Tom Ockerse, Gunnar Swanson, Teal Triggs, Russell Bestley, and Diane Gromala. Topics ranged from technology to gender issues to semiotics, with graphic design as the connective tissue, both in content and in form.

A paperback book-sized journal, *Zed*'s covers often featured soft-focus photographic imagery printed in a single color. Interior spreads emphasized text that was highly readable while using contemporary type treatments and angular shaped text columns. One illustration by Jonathan Barnbrook used what appeared to be mono-width typewriter type in rendering the tonal likeness of England's Queen Elizabeth. On the page opposite, also set in typed characters that created larger letterforms, he declared: "The most successful parasites always make the body they are destroying feel that it needs them for its continued survival." A possible interpretation in this context is the role of the avant garde — including design authorship — to mainstream graphic design practice.

Unlike many publications, *Zed* held an open call for submissions so that opportunities for publication were based on merit, which gave emerging designers and academics a new voice. Because it purported to bridge the gap between design practice and education, having an element of peer-review was crucial to establishing the journal's academic credibility.

124 /// Runes
125 /// Cuneiforms
126 /// Hieroglyphics
127 /// Virginia Commonwealth University, Richmond VA
128 /// Katie Salen
129 /// Tom Ockerse
130 /// Gunnar Swanson
131 /// Russell Bestley
132 /// Diane Gromala
133 /// Queen Elizabeth II
134 /// Mosquito

However, academic credibility is not always the goal, even when a graphic design professor publishes — as *News of the Whirled* demonstrates. *News of the Whirled* has been the unconventional publishing venture of Kenneth FitzGerald and his creative project, Ephemeral States. Produced initially in 1997 (the first issue was featured in its entirety within *Emigre 41*), four issues of the publication have been printed, each in a single monochromatic color: blue, brown, green, and purple. Referred to by one detractor in the letters section of *NOTW 3* as "an aesthetic and self-referential object," *News of the Whirled* featured fiction, non-fiction, poetry, photography, visual compositions, and found content by FitzGerald and other contributors.

News of the Whirled did not distinguish between art, literature, and design as disciplines or as creative processes. Its vocabulary of complex forms, densely overlapping image-text compositions, and challenging typography seem appropriate for the publication's eclectic nature, its obscure references, and its multiple meanings and interpretations. FitzGerald preferred to use "arranged and produced" rather than edited and designed to describe his role in the magazine's production, a Gesamtwerk of design-authorship. FitzGerald described his work on *News of the Whirled* in this way: "It's the result of intricate plotting, improvisation, procrastination, time, and budget pressures. I still sabotage my desire for refinement with accident, and vice versa."

135 /// Kenneth FitzGerald
136 /// Emigre 41, 1997
137 /// Blue
138 /// Brown
139 /// Green
140 /// Purple
141 /// Emmet Byrne
142 /// Jon Sueda
143 /// Alex DeArmond
144 /// Werkplaats Typografie
145 /// Fred Troller
146 /// A Fred Troller cover design
147 /// Mike Figgis
148 /// Leaving Las Vegas, 1995, Mike Figgis, director and screenwriter
149 /// The AA Field Guide to the Birds of Britain and Europe, 1998
150 /// New York City MTA Bus

These publications present a chronology of materials that show a long-standing engagement with the ideas inherent in design authorship. Some of the publications are largely self-exemplifying, in that the designers were aware of their roles in expanding designers' voices and staking out greater intellectual territory. Discrete elements — a magazine spread, a typeface design, an essay — represent design authorship at the micro level, while larger aesthetic, social, cultural, political, and economic themes can be derived from strands at the macro and meta scales.

Contemporary designer-authored publications carry this legacy forward. *Task Newsletter*, the joint project of Emmet Byrne, Jon Sueda and Alex DeArmond, is in its second annual issue. "*Task Newsletter* ...uses design as a perspective, designed objects as evidence of larger systems, and designers as researchers. ...will be published once a year as a collection of thematic explorations and reports on topics of interest to our readers. ...is hard to describe as anything but 'in flux.' ...is a labor of love (/hate)," as proffered on tasknewsletter.com [ellipses in original text]. A small paperback book of 160 pages, *Task Newsletter #2* has modest production values: interior pages have narrow margins and are simply printed with black ink on newsprint-grade paper, while the cover is printed solely in blue ink. It was designed by DeArmond while at the Werkplaats Typografie in Arnhem, The Netherlands.

Unlike the design-driven focus of *Emigre*, *Zed* and *FUSE* for example, a trend of some contemporary designer-authored publications is to embrace content besides design, using what might be considered a non-aesthetic, conceptual approach. *Task Newsletter #2* takes on science fiction and futurism through essays, photographs and interviews. The issue is sub-titled Not What If — What If Not.

Dot Dot Dot No. Six lists its subjects on the cover as: "Graph. Des., Art, Lang., Lit., Mus., Film, Etc" — graphic design is best represented by an illustrated article about the modernist book cover designs of Swiss-born Fred Troller. An interview with film-maker Mike Figgis, an article and back page 'test' about synesthesia, and examples of field guides (TO BIRDS, TO NEW YORK CITY'S BUSES, AND MORE) shows the topical range of *Dot Dot Dot*.

Dot Dot Dot has been published 20 times over 10 years, with the last issue in 2011. The magazine was co-founded and edited by Stuart Bailey and Peter Bilák, with David Reinfurt eventually replacing Bilák in that role. The later issues were published by the Princeton Architectural Press, which claims the magazine is: "The must-read journal on every designer's desk, *Dot Dot Dot* covers design in the widest possible sense. Steering clear of both commercial portfolio presentations and impenetrable academic theory, it offers intelligent, passionate, and clever writing on the tangled web of influences that determine the shape of contemporary cultural production."

A new publication and conceptual project, the heir to *Dot Dot Dot*, has been launched. "*The Bulletins of The Serving Library* put pressure on traditional distinctions between art director, graphic design, editor and author, through the way Bailey and Reinfurt freely roam between these roles by editing both images and text, designing, and authoring many of the articles themselves," as stated in an *Eye* magazine review by Alex Coles. Coles' review, unlike the optimistic and over-reaching marketing rhetoric of the PA Press referring to *Dot Dot Dot*, says the *Bulletins of The Serving Library* have reached "the point of obscurity."

Obscurity might refer to the untethering of designer-authored publications from topics familiar to graphic designers. As design typically addresses subjects, businesses and disciplines beyond its own self-definition, perhaps this is appropriate. After all, *Push Pin Graphic*, *Dot Zero* and *Octavo* all ventured into foreign territory.

Allied disciplines are already adding further and deeper analyses of this convergence of designing, writing, editing and entrepreneurial publishing. Assessing the history of graphic design through the lenses of cultural studies, linguistics, anthropology, and other fields is poignant, relevant, and refreshing. Another viewpoint might, however, lead to this contrary proposal: that the story of graphic design — its trends and styles, its tools and techniques, its senders and receivers, its producers and consumers, which is to say, its history — is best told by its practitioners.

Most of these works, therefore, occupy a paradoxical position, akin to the Heisenberg Uncertainty Principle, which claims — in its loose, popular definition — that the act of observation alters the thing being observed. The questions become: does the self-awareness central to design authorship affect its history, one of simultaneously doing, being, and telling? How does one reconcile the hybridity of designing (the verb — action, production) with the design (the noun — artifact, system)?

The practical answer might be that designers have stories to tell, and possess the visual, literary and entrepreneurial skills to tell them — even if other designers are the primary market for their publications.

151 /// Stuart Bailey and David Reinfurt (as Dexter Sinister)
152 /// Peter Bilák
153 /// Princeton Architectural Press
154 /// Eye
155 /// Alex Coles

INTERVIEW: DOUG POWELL

Doug Powell is a designer, entrepreneur, strategist and profession leader. He is a founding partner of the creative consultancy Schwartz Powell, which is based in Minneapolis, USA and focuses on the health and nutrition sector. Powell is the current president of the AIGA, America's professional association for design. He publishes his thoughts on the web blog Merge, a "conversation on the new ways designers are working."

MCCARTHY You've taken design authorship into two distinct realms. The first is the 'designer as entrepreneur' with the creation, community-building, marketing and eventual sale of your online diabetes tool HealthSimple. The second, as AIGA president, the 'designer as agent of social change' through your Design for Good initiative. How are the business concerns of an entrepreneur compatible with the desire for using design for social change?

POWELL I think these two issues are not only compatible but interdependent. We must recognize that in order to have impact as agents of social change, designers must also learn how to build our creative visions into solid, viable, scalable business ventures. Regardless of whether these ventures are expressed in the for-profit or non-profit realm (OR SOME HYBRID OF THE TWO), we must get better at taking our ideas out in the world. This is an extremely complex process that requires a discipline and a set of skills that most designers don't naturally possess — and most of us are not formally trained in — so that means we need to align ourselves with individuals and organizations who can help coach us through the process. It will require most designers to significantly expand their professional network. One of the explicit objectives of AIGA's Design for Good is to provide opportunities and support for designers to participate in building a social change idea into a viable business concept through hands-on experiences.

When you and I started our careers in the 1980s, designers largely had a passive relationship to content — it was usually supplied by a client with very specific ideas about 'what was said' and 'to whom it was said.' The client's payment bought designers' complicity in this position, one of reaction rather than proaction. Although this still exists as a dominant model, why has this proactive approach changed aspects of the profession?

I think most of us who "grew up" in that professional setting realized that we had more to contribute to the outcome than simply developing

01 /// Doug Powell
02 /// Merge
03 /// AIGA, Design For Good
04 /// The 1980s
05 /// Target
06 /// Target
07 /// Apple
08 /// Apple
09 /// William Tell

HEALTHSIMPLE (MATERIALS) ///
Doug Powell (SCHWARTZ POWELL DESIGN, INC.) ///
2005

a creative expression for someone else's content solution. We began challenging our clients to allow us into the process at a deeper level — at a level that would enable us to influence content as it was being developed. Gradually we saw some case studies of designers having an impact beyond just aesthetic presentation. Now we see some of the most successful organizations in the world embracing design as a core strength and asset — I'm thinking of Target, Apple, and now many of the auto companies to name just a few. Defining the value of design and the designer's role is difficult to do in strict business terms, and of course that is how most organizations operate. Designers must continually refine our articulation of this value.

How might the goals of positive social change (reduced poverty and crime, better and less expensive education, a more equitable economy, a sustainable environment, improved personal health, more affordable health care, civil rights, and so on) align with the growth model of free-market capitalism?

This is the million (OR BILLION) dollar question. One of the areas I think we will see this play out most profoundly is in sustainable energy. We are clearly in a crisis mode and it is becoming clear that we can no longer depend on the traditional sources to support our usage habits (I.E. MIDDLE EASTERN OIL). We are on the front end of wave of entrepreneurial activity that will transform that category, and hopefully provide a case study and roadmap for other industries.

To play devil's advocate a little, is there a danger that 'social good' might be perceived by some as similar to 'socialism' and be anathema to the market-driven goals of entrepreneurial design?

I'm not hearing this specific concern within the design community. There are other voices of dissent around the issues of design colonialism and helicopter activism, i.e. mostly western (AND MOSTLY WHITE) designers descending into the troubled developing world with their brilliant creative ideas, generating some buzz and winning some awards, and then abandoning the issue. This is a pattern we must guard against. The value of social design work will ultimately be judged by long-term, sustained, meaningful results and impact. It will take a significant commitment to achieve this.

Thank you!

INTERVIEW: RICK VALICENTI

Rick Valicenti is a Chicago-based graphic designer working in print and interactive media. The firm he founded, Thirst, primarily serves clients in the design, architecture and cultural sectors. Valicenti also creates speculative projects, for personally expressive reasons or for causes he feels strongly about. Valicenti has received major awards for his creative work, and it is in several institutional collections. He has edited the book Emotion as Promotion about Thirst's work.

MCCARTHY My first exposure to your work was from an article in *Eye* magazine that I bought in London during the summer of 1992! Since then, you've impressed me as someone who enjoys stimulating the discipline of graphic design through your various provocations. How do you balance Thirst's professional, client-based work with the experimental projects, the studio's constant reinvention, and the self-initiated designs you also produce?

VALICENTI In essence it is easy... I have created a studio environment that encourages curiosity and a 'researched or making' response to it by those who are both interested and interesting. The investment in this time has shown to be equitable as the results usually inform commissioned opportunities that follow.

Your years of work for Gilbert Paper seemed so symbiotically collaborative that it was almost like they were your creative sponsor, rather like the Medici family was to Leonardo da Vinci. How did you meld form and content, design and authorship, in that relationship?

I was blessed to have the professional and personal pleasure to serve four presidents and three marketing people at Gilbert and ultimately at Fox Paper after the acquisition. We all belonged to our own little chapter of the mutual respect club and knew that that if it worked for us, it was going to work in the market place — it did. As for melding the content and the creativity, it was easy, as at the end of the day it reflected the rich, un-selfish collaboration between design and the client — who at the end of the day was more patron to the profession than most at that level. After the sale to Neenah Paper, we still remain in contact and long for the glory days which we all know were special, special, special!

01 /// Rick Valicenti
02 /// Rick Valicenti, Emotion as Promotion: A Book of Thirst, 2005
03 /// Eye 6, 1992
04 /// Rick Valicenti, Gilbert Paper promotion, 1995
05 /// Gilbert Paper
06 /// Lorenzo de'Medici
07 /// Leonardo da Vinci
08 /// Fox River Paper
09 /// Neenah paper

10 /// Rick Valicenti, Suburban Maul, 2003
11 /// Greg Lindy Lux Sans, 2003
12 /// Cindy Ann Bader and Greg Lindy
13 /// Daisy
14 /// Orchid
15 /// Thank you

Your self-published book *Suburban Maul* (2003) was a critique of suburban sprawl, ostentatious consumption and national chain brands. Why was this booklet produced?

It was simultaneously a design commentary and a vehicle to promote as well as test a new typeface called LUX designed by Greg Lindy. I believe it is possible to serve both marketing and research commentary simultaneously. There are only three types of messages for communication designers to be engaged in: one, messages about value (ON SALE NOW! OR ENGINEERED FOR PERFECTION); two, messages of value; and three, messages of no value. Only designers can decide for themselves where they want to assign and employ their gifts of time and talent. In my case, I find both in short supply so it is best to make one project do all the things I need to do at that moment.

You've taken design authorship to the level of the performance. Once you spoke at a student design conference in Chicago with a daisy in one hand and an orchid in the other to make a point about beauty and aesthetics. How is being a designer as performer a form of authorship for you?

Whether one is communicating in person or through the medium of design, the most meaningful component to the experience is the artifact of real human presence. In my case, being me is easier than being someone else and so it should be for all of us.

When communication designers are asked to do communication design, it is practically impossible for them to be invisible if they are truly engaged in the content and the expression. Our personal sensibilities related to everything from words and pictures, color to media, are all a result of who we are. And it is the 'who we are' that impacts the 'what we do.'

Any final thoughts on the notion that design authorship has transformed graphic design?

I am not certain that authorship has transformed design, but is has awakened designers to the possibilities of engagement and their potential within the process we call design.

Thank you!

above /// **MEDIA PRODUCTION CENTER** (COLUMBIA COLLEGE, CHICAGO)(INTERIOR) /// Rick Valicenti and John Pobojewski (3ST) /// 2010
below left /// **SHOWBOAT** (LYRIC OPERA, CHICAGO) (POSTER) /// Rick Valicenti (3ST) /// 2010
below right /// **FUTURE HAUS** (GRAPIC ARTS STUDIO) (POSTER) /// Rick Valicenti and John Pobojewski (3ST) /// 2012

SHOW BOAT MUSIC BY JEROME KERN BOOK AND LYRICS BY OSCAR HAMMERSTEIN II
BASED ON THE NOVEL "SHOW BOAT" BY EDNA FERBER **LYRIC OPERA OF CHICAGO**

DESIGNINQUIRY: DESIGNLESS (WORKSHOP, VINDALHAVEN, MAINE) /// 2009

COMMUNITY DESIGN AUTHORSHIP

195

A common FEATURE to all design disciplines is the 'feedback loop.' At appropriate stages in the iterative process of design, feedback from clients, end-users, colleagues and production engineers is crucial to a design being shaped toward its target. Earlier in the process, feedback is typically more conceptual, focusing on broader themes and indicative of lateral thinking. As the design becomes more refined, through functional prototypes for example, feedback concerns become more specific: details, details, details.

Design authorship is now being acted out at the level of the community, with feedback — in the form of participation – being an important aspect. The terms 'co-design' and 'participatory design' refer to the idea of users being invited into the design process as co-authors. While one end of the user-as-designer spectrum is very limiting — merely filling in a pre-determined template, for example — the other end is a rich involvement with content and form.

In the summary for his presentation "On Relational Design" given at a University of Minnesota symposium on product design, Andrew Blauvelt stated: "This talk will look at how six themes — the birth of the user, the democratization of design, the rise of open systems, the preoccupation with context, the power of many, and the rise of the social — conspire to create a paradigm shift in how designers design today. Such designs explore the contingent situation, are highly conditional, embrace open-ended processes, and seek relational connections: all of which extend beyond the artifactual culture of modern design."

Instead of creating fixed artifacts of design (FURNITURE, ELECTRONIC PRODUCTS, PUBLICATIONS, POSTERS, WEB SITES AND SO ON), much participatory design concentrates on the process and on the system. Flexibility, modularity and inclusivity are valued in this approach. Bottom-up emergence is preferred to top-down imposition, often enabled by technological tools like social networking, user-uploaded content web sites and smart phones with myriad 'apps.' To crowd-source is to draw from the collective wisdom and creativity of users — globally and locally. A new term has been coined for this: 'glocalization.'

Design 21: Social Design Network is an organization that does this, in partnership with UNESCO (UNITED NATIONS EDUCATION, SCIENTIFIC AND CULTURAL ORGANIZATION). They state: "We believe the real

01 /// Andrew Blauvelt
02 /// University of Minnesota, Minneapolis MN
03 /// Smart phones
04 /// Design 21
05 /// UNESCO

06 // Milton Glaser
07 // Art Directors Club (before)
08 // Art Directors Club (after)
09 // Mark Randall
10 // James Victore
11 // Elizabeth Resnick
12 // Pieter Spinder
13 // Knowmads
14 // Moveon.org
15 // Bush in 30 Seconds, best animated ad
16 // George Bush
17 // Scott Stowell
18 // Fast food

beauty of design lies in its potential to improve life. That potential first manifests itself as a series of decisions that result in a series of consequences. The practice of social design considers these decisions on a greater scale, understanding that each step in the design process is a choice that ripples out into our communities, our world and our lives. These choices are the result of informed ideas, greater awareness, larger conversations and, most importantly, the desire to do good. Social design is design for everyone's sake."

Design 21 hosts design competitions for non-profit organizations that invite submitters to create work that is voted on by their peers. This method is democratic, inclusive, and through the use of the Internet, broadly distributed. Some might argue, however, that the feedback loop is more akin to a one-way popularity contest than employing the 'best practices' of the iterative design process.

'Designism,' a term attributed to American graphic design icon Milton Glaser, has been a series of symposia sponsored by the Art Directors Club of New York. Its topic has been the instigation of social change, as largely expressed through notable design figures — Mark Randall, James Victore, Elizabeth Resnick and so on — sharing their experiences and ideas with the goal of influencing others.

Social design, especially at the level of the community, makes design authorship a shared endeavor — it is shared at the point of creation and at the point of dissemination. While lacking a client in the conventional sense of a paid commission, many social design opportunities do have a specific problem they are trying to solve or a specific audience they are targeting. In the case of an actual client commission, Pieter Spinder, 'firestarter' of the experimental Dutch design school Knowmads, claims that his students "design with, not for clients."

In the American election year of 2004, MoveOn.org sponsored "Bush in 30 Seconds," a short video contest critiquing the presidency of George W. Bush. Over three hundred videos were submitted. Pop Quiz, the clever and engaging typographic entry by Scott Stowell and colleagues, is a compelling example of this. Clearly, Pop Quiz had a rhetorical mission to unmoor Bush from the presidency — it was done with urgent pacing, facts (THE SOURCES WERE CITED), and humor. Many of the videos were not as memorable as Stowell's, but still, they represent the emergent participation of content-creators with points of view.

The phenomenon of populist participation in design authorship leads to questions. Is there danger in too much user participation? Is there a chance that the lowest common denominator, or a regression towards the mean, will average everything out? Could a bland design mono-culture, similar to the fast-food industry, develop? Will the value of design as a distinct creative and intellectual endeavor cease to be? Will a 'like' response from many be superior to a reflective and insightful critique from one?

Q: WHO PROMISED $400 BILLION FOR MEDICARE AND THEN BUDGETED ONLY $40 BILLION?

SOURCES: speech 1/29/03 vs. Federal Budget 2004

A: GEORGE W. BUSH.

Q: WHICH U.S. PRESIDENT LOST MORE JOBS THAN THE LAST 11 PRESIDENTS COMBINED?

SOURCE: Bureau of Labor Statistics

A: GEORGE W. BUSH.

Q: WHAT'S WRONG WITH THIS PICTURE?

A:

above /// POP QUIZ (moveon.org's bush in 30 seconds entry)(video) /// Scott Stowell (open, ny) /// 2004
below /// THE 1000 JOURNALS PROJECT (distributed journals) /// Brian Singer (aka "someguy") and various participants /// 2000–ongoing

THE 1000 JOURNALS PROJECT (DISTRIBUTED JOURNALS) /// Brian Singer (AKA "SOMEGUY") and various participants /// 2000–ongoing

The 1000 Journal Project is an optimistic answer to some of these questions. Put into world circulation to invite collaboration and sharing of stories, thoughts and feelings, the journals are passed from person to person, reminiscent of the surrealist parlor game 'the exquisite corpse.' The journals are completely analog with hand-written text, collage elements, drawings, photographs and other inclusions. The 1000 Journal Project has aspects typically associated with new media: it is distributed across a network, involves linking, is interactive, is non-linear, is time-based, and it presents opportunities for anonymity or publicly declared disclosures.

The project's web site, 1000journals.com, explains: "Launched in 2000 by the San Francisco based artist 'Someguy,' the journals have reached over 40 countries and every US state. They've come to rest in hostels, cafes and law offices; been the subject of treasure hunts; brought to remote mountaintops; abandoned at airports and stolen at gunpoint."

One journal reveals powerful and yet humorous writing: "Here we are living in this fucked up world, riddled with violence, terrorists, materialism, ignorance, and stupid Christmas sweaters." Others' entries are more quotidian: "Well let me tell you a little bit more myself. I'm 16 (today is actually my Birthday. I'm a typical teenage girl, who regrets eating mcdonalds, but not really because its my BIRTHDAY!!!" Images are also touchingly varied: cartoons, illustrations by talented hands, torn paper collages, water-colorings and more. One participant included her URL — http://www.lynnerees.co.uk — which led to her site The Hungry Writer, featuring "Lynne Rees on food, memory and writing, with recipes, stories and writing prompts." In this regard, an analog journal led to a digital extension; as 'memory and writing' are the stuff of journals, this seems appropriate.

Not all of the world-traveling journals have returned to Someguy. Perhaps because of their personal, tactile and original character, these works of community design authorship continue to roam, or have found new homes.

19 /// The world
20 /// Victorian parlor game
21 /// Exquisite corpse
22 /// San Francisco CA
23 /// Someguy
24 /// Hostel, 2006
25 /// Cafe
26 /// Law office
27 /// Treasure
28 /// Remote mountaintop
29 /// Airport
30 /// Gunpoint
31 /// Christmas sweater
32 /// Lynne Rees

33 /// Slow Food
34 /// James Victore
35 /// Brooklyn NY
36 /// Dinner
37 /// Cash
38 /// Margo Halverson
39 /// Peter Hall
40 /// Melle Hammer
41 /// Vinalhaven Island ME

Besides community design authorship existing at the level of design creation, online tools for sharing and commentary have become prevalent. Design-related web logs, or 'blogs,' proliferate, with user comments often surpassing the original post in quantity, and on occasion, quality. Furthered by hyperlinking, these blogs and their commentators are participating in a new form of journalism, where the distinctions between content, medium, designer, author and reader are increasingly blurred.

In this context, feedback loops overlap with new iterations in a dizzyingly quick and responsive way. Speed, however, sometimes sacrifices critical depth — perhaps this is why blogs and books will peacefully co-exist as viable media for design authorship. As a reaction to the virtual nature of social interactions online, some designers host real-time, real-place events to create community within the analog world — think: 'the Slow Food Movement meets design.'

James Victore Presents: The Dinner Series is one such program. The week program is a blend of daily 'nine to five' design workshops at Victore's Brooklyn, New York studio followed by elbow-rubbing with "premier designer, artist, author or film maker" guests over a celebrity chef meal in the evening. The Dinner Series is limited to eight participants, but the $6000 fee, which does not include hotel or travel to New York, might be its biggest limitation.

Design Inquiry, now in its ninth year, offers an alternative model for design community-building.

The organization's web site states: "DesignInquiry is an alternative to the one-way delivery of a standard conference: each participant contributes and is equally responsible for the quality of the gathering; a collaborative production where we both learn and teach the aesthetics and ethics that are central to Design (AND LIFE). Days become nights; the program doesn't stop when dinner is served."

Founded by Margo Halverson, Peter Hall and Melle Hammer, Design Inquiry is immersive, collaborative, egalitarian, topical, experimental and, due to a selective application process based on the merit of proposals, intellectually rigorous. Their publication Design Inquiry Journal documents the event's concepts and creative production and shares it with the larger design community. The event is held in Vinalhaven, Maine, USA, an island on the Atlantic coast, and costs $900 for the week, which includes food and lodging.

Besides community design authorship existing in virtual and social environments, public installations reach viewers in the actual environment. Ranging from monumental to intimate in

scale — architectural elements to eye-level stickers — works in the public domain compete with advertising and transportation signage to attract the attention of passers-by. The relationship of the design to its site is crucial for balancing the message with its location, which is to say its context.

Portuguese firm R2 Design achieved notice with a self-initiated project when it installed religious expressions on the exterior wall of a former church in Lisbon, now a secular art gallery. The three-dimensional, white-on-white letterforms seem to recast the echos of prayer fragments back at society as clichés: 'oh my God,' 'go with God,' and many others. The installation of the sayings can be seen as historical, as heretical or as whimsical — R2 Design shows how they are woven into the cultural fabric of contemporary Portugal.

The notion of community in design authorship is complex and subjective. Some large-scale collaborative works like professional blogs and magazines require the specialized participation of many: designers, writers, editors, programmers, developers, publishers and more. Other communities are looser networks of shared interests, like typography, branding and book-binding. All approaches contribute to the idea of sharing, interacting, commenting and collaborating as a diffusive form of design authorship.

42 /// R2 Design (Lizá Defossez Ramalho and Artur Rebelo)
43 /// Portugal
44 /// R2 Design, Vai com Deus/Go with God, Lisbon, 2008
45 /// R2 Design, Vai com Deus/Go with God, Lisbon, 2008

below left /// VINYL BOAT LETTERING: DESIGNINQUIRY: MAKE/DO EXHIBITION (WORKSHOP, VINDALHAVEN, MAINE) /// 2011
below top right /// TIM VYNER'S "ENDLESS SKETCHBOOK": DESIGNINQUIRY: DESIGN CITIES (WORKSHOP, MONTRÉAL) /// 2011
below bottom right /// PANCAKES, BACON AND TYPOGRAPHY: DESIGNINQUIRY: FAIL AGAIN (WORKSHOP, VINDALHAVEN, MAINE) /// 2008

above /// **FORMS OF INQUIRY: THE ARCHITECTURE OF CRITICAL GRAPHIC DESIGN** (INSTALLATION VIEW)(IASPS, STOCKHOLM) /// 2008
below /// **FORMS OF INQUIRY: THE ARCHITECTURE OF CRITICAL GRAPHIC DESIGN** (INSTALLATION VIEW)(ARCHITECTURAL ASSOCIATION, LONDON) /// 2007

CURATING DESIGN AUTHORSHIP 203

Design AUTHORSHIP is often considered at the micro-level as graphic designers produce discrete works with an enlarged sense of agency. Whether publications, posters or interactive media, these artifacts position the designer as having a greater role in the communications paradigm, thereby enlarging the cultural, economic and political spaces for design activity.

Designer-authored works are occasionally brought together into themed exhibitions, as curators cast this work into new contexts. Additionally, acting as meta-authors, some curators produce design authorship at the level of the conceptual exhibition. Examples of both approaches are examined here: the exhibit of, and the exhibit as, design authorship. Both create community through inclusiveness and collective participation, and because exhibits are public events, they invite design's broadest users to consider authorship's influence.

The dual nature of the curator as meta-author is explored through eight exhibition case studies. These studies show the variety of ways in which traditional distinctions of subject (BY DESIGNER) and object (ABOUT DESIGNER) are becoming blurred and dynamic.

Exhibition curators establish themes for shows and gather the necessary artifacts to achieve conceptual cohesion. Often, works are selected from existing collections, borrowed from others' archives, invited from afield ('CALL FOR ENTRIES'), or even commissioned. The aim, usually, is to have the works contribute to a certain curatorial idea. This is generally supported with the exhibit's design and installation, supplemented with didactic or explanatory texts and furthered with promotional materials and a documentary catalog.

In art and design exhibitions, the curatorial act can be quite authorial in the sense of desiring intellectual ownership and establishing the relationship of the work to the viewer. In this meaning the term 'authorial' is subjective and intentional, even polemical. Exhibits of design authorship — while relatively new, and few — offer additional challenges and opportunities.

The American Center for Design's 100 Show competition from 1992 is an early precedent of curatorial meta-authorship that deserves acknowledgement. Although primarily known as a publication rather than an exhibition, the show's selection process bears relevance to this topic. Show chairperson Katherine McCoy invited Lorraine Wild, Bruce Mau and Rick Vermeulen as jurors, but empowered them to make their own selections as curators. Rather than voting or arriving at bland consensus, with opposing views potentially canceling each other out, McCoy defended

01 /// American Center for Design
02 /// American Center for Design 100 show catalog, 1992
03 /// Katherine McCoy
04 /// Lorraine Wild
05 /// Bruce Mau
06 /// Rick Vermeulen

07 /// This author, Steven McCarthy
08 /// Cristina de Almeida
09 /// Johanna Drucker
10 /// Johanna Drucker, History of the/my World, 1990
11 /// Daniel Jasper
12 /// Michael Bierut
13 /// Michael Bierut, Rethinking Design, 1992
14 /// Mohawk Paper
15 /// Maria Rogal
16 /// Martin Venezky
17 /// Martin Venezky, Speak, 2001
18 /// Ellen Lupton
19 /// Abbott Miller
20 /// Rudy Vanderlans
21 /// Katie Salen
22 /// Anne Burdick

their results as being biased and "...intentionally opinionated, uncovering new and significant work that the field of graphic design might not otherwise see." As one might expect, many of the individual works chosen had an increased sense of agency with evidence of the designer's expanded voice.

While individual projects represent the act of creation at the micro level, and series or bodies of work at the macro, this section is concerned with the next scale of design-authorship: the curated exhibition as an act of meta-authorship. Although the exhibit Designer as Author: Voices and Visions, co-curated by this author and Cristina de Almeida, was the first to directly address the concept (DA:VV 'CALL FOR ENTRIES' 1995, EXHIBIT 1996), a number of exhibits have since been mounted that show works of design authorship, or to position themselves as works of design authorship.

The call for entries for DA:VV asked for the works of designers who:

/// are as involved as thoroughly with literal content as they are with visual form
/// pose problems and questions as readily as they seek solutions, and use graphic design as a tool of investigation
/// are adept at using words, both typographically and for literal or poetic expression

Also inviting works from writers and editors, the call continued, seeking work from those who:

/// use type in ways that amplify meaning or adds a commentary on their writing
/// work graphically across disciplines, perhaps borrowing from art, language, technology, psychology, politics or literature

Because the organizing concept of DA:VV was neither design style nor design medium, the works juried into the exhibit had a range of visual and literal approaches. The artist's book *The History of the/my World* by Johanna Drucker, Daniel Jasper's anti-consumerist posters, Michael Bierut's *Rethinking Design* books for Mohawk Paper, Maria Rogal's visual critiques of women in advertising, and Martin Venezky's art direction of culture magazine *Speak* sat side-by-side. More prominent figures in the emerging field of design authorship, such as Ellen Lupton, Abbott Miller, Rudy Vanderlans and Katie Salen were displayed in DA:VV with lesser known, but still forward-thinking practicing graphic designers, faculty and students.

above /// **RETHINKING DESIGN** (BROCHURE SPREAD) /// Michael Bierut (DESIGNER, EDITOR), P. Scott Makela (SPREAD DESIGNER)(MOHAWK PAPERS) /// 1992
below left /// **PINK** (POSTER IN AND SHE TOLD 2 FRIENDS EXHIBITION) /// Sheila Levrant de Bretteville /// 1973
below right and bottom /// **AND SHE TOLD 2 FRIENDS** (CATALOG) /// Kali Nikitas (MICHAEL MELDELSON BOOKS) /// 1996

above /// **SOUL DESIGN** (CATALOG) /// Kali Nikitas, Soul Design works from upper left Robin Cottle, Jan Jancourt, Michael Kippenhan /// 1999
below /// **SOUL DESIGN** (INSTALLATION)(OSLO, NORWAY) /// 1999

Anne Burdick, guest editor of the *Emigre* Mouthpiece: Clamor Over Writing and Design issues, then a visiting faculty member at North Carolina State University, gave the keynote address at the DA:VV exhibit opening. Her lecture was a critical commentary on authorship, as her entire talk was woven together from the texts of others, which was disclosed at the end.

There have been numerous exhibits of artists' books, wherein text, image and reproduction technologies converge in expressive book-forms, and a plethora of exhibits and publications featuring commercial graphic design. The examples of important design authorship exhibits over the past two decades are far fewer in number. While this is not an exhaustive chronicle, some of those exhibits are discussed below.

The two primary approaches to curating such exhibits are: shows that feature works of design authorship (such as DA:VV), and shows in which the concept and organizing principle of the exhibit itself is a work of design authorship through the meta act of curating.

23 /// North Carolina State Wolfpack
24 /// Kali Nikitas
25 /// United States
26 /// Netherlands
27 /// Great Britain
28 /// Malaysia
29 /// Woman Made Gallery, Chicago IL
30 /// Linda van Deursen
31 /// Sheila Levrant de Bretteville
32 /// Lucille Tenazas
33 /// Irma Boom
34 /// Marlene McCarty
35 /// Dutch post office
36 /// Children's book
37 /// Dog

In 1996, designer educator Kali Nikitas invited two friends to each invite two others, and so on, as this particular "exhibit curated itself." *And She Told Two Friends* featured the work of women designers from the United States, The Netherlands, Great Britain and Malaysia, and was initially exhibited at the Woman Made Gallery in Chicago. The participants were a roster of influential design practitioners and educators: Katherine McCoy, Lorraine Wild, Linda van Deursen, Sheila Levrant de Bretteville, Ellen Lupton, Lucille Tenazas, Irma Boom, Marlene McCarty, Women's Design + Research Unit and others. Although most of works exhibited were not created with the notion of design authorship per se — many were client commissions — most of the projects were infused with a high degree of agency.

Nikitas' unique curatorial angle made *And She Told Two Friends* an original and innovative project. Tied to modes of communication and relationships in feminist networks, the exhibit was cohesive in spirit while being diverse in the work included. Postage stamps for the Dutch Post Office, a children's book, a typeface made from dog feces, and cultural posters all occupied the same conceptual territory. The exhibit was accompanied by a catalog that illustrated the work and included brief written passages explaining each friend's selection, and short

38 /// Johanna Drucker, The Next Word
39 /// Neuberger Museum of Art, Purchase NY
40 /// State University of New York
41 /// SUNY News Pulse
42 /// Yale, New Haven CT
43 /// Zuzana Licko
44 /// Font Bureau
45 /// Pedestal
46 /// Perimeter
47 /// Minneapolis, MN
48 /// Oslo, Norway
49 /// Arthur Redman
50 /// Rob Dewey

descriptions of the work itself. As an exhibit, *And She Told Two Friends* embodied the idea of the designer as author as curator. It was greater than the sum of its parts.

The exhibit's accompanying catalog documents the designs in the show with images and descriptive captions and features paragraph-length biographies; and — perhaps most telling — each friend wrote brief statements justifying their two chosen friends. Anne Burdick's blurb about inviting the WD+RU lauds the collective because "they refuse to keep quiet," especially on issues of gender equity, and ends with "Right on, sisters."

The Next Word: Text and/as Image and/as Design and/as Meaning was curated by Johanna Drucker and displayed at the Neuberger Museum of Art at SUNY Purchase (State University, New York), in the Fall of 1998. It included "visual art, artists' books, visual and concrete poetry, graphic design and new media by artists, poets and Web-based designers," according to the SUNY *News Pulse*. The media in the exhibit ranged widely, and reproduction technologies were emphasized as having a direct relationship to the act of creating visual/verbal narratives: handwriting, digital typography, collage, painting, letterpress and offset printing, and designing for the computer screen.

Many of the of the works in *The Next Word* were artists' books — possibly reflecting Drucker's own work in that medium — and other works that seemed to value self-expression. A couple of exceptions included the work of the Yale University graduate student collective Class Act, whose work tackled social and political themes, and the digital type designs of *Emigre*'s Zuzana Licko and Font Bureau, which were entrepreneurial projects.

In her catalog essay, Drucker wrote: "Books, visual poetry, fine art, and design are rarely exhibited within the same environment. This is often the result of logistical considerations since each activity has different audiences and poses different challenges to a curator."

The Next Word fits the model of an exhibit that brought disparate works of design authorship together, using the concept of designers and artists using words literally and of writers and poets using words visually. As an accomplished designer/artist who writes and an accomplished writer who designs, Drucker's exhibit was an extension of her own creative persona.

Soul Design, another curatorial project by Kali Nikitas, was produced in 1999. Eighteen graphic designers were invited to create tabloid-sized designs in response to the theme of honoring someone important to them personally. Bound only by the theme — which provided room for interpretation — the paper size, and a single color of ink, the designers created deeply personal, eclectic

designs that reached across the human condition. In this regard, the designed response to the curatorial brief was one of intention: the visual/verbal result addressed the theme in the way that a commercial project aims to satisfy a client's wishes.

The designs were printed on individual sheets in a press run of one thousand, and displayed in tidy stacks on knee-high pedestals around the gallery's perimeter. Viewers, initially in Minneapolis, USA and subsequently in Oslo, Norway, were encouraged to take copies of each print, dispersing the show's contents into the public realm. A catalog featured the designs along with explanatory texts, and an essay by Arthur Redman titled "On Balancing Individualism and Commitment to Community." A brief conclusion by the catalog's editor Rob Dewey stated, "Given the limited forums for discourse within the professional culture of graphic design, more and more designers are taking it upon themselves to initiate projects such as this exhibition to address critical issues."

51 /// Michael Worthington
52 /// Ed Fella
53 /// Nancy Skolos
54 /// Grandfather
55 /// Jan Jancourt
56 /// Alexei Tylevich
57 /// Girlfriend, 2006
58 /// Girlfriend, 2012
59 /// Pebbles, Girlfriend, 1988
60 /// The Smiths, Girlfriend in a Coma, 1987

As framed by Nikitas, and through exhibition in an art gallery setting, *Soul Design* was a forum for its designers' self-expressions. And yet, the de-commodification of the prints as art objects, by printing a sizeable edition and then giving them away free, made the transmission of message akin to mass media, although in an unorthodox manner. In this regard, *Soul Design* succeeded as an idea beyond the individually designer-authored works.

Nikitas conceived the topic of *Soul Design*, while the individual designers were bound only by the page size and the limitation of a single color of ink. Design authorship, in this context, functions as personal narrative, as art, even as therapy. Michael Worthington chose fellow designer Ed Fella; Nancy Skolos chose her grandfather; Jan Jancourt chose past, present, and future musicians; Alexei Tylevich, his girlfriend. Clearly, the designs say as much, or more, about the graphic designers as they do about the objects of their admiration.

In her catalog introduction, Nikitas champions the Soul Design participants who "...use their skills to communicate something rooted in their own history." Numerous gallery viewers took away snapshots of the designers' souls as they also took the printed graphic designs.

above /// **ADVERSARY: A TRAVELING EXHIBITION (OF) CONTESTING GRAPHIC DESIGN** (EXHIBIT INSTALLATION) /// Kenneth FitzGerald /// 2001
below /// **FORM/INFORM** (CATALOG COVER, SPREADS, AND INSTALLATION VIEW) /// Steven McCarthy /// 2003

Adversary: A Traveling Exhibition (of) Contesting Graphic Design was collated — a term he prefers to curated — by Kenneth FitzGerald in 2001. About the exhibition, FitzGerald wrote: Adversary presents graphic design that challenges and/or expands common conceptions of design's purpose, content and process. A primary challenge is to the construction of design as solely a commercial activity – and which promotes the politics of a consumer culture. Print and interactive works directly confront this representation and/or offer alternate forms/contents.

The show traveled to seven venues throughout the United States, including an art museum, a private gallery, several university galleries and made an appearance at the AIGA (AMERICA'S PROFESSIONAL ORGANIZATION FOR DESIGN) national conference in Washington, the US capital.

A review of *Adversary* titled The Path of Most Resistance: Para-Graphic Design at Zero Station by Chris Thompson stated: "[FitzGerald] explains that while he asked certain designers to participate, in many cases he just gave them the general theme of the show and asked them to put together whatever they wanted. This makes 'Adversary' less of an exhibition and more of an intervention." Appropriate to this assessment, many of Adversary's participants were designers with known provocative tendencies: Ed Fella, Elliot Earls, Rick Valicenti, Gunnar Swanson and Women's Design + Research Unit, among others. Much of the exhibit's work was created specifically for the adversary theme, but some contributions were already completed works that loosely fit the topic. FitzGerald collated it into a show that served the idea of the graphic design field critically examining its own existence in today's hyper-media culture.

Form\Inform, shown at the University of Minnesota's Goldstein Museum of Design in Fall 2003, was an exhibit that was both curated (with invitational works) and juried. *Form\Inform*'s curator, this book's author, described the show as: "an exhibition that examines the trajectory from graphic design education to professional practice. Each designer's submission consists of a single student project, a current piece of professional work, and a brief statement that puts the two in context."

The Goldstein Museum's curator of graphic design conceived of *Form\Inform*'s concept, while a jury consisting of educator Kali Nikitas, and designers Steve Sikora and Tim Larsen reviewed submissions. Because of the nature of the exhibit (the relationship between designers' student projects and their mature works, as expressed in a written essay) complex choices had to be made about what was included. The curator's statement said, "*Form\Inform* is ultimately about the stories told by the artifacts, their creators, and the conditions for their existence."

61 /// Kenneth FitzGerald
62 /// Adversary
63 /// Voice2, AIGA National Conference, Washington DC, 2002
64 /// Our nation's capital
65 /// Chris Thompson
66 /// Zero Station, Portland ME
67 /// Elliot Earls
68 /// Ed Fella correspondence to Rick Valicenti
69 /// Gunnar Swanson, Talking Head
70 /// University of Minnesota Duluth Bulldogs
71 /// Goldstein Museum of Design, Minneapolis MN
72 /// Kali Nikitas
73 /// Steve Sikora
74 /// Tim Larsen

75 /// Maya Drozdz
76 /// Chris Corneal
77 /// Jennifer Morla
78 /// Bob Aufuldish
79 /// Amy Franceschini
80 /// Great Britain
81 /// Croatia
82 /// Turkey

Design authorship in *Form\Inform* can be literally interpreted, as the designers authored their own accompanying texts and made micro-level curatorial decisions about what to submit. It can be viewed at the meta-level as an overall theme determined the exhibit's contents. This context made art foundation projects and studio experiments from years, even decades, earlier relate to contemporary packaging, book designs, promotional materials, cultural posters and digital typeface designs. Further merging roles, the curator edited and designed the exhibit catalog and designed the gallery installation — a typical designer as author Gesamtwerk.

I Profess: the Graphic Design Manifesto exhibit was jointly curated and juried by Maya Drozdz and Chris Corneal in 2004. The call for entries challenged graphic design faculty to create posters that would visualize their teaching philosophies. The show's web site stated "The resulting exhibit showcases a wide range of viewpoints and pedagogical and ideological priorities that will serve as inspiration and as starting points for dialog among students and faculty. With this exhibit, the curators aim to encourage debate and to provoke the next generation of graphic designers to actively shape the future of our profession."

I Profess was exhibited in seven venues over three years. Most of the participants were American graphic design educators — including some with highly visible commercial consulting practices, like Jennifer Morla, Bob Aufuldish and Amy Franceschini — with additional representation from Great Britain, Croatia and Turkey.

Although the poster as a format is not necessarily the best medium to carry the message — rather it is the discipline's favorite canvas for virtuosity — the show's visual and conceptual variety was impressive. Posters are ideally suited for gallery presentation, as design authorship in this context is presented not unlike visual art.

This brings the complexities of the design authorship exhibit curator as meta-author to the fore. As the various roles assert themselves, what is the border — or the relationship — between subject (BY DESIGNER) and object (ABOUT DESIGNER)? Between immersion and self-promotion, between display and critique, between communication and expression, and between process and product? On one hand, the idea of curatorial meta-authorship is a shift in scale, a different hierarchical arrangement. On the other, it is a broadening and blending of roles: curator, editor, art director, writer, exhibit designer, social networker, political activist, budget manager, and so on.

Cultural parallels to the idea of meta-authorship are worthy of comparison. In twentieth century visual art, curated exhibitions were often the way that a movement or style was codified. Often times the exhibit emerged as like-minded artists organized their own themed show, about the art and by the artists. Curated and designed scenarios are now fluid, ever changing in scale and context.

The idea of curating as meta-design authorship means redefining roles and erasing distinctions. New combinations of activity give rise to diverse contexts, which in turn spawn new activities.

I PROFESS:
the graphic design manifesto

above /// **I PROFESS: THE GRAPHIC DESIGN MANIFESTO** (EXHIBIT INSTALLATION) /// Maya Drozdz and Chris Corneal /// 2004
below /// **FORMS OF INQUIRY: THE ARCHITECTURE OF CRITICAL GRAPHIC DESIGN** (INSTALLATION VIEW)(ARCHITECTURAL ASSOCIATION, LONDON) /// 2007

BRICK CONCRETE
EARTH GLASS
INSULATION STEEL
STONE WOOD

83 /// Michael Leyton
84 /// Zak Kyes
85 /// Architectural Association School of Architecture, London
86 /// Mark Owens
87 /// Zak Kyes and Mark Owens, Forms of Inquiry: The Architecture of Critical Graphic Design, 2009
88 /// Åbäke
89 /// Demolition of Pruitt-Igoe housing project, St. Louis, 1972
90 /// Åbake, Pruitt-Igoe, 2009
91 /// St. Louis

Exhibition curating spills from the cultural realm into politics and commerce, as designers as authors as curators as designers continuously transform.

Nikitas approached her curatorial projects with a strong vision of the overall exhibition, establishing themes with personal conviction. The individual designs mattered less than the governing concept. Drucker's *The Next Word* was a survey of works that occupied the overlap between art, design and literature. The theme of 'next word' seemed more like the definition 'adjacent' (NEXT TO) rather than 'subsequent' (FOLLOWING NEXT), emphasizing lateral relationships over sequential ones. *Form\Inform* depended on the sequential relationships between designers' student works and their professional output, whereas *I Profess* presented a series of posters as design professors' visualized manifestos.

These studies reveal curatorial approaches encompassing serial, sequential and conceptual methods, and might be best explained using the analytical tools of group theory. "The power of group theory lies in its ability to identify organization, and to express organization in terms of generative actions that structure a space," claims Michael Leyton. Maybe Kenneth FitzGerald has a point with his term collator — an arrangement is made from within a grouping of design works and this arrangement is dynamic.

Curatorial activity involving design authorship continues to appeal to those who wish to aggregate, combine, contrast or comment on designer-authored works or themes. In 2007, Zak Kyes curated *Forms of Inquiry: The Architecture of Critical Graphic Design* at the Architectural Association, London, and co-edited the catalog book with Mark Owens. Formsofinquiry.com states: "The exhibition features works that have originated as self-propelled inquiry, either professional or personal, and have been developed into a myriad of media and forms."

The exhibit content more or less references architecture, such as Åbäke's piece commenting on the demolition of the Pruitt-Igoe apartments in St. Louis, USA, and David Bennewith and Karel Martens' graphic translation of the windows of Le Corbusier's Notre Dame du Haut chapel. But its main emphasis seems to be a conceptual alignment with architecture's lofty role in unbuilt spec-

ulation. Kyes states in an interview in Task Newsletter, referring to the AA's Bedford Press: "The Print Studio was originally established in 1971/72 by Denis Crompton of Archigram to shape the school's architectural discourse through the production and distribution of publications. Books have been a key reason for the school's success during times when many projects were never intended to be realized. Consequently, the book became an ideal architectural site."

This brings to mind the quote, inclusive of its many variations: 'writing about music is like dancing about architecture.' A more positive interpretation is that any transgressive approach to another discipline can have beneficial, and previously unconsidered, outcomes. Critical graphic designing about architecture is a valid interdisciplinary activity. After all, as scientists have observed, the 'Edge Effect' between ecosystems — where sea meets land, plain meets forest, savannah meets wetland — increases bio-diversity.

92 /// David Bennewith
93 /// Karel Martens
94 /// David Bennewith and Karel Martens, Notre Dame du Haut Ronchamp, 2009
95 /// Notre Dame du Haut
96 /// Le Corbusier
97 /// Task Newsletter #2, 2009
98 /// Bedford Press
99 /// Denis Crompton
100 /// The Archigram Archival Project
101 /// Allan Fowler, Where Land Meets Sea, 1997
102 /// Clare Leighton, Where Land Meets Sea, 1997
103 /// Annalies Corbin and J.W. Joseph, When the Land Meets the Sea, 2011
104 /// Christiana Payne, When the Sea Meets the Land, 2007
105 /// Connor Garvey, Where Ocean Meets Land, 2011
106 /// Nancy Langston, Where Land & Water Meet, 2006

Design authorship through exhibition curating signals both a maturation of design connoisseurship and its concurrent democratization. Curating as meta-design authorship isn't simply about the exhibit — it is about the idea of design authorship as an expansive activity, transgressing boundaries and addressing new ways of thinking and doing.

Because exhibitions tend to be social events — groups of exhibiting designers' works are presented to the public, to critics, to the media — curating can be thought of as a community-oriented pursuit. It is about sharing and revealing through a plural form of authorship.

INTERVIEW: ARMIN VIT

Armin Vit is a designer, writer, entrepreneur and web publisher currently working from Austin, Texas, USA. Originally from Mexico, he has worked in Atlanta, Chicago and for Pentagram in New York. Vit's Under Consideration, a multi-media design practice, had one of its web logs included as the only 'blog' in the Cooper-Hewitt Museum's National Design Triennial. Besides Graphic Design Referenced, *Vit and Bryony Gomez-Palacio have co-authored the book* Women of Design.

MCCARTHY 'Inclusive' is the word I think of when considering your work. Your blogs (Speak Up, Quipsologies, Brand New) that invite user participation, the *Graphic Design Referenced* book that you and Bryony Gomez-Palacio recently co-authored — it's got almost everything! — and even your curating of the branding part of the Walker Art Center's Graphic Design: Now in Production exhibit that featured viewers voting on logos, all cast a wide net of inclusion. Why is the participation of others so important to your message?

VIT There are a couple of reasons. The first is that it's a reaction to the way design publishing had been for so many years before the mid-2000s: everything was very unilateral, a one way conversation. Books, magazines, and events were not meant to be replied to. The most interactivity one could hope for was a letter to the editor, and other than *Emigre*, no one really knew how to exploit them. So with Speak Up, it was all about dialog, about completely opening up the conversation and equalizing everyone's position. Even though I was the 'editor' I had no real expertise or authority at the time to take any big stances. Which brings me to the second reason: We don't consider ourselves the ultimate experts or as having the final word on anything, we prefer to keep our projects open so that they are informed and enriched by our audience. It's also about not taking everything so seriously and letting others in on the fun.

How do you think this focus on the user, on 'community,' has shaped contemporary graphic design? Is it dependent on technological mediation?

Yes and no. What we see most as examples of this are blogs or social media or whatever

01 /// Armin Vit
02 /// Austin TX
03 /// Mexico
04 /// Atlanta GA
05 /// Howdy From Chicago
06 /// Pentagram
07 /// Under Consideration
08 /// Cooper Hewitt National Design Museum, New York NY
09 /// Under Consideration at the Cooper Hewitt National Design Triennial, 2006
10 /// Armin Vit, Graphic Design Referenced, 2009
11 /// Bryony Gomez-Palacio
12 /// Bryony Gomez-Palacio and Armin Vit, Women of Design, 2008
13 /// Walker Art Center, Minneapolis MN

14 /// Speak Up
15 /// Quipsologies
16 /// Brand New
17 /// Graphic Design: Now in Production, catalog, 2012
18 /// Emigre 40, "Letters to the Editor," 1996
19 /// Threadless.com
20 /// Pinterest
21 /// Thank you

online platforms there are that bring designers together (LIKE THREADLESS OR PINTEREST) and those simply could not exist in analog form. They are perfect examples of technology-enabled communities redefining how graphic design is produced and vetoed. But there are also ramifications that are independent of technology, like the rise of collaboratives or printing centers where designers gather to produce things. I think there is more of a need for designers to collaborate and come together in person, even though we are more connected than ever.

Many of your projects seem self-initiated, from entrepreneurial ventures to publishing designs that you feel merit sharing with an audience. How did you come to design authorship — through writing, designing, new media, identity, collaboration, typography?

It was a combination of all of those. If not through expertise of each of those areas at least through appreciation and interest in them. I'm neither the best writer, designer, business man, or coder, but I feel fairly confident in that I'm not making a fool of myself in any one area to not try things. The other part of it is a combination of opportunity and necessity. Opportunity in that we sneaked our way online before anyone else did and necessity in that we needed to monetize all the time spent online and on these ideas we had. I enjoy design authorship but I enjoy a good ROI [return on investment] just as much.

Any final thoughts on the notion that design authorship has transformed graphic design?

We've removed the client or the publisher from the equation. I think you can ask any designer and they'll tell you that they feel clients or publishers hinder their creativity or their plans or their way of doing things. With design authorship we are in control of the final product and the theory goes that we are the experts so we are creating better end products that are truer to our vision. In our case, I just feel there is a very welcome liberation in what we do, and that allows us to infuse our projects with our own voice... Whether that transforms graphic design for the better or the worse is for others to decide, but it sure feels a lot better than having a focus group tell you what you can or can't do.

Thank you!

BRAND NEW CONFERENCE (POSTER) /// Armin Vit (UNDER CONSIDERATION) /// 2011

INTERVIEW: MICHAEL LONGFORD

219

Michael Longford is Associate Dean of Research in the Faculty of Fine Arts at York University in Toronto, Canada. His grant-supported research and digital creative projects have been exhibited internationally. Longford's most recent project, Tentacles, co-developed with the Ontario College of Art and Design and the Canadian Film Centre uses a smartphone to create a multi-user ambient gaming experience projected into public spaces. Tentacles was included in the Talk to Me exhibition at the Museum of Modern Art in 2011.

MCCARTHY You have a long-standing interest and involvement with technologically mediated communication — the Digital Cities Project, the Mobile Media Lab and more. How have mobile devices, open source software, WiFi and other networks affected the idea of a design, or any communication, being 'authored?'

LONGFORD Each of these technological developments has a role to play in facilitating a global network of instant connectivity to which those with economic means have access. With the introduction of social media to these networks accessible any time, anywhere, we've seen unprecedented amounts of 'authored' content in the form of text, sound and images shared amongst users. Perhaps even more remarkable is the speed of transmission, and the access to mass audiences afforded by a communication model that is simultaneously many to many. One could argue that in this new 'media-scape' the role of design in helping to shape form and content has been severely diminished. After all, in the era of citizen scientist, citizen journalist, and citizen designer everyone has access to the means to production (DIGITAL TOOLS) and distribution networks (INTERNET). Moreover, wikis, blogs, content management systems and other drop and drag authoring tools offer a limited design vocabulary in favor of interoperability and ease of use. Of course individual designers and design collectives will benefit from instant access to distribution networks for non-commissioned work. But I think there is a larger role for design to play in the building of systems that allow for a range of users with a variety of experience and expertise to become makers and authors of their own media-rich experiences, which can be shared across a number of platforms.

In this media environment, it seems that conventional notions of originality, attribution, ownership and so on, are in flux. How has access to media changed ideas about design authorship?

I can think of a couple of ways. First, we have recognized that our design preoccupation with the final product needs to shift to process.

01 /// Michael Longford
02 /// York University, Toronto
03 /// Toronto, Canada
04 /// Octopus
05 /// Ontario College of Art & Design (OCAD)
06 /// Canadian Film Centre
07 /// Talk To Me, Museum of Modern Art, New York NY
08 /// Digital Cities Project
09 /// Mobile Media Lab
10 /// WiFi

11 /// Creative Commons
12 /// Copyleft
13 /// Twitter feed
14 /// Apple
15 /// Google
16 /// Flickr
17 /// Like
18 /// Thank you

Process is the product. Designing open systems allowing for multiple outcomes means putting control of the final product in the hands of users. This idea runs counter to the modernist notion of the designer as problem solver, capable of reducing a complex set issues to simple single-minded solutions. Instead, designers are being asked to create systems giving everyone access to the design process and in turn handing over control of the final outcome. Inherent in these systems is the questioning of individual authorship, ownership, and ways in which the technology has changed the means and access to distribution supported by organizations such as Creative Commons and the Copyleft movement.

...

Perhaps as a response to this we've seen a renewed interest in the hand-made. Many designers have turned away from a primacy of digital technologies to embrace the hand-made and more traditional methods of making. This trend does not signal the rejection of digital technologies, but an integration of handwork with computation. The authored results are often unique objects, one offs, and limited print runs linked to alternative distribution networks such as galleries, design shops, and small presses.

...

Whatever choices designers make regarding the integration of these technologies in their design practice, it is critical that they stay engaged in shaping all aspects of technologically mediated communication — from concept, though systems design, to reflection as end users.

Although interactive and mobile media might point towards distributed creativity and communication, certain voices and expressions seem to emerge. Where do you see the future of writer and reader, designer and user, and artist and critic in this decentralized and increasingly complex world?

In a media environment dominated by social media, Twitter feeds, search engines, filtering systems, sampling, canned design and communication templates, one might wonder if labels of writer and reader, designer and user, artist and critic are still useful as roles become blurred. Yet at the same time, I think we need to be increasingly concerned about the ability of corporations to capitalize on the free labor of contributors and monetize what many would consider to be free content. Perhaps as those companies once working on the margins become the establishment — Apple, Google, Flickr and Facebook, for example — we'll want to revisit the value we attribute to single authorship.

Thank you!

TENTACLES (PHONE INTERFACE ABOVE, INSTALLATION BELOW) /// Michael Longford /// 2009

SEE SMALL (ARTIST'S BOOK) /// Steven McCarthy and Nathalie Valette /// 1987

AFTERWORD

An enormous maple tree stands in my Minnesota backyard. Its trunk has a diameter of more than a meter and its branches reach beyond the roof of the three-story house. Each major branch itself would be a respectably sized tree. Every spring the maple sheds its seeds, hundreds of thousands of helicopter-like genetic messengers. They carpet the lawn with hope, but despite their enthusiasm, none will grow into a magnificent tree.

Much publishing is like this fertile, yet futile, effort. The sub-cultural 'zines collected by devoted fans, artists' books in minor gallery shows, niche journals that cease production after an issue or two, blogs that few read, small edition fine press books that adorn private libraries, on-demand digital books that make authors of all — the human urge to produce, and reproduce, is strong.

Which of these efforts will be the next S,M,L,XL *designed by Bruce Mau – a book whose girth suggests my maple? The iconic magazine* Portfolio, *art-directed by Alexi Brodovitch over three issues between 1950 and 1951? An inventive novel comparable to Chip Kidd's* The Cheese Monkeys *or Graham Rawle's* Woman's Day? *April Greiman's deeply personal issue of* Design Quarterly? *Quentin Fiore's stunning visualization of Marshall McLuhan's* The Medium is the Massage? Emigre *magazine, paradigm shifter? The cohesive, yet varied, series of Penguin Books? The next Design Observer? These originally modest seeds are now the towering trees of recent publication design history.*

In 1987 a college friend and I collaborated on a little book. Titled See Small, *it was letterpress printed in three colors and accordion folded with hard covers in an edition of forty. It featured a scant amount of text engaged in word play, and images made from graphite rubbings of coins, keys, a spoon. We sold a dozen or so* (BUT TO WHOM?) *through a gallery in San Francisco that specialized in artists' books. It was also exhibited, but soon became forgotten as life moved on and more books were designed.*

Over twenty years later, a new resource appeared on the Internet. WorldCat.org has the ability to search not only books and articles, but also digital works, films, printed ephemera and so on. See Small *was searched — and found! Like a protected seed at the Svalbard Global Seed Vault in Norway, one copy resides in Yale University Library's special collections, available to scholars and students of art, design, literature and poetry.*

While its growth into a mighty maple tree is doubtful, See Small's *role is to inspire others to plant their own seeds. I hope that* The Designer As… *serves the same purpose. Besides being explanatory, historical, critical and analytical, it is my wish that designers and students of design see this book as inspirational. By embracing the tenets of design authorship, designers can — and should — participate more holistically in our common future.*

This call to action was stated somewhat presciently in a modest brochure titled Propaganda *that was produced by the Minnesota chapter of the AIGA, America's professional association for design, in 1989.* Propaganda, *with "content" organized by Rob Dewey, states: "The complex pluralism of our media environment has forced graphic design practice to evolve beyond rational problem-solving,*

personal expression, or the desire to balance the two. Direct engagement with the subject, object and contexts of design by passionate designers, including those working outside the culture of professional graphic design, has fostered the rise of new post-rational design methods that focus on collaboration with the audience, the sharing of expertise, and a recognition of the diversity of experience. Those working in the post-rational mode do not proceed with pre-defined problem statements but instead conduct investigations and participate in multiple dialogues through which appropriate metaphors are discovered. This evolution has expanded the scope and potential of graphic design."

The theories, histories, projects and processes of design authorship have since furthered this evolution. The expanded definition of design now includes authorship, production, activism, entrepreneurism, curating and collaborating — new models for communicating.

Whether by writing, designing, editing and publishing; whether by harnessing the tools and techniques of design to advocate social change; whether by creating personally expressive and communicative works; whether by initiating entrepreneurial products and services; or whether by designing environments and networks for community interaction, the designer as author (AND ...) *faces exciting opportunities!*

PROPAGANDA (BROCHURE) /// Rob Dewey (AIGA MINNESOTA) /// 1989

225

URL INDEX

CHAPTER 1

DESIGN AUTHORSHIP EXPLAINED

01 /// **Grunge style** /// http://www.collapseboard.com/everett-true/the-greatest-song-of-the-grunge-era-did-not-come-from-the-states/attachment/grunge/
02 /// **Stock grunge design elements** /// http://www.123rf.com/photo_9225532_set-of-grunge-design-elements.html
03 /// **Say it in print** /// http://www.smashingmagazine.com/2009/10/02/the-ultimate-round-up-of-print-design-tutorials/
04 /// **Calligraphy** /// http://www.calligraphybusinessguide.co.uk/
05 /// **Package design** /// http://www.designincstudios.com/imaginativepackagedesigns.html
06 /// **David Hockney photo montage** /// http://www.pinkblueandyou.co.uk/index.php/the-true-meaning-of-photomontage/
07 /// **Swiss modernism** /// http://wiedler.ch/felix/books
08 /// **Mrinal Kanti Bhadra, A Critical Survey of Phenomenology and Existentialism, 1990** /// http://www.exoticindiaart.com/book/details/critical-survey-of-phenomenology-and-existentialism-IDE105/
09 /// **Jon Sueda holding Task Newsletter #1** /// http://www.cca.edu/academics/gallery/jsueda/11492
10 /// **Michael Bierut** /// http://blogs.elon.edu/com565/2011/12/02/79-short-essays-on-design-3/
11 /// **Paul Rand** /// http://mimobett.blogspot.com/2012/05/paul-rand-was-born-in-august-151914.html
12 /// **Paul Rand signature** /// http://www.paul-rand.com/assets/backgrounds/
13 /// **Yale Bulldog** /// http://www.jasig.org/bedework/deployments/yale-university
14 /// **Gordon Salchow** /// http://hongchinh.vn/tin-tuc/121/Hai-van-de-trong-giao-duc-thiet-ke.html
15 /// **University of Cincinnati Bearcats** /// http://www.gobearcats.com/ot/cinn-wallpaper.html
16 /// **Gordon Salchow, Spring Design Lecture Series, University of Cincinnati, 1979** /// http://www.aiga.org/fellow-gordon-salchow/
17 /// **Direct mail** /// http://njcprinting.wordpress.com/2012/08/07/a-little-extra-prodding-when-to-rely-on-follow-up-direct-mail-pieces/
18 /// **Direct Marketing Association** /// http://www.searchenginestrategies.com/archives/2007/newyork/the-dma.html
19 /// **Ohio Environmental Protection Agency** /// http://www.coxcolvin.com/Ohio_Vows_To_Leave_NACAA.php
20 /// **Tree** /// http://www.cityoflisbon-ia.gov/index.asp?Type=B_BASIC&SEC=%7BC551ED0A-1901-4A92-AF13-B3F772E84914%7D
21 /// **Junk Mail** /// http://www.apartmenttherapy.com/junk-mail-art-67812

DESIGN AUTHORSHIP'S ENABLING TECHNOLOGIES

01 /// **Personal computer and desktop printer** /// http://www.extremetech.com/computing/92640-ibm-personal-computer-its-30-year-legacy-slideshow
02 /// **Letterpress printing press** /// http://www.murketing.com/journal/?p=1301
03 /// **Moveable type** /// http://justagwailo.com/tag/movable-type
04 /// **Silkscreen printing** /// http://www.bannerstoday.com/silk_screen_lettering.htm
05 /// **Underwood typewriter** /// http://old-photos.blogspot.com/2010_09_01_archive.html
06 /// **Photocopiers** /// http://blogs.arts.ac.uk/libraryservices/2009/02/06/new-photocopiers-at-southampton-row-library/
07 /// **Offset press** /// http://www.asia.ru/en/ProductInfo/829027.html
08 /// **Accordion folds** /// http://xpedx.edviser.com/default.asp?req=glossary/term/18
09 /// **Anthony Burrill** /// http://www.walkerart.org/magazine/2011/anthony-burrills-advice-for-living
10 /// **Gulf of Mexico** /// http://www.worldatlas.com/aatlas/infopage/gulfofmexico.htm
11 /// **BP** /// http://www.cartype.com/pages/387/bp
12 /// **Happiness Brussels** /// http://www.happiness-brussels.com/
13 /// **Coalition to Restore Coastal Louisiana** /// http://lacoast.gov/ocmc/MailContent.aspx?ID=1447
14 /// **Hamilton Wood Type Museum, Two Rivers WI** /// http://www.cityprofile.com/wisconsin/hamilton-wood-type-and-printing-museum.html
15 /// **Welcome to Two Rivers** /// http://www.virtualtourist.com/travel/North_America/United_States_of_America/Wisconsin/Two_Rivers-897851/TravelGuide-Two_Rivers.html
16 /// **Wisconsin** /// http://www.luventicus.org/maps/unitedstates/wisconsin.html
17 /// **Matthew Carter** /// http://www.computerarts.co.uk/interviews/matthew-carter
18 /// **Matthew Carter, Carter Latin, 2003** /// http://www.monotypeimaging.com/ProductsServices/TypeDesignerShowcase/MatthewCarter/Samples.aspx?type=samp2
19 /// **Matthew Carter (left) and Jim Van Lanen (right)** /// http://www.flickr.com/photos/nicksherman/4147817804/
20 /// **Bill Moran** /// http://www.sdaf.org/events/bill-moran/
21 /// **Polymer plate for letterpress printing** /// http://www.moetmoet.nl/polymer-plate-making-for-letterpress/
22 /// **Stapler** /// http://commons.wikimedia.org/wiki/File:Black_Stapler.jpg
23 /// **Spiral binding** /// http://www.shutterstock.com/pic-90873095/stock-photo-open-diary-with-blank-pages-with-spiral-binding-isolated-on-white-background.html
24 /// **Radar** /// http://linuxgazette.net/issue42/gm/musings.html
25 /// **Riot Grrrl, Riot Grrrl** /// http://msamberking.com/?p=10
26 /// **www.moma.org** /// http://www.moma.org/explore/inside_out/2011/05/18/looking-at-zines
27 /// **Riot Grrrl, Riot Don't Diet** /// http://www.flickr.com/photos/bubafra/5288143816/
28 /// **Typewriter ribbon** /// http://www.monstermarketplace.com/classic-typewriters/b100-universal-ribbon-3-pack
29 /// **Typewriter font Pica** /// http://furnaceinthehayloft.tumblr.com/
30 /// **Typewriter font Elite** /// http://www.selectric.org/selectric/index.html
31 /// **Wite-Out** /// http://agbeat.com/economic-news/mortgage/countrywide-agents-found-to-have-unusual-number-of-wite-out-dispensers-on-desks/
32 /// **QWERTY keyboard** /// http://www.dayiwasborn.net/496162
33 /// **Rachel Marsden** /// https://twitter.com/rachmarsden
34 /// **Rachel Marsden, Little Book of Fears, 2005** /// http://bookartobject.blogspot.com/2012/02/rachel-marsden-group-1-introduction.html
35 /// **Piggyback** /// http://www.justjared.com/photo-gallery/2761050/taylor-swift-piggy-back-ride-on-i-knew-you-were-trouble-set-04/
36 /// **Make-ready** /// http://www.esopusmag.com/gallery.php?Id=3777
37 /// **School of Art & Design t-shirt** /// http://www.egesoyuer.com/index.php?/projects/artdesign-t-shirt/
38 /// **SUNY (State University of New York) Purchase** /// http://solecollector.com/forums/Top-50-Druggiest-Colleges/11:4:1105999/#axzz2GbC3GIjs
39 /// **Clifton Meador** /// http://www.theartdoc.com/artists/
40 /// **Philip Zimmerman** /// http://philipzimmermann.blogspot.com/
41 /// **Warren Lehrer** /// http://www.uuphost.org/purchase/lehrer.html
42 /// **Brad Freeman** /// http://blogs.colum.edu/interarts-cbpa/2012/08/05/upcoming-cbpa-exhibition-features-unique-version-of-from-a-to-z/
43 /// **Clifton Meador, A Long Walk, 1993** /// http://www.artistsbooksonline.org/works/walk.xml
44 /// **Philip Zimmerman, Sanctus Sonorensis, 2009** /// http://bookartcollective.com/?p=107
45 /// **Warren Lehrer, A Life in Books: The Rise and Fall of Bleu Mobley, 2012** /// http://www.theatlantic.com/entertainmentarchive/2011/12/a-real-book-made-of-101-fake-books/250604/
46 /// **Brad Freeman, JAB5 (Journal of Artists Books), 1996** /// http://www.artistsbooksonline.org/works/ja05/object.xml

47 /// **Printed Matter, Inc.** /// http://whatwelikenyc.com/tag/printed-matter/
48 /// **New York NY** /// http://www.theworkingworld.org/index.php?action=NewYork
49 /// **Risograph** /// http://ambcomputers.en.ecplaza.net/riso-hc-5500-dubai-ink--152611-720632.html
50 /// **Felix Pfaeffli** /// http://blog.hermanmillerasia.com/post/2012/07/18/Then-x-Ten-interview-Felix-Pfaffli.aspx
51 /// **Südpol, Lucerne** /// http://www.tonart-audiotechnik.ch/cms/front_content.php?idcat=103&idart=26977
52 /// **Switzerland** /// http://www.answers.com/topic/switzerland
53 /// **Landfill Editions** /// http://cheapandplastique.wordpress.com/2010/05/04/pick-me-up-contemporary-graphic-art-fair-london/
54 /// **Jiro Bevis, Ditto Press Poster, 2009** /// http://www.dittopress.co.uk/singlejob.php?j=34&i=0
55 /// **blog.eyemagazine.com** /// http://www.eyemagazine.com/blog/post/ditto-hard-copy
56 /// **Occuprint** /// http://occuprint.org/Info/About
57 /// **Occupy Wall Street** /// http://usnews.nbcnews.com/_news/2012/09/16/13891055-one-year-later-what-ever-happened-to-occupy-wall-street?lite
58 /// **Nina Montenegro** /// http://ninamontenegro.com/ABOUT_%26_BLOG.html
59 /// **Nina Montenegro, Outgrow the Status Quo, 2012** /// http://occuprint.org/Posters/OutgrowTheStatusQuo
60 /// **Monika Ciapala** /// http://lgbthistorymonth.org.uk/featured-left/meet-the-badge-maker/
61 /// **Cascading style sheets** /// http://newsletter.blizzardinternet.com/the-history-future-of-css/2008/04/11/
62 /// **Antonio Lupetti** /// http://soundcloud.com/woork/dropbox/profile
63 /// **Computer-controlled laser cutter** /// http://www.yueminglaser.com/laser-cutting-machine/laser-machine-297.html
64 /// **CNC router** /// http://www.veloxcnc.com
65 /// **Dafi Kühne** /// http://www.geolocation.ws/v/L/6915531863/dafi-khne-in-his-studio/en
66 /// **Zurich, Switzerland** /// http://zurich.all-about-switzerland.info/zurich-cityguide-sightseeing-landmarks-museums.html
67 /// **Dafi Kühne, Voodoo Rhythm Dance Night, 2011** /// http://www.babyinktwice.ch/index47.php
68 /// **Dafi Kühne, Zurich Milano, 2011** /// http://hellotothisday.tumblr.com/
69 /// **Hatch Show Print, Nashville TN** /// http://fineartamerica.com/products/hatch-show-print-sandy-macgowan-greeting-card.html
70 /// **Nashville TN** /// http://travelblog.viator.com/highbrow-and-lowbrow-in-downtown-nashville/
71 /// **Nashville (ABC)** /// http://www.celebritybug.net/2012/10/nashville-season-1-episodes.html
72 /// **Nashville (Altman, 1975)** /// http://www.impawards.com/1975/nashville_ver1.html
73 /// **Lovin' Spoonful, Nashville Cats, 1966** /// http://boogiewoogieflu.blogspot.com/2007_12_01_archive.html
74 /// **A Nashville Cat** /// http://www.neatorama.com/2011/07/28/banjo-cat/
75 /// **Amaranth Borsuk** /// http://www.amaranthborsuk.com/
76 /// **Brad Bouse** /// http://www.entrepreneur.com/article/225153#
77 /// **Amanda Borsuk and Brad Bouse, Between Page and Screen, 2012** /// http://www.betweenpageandscreen.com/
78 /// **imprint.printmag.com** /// https://plus.google.com/117074023999778850924/posts
79 /// **Evelin Kasikov** /// http://handandeye.wordpress.com/category/people/page/2/
80 /// **Estonia** /// http://www.circlist.com/rites/estonia.html
81 /// **London UK** /// http://ucsdherbst.org/mmw-in-london/
82 /// **René Knip, Fire Basket, 2007** /// http://style-files.com/2007/04/28/poetic-fire-basket/
83 /// **Dutch** /// http://nikkigsblog.wordpress.com/2010/03/26/can-you-crush-coffee-beans-and-snort-them/
84 /// **René Knip** /// http://cultuurgids.avro.nl/front/archiefkunstuur.html?trefwoord=Rene%20Knip

TIMELINE OF DESIGN AUTHORSHIP

01 /// **William Morris** /// hhttp://theyoungcreatives.wordpress.com/2012/05/06/the-classic-creatives-william-morris/
02 /// **Hendrik Werkman** /// http://www.dvhn.nl/nieuws/cultuur/article9173381.ece/Onthulling-gevelsteen-drukkerij-Werkman
03 /// **Kurt Schwitters** /// http://weimarart.blogspot.com/2010/09/kurt-schwitters-cathedral-of-erotic.html
04 /// **Jan Tschichold** /// http://mzinleipzig.blogspot.com/2012/05/re-stock-mzin-jan-tschichold-1948-1974.html
05 /// **Eric Gill** /// http://stoneletters.wordpress.com/2012/07/14/howard-costers-portrait-photograph-of-eric-gill-and-eric-gills-pencil-sketch-of-howard-coster/
06 /// **Willem Sandberg** /// http://www.thinkingform.com/2012/10/24/thinking-willem-sandberg-24-10-1897/
07 /// **Herbert Spencer** /// http://www.designweek.co.uk/news/obituary-herbert-spencer-1924-2002/1110295.article
08 /// **Alexey Brodovitch** /// http://www.iconofgraphics.com/Alexey-Brodovitch/
09 /// **Milton Glaser** /// http://llistodesign.blogspot.com/2012/06/i-love-new-york.html
10 /// **Seymour Chwast** /// http://freshjive.wearegiants.com/tag/seymour-chwast/
11 /// **Edward Sorel** /// http://www.edwardsorel.com/bio.htm
12 /// **Peter Cook** /// http://sv.wikipedia.org/wiki/Fil:Peter_Cook_from_Archigram,_Architects_Association.jpg
13 /// **Ken Garland** /// http://firstthingsfirst.gdnm.org/category/artists-research/ken-garland/
14 /// **Lorraine Schneider** /// McCall's, May 1971, courtesy of designer
15 /// **Marshall McLuhan** /// http://juliekinnear.com/blogs/famous-torontonians-marshall-mcluhan.html
16 /// **Quentin Fiore (second from left)** /// http://www.paulhazel.com/tag/the-medium-is-the-massage/
17 /// **Ralph Eckerstrom** /// http://www.ebay.com/itm/1963-Press-Photo-Ralph-Eckerstrom-Denver-Awards-Banquet-/261016801618
18 /// **Massimo Vignelli** /// http://www.ikewrites.com/2012/01/10/and-above-all-timeless/-
19 /// **Pierre Bernard (Grapus)** /// http://www.posterpage.ch/div/news06/n060204.htm
20 /// **Tom Phillips** /// http://tpexhibitions.blogspot.com/2012/04/seventy-fifth-birthday-celebrations.html
21 /// **Wolfgang Weingart** /// http://jesseturri.wordpress/?p=146
22 /// **Rick Vermeulen (left)** /// http://www.instituutvoorbeeldenvorm.nl/index.php?id=1333
23 /// **Tibor Kalman** /// http://www.charlierose.com/view/interview/4306
24 /// **Zuzana Licko and Rudy Vanderlans** /// http://www.printmag.com/Article/Design-Couples-Rudy-Vanderlans-and-Zuzana-Licko
25 /// **Guerrilla Girl** /// http://wupa.wustl.edu/record_archive/1998/03-19-98/2368.html
26 /// **April Greiman** /// http://www.flickr.com/photos/fontblog/5775442384/
27 /// **Simon Johnston** /// http://blogs.artcenter.edu/dottedline/tag/simon-johnston/
28 /// **Mark Holt** /// http://cerysmaticfactory.info/8vo_working_with_wim_090511.html
29 /// **Warren Lehrer** /// http://www.amazon.com/Warren-Lehrer/e/B001IO9KW6
30 /// **Michael Burke** /// http://vignellicenter.rit.edu/news/news-features/braun-history-lecture-with-michael-burke/
31 /// **Hamish Muir** /// http://adrobbins.blogspot.com/2009/03/ecp-hamish-muir-on-typography.html
32 /// **Gran Fury** /// http://greg.org/archive/2003/04/13/on_gran_fury_on_the_art_of_protest.html
33 /// **Kalle Lassn** /// http://www.badische-zeitung.de/ausland-1/es-wird-schwaerme-von-besetzern-geben--53989888.html
34 /// **Frank Heine** /// http://www.linotype.com/2754/frankheine.html
35 /// **David Comberg (Class Action)** /// http://www.design.upenn.edu/people/comberg_david

36 /// **Jonathan Barnbrook** /// http://arsenale2012.com/news/?id=11&lang=eng
37 /// **Anne Burdick** /// http://www.flickr.com/photos/youraccount/7088482243/
38 /// **Art Spiegelman** /// http://www.hypergeek.ca/2011/01/art-spiegelman-awarded-the-2011-grand-prix-de-la-ville-dangouleme.html
39 /// **Jacqueline Thaw (Class Action)** /// http://www.masongross.rutgers.edu/visual-arts/faculty/jacqueline-thaw
40 /// **Michael Bierut** /// http://www.adcglobal.org/archive/hof/2003/?id=197
41 /// **Neville Brody** /// http://www.theblanksheetproject.com/creative/1/neville_brody
42 /// **Jon Wozencroft** /// http://www.digplanet.com/wiki/Jon_Wozencroft
43 /// **Katie Salen** /// http://libraryofgames.org/portfolio-post/library-of-games-extrasode-katie-salen-interview/
44 /// **Shepard Fairey** /// http://www.rollingstone.com/music/news/shepard-fairey-overwhelmed-by-rolling-stones-logo-redesign-20120629
45 /// **Auriea Harvey** /// http://memoir.okno.be/?id=873
46 /// **Sian Cook (WD+RU)** /// http://profesionalpracticeuel.blogspot.com/
47 /// **Amy Franceschini** /// http://www.codypickens.com/index.php?/portrait/creatives/
48 /// **Olivier Laude** /// http://www.flickr.com/photos/sfgirlbybay/222658799/
49 /// **Tony Credland** /// http://www.flickr.com/photos/esadmatosinhos/5912870932/
50 /// **Jop van Bennekom** /// http://www.behance.net/gallery/Writers/6408997
51 /// **Bruce Mau** /// http://www.tcg.org/events/conference/2010/speakers.cfm
52 /// **Steven Heller (co-founder SVA MFA in Design Writing)** /// http://observermedia.designobserver.com/audio/steven-heller/34038/
53 /// **Michael Macrone** /// https://twitter.com/MichaelMacrone
54 /// **Kenneth FitzGerald** /// http://observermedia.designobserver.com/audio/kenneth-fitzgerald/9037/
55 /// **James Victore** /// http://www.forbes.com/sites/calebmelby/2011/09/07/graphic-designer-james-victore-clients-should-be-brave/
56 /// **Stuart Bailey** /// http://www.sommerakademie.zpk.org/en/former-academies/2010/speakers/stuart-bailey.html
57 /// **Peter Bilak** /// http://www.digplanet.com/wiki/Peter_Bi%C4%BEak
58 /// **Marcia Lausen** /// http://wall.aa.uic.edu:62730/pub/new/Old_ColNewsEvents_Website_9-8-2005/col_new_foc_ind.idc?focus=new
59 /// **Dori Tunstall** /// http://www.re-public.gr/en/?p=358
60 /// **David Reinfurt** /// http://thepressureisgoodforyou.blogspot.com/2009/03/david-reinfurt-at-walker.html
61 /// **Stephen Melamed** /// http://www.core77.com/reactor/09.03_IDSA_NEC.asp
62 /// **Josh On** /// http://lokidesign.net/2356/2007/11/interview-with-josh-on/
63 /// **Tibor Kalman** /// http://www.fayeandco.com/category/books/page/6/
64 /// **Chip Kidd** /// http://nymag.com/daily/intelligencer/2008/03/chip_kidd.html
65 /// **Armin Vit** /// http://article.wn.com/view/2012/06/07/Sappi_Reveals_2012_Ideas_that_Matter_Grant_Program_Judges/
66 /// **Kate Bingaman-Burt** /// http://pinterest.com/kateconsumption/
67 /// **William Drenttel and Jessica Helfand** /// http://www.ruralintelligence.com/index.php/parties_section/parties_articles_parties/a_big_fundraiser_for_a_small_library_in_falls_village/
68 /// **Nicholas Blechman** /// http://www.adcawards.org/jury/illustration/?id=928
69 /// **Rick Poynor** /// http://www.offf.ws/2011/?page_id=1901
70 /// **Rick Valicenti** /// http://www.aiga.org/medalist-rickvalicenti/
71 /// **Peter Lunenfeld** /// http://www.decadeofwebdesign.org/speakers.html
72 /// **Metahaven** /// http://www.flickr.com/photos/manifestabiennial/4681281559/
73 /// **Abake** /// http://www.kitsune.fr/journal/2010/07/music/jerry-bouthier-at-lovebox-festival/
74 /// **Cristina de Almeida** /// http://file-magazine.com/citylikeyou/profiles/steven-mccarthy
75 /// **Steven McCarthy** /// http://file-magazine.com/citylikeyou/profiles/steven-mccarthy
76 /// **Kali Nikitas** /// http://www.kalinikitas.com/?-cat=14&paged=14
77 /// **Johanna Drucker** /// http://gseis.ucla.edu/people/drucker
78 /// **Maya Drozdz (right)** /// http://www.etsy.com/blog/en/2010/featured-seller-visualingual/
79 /// **Chris Corneal** /// http://www.facebook.com/photo.php?fbid=1046800330174&set=t.1230636855&type=3&theater
80 /// **Zak Kyes** /// http://kaleidoscope-press.com/issue-contents/kaz-kyes-interview-by-hans-ulrich-obrist/
81 /// **Daniel Jasper** /// courtesy of author
82 /// **Tom Starr** /// http://www.northeastern.edu/news/stories/2010/03/tomstarr.html
83 /// **Walter Benjamin** /// http://skepticism.org/timeline/september-history/8791-death-walter-benjamin-literary-critic-writer-suicide.html
84 /// **Roland Barthes** /// http://lareviewofbooks.org/author.php?id=555
85 /// **Michel Foucault** /// http://www.makefive.com/categories/debate/philosophy/top-5-philosophers/michel-foucault
86 /// **Mark Owens** /// http://artswriters.org/index.php?action=grantee_detail&grantee_id=129&year=2011
87 /// **Elizabeth Sacartoff** /// byline, courtesy of author
88 /// **Gunnar Swanson** /// http://www.underconsideration.com/speakup/profiles/gunnar_swanson.html
89 /// **Katherine and Michael McCoy** /// http://cozine.com/2006-may/designing-for-a-better-world/
90 /// **Will Novosedlik** /// http://www.appliedartsmag.com/blog/?attachment_id=6989
91 /// **Michael Rock** /// http://www.brendanmcgetrick.com/anything/2008/09/04/michael-rock-graphic-designer/
92 /// **Ellen Lupton** /// http://www.metropolismag.com/pov/20081020/designer-as-ghostwriter
93 /// **Renée Riese Hubert** /// http://lifeinlegacy.com/display.php?weekof=2005-05-20
94 /// **Denise Gonzalez Crisp** /// http://www.google.com/imgres?hl=en&sa=X&tbo=d&biw=1258&bih=871&tbm=isch&tbnid=qRpL79fwi6K_pM:&imgrefurl=http://vimeo.com/15836939&docid=TxsjUXcdmnuALM&imgurl=http://b.vimeocdn.com/ts/960/520/96052059_640.jpg&w=640&h=357&ei=kxr3ULDLOojoiwK9sIHgCg&zoom=1&iact=hc&vpx=448&vpy=447&dur=32&hovh=168&hovw=301&tx=195&ty=77&sig=109939852770808905976&page=3&tbnh=125&tbnw=200&start=79&ndsp=50&ved=1t:429,r:97,s:0,i:383
95 /// **Mike Sharples** /// http://article.wn.com/view/2012/06/15/Reader_Idea_Personal_Inquiry_Projects_With_The_Learning_Netw/
96 /// **Abbott Miller** /// http://fyi.mica.edu/event/abbott_miller_pentagram#.UPcYOonjIYw
97 /// **Monika Parrinder** /// http://www.dipity.com/Qiongwang/personal/
98 /// **Anthony Dunne** /// http://www.bidt.org/doc/11/33.html
99 /// **Fiona Raby** /// http://www.bidt.org/doc/11/33.html
100/// **Cheryl Towler Weese** /// http://archive.sta-chicago.org/judges.php
101/// **Gérard Mermoz** /// http://www.cidadevirtual.pt/up-arte/dois/mermoz-i.html
102/// **Katherine Moline** /// http://www.cofa.unsw.edu.au/about-us/staff/129
103/// **Kate Sweetapple** /// http://www.newsroom.uts.edu.au/news/2010/08/powerhouses-of-design
104/// **Tara Winters** /// https://497fa7b1-a-62cb3a1a-s-sites.googlegroups.com/site/detm2005/Section1_10.pdf?attachauth=ANoY7cpfyxdJnSqeXXPDqNeIvPa6oPJq-G4lolELi4VBSktshVWDz9bfgo50YfCq7qgFPtNSJ-amYsJ4AIX-

deWLW3b8ZRcPgQnQc-KH1OsJaRfCwQh4xaJTSV_mSYXQt-54KQn4zZqGqIjx1rLiDyE26!94YwUrKfnu-8lpKg7xYIKE3_LC-SpbcAoRIwZF8PGxvcYfJKdJ-N6N_tOLDcL0hqxuCoMt-1xNCA%3D%3D&attredirects=0

105 /// **Maria Rogal** /// http://mariarogal.com/about/
106 /// **Dmitri Siegel** /// http://skiingbusiness.com/6910/newswire/patagonia-urges-people-to-not-buy-its-products/
107 /// **Kate Bowden** /// http://www.cutandmake.de/
108 /// **Rebecca Targ** /// https://twitter.com/rebeccatarg
109 /// **William Morris, The Story of the Glittering Plain or the Land of Living Men, 1891** /// http://www.davidbrassrarebooks.com/wp-content/plugins/wp-shopping-cart/single_book.php?sbook=1413
110 /// **William Morris, The News from Nowhere, 1892** /// https://itunes.apple.com/au/app/news-from-nowhere-by-william/id321540764?mt=8
111 /// **Hendrik N. Werkman, The Next Call, 1923** /// http://www.casualoptimist.com/2009/02/15/hn-werkman/
112 /// **Kurt Schwitters, Merz 11, 1924** /// http://www.burningsettlerscabin.com/?tag=kurt-schwitters
113 /// **Jan Tschichold, The New Typography, 1928** /// http://waterfallzine.com/702/04/2012/the-new-typography/
114 /// **Eric Gill, An Essay On Typography, 1931** /// http://crazybearstudio.blogspot.com/2012/02/eric-gill-essay-on-typography.html
115 /// **Willem Sandberg, Experimenta Typographica, 1956** /// http://www.rockpaperink.com/content/article.php?id=55
116 /// **Herbert Spencer, Typographica 7, 1953** /// http://grainedit.com/2009/02/24/typographica-7-edited-by-herbert-spencer/
117 /// **Alexi Brodovitch, Portfolio, 1951** /// http://samsmyth.tumblr.com/post/12032629824/pinkjetpack-portfolio-magazine-volume-1-issue
118 /// **Push Pin Studios, Push Pin Graphic 76, 1978** /// http://theanimalarium.blogspot.com/2010/05/ladybirds-parade.html
119 /// **Archigram Architects, Archigram 4, 1964** /// http://we-make-money-not-art.com/archives/2012/12/a-guide-to-archigram-196174.php
120 /// **Ken Garland, First Things First, 1964** /// http://www.kengarland.co.uk/KG%20published%20writing/first%20things%20first/index.html
121 /// **Lorraine Schneider, War Is Not Healthy for Children and Other Living Things, 1967** /// http://www.fanpop.com/clubs/the-60s/images/666933/title/war-not-healthy-fanart
122 /// **Marshall McLuhan and Quentin Fiore, The Medium is the Massage: An Inventory of Effects, 1967** /// http://spacecollective.org/sjef/4148/The-medium-is-the-massage
123 /// **Ralph Eckerstrom and Massimo Vignelli, Dot Zero 4, 1967** /// http://observatory.designobserver.com/entry.html?entry=11547
124 /// **Grapus Studio, Against Apartheid, 1984** /// http://www.dipity.com/dwolf/Digital-Art-Timeline/
125 /// **Tom Philips, A Humument, 1970** /// http://www.reviewbookshop.co.uk/events-diary/tom-phillips--a-humument_1337691766.html
126 /// **Wolfgang Weingart, Typographic Process Nr. 5: Typography as Painting, 1971-74** /// http://www.moma.org/collection/browse_results.php?criteria=O%3AAD%3AE%3A6289&page_number=4&template_id=1&sort_order=1
127 /// **Rick Vermeulen, Hard Werken, Hard Werken 3, 1979** /// hhttp://sethdesilva.gdnm.org/2011/10/20/the-netherlands-rotterdam-hard-werken-rem-koolhaas-utopia-1970/
128 /// **Tibor Kalman, M&Co, Waste Not A Moment, 1984** /// http://designhouse.ca/catalog/accessories/clock-and-watches/onomatopoeia-m-and-co/578
129 /// **Rudy Vanderlans, Emigre 19, 1990** /// http://www.domusweb.it/en/design/states-of-design-06-in-your-face-/
130 /// **Guerilla Girls, Women Artists Earn Only 1/3 of What Men Do, 1985** /// hhttp://www.guerrillagirls.com/posters/twothirds2.shtml
131 /// **Simon Johnston, Mark Holt, Michael Burke, Hamish Muir, Octavo 86.2, 1987** /// http://www.modernism101.com/octavo_2.php
132 /// **Warren Lehrer, GRRRHHHH: A Study of Social Patterns, 1987** /// http://www.earsay.org/projects/books/warren-lehrer-with-dennis-bernstein-and-sandra-brownlee-g-grrrhhhh-a-study-of-social-patterns/
133 /// **April Greiman, Design Quarterly 133, 1986** /// http://madeinspaceshop.com/
134 /// **Gran Fury, The Government Has Blood on Its Hands, 1988** /// http://artqueer.tumblr.com/post/17165449982/gran-fury-the-government-has-blood-on-its-hands
135 /// **Kalle Lasn, Adbusters 4, 2006** /// http://www.chrissauve.com/index.php?/editorial/adbusters-magazine/
136 /// **Frank Heine, Remedy, 1991** /// http://luc.devroye.org/myfonts-frankheine/
137 /// **Jon Wozencroft, Neville Brody, FUSE, 1991-2000** /// http://www.researchstudios.com/shop/fuse-1-20-from-invention-to-antimatter-twenty-years-of-fuse/
138 /// **Michael Bierut, ReThinking Design, 1992-1995** /// http://www.popscreen.com/search?q=Rethinking+Design+Thinking
139 /// **Jonathan Barnbrook, Manson, 1992** /// http://cuaderno.tigdstudio.it/2007/07/barnbrook-graphic-design.html
140 /// **Art Spiegelman, Maus: A Survivor's Tale, 1992** /// http://www.englishdaybyday.net/article-maus-art-spiegelman-101166698.html
141 /// **Class Action, Aiding Awareness: Women's Stories, 1994** /// http://www.design.upenn.edu/people/comberg_david
142 /// **Anne Burdick, Electronic Book Review, 1994-present** /// http://www.electronicbookreview.com/
143 /// **Katie Salen, et al, Zed , 1994-2000** /// courtesy of the author
144 /// **Shepard Fairey, Obey Giant, 1995** /// http://www.thegiant.org/wiki/index.php/Obey_'95_HPM_on_Paper
145 /// **Auriea Harvey, Entropy8, 1995** /// http://entropy8.com/syncen/index.html
146 /// **Women's Design Research Unit (WD+RU), Pussy Galore, 1995** /// http://www.eaglefonts.com/pussygalore-ttf-105849.htm
147 /// **Amy Franceschini, Olivier Laude, Michael Macrone, Atlasmagazine.com, 1995** /// http://www.atlasmagazine.com/win98r.html
148 /// **Cactus/Tony Credland, Feeding Squirrels to the Nuts 2, 1995-1999** /// http://www.cactusnetwork.org.uk/squirrels1.htm
149 /// **Kenneth FitzGerald, News of the Whirled #3, 2002** /// http://www.ephemeralstates.com/the-news-of-the-whirled/
150 /// **Jop van Bennekom, Re-Magazine #7, Autumn 2001** /// http://referencelibrary.blogspot.com/2012/07/re-magazine-7-autumn-2001.html
151 /// **James Victore, Use a Condom, 1997** /// http://observatory.designobserver.com/slideshow/graphic-intervention/15768/1328/26
152 /// **Bruce Mau, Incomplete Manifesto for Growth, 1998** /// http://islandgirl-writes.blogspot.com/2008/05/bruce-mau-incomplete-manifesto-for.html
153 /// **First Things First 2000** /// http://www.mobius-studio.com/first-things-first/
154 /// **Stuart Bailey, Peter Bilák, David Reinfurt, Dot Dot Dot #4, 2002** /// http://www.mixed-media.info/writing.html
155 /// **Jonathan Barnbrook, Designers, Stay Away from Corporations that Want You to Lie for Them, 2001** /// http://www.bangkokpost.com/print/247872/
156 /// **Josh On, Theyrule.net, 2001** /// http://theyrule.net/
157 /// **Chip Kidd, Cheese Monkeys: A Novel in Two Semesters, 2001** /// http://infovore.org/archives/2012/05/25/good-is-dead-blog-all-dog-eared-pages-chip-kidds-the-cheese-monkeys/
158 /// **Armin Vit, Speak Up/Under Consideration, 2001-09** /// http://www.underconsideration.com/speakup/
159 /// **Marcia Lausen, Stephen Melamed, Elizabeth (Dori) Turnstall, Design for Democracy, 2000** /// http://www.aiga.org/design-for-democracy-book/

160 /// **Kate Bingaman-Burt, obsessiveconsumption.com, 2002** /// http://www.obsessiveconsumption.com
161 /// **Michael Bierut, William Drenttel, Jessica Helfand, Rick Poynor, Design Observer, 2003–present** /// http://designobserver.com/
162 /// **Nicholas Blechman, Empire (Nozone IX), 2004** /// http://blog.objectsinspaceandtime.com/ost/the-2006-national-design-triennial-junk-drawer-curation
163 /// **Winterhouse Editions, The National Security Strategy of the United States of America, 2003** /// http://www.probook.co.il/Publisher.aspx?name=Winterhouse%20Editions
164 /// **Rick Valicenti, Suburban Maul, 2003** /// http://vimeo.com/18499366
165 /// **Abake, I Am Still Alive #21, 2011** /// http://www.ofluxo.net/ver-para-ler-5/
166 /// **Shepard Fairey, Obama Hope, 2008** /// http://www.petrusboots.com/350_obama_trickle-down.htm
167 /// **Chip Kidd, The Learners, 2008** /// http://www.quimbys.com/blog/store-events/chip-kidd-2/
168 /// **Peter Lunenfeld (editor), Utopian Entrepreneur (MIT Mediaworks Pamphlet), 2001** /// http://www.amazon.com/Utopian-Entrepreneur-Mediaworks-Pamphlets-Brenda/dp/0262621533
169 /// **Kali Nikitas, curator, Soul Design, 1999** /// http://www.flickr.com/photos/robdewey/3291389016/
170 /// **Kenneth FitzGerald, collator, Adversary: an Exhibition (of) Contesting Graphic Design, 2001** /// http://www.ephemeralstates.com/adversary/index.html
171 /// **Metahaven, Facestate, 2011** /// http://www.walkerart.org/magazine/2011/metahavens-facestate
172 /// **Cristina de Almeida & Steven McCarthy, curators; Designer as Author: Voices and Visions, 1996** /// courtesy of the author
173 /// **Kali Nikitas, curator; And She Told 2 Friends: An International Exhibit of Graphic Design by Women, 1996** /// http://www.flickr.com/photos/72866633@N00/6645291301/
174 /// **Johanna Drucker, curator, The Next Word: Text and/as Image and/as Design and/as Meaning, 1998** /// http://books.google.com/books/about/The_next_word.html?id=E1ZKAQAAIAAJ
175 /// **Maya Drozdz, curator, Outside In, 2004** /// http://www.lulu.com/shop/maya-drozdz/outside-in/paperback/product-291403.html
176 /// **Maya Drozdz & Chris Corneal, curators, I Profess: The Graphic Design Manifesto, 2004** /// http://msugraphicdesign.typepad.com/msu_graphic_design/msu_aiga/
177 /// **Jacqueline Thaw, curator, Trigger: Projects Initiated by Graphic Designers, 2006** /// http://philadelphia.aiga.org/news_archive2005.html
178 /// **Mark Owens & Zak Kyes, curators, Forms of Inquiry: The Architecture of Critical Graphic Design, 2007** /// http://www.amazon.com/Forms-Inquiry-Zak-Kyes/dp/1902902629
179 /// **Walter Benjamin, Reflections, 1978** /// http://www.tower.com/reflections-essays-aphorisms-autobiographical-writings-walter-benjamin-paperback/wapi/100346887
180 /// **PM Magazine, August–September 1940** /// http://www.drleslie.com/PMADMagazines/6_6_8940.shtml
181 /// **Roland Barthes, The Death of the Author, 1967 (as it appeared in Aspen 5+6)** /// http://brickbatbooks.blogspot.com/2012/03/featured-aspen-magazine-in-box-56.html
182 /// **Daniel Jasper, curator, Products of our Time, 2007** /// http://goldstein.design.umn.edu/exhibitions/upcoming/jeremysenglyseniorshow.html
183 /// **Tom Starr, curator, We The Designers, 2007** /// http://www.sessions.edu/notes-on-design/resources/we-the-designers-exhibit/
184 /// **Michel Foucault, Language, Countermomory, Practice, 1977** /// http://www.flickr.com/photos/michaelkelleher/4278446745/
185 /// **Blueprint, 1989** /// courtesy of the author
186 /// **Blueprint, 1989** /// courtesy of the author
187 /// **Katherine McCoy, chair, Fourteenth Annual 100 Show Design Year in Review, 1992** /// http://www.flickr.com/photos/robdewey/3926551266/
188 /// **Eye Vol.3 No.9, 1993** /// http://www.eyemagazine.com/magazine/issue-9
189 /// **Eye Vol.4 No.15, 1994** /// http://www.eyemagazine.com/magazine/issue-15
190 /// **Renée Riese Hubert, guest editor, Visible Language vol.25 2/3, 1991** /// courtesy of the author
191 /// **Essays on Design: AGI's Designers of Influence, 1997** /// http://www.paul-rand.com/foundation/books_thoughtsOnPaulRand/#.UQAMxYnjlxk
192 /// **Emigre 21, 1992** /// http://studiosnack.com/2011/01/typographers-designers-short-list/
193 /// **Anne Burdick, editor, Emigre 35, 1995** /// http://www.muamat.com/classifieds/1120/posts/5_Buy_and_Sell/46_Books/3602502__DESIGN_STUDENTS_EMIGRE_SUMMER_1995_Essays_writing_design_Emigr.htmlT
194 /// **Anne Burdick, editor, Emigre 36, 1995** /// http://www.emigre.com/EMag.php?issue=36
195 /// **Eye No.20, 1996** /// http://www.eyemagazine.com/magazine/issue-20
196 /// **Design Issues 10.2, 1994** /// http://www.cellarstories.com/shop/cellar/129687.html
197 /// **Emigre 43, 1997** /// http://www.emigre.com/EMag.php?issue=43
198 /// **Steven Heller, editor, The Education of a Graphic Designer, 1998** /// http://www.betterworldbooks.com/the-education-of-a-graphic-designer-the-education-of-a-graphic-designer-id-1880559994.aspx
199 /// **Ellen Lupton & Abbott Miller, Design, Writing, Research: Writing on Graphic Design, 1996** /// http://guides.lib.umich.edu/content.php?pid=30241&sid=223432
200 /// **Mike Sharples, How We Write: Writing as Creative Design, 1999** /// http://abc-anglophiles.blogspot.com/
201 /// **Rudy Vanderlans, editor, Emigre 39, 1996** /// http://mobiletest.moma.org/explore/collection/object/112337.iphone?moma_url_type=int&moma_title=Emigre%2039,%20The%20Next%20Big%20Thing#object_112337
202 /// **I.D. Vol.47 No.2, 2000** ///
203 /// **AIGA Journal of Graphic Design, vol.16 no.2, 1998** /// http://www.clementmok.com/files/98_AIGAjournal.pdf
204 /// **Rick Poynor, Vaughan Oliver: Visceral Pleasures, 2000** /// http://www.artbooks.de/v23/visceral_pleasures.html
205 /// **Eye No.38, 2000** /// http://www.eyemagazine.com/magazine/issue-38
206 /// **Journal of Aesthetic Education, 2002** /// http://www.press.uillinois.edu/journals/jae.html
207 /// **Rick Poynor, No More Rules: Graphic Design and Postmodernism, 2003** /// http://yalepress.yale.edu/book.asp?isbn=9780300100341
208 /// **Anthony Dunne & Fiona Raby, Design Noir: The Scret Life of Electronic Objects, 2001** /// http://softarchive.net/blogs/rosea/design_noir_the_secret_life_of_electronic_objects.919435.html
209 /// **Print Vol.55 No.1, January/February, 2001** /// http://designarchives.aiga.org/#/entries/%2Bid%3A1033/_/detail/relevance/asc/0/7/1033/print-magazine-cover/1
210 /// **Eye No.41, 2001** /// http://www.eyemagazine.com/magazine/issue-41
211 /// **Design Issues 22.2, 2006** /// http://www.mitpressjournals.org/toc/desi/22/2
212 /// **Michael Rock, 2x4.org: Fuck Content, 2005** /// http://2x4.org/
213 /// **Visual:Design:Scholarship Vol.2 No.2, 2007** /// http://research.agda.com.au/library/group/1202871096_document_01_vds020205.pdf
214 /// **Visual:Design:Scholarship Vol.2 No.2, 2007** /// http://research.agda.com.au/library/group/1202871019_document_01_vds020204.pdf
215 /// **Visual:Design:Scholarship Vol.3 No.1, 2007** /// http://research.agda.com.au/library/group/1202870760_document_01_vds030101.pdf

216 /// **Visual:Design:Scholarship Vol.3 No.1, 2007** /// http://research.agda.com.au/library/group/1202870848_document_01_vds030103.pdf
217 /// **Maria Rogal, Designer as Author, 2009** /// http://www.mariarogal.com/teaching/designer-as-author/
218 /// **Dmitri Siegel, Design Observer: Designers and Dilettantes, 2007** /// http://observatory.designobserver.com/entry.html?entry=5947
219 /// **Kate Bowden, How Should We Critique 'Critical Design'?, 2007** /// http://monomo.co.uk/blog
220 /// **Print, October, 2008** /// http://greg.gmake.tv/print-magazine/
221 /// **Journal of Design History Vol.22 No.4, 2009** /// http://jdh.oxfordjournals.org/content/22/4.toc
222 /// **Design Issues 27.1, 2010** /// http://www.mitpressjournals.org/toc/desi/27/1

INTERVIEW: RICK POYNOR

01 /// **Rick Poynor** /// http://alwaysreadthesmallprint.com/welcome/?p=6419
02 /// **Eye No.1, 1990** /// http://www.eyemagazine.com/magazine/issue-1
03 /// **Design Observer** /// http://www.226-design.com/wblog/mt-search.cgi?blog_id=10&tag=Design&limit=20
04 /// **Print, 2011** /// http://designspiration.net/image/515944492184/
05 /// **Royal College of Art, London** /// http://asklogo.com/show/detail/R/royal-college-of-art-logo#.URAk_InjIxk
06 /// **London, England** /// http://hawkebackpacking.com/england_london.html
07 /// **Rick Poynor, Typography Now: The Next Wave, 1992** /// http://www.everyotherbook.com/?page=shop/flypage&product_id=5192
08 /// **Rick Poynor, Transgression: Graphisme et Post Modernisme (No More Rules, French translation), 2003** /// http://paris.blog.lemonde.fr/2006/10/03/2006_10_transgressions_/
09 /// **Rick Poynor, Obey the Giant, 2007** /// http://www.betterworldbooks.com/obey-the-giant-id-3764385006.aspx
10 /// **Daniel Weil** /// http://www.dezeen.com/2009/12/11/super-contemporary-interviews-daniel-weil/
11 /// **Pentagram** /// http://ang.wikipedia.org/wiki/Bili%C3%BE:Pentagram_satan.GIF
12 /// **Blueprint** /// http://www.mediauk.com/magazines/342207/blueprint magazine/logo archive
13 /// **Typographica No.8, December 1963** /// http://www.modernism101.com/spencer_typographica_ns_08.php
14 /// **Herbert Spencer** /// from Rick Poynor, Typographica, 2001
15 /// **Rudy Vanderlans** /// http://tipografos.net/designers/vanderlans.html
16 /// **Emigre 10, 1988** /// http://paulineclancy.com/hello/?p=168
17 /// **The Penrose Annual, 1964** /// http://ayana-campbell.blogspot.com/2011_04_01_archive.html
18 /// **Herbert Spencer, Pioneers of Modern Typography, 1969** /// http://www.typegoodness.com/2009/10/pioneers-of-modern-type/
19 /// **Vaughan Oliver** /// http://www.computerarts.co.uk/interviews/vaughan-oliver
20 /// **New York NY** /// http://www.drug-rehab.org/new_york.html
21 /// **Rick Poynor, Vaughan Oliver: Visceral Pleasures, 2000** /// http://www.artbooks.de/v23/visceral_pleasures.html
22 /// **David Carson** /// http://www.3news.co.nz/Top-designers-no-show-costs-NZ-organiser-thousands/tabid/423/articleID/207909/Default.aspx
23 /// **David Carson design** /// http://www.visualkontakt.com/p/david-carson-design.html
24 /// **David Carson-esque design** /// http://dannygapar.deviantart.com/art/David-Carson-esque-War-Poster-93979897
25 /// **Thank you** /// http://www.sentiments-grimsby.co.uk/thank-you-cards.php?pagenumber=27

INTERVIEW: ELLEN LUPTON

01 /// **Ellen Lupton** /// http://conceptedmag.com/article/ellen-lupton-talks-design-education/
02 /// **Cooper-Hewitt National Design Museum, New York NY** /// http://www.150.si.edu/sibuild/coop.htm
03 /// **New York NY** /// http://www.etsy.com/listing/64471500/vintage-new-york-postcard-howdy-from-new
04 /// **Maryland Institute College of Art, Baltimore MD** /// http://www.firststudent.com/schools/MarylandInstituteCollegeofArt.htm
05 /// **Baltimore MD** /// http://aee-baltimore.org/
06 /// **Ellen Lupton and Abbott Miller, Design Writing Research, 1999** /// http://jasonsantamaria.com/reading/design-writing-research
07 /// **Abbott Miller** /// http://creativity-online.com/news/dance-design-and-magazines/135896
08 /// **Ellen Lupton and Abbott Miller, The ABC's of Bauhaus, The Bauhaus and Design Theory, 2000** /// http://geotypografika.com/2008/04/10/jenny-tondera-ellen-lupton/
09 /// **Graphic Design: Now in Production** /// http://projectprojects.com/graphic-design-now-in-production/
10 /// **Michael Rock** /// http://fac.arch.hku.hk/event/michael-rock-superficiality/
11 /// **Baltimore MD (continued)** /// http://aee-baltimore.org/
12 /// **Dave Eggers** /// http://www.huffingtonpost.com/lee-daniel-kravetz/dave-eggers-scholarmatch_b_2365307.html
13 /// **Jonathan Safran Foer** /// http://99u.com/articles/7026/99-Conference-2011-Key-Insights-on-Idea-Execution
14 /// **Bruce Mau** /// http://www.architizer.com/en_us/blog/dyn/tag/bruce-mau-design/#.URGrCInjIxk
15 /// **Craig Mod** /// http://la.anatomiadelaedicion.com/2011/07/craig-mod-libros-y-edicion-posartefacto/
16 /// **A List Apart** /// http://mervi.helmikuu.net/2013-01-new-list-apart
17 /// **Information Architects** /// http://www.boostinspiration.com/web-design/responsive-web-design-quick-guide-creative-examples/
18 /// **Switzerland** /// http://www.flags.net/SWIT.htm
19 /// **Bauhaus** /// http://www.bc.edu/bc_org/avp/cas/fnart/fa267/gropius.html
20 /// **Bauhaus** /// http://48-music.blogspot.com/2011/08/bauhaus.html
21 /// **Ellen Lupton, Graphic Design Thinking, 2011** /// http://laurenpadams.com/2011/02/graphicdesignthinking
22 /// **Ellen Lupton, D.I.Y.: Design It Yourself, 2006** /// http://www.flickr.com/photos/myopiapix/115847886/
23 /// **Princeton Architectural Press** /// http://www.flickr.com/photos/myopiapix/115847886/
24 /// **Ellen Lupton, Graphic Design: The New Basics, 2008** /// http://jpgds120.blogspot.com/2010/04/new-basics.html
25 /// **Montreal, Canada** /// http://www.canadatop.com/article/Montreal+canada
26 /// **Thank you** /// http://kamloopsfoodbank.org/a-generous-thank-you

CHAPTER 2

WRITING NEEDS GRAPHIC DESIGN

01 /// **N. Katherine Hayles** /// http://transliteracies.english.ucsb.edu/post/conference-2005/participants/n-katherine-hayles
02 /// **Beatrice Warde** /// http://www.polyvore.com/biograf%C3%ADas_beatrice_warde_primera_dama/thing?id=58489603
03 /// **Crystal goblet** /// http://www.crystalacarte.com/crystal-wine-goblet-olinda-578.htm
04 /// **Roman alphabet** /// http://www.inthisveryroom.com/Font-Choices/
05 /// **Robert Venturi** /// http://www.vanityfair.com/online/daily/2012/08/farewell-to-robert-venturi-las-vegas-architect
06 /// **Pro wrestler** /// http://blog.larryweaver.com/2008/01/ufc-vs-wwe-pro-wrestlers-mma-fighters.asp

07 /// **Pro wrestler, ITC Edwardian Script** /// courtesy of the designer
08 /// **B** /// http://playrific.com/m/1604/practice-drawing-the-letters-game
09 /// **Hrant Papazian** /// https://www.fontfont.com/designers/hrant-papazian
10 /// **Hrant Papazian, Mas Lucida, 1998** /// http://luc.devroye.org/fonts-39560.html
11 /// **Saccades** /// http://en.wikipedia.org/wiki/File:Reading_Fixations_Saccades.jpg
12 /// **Zuzana Licko** /// http://tipografos.net/designers/zuzana-licko.html
13 /// **Gerard Unger** /// http://design.nl/item/gerard_unger_honoured_by_university_of_hasselt
14 /// **Gerard Unger, While You're Reading, 2007** /// http://aworkinglibrary.com/library/book/while_youre_reading/
15 /// **MIT Press** /// https://libraries.mit.edu/sites/news/access-event/9405/
16 /// **Bruce Sterling** /// http://commons.wikimedia.org/wiki/File:Bruce_Sterling_at_ARE_2010.jpg
17 /// **Bruce Sterling, Shaping Things, 2005** /// http://magicalnihilism.com/category/systems/
18 /// **Lorraine Wild** /// http://adht.parsons.edu/designstudies/2012/10/07/conversation-with-lorraine-wild-expanding-the-purview-of-communication-design/
19 /// **N. Katherine Hayles** /// http://www.rit.edu/alumni/ihf/inductee.php?inductee=8
20 /// **N. Katherine Hayles, Writing Machines, 2002** /// http://myweb.fsu.edu/jjm09f/writing19.html
21 /// **Anne Burdick** /// http://www2.artcenter.edu/80years/voices/burdick.php
22 /// **Brenda Laurel** /// http://www.ted.com/speakers/brenda_laurel.html
23 /// **Brenda Laurel, Utopian Entrepreneur, 2001** /// http://www.mediamatic.net/5636/en/utopian-entrepreneur
24 /// **Denise Gonzalez Crisp** /// http://www.flickr.com/photos/annmaryliu/4967902991/
25 /// **Paul D. Miller (aka DJ Spooky)** /// http://www.bar-none.com/dj-spooky.htmlV
26 /// **Paul D. Miller, Rhythm Science, 2004** /// http://ffffound.com/image/f40b5c34c58739b12039ea1d3dc97c8b49ed4c1f
27 /// **COMA (Cornelia Blatter)** /// http://design.nl/item/from_otis_in_la_to_coma_in_amsterdam
28 /// **COMA (Marcel Hermans)** /// http://design.nl/item/from_otis_in_la_to_coma_in_amsterdam
29 /// **Peter Lunenfeld holding User:InfoTechnoDemo, 2001** /// http://www.mediamatic.net/41942/en/peter-lunenfeld
30 /// **Mieke Gerritzen** /// http://e-boekenstad.nl/unbound/index.php/page/2/
31 /// **T-shirt** /// http://ericrivera.com/zencart/index.php?main_page=index&cPath=1
32 /// **Daily paper** /// http://www.yoozpaper.com/
33 /// **Les Brown & his Orchestra with Doris Day, Sentimental Journey, 1944** /// http://www.authentichistory.com/1939-1945/3-music/13-Homecoming/19441120_Sentimental_Journey-Doris_Day_Les_Brown.html
34 /// **Kris Sowersby** /// http://www.getfrank.co.nz/editorial/features/interview-kris-sowersby
35 /// **Sarah Maxey** /// http://www.typographichub.org/diary/entry/type-writing/
36 /// **Kate Camp** /// http://www.nzatfrankfurt.govt.nz/news/poet-kate-camp-talks-rilke-and-life-berlin
37 /// **New Zealand** /// http://www.operationworld.org/newz
38 /// **Katherine McCoy** /// http://www.ashleyattwood.co.uk/public_html/?cat=25
39 /// **Cranbrook Academy of Art, Bloomfield Hills MI** /// http://www.metromodemedia.com/features/Cranbrook0047.aspx
40 /// **Colorado** /// http://www.myonlinemaps.com/colorado.php
41 /// **High Ground** /// http://www.highgrounddesign.com/workshops/currentframe2.htm
42 /// **Stevie Wonder, Higher Ground, 1973** /// http://www.kananabid.com/cgi-bin/auction/view?cmd=view&listingID=12124
43 /// **Katherine McCoy, See Read Image Text, 1989** /// http://www.poisongalore.org/web/lezioni/26/2605.htm
44 /// **Jonathan Safran Foer, Extremely Loud & Incredibly Close, 2005** /// http://incunabularillumination.blogspot.com/2011/05/extremely-loud.html
45 /// **Jonathan Safran Foer** /// http://gawker.com/5583306/jonathan-safran-foer
46 /// **Anne Chalmers** /// https://plus.google.com/photos/118156424601845989090/albums/5086380827222044849/5086380943186161906?banner=pwa
47 /// **Miklós Tótfalusi Kis, Janson, 1685** /// http://www.fonts.com/font/linotype/janson-text/complete-family-pack
48 /// **Oskar Schell (as played on screen by Thomas Horn)** /// http://screenpicks.com/2011/12/review-extremely-loud-is-incredibly-dramatic/
49 /// **Steven Hall** /// http://www.simontrewin.com/?p=143
50 /// **Steven Hall, The Raw Shark Texts, 2007** /// http://www.gq-magazine.co.uk/create-britain/home/creatives?page=5
51 /// **An oncoming shark** /// http://www.hoax-slayer.com/shark-behind-divers.shtml
52 /// **Zenon Fajfer** /// http://hl.wbp.lublin.pl/wbp/index.php/archiwum/imprezy/2010/393-fotorelacja-z-czwartego-dnia-tygodnia-bibliotek.html
53 /// **London, England** /// http://www.healthinsurancesolutions.co.uk/london
54 /// **Visual Editions typeface** /// http://www.flickr.com/photos/visualeditions/4818752166/

TYPOGRAPHIC DESIGN AUTHORSHIP

01 /// **Arial** /// http://www.silexlabs.org/1639/exchange/exchange-silex/fonts/font-arial/
02 /// **Zapfino Extra X Pro Regular** /// http://www.fontshop.com/fonts/singles/linotype/zapfino_extra_x_pro_regular/
03 /// **William Morris** /// http://www.hrc.utexas.edu/exhibitions/web/morris/
04 /// **Kelmscott Press** /// http://www.victorianweb.org/authors/morris/kelmscott.html
05 /// **William Morris, The Story of the Glittering Plain, 1891** /// http://morrisedition.lib.uiowa.edu/storyglitteringplain.html
06 /// **William Morris, The Story of the Glittering Plain, ebook edition 2011** /// http://www.kobobooks.com/ebook/The-Story-of-Glittering-Plain/book-FzkMzhiDsE2rHUfetSDJRA/page1.html
07 /// **William Morris, News From Nowhere, 1892** /// http://preraphaelitepaintings.blogspot.com/2010/08/william-morris-news-from-nowhere-text.html
08 /// **William Morris, News From Nowhere, CreateSpace Independent Publishing Platform, 2008** /// http://www.amazon.com/News-From-Nowhere-William-Morris/dp/1440468710
09 /// **Commonweal, 1890** /// http://www.lib.umich.edu/pursuit-ideal-life-art-william-morris/writings.html
10 /// **University of Oxford, Oxford UK** /// http://armstrong.chem.ox.ac.uk/
11 /// **University of Maryland Terrapins** /// http://collegefabricstore.com/university-of-maryland-c-81_93.html
12 /// **William Morris, Golden, 1890** /// http://havingalookathistory-ofgraphicdesign.blogspot.com/2012/06/kelmscott-press.html
13 /// **Nicholas Jenson** /// http://picasaweb.google.com/lh/photo/ZchUfhlwvAR70fADuPzx-A
14 /// **William Morris, Troy, 1892** /// http://www.fontsplace.com/p22-morris-troy-premium-font-download.html
15 /// **William Morris, Chaucer, 1893** /// http://www.volcano-type.de/fonts/categories/roughgrunge/chaucer/chaucer
16 /// **Philip Meggs** /// http://www.aiga.org/medalist-philipbmeggs/
17 /// **Eric Gill** /// http://www.linotype.com/391/ericgill.html
18 /// **Eric Gill, Gill Sans, 1926** /// http://idsgn.org/posts/know-your-type-gill-sans/
19 /// **Paul Renner, Futura, 1927** /// http://centerforbookarts.blogspot.com/2012/02/tuesday-typefaces-futura.html
20 /// **London Underground** /// http://www.europosters.eu/london-london/
21 /// **Edward Johnston** /// http://hans.presto.tripod.com/

isbn/1854142313.html
22 /// **Edward Johnston, Johnston Sans, 1919** /// http://flickriver.com/photos/36844288@N00/3679629462/
23 /// **Simon Loxley** /// http://www.congresotipografia.com/la-vida-secreta-de-las-letras/
24 /// **Simon Loxley, Type: The Secret History of Letters, 2004** /// http://www.typeoff.de/2008/02/24/on-the-terror-of-glyphs-and-the-joy-of-reading/
25 /// **Eric Gill, Perpetua, 1929** /// http://stoneletters.wordpress.com/2010/12/25/fournier-and-perpetua-a-clarification/
26 /// **Eric Gill, Joanna, 1937** /// http://www.identifont.com/similar?PL
27 /// **Kool & the Gang, Joanna, 1983** /// http://www.45cat.com/record/de829
28 /// **Hague & Gill** /// http://www.flickriver.com/photos/tags/highwycombe/interesting/
29 /// **The Golden Cockerel Press** /// http://www.wolfsonian.org/taxonomy/term/95/0?page=269
30 /// **Eric Gill, An Essay on Typography, 1931** /// http://www.designweek.co.uk/we-like/the-phaidon-archive-of-graphic-design/3035143.article
31 /// **Eric Gill, Portrait of René Hague, 1925** /// http://www.harvardartmuseums.org/art/297969
32 /// **Jan Tschichold** /// http://www.thinkingform.com/2012/04/02/thinking-jan-tschichold-04-02-1902-2/
33 /// **Jan Tschichold, "Die Neue Typographie" lecture invitation, 1927** /// http://www.thisisdisplay.org/collection/jan_tschichold_die_neue_typographie_lecture_invitation/
34 /// **Herbert Bayer, Universal Alphabet, 1925** /// http://examthemes.blogspot.com/2012/11/typography-brief-history-of-20th.html
35 /// **Herbert Bayer** /// http://kaufmann-mercantile.com/now-haus/
36 /// **Theo Van Doesburg** /// http://dadasurr.blogspot.com/2011/09/theo-van-doesburg.html
37 /// **Theo Van Doesburg, Alphabet, 1919** /// http://www.textwrap.net/2010_04_01_archive.html
38 /// **Paul Renner** /// http://ydnaarmstrong.blogspot.com/2009/10/futura.html
39 /// **Paul Renner, Futura original drawings** /// http://blog.fonts.com/2010/11/03/futura-now-available-via-fonts-com-web-fonts/
40 /// **Apple Macintosh, 1984** /// http://www.pcmag.com/slideshow/story/262715/the-most-influential-technologies-round-1-desktop-and-laptop/3
41 /// **Apple LaserWriter, 1985** /// http://www.macworld.com/article/1150845/laserwriter.html
42 /// **Vector versus bitmap** /// http://sthcpennisicreativemedia.blogspot.com/2011/05/vector-vs-bitmap-images.html
43 /// **Emigre** /// http://www.backspace.com/notes/topic/self/1
44 /// **Berkeley CA** /// http://www.tripadvisor.com/LocationPhotos-g32066-Berkeley_California.html
45 /// **Rudy Vanderlans, Emigre 1, 1984** /// http://www.emigre.com/EMag.php?issue=1
46 /// **Zuzana Licko and Rudy Vanderlans** /// http://www.typographia.com.ar/typo2/page/2/
47 /// **Zuzana Licko, Lo Res Cyrillic, 1985** /// http://www.emigre.com/EF.php?fid=211
48 /// **Zuzana Licko, Matrix Italic, 1991, 2007** /// http://luc.devroye.org/myfonts-chromatic/
49 /// **The Matrix, 1999** /// http://www.cinemablend.com/reviews/The-Matrix-438.html
50 /// **Zuzana Licko, Narly, 1993** /// http://www.myfonts.com/fonts/emigre/narly/
51 /// **Gnarly** /// http://chartroose.wordpress.com/2008/09/30/surfer-dudes-guess-that-gnarly-gnovel-5/
52 /// **Zuzana Licko, Totally Gothic, 1990** /// http://www.myfonts.com/fonts/emigre/totally-gothic/
53 /// **Zuzana Licko, Filosofia, 1996** /// http://www.type.co.uk/a_to_z_listing/d/28742
54 /// **Zuzana Licko, Base Nine, 1995** /// http://www.myfonts.com/fonts/emigre/base-9-and-12/
55 /// **Zuzana Licko, Mrs. Eaves, 1996** /// http://xk9.com/bones/tt-008/

56 /// **John Baskerville** /// http://www.allposters.com/-sp/John-Baskerville-Engraving-Posters_i9038322_.htm
57 /// **Zuzana Licko, Mrs. Eaves Just Ligatures, 1996** /// http://ilovetypography.com/2007/09/09/decline-and-fall-of-the-ligature/
58 /// **Zuzana Licko, Mr. Eaves, 2009** /// http://www.designworklife.com/2009/10/22/mrs-eaves-has-a-mate/
59 /// **Jonathan Barnbrook, Prototype, 1995** /// http://www.identifont.com/show?96G
60 /// **Jonathan Barnbrook** /// http://www.flickr.com/photos/fontblog/4699468362/
61 /// **Jonathan Barnbrook, Priori, 2003** /// http://www.miscportfolio.com/tipo/
62 /// **Jonathan Barnbrook, Priori Sans, 2006** /// hhttp://www.whatfontis.com/Priori-Sans-Bold-OT.font
63 /// **Jonathan Barnbrook, Mason Sans Bold OT, 2008** /// http://www.fontshop.com/fonts/singles/emigre/mason_sans_bold_ot/
64 /// **Sign painting** /// http://kaufmann-mercantile.com/show-card-writing/
65 /// **Stone carving** /// http://typestack.com/uncategorized/the-right-type-of-education/
66 /// **Eye, Winter 1994** /// http://www.eyemagazine.com/magazine/issue-15
67 /// **Rick Poynor** /// http://www.mousharaka.com/en/node/155
68 /// **Adbusters** /// http://www.adbusters.org/cultureshop/backissues/93
69 /// **Fabulous Las Vegas** /// http://www.leontravelclub.com/las-vegas.html/las-vegas-city-4
70 /// **Tibor Kalman** /// http://www.projectswatches.com/architects/tibor-kalman-1949-1999/
71 /// **Jonathan Barnbrook, Stay Away from Corporations That Want You to Lie for Them, 1999** /// http://maxbruinsma.nl/index1.html?authors.html
72 /// **Tate Modern, London** /// http://alexastrautmanis.blogspot.com/2012/01/tate-modern.html
73 /// **Nicholas Bourriaud** /// http://giancinephile.typepad.com/blog/2011/08/mind-map-n-26-ten-people-to-meet-part-deux-.html
74 /// **Nicholas Bourriaud, Relational Aesthetics, 1998** /// http://www.joeltparsons.com/index.php?/collaborations/wish-you-were-here/
75 /// **David Carson** /// http://www.thedrum.com/news/2011/06/27/twitter-debate-erupts-between-designer-david-carson-and-magazine-bearing-his-name
76 /// **Lars Müller, Helvetica: Homage to a Typeface, 2002** /// http://librosparapablo.blogspot.com/2012/07/helvetica-homage-to-typeface.html
77 /// **Lars Müller** /// http://www.lars-mueller-publishers.com/en/backstage/festarch-2012-in-perugia
78 /// **Helvetica** /// http://centerforbookarts.blogspot.com/2012/04/tueday-typefaces-helvetica.html
79 /// **Christian Schwartz, Neue Haas Grotesk (revival), 2011** /// http://www.rockpaperink.com/content/column.php?id=69&catid=74
80 /// **Max Miedinger** /// http://www.linotype.com/522/maxmiedinger.html

THE VISUAL-VERBAL TEXT

01 /// **Anne Burdick** /// https://twitter.com/anneburdick
02 /// **Eye, Summer 1993** ///http://www.eyemagazine.com/magazine/issue-9
03 /// **Ellen Lupton** /// http://www.behance.net/gallery/Photography-Ellen-Lupton/174151
04 /// **Stèphane Mallarmé** /// http://www.atuttascuola.it/siti/stella/stephane_mallarme.htm
05 /// **Stéphane Mallarmé, Un Coup de Dés Jamas N'Abolira Le Hasard, 1897** /// http://www.harpreetkhara.com/archives/14739
06 /// **Ruth and Marvin Sackner** /// http://www.123people.com/ext/frm/?ti=person%20finder&search_term=marvin%20sackner&search_country=US&st=person%20finder&target_url=aHR0cHM6Ly9waWNhc2F3ZWIuZ29vZ2xlLmNvbVS8xM-

TA1MzkwNzU5MzQxNDc1OTk3MDEvQXZhbnRHYXJkZVZlc-
m9uYT9hdXRoa2V5PWNoakFoZEVISFFrIzUOODYOOTY3N-
TM1NDQxNDcyOTg%3D

07 /// **The Sackner Archive, entrance to publications storage** ///
http://www.paulj.myzen.co.uk/blog/futurism/?page_id=357

08 /// **Fluxus typography** /// http://stendhalgallery.com/?p=4964

09 /// **Inism typography** /// http://inism.blogspot.com/

10 /// **Tristan Tzara** /// http://archives-dada.tumblr.com/
post/22254890348/man-ray-tristan-tzara-1924-gelatin-silver

11 /// **Tristan Tzara, Calligramme, 1917** /// http://concept.
bohemiaerosa.org/studijni-texty-study-scripts/
collatanea-prosperova-knihovna/slovo-a-obraz/kaligram

12 /// **Guillaume Apollinaire** /// http://www.maulpoix.net/
blogjmm/wordpress/apollinaire-en-arlequin/

13 /// **Guillaume Apollinaire, Calligramme, 1914** /// http://
www.ciudadluz.net/eiffel/eiffel2.htm

14 /// **Piet Zwart** /// http://www.noupe.com/spotlight/piet-zwart-
the-rebellious-type.html

15 /// **Piet Zwart, Wij Nu Experimenteel Toneel, 1925** ///
http://80magazine.wordpress.com/category/piet-zwart/

16 /// **Steve McCaffery** /// http://writingencounters.squarespace.
com/journal/tag/steve-mccaffery

17 /// **Typewriter** /// http://www-03.ibm.com/ibm/history/
exhibits/modelb/modelb_intro.html

18 /// **Tom Philips, Humument Self-Portrait at Fifty, 1987**///
http://www.npg.org.uk/collections/search/portraitLarge/
mw74240/Tom-Phillips-Humument-Self-Portrait-at-Fifty

19 /// **Tom Philips, A Humument, 1980** /// http://humument.
com/intro.html

20 /// **A Humument App** /// http://tpexhibitions.blogspot.
com/2011/01/humument-app-now-available-for-iphone.html

21 /// **Chip Kidd** /// http://monsieurbandit.blogspot.com/2011/03/
chip-kidd-again.html

22 /// **Chip Kidd, The Cheese Monkeys, 2001** /// http://
www.quipidity.com/tag/the-cheese-monkeys/

23 /// **Carnival** /// http://seedsofgrowth.com/carnival-of-business-14

24 /// **Carnaval** /// http://en.wikipedia.org/wiki/File:Carnaval_San_
Francisco_2006.jpg

25 /// **Rubber Stamp** /// http://www.acclaimimages.com/_gallery
_image_pages/0269-0608-2813-1311.html

26 /// **Fiona McMahon** /// http://www.lesdebats.fr/guest/
fiona-mcmahon/

27 /// **Ryan Cox** /// http://www.facebook.com/photo.php?fbid=5521
5336331&set=pb.634981331.-2207520000.1354839309&type
=3&theater

28 /// **Marjorie Perloff** /// http://scarriet.wordpress.
com/2012/08/17/is-marjorie-perloff-someones-crazy-aunt/

29 /// **Joanna Drucker** /// http://epc.buffalo.edu/authors/drucker

30 /// **W.H. Mallock, A Human Document, 1892** /// http://
thestrangestbooksicanfind.wordpress.com/2011/04/

31 /// **W.H. Mallock** /// http://uk.ebid.net/for-sale/1907-print-w-h-
mallock-english-sociologist-22822738.htm

32 /// **Abstract color field painting (Morris Louis, Where, 1960)**
/// http://artfortheblogofit.blogspot.com/2010/01/
color-field-painting.html

33 /// **Pictorial symbolism (Salvador Dali, Flight of a
Bumblebee, 1944)** /// http://madamepickwickartblog.
com/2009/11/what-dreams-may-come/

34 /// **Comic book panel** /// http://blog.typograffit.com/2010/11/
comic-book-sound-effects/

35 /// **Jennifer Wagner-Lawler** /// http://cas2.memphis.edu/
accolades/2007/casdra.htm

36 /// **James Maynard** /// http://jacketmagazine.com/38/
jwb04b-maynard-jim-jw-rd.shtml

37 /// **Jonathan Safran Foer** /// http://www.esquire.com/blogs/
books/My-Explosion-blog

38 /// **Automatic Die Cutting machine** /// http://lsqiao.
en.made-in-china.com/productimage/obZnvdYOl-
JVu_2f0j00MCmacwpJMToI/China-Automatic-Die-Cutting-
Machine-1080E-Model-Autoplaten-.html

39 /// **Bruno Schulz** /// http://souciant.com/category/reads/
fiction/

40 /// **Bruno Schulz, The Street of Crocodiles, 1934** /// http://
en.wikipedia.org/wiki/The_Street_of_Crocodiles

41 /// **Crocodile** /// http://www.naturephoto-cz.com/american-
crocodile-photo-1638.html

42 /// **J.D. Salinger, The Catcher in the Rye, 1951** /// http://
articles.nydailynews.com/2010-01-30/entertainment/
27052607_1_salinger-rye-big-screen

43 /// **Véronique Vienne** /// http://www.posterpage.ch/exhib/
ex151jeke/ex151jek2.htm

44 /// **Ken Garland, First Things First, 1964** /// http://www.
patrickstjohn.org/first-things-first-manifestos-1964-and-2000

45 /// **Adrian Frutiger, Apollo, 1962** /// http://store1.adobe.com/
cfusion/store/html/index.cfm?store=OLS-US&event=
displayFont&code=APOQ10005000

46 /// **Giambattista Bodoni, Bodoni, 1798** /// http://www.
fonthaus.com/fonts/bitstream/Bauer_Bodoni/BT001117

47 /// **Rick Poynor** /// http://www.flickr.com/photos/
graphicdesignmuseum/4206016400/

48 /// **Quark Xpress** /// http://www.amazon.co.uk/Quark-Inc-
QuarkXpress-4-1-Mac/dp/B000058DTJ

49 /// **Thomas Hine** /// http://www.thomashine.com/bio.htm

50 /// **The New York Times** /// http://usdailyreview.com/
what-does-the-shift-in-ny-times-ad-revenue-mean-to-digital-
publishers

51 /// **Chip Kidd, The Learners, 2008** /// http://www.
designrelated.com/inspiration/view/Karen/entry/1740/
the-learners-by-chip-kidd

TYPOGRAPHY AND LIFE: A COMPARISON

01 /// **Eric Gill** /// http://www.traditioninaction.org/HotTopics/
j005htGill_Distributism_Odou.htm

02 /// **Jonathan Barnbrook** /// http://origin.static.computerarts.
co.uk/interviews/jonathan-barnbrook

03 /// **Jan Tschichold** /// http://kenzietubbs.blogspot.
com/2009/08/who-is-jan-tschichold.html

04 /// **Alexi Brodovitch** /// http://www.richardavedon.com/index.
php#mi=2&pt=1&pi=10000&s=14&p=0&a=0&at=0

05 /// **Paul Rand** /// http://anewdesigns.blogspot.com/2010/08/
angry-paul-rand.html

06 /// **Push Pin Graphic** /// http://fnar370.wordpress.com/tag/
pushpin/

07 /// **Octavo** /// http://www.thinkingform.com/2012/08/08/
thinking-8vo-86-1/

08 /// **Emigre** /// http://zeynepselcukva312.wordpress.
com/2010/12/21/emigre-magazine/

09 /// **Ellen Lupton** /// http://www.thinkingwithtype.com/

10 /// **Stuart Bailey** /// http://reactor-reactor.blogspot.
com/2008/02/personal-views-37-stuart-bailey-on.html

11 /// **Eric Gill, Gill Sans, 1926** /// http://www.tumblr.com/
tagged/gill-sans

12 /// **Stanley Morison** /// http://www.unostiposduros.com/
el-arte-del-impresor/

13 /// **Gill Sans Monotype Sample** /// http://whatkidsenjoy.com/
qbtki/Eric-Gill

14 /// **Gerard Mermoz (left)** /// http://www.123people.com/ext/
frm?ti=person%20finder&search_term=gerard%20
mermoz&search_country=US&st=person%20finder&tar-
get_url=aHR0cDovL3d3dy50aGVoZXJiZXJ0Lm9yZy9pbmR-
leC5waHAvaW1hZ2UvNzUxL2hvbWUvbmV3cy9tYWpvci-
1uZXctaW50ZXJuYXRpb25hbC1leGhpYml0aW9uLW9wZWSz-
WF0LXRoZS1oZQ%3D%3D

15 /// **Beatrice Warde** /// http://theworldsgreatestbook.com/
crystal-goblet-beatrice-warde/

16 /// **Chichester, England** /// http://pippahunnechurch.com/
about/chichester-england

17 /// **Edward Johnston** /// http://www.linotype.com/733/
edwardjohnston.html

18 /// **Central School of Art and Design, High Holborn, London** ///
https://www.frieze.com/issue/article/history-lessons/

19 /// **London, England** /// http://flynationwide.co.za/fly-to-london/

20 /// **London Underground** /// http://oursurprisingworld.com/
london-underground-great-britan/

21 /// **London and North Eastern Railway timetable** /// http://
www.flickriver.com/photos/36844288@N00/3866730671/

22 /// **Brighton, England** /// http://www.flickr.com/photos/

davel59/5474663344/
23 /// **Canterbury Cathedral, Church of England** /// http://www.telegraph.co.uk/news/religion/7054097/Average-age-of-churchgoers-now-61-Church-of-England-report-finds.html
24 /// **Roman Catholic Church** /// http://webpages.scu.edu/ftp/jronen/RomanCatholicChurch.htm
25 /// **Eric Gill, The Four Gospels, Golden Cockerel Press, 1931** /// http://myloc.gov/Exhibitions/Bibles/OtherBibles/ExhibitObjects/TwentiethCenturyBiblewithIllustrationsbyEricGill.aspx?Enlarge=true&ImageId=886c5b91-a9b5-4fbf-a7e2-776c45f18484%3A8275982c-7354-4f46-af30-5948c4102449%3A337&PersistentId=1%3A886c5b91-a9b5-4fbf-a7e2-776c45f18484%3A17&ReturnUrl=%2FExhibitions%2FBibles%2FOtherBibles%2FExhibitObjects%2FTwentiethCenturyBiblewithIllustrationsbyEricGill.aspx
26 /// **Golden Cockerel Press** /// http://cafecartolina.blogspot.com/2010/10/inspiration-golden-cockerel-press.html
27 /// **Eric Gill, The Stations of the Cross (The Entombment), 1918** /// http://www.artbible.net/3JC/-Mat-27,45_Entombment,freedom_Tombeau,%20liberation/17_21th_siecle/slides/20%20GILL%20THE%20ENTOMBMENT.html
28 /// **Eric Gill, The Creation of Man, League of Nations, Geneva, 1938** /// http://www.stay-tuned-to-sw.de/geneva_3.html
29 /// **Count Harry Kessler** /// http://www.nytimes.com/2011/12/25/books/review/journey-to-the-abyss-the-diaries-of-count-harry-kessler-1880-1918-book-review.html
30 /// **Eric Gill, Art Nonsense and Other Essays, 1929** /// http://www.peterharrington.co.uk/store/art-architecture-design/product/art-nonsense-and-other-essays/
31 /// **Eric Gill, An Essay on Life and Works in the England of 1931, & Particularly Typography, 1931** /// http://www.abebooks.com/books/type-typefaces-typographer-design-typophiles/typography-books.shtml
32 /// **Eric Gill, An Essay on Typography, 1988** /// http://endinginabook.designwallah.com/case3/
33 /// **Eric Gill, Money and Morals, 1934** /// http://www.biblio.com/eric-gill/money-morals~41906266~title
34 /// **Eric Gill, Trousers and the Most Precious Ornament, 1937** /// http://pinterest.com/pin/33425222204639192/
35 /// **Eric Gill, Autobiography, 1940** /// http://www.wolfsonian.org/taxonomy/term/95/0?page=89
36 /// **St. Bride Printing Library, London** /// http://privatelibrary.typepad.com/the_private_library/2011/05/special-libraries-as-prototypes-for-the-private-library.html
37 /// **Primitive Types, 1999** /// http://stbride.org/friends/publications/soanepr.html
38 /// **Eric Gill and the Guild of Saint Joseph & Saint Dominic, conference poster** /// http://nanovic.nd.edu/events/2009/11/19/1733-conference-eric-gill-and-the-guild-of-saint-joseph-saint-dominic/
39 /// **University of Notre Dame, Notre Dame IN** /// http://www.insideindianabusiness.com/newsitem.asp?ID=37412
40 /// **Central Saint Martins College of Art & Design, London** /// http://shatasm.blogspot.com/2011/06/chapter-71-cheryl-eastap.html
41 /// **Royal College of Art, London** /// http://www.dezeen.com/tag/royal-college-of-art/
42 /// **Damien Hirst** /// http://artobserved.com/2008/07/update-damien-hirst-goes-to-auction-at-sothebys-september-15-16-2008/
43 /// **Peter Chelkowski & Hamid Dabashi, Staging a Revolution: The Art of Persuasion in the Islamic Republic of Iran, 1999** /// http://www.justseeds.org/blog/2009/09/lists_a_dozen_poster_books_of.html
44 /// **Iman, I Am Iman, 2001** /// http://www.goodreads.com/review/show/144226925
45 /// **Damien Hirst, I Want to Spend the Rest of My Life Everywhere With Everyone One to One Always Forever Now, 1997** /// http://www.peterharrington.co.uk/store/art-architecture-design/product/i-want-to-spend-the-rest-of-my-life-everywhere-with-everyone-one-to-one-always-forever-now-3/
46 /// **Eye, Winter 2000** /// http://www.eyemagazine.com/magazine/issue-38
47 /// **Rick Poynor, Typography Now Two, 1996** /// http://www.gutenberg-intermedia.de/en/2009/09/
48 /// **AIGA, Voice 2 conference website** /// http://voiceconference.aiga.org/speakers/barnbrook_jonathan.html
49 /// **ICOGRADA: International Council of Graphic Design Associations: A Partner of the International Design Alliance** /// http://arts.brighton.ac.uk/collections/design-archives/archives/icograda
50 /// **ATYPI: Association Typographique Internationale** /// http://www.segura-inc.com/news/53/atypi
51 /// **First Things First 2000** /// http://champlaincore2012.blogspot.com/2012/04/cultural-worker-and-design.html
52 /// **Jonathan Barnbrook, Adbusters "Design Anarchy" issue, 2001** /// http://baltimore.aiga.org/537/
53 /// **Jonathan Barnbrook, Barnbrook Bible, 2007** /// http://www.virusfonts.com/store/books
54 /// **VirusFonts** /// http://fontdeck.com/foundry/virusfonts
55 /// **Adrian Shaughnessy** /// http://www.matdolphin.com/blog/2012/10/04/adrian-shaughnessy-already-said-it-better-than-us/
56 /// **Clerical collar** /// http://blog.beliefnet.com/deaconsbench/2010/07/why-a-priest-should-wear-the-collar.html
57 /// **London Soho** /// http://www.etraveltrips.com/blog/hip-and-fun-london/
58 /// **Seedy sex shop** /// http://www.telegraph.co.uk/news/worldnews/northamerica/usa/2144429/Kid-friendly-sex-shop-opens-in-New-York.html
59 /// **Jonathan Barnbrook with Margaret Richardson** /// http://www.flickr.com/photos/bluesmuse/favorites/?view=lg
60 /// **Charles Manson** /// http://socialpsychol.wordpress.com/2012/03/29/charles-manson/charles-manson-mugshot/
61 /// **Freemasonry** /// http://www.fallscity.org/history/zunck/fcnews/masons.html
62 /// **Jonathan Barnbrook, Mason, 1992** /// http://p-adamek0912-dc.blogspot.com/2009/09/jonathan-barnbrook.html
63 /// **Jonathan Barnbrook, Spindly Bastard, 1995** /// http://www.fonts.com/font/virus-fonts/bastard/spindly
64 /// **Jonathan Barnbrook, Fat Bastard, 1995** /// http://p-adamek0912-dc.blogspot.com/2009/09/jonathan-barnbrook.html
65 /// **Mike Myers as Fat Bastard** /// http://tvtropes.org/pmwiki/pmwiki.php/Main/FatBastard
66 /// **Jonathan Barnbrook, Prozac Lite, 1995** /// http://www.type.co.uk/a_to_z/id/10220
67 /// **Prozac** /// http://www.interbrand.com/en/our-work/Eli-Lilly-Prozac.aspx
68 /// **Jonathan Barnbrook, Exocet, 1992** /// http://fonts.radio-electronics.co/font/Exocet/Exocet%20font.htm
69 /// **Exocet missile** /// http://surbrook.devermore.net/adaptationsvehicles/militaryair/postwar/other/exocet.html
70 /// **Jonathan Barnbrook and Marcus Leis Allion, Coma, 2001** /// http://www.fontshop.com/blog/fontmag/002/02_virus/02_virus_coma_l.htm
71 /// **Coma, 1978** /// http://www.myrls.me/torrent-free-download/spiaczka-coma-1978-pl-480p-brrip-x264-ac3-slisu-lektor-pl/
72 /// **Jonathan Barnbrook and Marcus Leis Allion, Expletive, 2000** /// http://www.identifont.com/similar?973
73 /// **Jonathan Barnbrook and Marcus Leis Allion, Apocalypso, 1997** /// http://marketplace.veer.com/font/Apocalypso-VIT0000001
74 /// **Jonathan Barnbrook, Drone, 1995** /// http://www.identifont.com/show?968
75 /// **Drone** /// http://dronewarsuk.wordpress.com/2012/05/16/drones-as-military-use-expands-civil-use-being-developed/
76 /// **Jonathan Barnbrook, Tourette Extreme, 2005** /// http://www.type.co.uk/categories/sp/Engraved/let/T/id/14669
77 /// **Georges Gilles de la Tourette** /// https://www.healthtap.com/#topics/list-of-famous-people-with-tourette-syndrome
78 /// **Jonathan Barnbrook, Nixon Script, 1997** /// http://luc.devroye.org/fonts-23584.html

79 /// **Richard Nixon** /// http://www.npr.org/blogs/itsallpolitics/2011/11/16/142614581/illegal-during-watergate-unlimited-campaign-contributions-now-fair-game
80 /// **Jonathan Barnbrook, Regime, 2010** /// http://www.fonts.com/font/virus-fonts/regime/bold
81 /// **Michelle Trudo** /// http://www.facebook.com/michtrudo?v=app_2318966938
82 /// **Religious cult** /// http://arbitblogs.wordpress.com/tag/manchester-united-cult/
83 /// **David Earls** /// http://www.earls.me/David_Earls_Graphic_Design_and_Permaculture.html
84 /// **Malcolm Yorke** /// http://www.omnesamici.co.uk/CGSthenandnow/YorkeMalcolm.html
85 /// **Teutonic iron cross for iphone** /// http://www.zazzle.ca/iron_cross_teutonic_order_speckcase-176925500333057491
86 /// **Plus sign** /// http://www.plasticjungle.com/blog/2012/04/11/the-frugal-way-to-spend-a-secret-reward-card/plussign/
87 /// **Chi rho** /// http://galatiansfour.blogspot.com/2012/07/why-do-they-use-chi-rho.html
88 /// **The Letter X** /// http://etc.usf.edu/clipart/76200/76232/76232_x-gothlettr.htm
89 /// **Crosshairs** /// http://ohiocitizen.org/consumers-counsel-in-kasichs-crosshairs/
90 /// **Eric Gill, Crucifix, Chalice and Host, 1917** /// http://tapirr.livejournal.com/1345372.html
91 /// **Ragged-right versus justified text** /// http://www.smashingmagazine.com/2011/08/15/mind-your-en-and-em-dashes-typographic-etiquette/
92 /// **Jonathan Barnbrook, Mason Sans, 1992** /// http://providecoalition.com/cmg_keyframes/story/almost_perfect_font/

INTERVIEW: KENNETH FITZGERALD

01 /// **Kenneth FitzGerald** /// http://oduart.wordpress.com/2008/02/
02 /// **Old Dominion University, Norfolk VA** /// http://www.governor.virginia.gov/governorsClassic/resources.cfm
03 /// **Norfolk VA, 1940** /// http://www.nrha.us/content/publications
04 /// **Adversary: an Exhibition (of) Contesting Graphic Design**
05 /// **Thank you** /// http://www.afamousartist.com/thankyou.html

INTERVIEW: ANNE BURDICK

01 /// **Anne Burdick** /// http://merfeldphotography.com/portraits/
02 /// **Leipzig, Germany** /// http://bibliophemera.blogspot.com/2011/01/any-bookseller-in-leipzig-will-do.html
03 /// **Leipzig Book Fair** /// http://blog.magazin-deutschland.de/tag/buchmesse-leipzig/
04 /// **Art Center College of Design, Pasadena CA** /// http://www.durandpro.com/PDP%2005%20Art%20Center%20College%20of%20Design.htm
05 /// **Pasadena CA** /// http://www.pasadenafarmersmarket.org/pasadena_farmers_market_victory_park.html
06 /// **Anne Burdick, What has writing got to do with design?, Eye No.9, Summer 1993** /// courtesy of the designer
07 /// **Eye No.9, Summer 1993** /// courtesy of the designer
08 /// **Stuart Bailey** /// http://lectures.visarts.ucsd.edu/VALS_SP2012/artists/about_bailey.html
09 /// **Metahaven** /// http://vimeo.com/17595552
10 /// **Mieke Gerritzen** /// http://studiumgenerale2010.blogspot.com/2010/09/mieke-gerrizen-23-september-1530-k22.html
11 /// **Denise Gonzalez-Crisp** /// http://www.flickr.com/photos/annmaryliu/4968489994/
12 /// **Brian Roettinger** /// http://theyoungwolff.blogspot.com/2009/11/1120-artist-portrait-for-brand-x.html
13 /// **Project Projects** /// http://www.sarakerensphotography.com/blog/2012/03/20/projects-projects-with-adam-prem-and-rob/
14 /// **Michel Foucault** /// http://geopoliticaticus.wordpress.com/tag/michel-foucault/
15 /// **Chameleon** /// http://facinatingamazinganimals.wordpress.com/2012/07/01/visits-from-a-chameleon-other-animals/
16 /// **Electronic Book Review** /// http://www.electronicbookreview.com/
17 /// **Made Up: Design's Fictions** /// http://blogs.artcenter.edu/dottedline/tag/made-up/
18 /// **Thank You** /// http://www.fuelcycles.com/?p=586

CHAPTER 3
CULTURAL LEGITIMACY

01 /// **Rick Poynor** /// http://vernissage.tv/blog/2006/04/09/rick-poynor-communicate-museum-of-design-zurich-interview-part-2/
02 /// **Dmitri Siegel** /// http://tmagazine.blogs.nytimes.com/2009/07/09/the-insider-dmitri-siegel/
03 /// **Elliott Earls** /// http://monicabreen.com/elliott/
04 /// **Print, October 2011** /// http://www.printmag.com/Article/October-2011-Table-of-Contents
05 /// **Metahaven** /// http://www.valeriebennett.com/ongoing/architects/
06 /// **Deterritorial Support Group** /// http://www.guardian.co.uk/world/2011/dec/15/ikea-anarchists-derritorial-support-group

DESIGNER AS AUTHOR ACTIVIST

01 /// **Walter Benjamin** /// http://walterbenjaminportbou.cat/en/content/walter-benjamin
02 /// **Christina de Almeida** /// http://www.guardian.co.uk/world/2011/dec/15/ikea-anarchists-derritorial-support-group
03 /// **Adbusters corporate flag for sale** /// http://ironicsurrealism.com/2011/10/08/canadian-adbusters-sounded-1st-occupy-wallstreet-call-2-arms-who-are-they/
04 /// **Nicholas Blechman, Empire, 2007** /// http://www.mediabistro.com/unbeige/nicholas-blechmans-nozone-is-still-all-too-resonant_b4355
05 /// **Nicholas Blechman** /// http://www.aarome.org/people/current/rome-prize-fellows-and-projects?expand=396#396
06 /// **Iraq** /// http://travel.state.gov/travel/cis_pa_tw/cis/cis_1144.html
07 /// **Peter Buchanan-Smith** /// http://www.mediabistro.com/unbeige/seven-questions-for-peter-buchanan-smith_b4126
08 /// **Amy Gray** /// http://pinterest.com/supershopgirl/following/
09 /// **Pope** /// http://www.nationnews.com/articles/view/pope-prays-for-peace/
10 /// **Pope** /// http://www.poetryfoundation.org/bio/alexander-pope
11 /// **Prem Krishnamurthy** /// http://www.gestalten.com/event/talk-project-projects-prem-krishnamurthy
12 /// **Apple Store** /// http://newtech.aurum3.com/brand/apple-store-2-0-coming-soon/
13 /// **Charles S. Anderson** /// http://www.linkedin.com/pub/charles-anderson/48/61/973
14 /// **Thomas Frank** /// http://videocafe.crooksandliars.com/heather/thomas-frank-tea-party-movement-led-charac
15 /// **Matt Weiland** /// http://www.flickr.com/photos/penamericancenter/3493003458/
16 /// **Thomas Frank and Matt Weiland, Commodify Your Dissent, 1997** /// http://www.tcfrank.com/books/commodify-your-dissent/
17 /// **Lorraine Schneider** /// http://www.anothermother.org/wp-content/uploads/2009/10/AMPLorraine0001.pdf
18 /// **Shepard Fairey** /// http://www.nationaljournal.com/archives/2010/09/shepard_fairey.php
19 /// **Roland Barthes** /// http://politicsoffashionuiuc.wordpress.com/tag/roland-barthes/
20 /// **Pratt Institute; Brooklyn NY** /// http://inhabitat.com/gorgeous-myrtle-hall-shows-off-pratt-institutes-commitment-to-sustainability/
21 /// **North Vietnam** /// http://www.epier.com/product.asp?235050
22 /// **South Vietnam** /// http://novaonline.nvcc.edu/eli/evans/

23 /// **Another Mother for Peace** /// http://www.anothermother.org/
24 /// **Mothers Day card** /// http://clickamericana.com/eras/1910s/mothers-day-presidential-proclamation-1914
25 /// **United States Congress** /// http://www.nowpublic.com/world/us-congress-moving-right-centuries-old-wrong-0
26 /// **League of Nations, Geneva, Switzerland** /// http://www.switzerland-trips.com/Geneva/Geneve-attractions-activities.html
27 /// **Andre the Giant** /// http://www.onlineworldofwrestling.com/bios/a/andre-the-giant/
28 /// **obeygiant.com** /// http://www.obeygiant.com/
29 /// **Jim Fitzpatrick** /// http://advertising101.bluecrayon.co.uk/2011_03_01_archive.html
30 /// **Che Guevara** /// http://arjunravichandran.wordpress.com/2011/08/19/the-ghost-of-che-guevara/
31 /// **T-shirt** /// http://beautyeditor.ca/2012/01/25/got-curlyhairproblems-ive-got-answers-4-tips-i-swear-by-for-lovely-low-maintenance-curls-really/
32 /// **Karl Marx** /// http://www.marxists.org/xlang/marx.htm
33 /// **Alberto Korda, Guerrillero Heroico, 1960** /// http://www.tumblr.com/tagged/alberto-korda?before=1333049946
34 /// **Alberto Korda photographed by Paal Audestad** /// http://photo.net/photodb/photo?photo_id=788907
35 /// **Paal Audestad, Self Portrait** /// http://www.paalaudestad.com/#/About/
36 /// **Fidel Castro** /// http://www.freeinfosociety.com/article.php?id=23
37 /// **Associated Press office** /// http://www.mediaite.com/?attachment_id=501737
38 /// **Mannie Garcia** /// http://www.mediaite.com/?attachment_id=501737
39 /// **Mannie Garcia, Sen. Barack Obama, 2006** /// http://granitegrok.com/blog/2012/05/hope-we-dont-get-caught
40 /// **Lisa Cartwright** /// http://communication.ucsd.edu/people/faculty/lisa-cartwright.html
41 /// **Stephen Mandiberg** /// http://lab.softwarestudies.com/2007/05/about-software-studies-ucsd.html
42 /// **Sarah Palin** /// http://www.teapartytribune.com/2011/01/29/the-real-truth-about-sarah-palin-ouch/
43 /// **Sarah Palin Nope** /// http://www.zazzle.com/sarah_palin_nope_postcard-239801162025936854
44 /// **Sarah Palin Nope** /// http://www.bilerico.com/2008/10/early_voting_envy.php
45 /// **Sarah Palin Nope** /// http://my.opera.com/Scattergood66/albums/showpic.dml?album=588816&picture=8443302
46 /// **Bill Clinton** /// http://www.askmen.com/galleries/men/bill-clinton/picture-2.html
47 /// **Bill Clinton Grope** /// http://www.sodahead.com/united-states/this-soviet-style-poster-of-president-elect-barack-obama-reminds-me-mostly-of/question-187631/?link=ibaf&q=&imgurl=http://images.sodahead.com/polls/000187631/polls_Obama_Poster_Clinton_Grope_1_5424_208456_answer_4_xlarge.png
48 /// **Bill Clinton Grope** /// http://imgfave.com/search/funny%20bill%20clinton%20grope%20humor%20lol%20political
49 /// **Bill Clinton Grope** /// http://www.qatarliving.com/node/515842
50 /// **Pope** /// http://toddswift.blogspot.com/2010/09/pope-on-ropes.html
51 /// **Pope** /// http://www.flickr.com/photos/wfabry/2907762323/
52 /// **Pope** /// http://underdesign.wordpress.com/2010/08/30/hope-nope-dope-pope-knockoff-bumper-sticker-found-in-the-wild/
53 /// **Obama Dope** /// hhttp://www.fireandreamitchell.com/obama-satire/
54 /// **Obama Dope** /// http://www.flickr.com/photos/57901223@N00/3879145982/
55 /// **Obama Dope** /// http://macsgang.tumblr.com/post/22284214761
56 /// **Obama Viva** /// http://principalisandpowers.blogspot.com/2009/03/art-of-politics-in-age-of-obama.html
57 /// **Obama Che** /// http://lundesigns.blogspot.com/2008_02_01_archive.html
58 /// **Obama Rope** /// http://jimcrowmuseum.blogspot.com/2012/07/does-image-of-obama-with-rope-around.html
59 /// **Obama Rope** /// http://politics.gather.com/viewArticle.action?articleId=281474981595112
60 /// **Occupy Hope** /// http://latimesblogs.latimes.com/culturemonster/2011/11/shepard-fairey-creates-new-poster-for-occupy-movement.html
61 /// **James Montgomery Flagg, I Want You for the U.S. Army, 1917** /// http://www.history.army.mil/art/Posters/WWI/WWI.htm
62 /// **Okwui Enwezor** /// http://newsgrist.typepad.com/robertgoldwaterlibrary/2006/03/interview_with_.html
63 /// **Obama Hope at the National Portrait Gallery** /// http://www.nytimes.com/2009/01/25/weekinreview/25kennedy.html
64 /// **National Portrait Gallery, Washington DC** /// http://www.visitingdc.com/washington-dc/national-portrait-gallery-washington-dc.htm
65 /// **Martin Sullivan** /// http://newsdesk.si.edu/photos/martin-sullivan
66 /// **Michael Rock** /// http://www.icaboston.org/programs/talks/michael_rock/
67 /// **Barbara Avedon (far right)** /// http://www.luxecoliving.com/lifestyle/peace-war-is-not-healthy-for-children-and-other-living-things/
68 /// **Max Friedman** /// http://www.american.edu/cas/faculty/friedman.cfm
69 /// **Liz McQuiston** /// http://www.rave.ac.uk/about/our-people/staff-profiles/

DESIGNER ADVOCACY ACROSS MEDIA

01 /// **Annie Leonard** /// hhttp://www.berkeleyside.com/2010/09/29/annie-leonard-interview/
02 /// **Ruben DeLuna** /// http://freerange.com/studio/team
03 /// **The Story of Stuff Project** /// https://twitter.com/storyofstuff
04 /// **François Alaux** /// http://www.imdb.com/media/rm2838737920/nm3725519
05 /// **Hervé de Crécy** /// http://www.commeaucinema.com/personne/herve-de-crecy,152006
06 /// **Ludovic Houplain** /// http://www.filmindustrynetwork.biz/oscar-winning-animation-logorama/2803
07 /// **Los Angeles CA** /// http://www.etsy.com/listing/78875523/los-angeles-california-large-letter
08 /// **Ronald McDonald** /// http://www.forbes.com/sites/johnclarke/2012/07/30/hey-fat-boy-eat-a-salad-mcdonalds-launches-new-campaign-in-time-for-olympics/
09 /// **McDonald's** /// http://www.ranklogos.com/websites-logos/mcdonalds-logo/
10 /// **Michelin Man** /// http://carolinarunner.wordpress.com/2012/06/21/edouard-michelin-memorial-5k-august-18-2012-michelin-conference-center-greenville-sc/
11 /// **Mr. Pringles** /// http://steeshes.com/2012/05/14/mr-pringles/
12 /// **Mr. Pringles (new)** /// http://ipfinance.blogspot.com/2012/02/will-they-taste-different-now-pringles.html
13 /// **Esso** /// http://carltonbanks.wordpress.com/category/mp3/page/11/
14 /// **Mr. Clean** /// http://www.basicsplus.com/MR-CLEAN-Mr-Clean-Magic-Eraser-Cleaning-Pads-23
15 /// **Pizza Hut** /// http://blog.yipit.com/2012/08/14/pizza-hut-coupon-code-2012/
16 /// **Chevrolet** /// http://www.1carpictures.com/p-chevrolet_logo-1739.html
17 /// **Apples** /// http://www.mexicopubliclibrary.org/node/78
18 /// **Nicholas Schmirkin with Academy Award** /// http://www.ctpost.com/entertainment/slideshow/2010-OSCARS-Backstage-451.php
19 /// **Naomi Klein** /// http://www.newyorker.com/reporting/2008/12/08/081208fa_fact_macfarquhar
20 /// **Naomi Klein, No Logo: Taking Aim at the Brand Bullies, 1999** /// http://everyonecouldbe.blogspot.com/2009/05/no-logo-brands-globalization-resistance.html
21 /// **Kalle Lasn** /// http://gulagbound.com/22740/the-neo-

marxist-globalist-engineers-of-leaderless-ows/#.UKakLGI25xk
22 /// **Steven Johnson** /// http://www.ted.com/speakers/steven_johnson.html
23 /// **Janet Murray** /// http://borderhouseblog.com/?p=1903
24 /// **Steven Johnson, Interface Culture, 1999** /// http://rosenfeldmedia.com/uxzeitgeist/books/0465036805
25 /// **Janet Murray, Hamlet on the Holodeck, 1998** /// http://www.escritasmutantes.com/index.php?id=7&sub=7
26 /// **Dreamweaver CS6** /// http://www.misco.co.uk/Product/191443/Adobe-Dreamweaver-CS6-Win
27 /// **Gary Wright, Dream Weaver, 1976** /// http://70spop.wordpress.com/2011/07/29/dream-weaver-by-gary-wright-warner-bros-1976/
28 /// **Flash** /// http://i-techgadgets.com/adobe-flash-cs6
29 /// **The Flash** /// http://byte-consult.be/2011/06/18/5-reasons-for-creating-a-flash-only-website-anno-2011/
30 /// **Processing** /// http://en.wikipedia.org/wiki/Processing_(programming_language)
31 /// **Processor** /// http://www.amazon.com/KitchenAid-KFP735WH-9-Cup-Food-Processor/dp/B004LGWL9W
32 /// **Jonathan Harris** /// http://textoflight.com/tag/art/
33 /// **Query Count** /// http://www.wordcount.org/querycount.php
34 /// **The Netherlands** /// http://www.travelnotes.org/Europe/netherlands.htm
35 /// **LUST Lab** /// http://vimeo.com/lustlab
36 /// **Graphic Design Museum, Breda** /// http://www.camping-liesbos.nl/index.php?pg=surroundings&id=44&lg=en
37 /// **Walker Art Center, Minneapolis MN** /// http://www.walker-art.org/
38 /// **Kinect sensor** /// http://www.xboxkinectfans.com/the-next-challenge-for-kinect-is-natural-speech-3946.html/microsoft-kinect-sensor
39 /// **QR code** /// http://www.qrstuff.com/
40 /// **Cooper Hewitt National Design Museum, New York NY** /// http://teachinghistory.org/history-content/national-resources/23497
41 /// **Heraclitus** /// http://martinsj2.wordpress.com/2012/04/12/cycling-and-philsophy-part-2/

INTERVIEW: MIEKE GERRITZEN

01 /// **Mieke Gerritzen** /// http://www.droog.com/blog/2010/03/qa-with-mieke-gerritzen/copy-of-mieke-gerritzen/
02 /// **Museum of the Image, Breda** /// http://www.thedisciplesofdesign.co.uk/2011/12/the-museum-of-image-part-1/
03 /// **Breda, The Netherlands** /// http://florinas.wifeo.com/autres-voyages.php
04 /// **Sandberg Institute, Amsterdam** /// http://dgi-indonesia.com/artvertising
05 /// **Mieke Gerritzen, Mobile Minded, 2002** /// http://www.amazon.com/Mobile-Minded-Miekke-Gerritzen/dp/9063690177
06 /// **Mieke Gerritzen, Style First, 2003** /// http://www.booksamillion.com/p/Style-First/Musee-De-Design-Et-DArts/9783764384388
07 /// **Mieke Gerritzen, Everyone is a Designer in the Age of Social Media, 2010** /// http://mediaadvertisingcommerce.wordpress.com/page/2/
08 /// **Tony Stan, ITC Garamond, 1977** /// http://www.identifont.com/list?3+garamond+12+1NA+1+3PJ+1+N19+7+N15+7+4DE+7+C4D+7+V7+7+MI+7+6DT+7+2VK+7+M5+7+W5+7+NV+7+VS+7+29C+7+G8+7+6DU+7+221+7+-27J+7+3Z3+7+F5+7+NJA+7+26P+7+26T+7+EF7+7+H-K5+7+622+7+55T+8+5HG+8+5RE+8
09 /// **Tristan Tzara, Dadaphone No.7, 1920** /// http://www.arthistoryarchive.com/arthistory/dada/Tristan-Tzara.html
10 /// **Thank you** /// http://forums.bestbuy.com/t5/media/v2/gallerypage/image-id/610i9D04220149031B4F

INTERVIEW: NOEL DOUGLAS

01 /// **Noel Douglas** /// http://www.beds.ac.uk/howtoapply/departments/ad/staff/noel-douglas

02 /// **University of Bedfordshire, Bedford UK** /// http://blogs.biomedcentral.com/orblog/2011/07/21/university-of-bedfordshire-adopts-open-repository/
03 /// **Great Britain** /// http://nl007.k12.sd.us/Classes/English%20IV/Brit%20Lit/Great_Britain_map.htm
04 /// **Occupy Design** /// http://designeducator.info/?p=638
05 /// **Occuprint** /// http://occuprint.org/Info/About
06 /// **Occupy Wall Street** /// http://www.businessinsider.com/anonymous-occupy-wall-street-2011-9?op=1
07 /// **Kickstarter** /// http://www.firstsecondbooks.com/behind-the-scenes/publishing-vs-kickstarter/
08 /// **99%** /// http://www.malleusmaleficarum.org/shop/we-are-the-99-t-shirt/
09 /// **Paris Metro** /// http://www.ipreferparis.net/2009/11/metro-station-of-the-month-abbesses.html
10 /// **Superstudio, Megastructure, 1969** /// http://www.megastructure-reloaded.org/superstudio/
11 /// **Yakov Chernikhov, Constructivist Architectural Fantasy** /// http://www.darkroastedblend.com/2007/05/communist-gothic.html
12 /// **Stephen Duncombe** /// http://eyebeam.org/people/stephen-duncombe
13 /// **Stephen Duncombe, Dream: Re-imagining Progressive Politics in an Age of Fantasy, 2007** /// http://mrzine.monthlyreview.org/2007/sherman230207.html
14 /// **Hippie** /// http://www.istockphoto.com/stock-photo-9197225-hippy-girl-with-tie-dye-amp-peace-sign.php
15 /// **Indignados occupy Prato della Valle Square, Padua, Italy** /// http://www.demotix.com/news/920513/indignados-occupy-prato-della-valle-square-padua#media-920498
16 /// **Tahrir Square, Cairo, Egypt** /// http://www.telegraph.co.uk/news/picturegalleries/worldnews/8293891/Egypt-crisis-protests-continue-in-Cairo.html?image=12
17 /// **Awwwww thank you!** /// http://www.moocomments.com/comments/1773/awww-thank-you.html

CHAPTER 4

CRITICAL DESIGN AND DESIGN FICTION

01 /// **Fiona Raby and Tony Dunne** /// http://www.designinginteractions.com/interviews/DunneandRaby
02 /// **Dunn and Raby, Design Noir, 2001** /// http://www.bookworld.com.au/book/design-noir-the-secret-life-of-electronic-objects/6401525/
03 /// **Gallery Z33; Hasselt, Belgium** /// http://belgchic.blogspot.com/2011_05_01_archive.html
04 /// **Martí Guixé** /// http://www.food-designing.com/about.htm
05 /// **Martí Guixé, Food Bank Bench, 2001** /// http://www.flickriver.com/photos/tags/martiguixe/interesting/
06 /// **Jurgen Bey** /// http://www.the-great-indoors.com/2011/InternationalJury
07 /// **Jurgen Bey, Linen Closet, 2002** /// http://www.z33.be/en/projects/nr-15-designing-critical-design
08 /// **Fiona Raby & Anthony Dunne, Evidence Doll, 2005** /// http://www.rektoverso.be/artikel/sois-fonctionnelle-et-tais-toi
09 /// **Droog Design, Chest of Drawers, 1991** /// http://inhabitat.com/page/2/?s=droog
10 /// **Kate Bingaman-Burt, Hand-Drawn Credit Card Statement, 2004** /// http://www.creditcardcompare.com.au/blog/incredible-credit-card-art.php
11 /// **Kate Bingaman-Burt** /// http://www.adxportland.com/news/featured-member-kate-bingaman-burt
12 /// **Tobias Wong** /// http://areaware.com/about.asp?dAboutID=19
13 /// **Tobias Wong, Coke Spoon 2, 2005** /// http://www.flavorwire.com/95343/remembering-tobias-wong-1974-2010
14 /// **Daniel Jasper** /// http://dha.design.umn.edu/faculty/DJasper.html
15 /// **Martí Guixé, Fill-In-The-Blank Wall Clock, 2010** /// http://theaccessorator.com/2010/03/marti-guixe-a-new-clock-for-alessi.html
16 /// **Tibor Kalman** /// http://andyjacobson.typepad.com/design/2006/03/tibor_kalman_my.html
17 /// **Tibor Kalman, M&Co. Wristwatch, 1984** /// http://

18 /// **Woman soldier** /// http://www.123rf.com/photo_5844913_female-soldier.html
19 /// **Woman soldier** /// http://www.telegraph.co.uk/news/newstopics/onthefrontline/3089327/Army-warned-by-own-lawyers-over-ban-on-women-serving-in-combat-units.html
20 /// **U.S.-Iraq war** /// http://www.instablogs.com/just-another-anniversary-anti-iraq-war-protests-in-us-are-mere-pretensions.html
21 /// **Gerrard O'Carroll** /// http://www.bdonline.co.uk/news/gerrard-o%E2%80%99carroll-dies-at-47/5002431.article
22 /// **Don't Panic** /// http://www.dexigner.com/news/11047
23 /// **Products of Our Time** /// courtesy of the author
24 /// **Connections: Experimental Design** /// http://redobjects.unsw.edu.au/system/assets/273/original/Connections_Cat.pdf
25 /// **Dr. Katherine Moline** /// http://www.cofa.unsw.edu.au/about-us/staff/129
26 /// **Designing Critical Design** /// http://www.youtube.com/watch?v=JzCm6H_fG9Y
27 /// **Jan Boelen** /// http://www.z33.be/nieuws/2012/01/03/2012-wordt-een-bijzonder-kunstjaar-jan-boelen-kijkt-vooruit
28 /// **Forms of Inquiry** /// http://www.manystuff.org/?p=3207
29 /// **Zak Kyes** /// http://www.alternativearchive.com/ouning/?page=12
30 /// **Jonathan Barnbrook** /// http://en.wikipedia.org/wiki/Jonathan_Barnbrook
31 /// **Jonathan Barnbrook, Mason Sans, 1992** /// http://www.myfonts.com/newsletters/cc/201010.html
32 /// **Gran Fury, Read My Lips, 1988** /// http://bandofthebes.typepad.com/bandofthebes/2012/01/how-aids-was-branded-gran-fury-25-years-later.html
33 /// **1986 Plymouth Gran Fury Salon** /// http://www.allpar.com/history/plymouth/1986.html
34 /// **Shepard Fairey** /// http://www.thegiant.org/wiki/index.php/Shepard
35 /// **Shepard Fairey, Obey Giant, 1990** /// http://www.breakingcopy.com/obey-thoven/
36 /// **Bennetton** /// http://idnworld.com/potm/?id=Benetton-EnterpriseVision
37 /// **Colors Magazine, Issue 4, 1993** /// http://www.sfmoma.org/explore/collection/artwork/18680
38 /// **Adbusters, Issue 100, March/April 2012** /// http://imedia.brookes.ac.uk/moores/entry/3_-_adbusters_ratm/
39 /// **Superstudio** /// http://turquoise-dreams.blogspot.com/2011/08/60-s-radicalism-in-architecture.html
40 /// **Archigram, Plug-in City, 1964** /// http://va312ozgunkilic.wordpress.com/2010/12/07/archigram-plug-in-city/
41 /// **Archizoom, No Stop City, 1969** /// http://mestra-dodcnm2011.wordpress.com/category/post/page/8/
42 /// **Rem Koolhaas** /// http://www.archdaily.com/tag/rem-koolhaas/
43 /// **Rem Koolhaas, Seattle Public Library, 2004** /// http://homepage.tudelft.nl/7n25d/referentiebeelden.html
44 /// **Alessandro Mendini** /// http://www.designtalestudio.com/dts/people/alessandro-mendini/
45 /// **The Design Museum, London** /// http://www.phaidon.com/agenda/architecture/articles/2012/july/11/phaidons-eye-on-the-architecture-world-11-07-12/
46 /// **Kean Etro** /// http://esquire24h.blogspot.com/2009/06/kean-etro-me-da-buen-rollo.html
47 /// **Race car driver** /// http://pjtoycar.blogspot.com/2009_03_01_archive.html
48 /// **Bruce Sterling** /// http://www.core77.com/blog/object_culture/interview_with_bruce_sterling_10220.asp
49 /// **Bruce Sterling, Islands in the Net, 1988** /// http://nomadicutopianism.wordpress.com/tag/bruce-sterling/
50 /// **Julian Bleecker** /// http://www.walkerart.org/magazine/2013/2012-year-according-julian-bleecker
51 /// **Julian Bleecker and Nicholas Nova, A Synchronicity: Design Fictions for Asynchronous Urban Computing, 2009** /// http://www.experientia.com/blog/a-synchronicity-a-book-by-julian-bleecker-and-nicholas-nova/
52 /// **Art Center College of Design, Made Up** /// http://www.artcenter.edu/mdp/madeup/exhibition.html
53 /// **Art Center College of Design, Pasadena CA** /// http://www.artcenter.edu/archives/hillside/frontsteps.html
54 /// **Tim Durfee** /// http://www.ltdesignweek.com/speakers/
55 /// **Denise Gonzales-Crisp** /// http://pittsburgh.aiga.org/pgh365/judges/
56 /// **William Morris, News From Nowhere, 1892** /// http://preraphaelitepaintings.blogspot.com/2010/09/news-from-nowhere.html
57 /// **Noam Toran** /// http://www.sequoiatees-dcs.com/artists?p=21
58 /// **Mad Men** /// http://www.amazon.com/Mad-Men-Season-Jon-Hamm/dp/B000YABIQ6
59 /// **Design Within Reach** /// http://www.bradblondes.com/
60 /// **Amy Francheschini** /// http://www.flickr.com/photos/creativearts-sfsu-edu/4636394427/sizes/o/
61 /// **Twitter** /// http://www.aejmc.org/topics/archives/3563
62 /// **Trojan horse** /// http://storyality.wordpress.com/2012/12/20/storyality-31-which-screenplay-guru-books-to-read/trojan-horse/
63 /// **David Mack, Kabuki: Skin Deep, 1999** /// http://www.amazon.com/Kabuki-Volume-Skin-Deep-v/dp/1582400008
64 /// **David Mack, Kabuki: Reflections, 1998** /// http://www.heroream.com/previews/Mar2008/mar_2008_pre_outrealm.html
65 /// **David Mack** /// http://torvald.gjovaag.com/2007ECCC.html
66 /// **Asian martial arts** /// http://themartialartsupplier.com/
67 /// **Stefan Hall** /// http://www.highpoint.edu/blog/2012/10/professor-fleshes-out-zombie-end-of-world-themes-in-media/
68 /// **Jim Casey** /// http://beluthahatchie.blogspot.com/2010/03/icfa-31-wrap-party.html
69 /// **Amy Franceschini, Kosovo Elf, 1999** /// http://www.myboite.it/burekeaters/?p=287
70 /// **The Jetsons** /// http://www.nydailynews.com/new-york/russian-tycoon-launches-investment-firm-develop-robot-technology-daily-life-article-1.1096760
71 /// **Brazil, 1985** /// http://www.cyberpunkreview.com/2006/05/
72 /// **Brazil** /// http://www.littleexplorers.com/southamerica/brazil/flag/
73 /// **Brazil** /// http://www.inquisitr.com/172470/brazil-economy-surpasses-uk-for-first-time/
74 /// **Chuck Palahniuk** /// http://students.english.ilstu.edu/rrjohns/hypertext/creation/index.html

THE ART DESIGN ZONE

01 /// **Oscar Wilde** /// http://gayspirituality.com/lgbt/on-the-road-to-an-integral-worldview-oscar-wilde/
02 /// **Oscar Wilde, The Picture of Dorian Gray, 1890** /// http://www.artilleries.org/2011/10/belated-birthdays-oscar-wilde.html
03 /// **The Picture of Dorian Gray, 1945** /// http://www.pixmule.com/the-picture-of-dorian-gray-1945/8/
04 /// **Chris Jordan** /// http://www.chrisjordan.com/contact.php
05 /// **Cell phone** /// http://rockymountpta.com/?p=1879
06 /// **Charger** /// http://www.phonecan.com/index.php/wireless-101-chargers
07 /// **Circuit board** /// http://www.reatechnologies.com/circuitbrd.html
08 /// **Car** /// http://www.thecarconnection.com/news/1081610_2013-detroit-auto-show-electric-car-sales-paying-for-americas-roads-car-news-headlines
09 /// **Cigarette butt** /// http://richardwiseman.wordpress.com/2009/10/16/its-the-friday-puzzle-29/
10 /// **Glass bottles** /// http://orientglassware.en.made-in-china.com/product/nMCQmVwYYEDs/China-Glass-Bottle.html
11 /// **Wooden palettes** /// http://www.linefour.com/3D-INDUSTRIAL/WOODEN-PALETTE/flypage.tpl.html
12 /// **Oil drum** /// http://grahamhughes.photoshelter.com/image/I0000kV3SU_eaZtg
13 /// **Design for the Other 90% exhibition** /// http://www.blog-affiliations.org/?p=344
14 /// **Worldbike** /// http://worldbike.org/about-worldbike-three
15 /// **Worldbike in action** /// http://tirititraun.wordpress.com/
16 /// **LifeStraw** /// http://online.wsj.com/article/SB121372818319181665.html

17 /// **LifeStraw in action** /// http://www.good.is/lifestraw
18 /// **Tomato** /// http://njlhealthandbeauty.wordpress.com/2011/06/20/tomato-coconut-gazpacho/
19 /// **John Warwicker, Tomato member** /// http://simonc2008.blogspot.com/
20 /// **Tomato, Mmm…Skyscraper I Love You, 1994** /// courtesy of the designer
21 /// **Franz Kline, Untitled, 1957** /// http://www.beatmuseum.org/kline/untitled57.html
22 /// **Ron Mueck, Dead Dad, 1996–97** /// http://liliwilkinson.com.au/blog/2010/04/18/ron-mueck
23 /// **Andy Warhol** /// http://www.english-online.at/art-architecture/andy-warhol/andy-warhol-icon-of-pop-art-movement.htm
24 /// **Andy Warhol, Campbell's Soup Can, 1964** /// http://www.artchive.com/artchive/W/warhol.html
25 /// **Robert Rauschenberg** /// http://www.bsattler.com/blog/wp-content/uploads/2008/05/
26 /// **Robert Rauschenberg, Retroactive II, 1963** /// hhttp://faariscar.blogspot.com/2011/04/art-knowledge-news-keeping-you-in-touch_21.html
27 /// **Jasper Johns** /// http://raymonddifley.com/blog/page/2/
28 /// **Jasper Johns, Three Flags, 1958** /// http://robinrile.com/blog/?tag=dnc
29 /// **Barbara Kruger** /// http://articles.latimes.com/2012/jul/14/entertainment/la-et-cm-barbara-kruger-and-catherine-opie-resign-from-moca-board-20120714
30 /// **Barbara Kruger, Untitled (We Don't Need Another Hero), 1987** /// http://www.flcart.com/past/nozkowski.php
31 /// **Ryan McGinness** /// http://galleristny.com/2012/06/ryan-mcginness-on-women-and-showing-work/
32 /// **BLK/MRKT Gallery, Los Angeles CA** /// http://www.artslant.com/la/venues/show/61-blkmrkt-gallery-editions
33 /// **Sponsorship Redux, private reception invitation, 2011** /// http://news.upperplayground.com/blogs/sponsor-shipredux-with-ryan-mcginness-subliminal-projects-and-upper-playground-get-their-logo-messed-with
34 /// **Sponsorship Redux, poster, 2011** /// http://www.thecitrusreport.com/2011/headlines/sponsor-shipredux-with-ryan-mcginness-subliminal-projects/
35 /// **Andy Warhol Museum, Pittsburgh PA** /// http://www.artandeducation.net/author/the_andy_warhol_museum/
36 /// **Paula Scher** /// http://www.cooperhewitt.org/conversations/2010/12/12/world-according-paula-scher
37 /// **Pentagram** /// http://breezycreativedesign.com/2010/04/30/past-present-and-future-of-pentagram/
38 /// **Pentagram** /// http://nl.wikipedia.org/wiki/Bestand:Pentagram.png
39 /// **Pentagram.com** /// http://www.pentagram.com/work/#/all/all/newest/
40 /// **Steven Heller** /// http://interactiondesign.sva.edu/events/entry/steven_heller/
41 /// **Atlantic.com** /// http://www.theatlantic.com/entertainment/archive/2011/10/paula-scher-makes-enormous-maps-that-are-only-sort-of-right/246880/

SAMPLING AND REMIXING

01 /// **Copyright** /// http://blog.legalzoom.com/intellectual-property/center-for-copyright-informations-six-strikes-plan-against-piracy/
02 /// **Kurt Schwitters** /// http://www.aaa.si.edu/collections/images/detail/laszlo-moholynagy-4619
03 /// **Kurt Schwitters, A Ramaat, 1942** /// http://www.flickr.com/photos/28710988@N04/galleries/72157624232281565/
04 /// **Hannah Höch** /// http://www.dada-companion.com/hoech/
05 /// **Hannah Höch, The Art Critic, 1919-20** /// http://theviralmedialab.org/1230/2011/11/remix-redux-rewind/
06 /// **John Heartfield** /// http://forum.prisonplanet.com/index.php?topic=97053.0
07 /// **John Heartfield, Der Sinn Des Hitlergrusses (The Meaning of the Hitler Salute), 1932** /// http://www.studyblue.com/notes/note/n/hoch/deck/182380
08 /// **Richard Hamilton** /// http://www.thebeatles.org/image/5363/richard-hamilton
09 /// **Richard Hamilton, Just what is it that makes today's homes so appealing, so different?, 1956** /// http://retrorenovation.com/2011/09/18/pop-art-and-how-it-started-richard-hamilton-1956-just-what-is-it-that-makes-todays-homes-so-appealing-so-different/
10 /// **Richard Prince** /// http://artinvestment.ru/en/news/artnews/20090311_richard_prince.html
11 /// **Richard Prince, Untitled (Cowboy), 1993** /// http://tuckerneel.wordpress.com/2010/07/27/lorenzo-hurtado-segovia-by-deborah-calderwood/
12 /// **Don Joyce and Mark Hosler of Negativland** /// http://article.wn.com/view/2012/06/09/Teen_Hossler_back_at_US_Open/
13 /// **Negativland, U2, 1991** /// http://plasticburning.blogspot.com/2011/02/u2-negativland-original-package.html
14 /// **Girl Talk (Greg Gillis)** /// http://www.villagevoice.com/music/2010/11/worst_girl_talk_mashups.php
15 /// **Girl Talk, Feed the Animals, 2008** /// http://blogs.riverfronttimes.com/rftmusic/2008/06/new_girl_talk_cd_out_now_name.php
16 /// **Kenneth Goldsmith** /// http://peoplelikeus.org/tag/podcast/
17 /// **Graham Rawle, Woman's World, 2008** /// http://chazzw.wordpress.com/2010/01/04/womans-world-graham-rawle/
18 /// **Graham Rawle** /// http://www.dandad.org/awards/student/2010/juries/15/illustration/164/graham-rawle
19 /// **DJ Spooky (Paul D. Miller)** /// http://www.clubzone.com/events/179158/vancouver/livecity-yaletown/dj-spooky-and-dbr
20 /// **Paul D. Miller, Rhythm Science, 2004** /// http://mitpress.mit.edu/catalog/item/default.asp?ttype=2&tid=10060
21 /// **Luna van Loon** /// http://www.linkedin.com/in/lunavanloon
22 /// **Mixel** /// http://writerbay.wordpress.com/2011/11/10/become-an-artist-with-mixel%E2%80%99s-remixable-ipad-collage-app/mixel-logo-large-2/
23 /// **Enrique Radigales** /// http://eyebeam.org/people/enrique-radigales
24 /// **Furtherfield.org** /// http://www.furtherfield.org/profile/enrique
25 /// **William Mitchell** /// http://archpaper.com/news/articles.asp?id=4674
26 /// **Massachusetts Institute of Technology (MIT), Cambridge MA** /// http://alum.mit.edu/pages/sliceofmit/2010/08/05/mit-seal/
27 /// **William Mitchell, The Reconfigured Eye, 1992** /// http://mitpress.mit.edu/catalog/item/default.asp?ttype=2&tid=6171
28 /// **Convergence** /// http://con.sagepub.com/
29 /// **Satromizer effect (portrait of Jon Satrom, creator)** /// http://www.creativeapplications.net/iphone/satromizer-iphone/
30 /// **Kenneth Goldsmith, Uncreative Writing, 2011** /// http://www.amazon.com/Uncreative-Writing-Managing-Language-Digital/dp/0231149913
31 /// **Stanford University Libraries & Academic Information Resources logo** /// http://www.archive-it.org/home/SSRG
32 /// **Bansky (unmasked)** /// http://www.dailymail.co.uk/femail/article-1034538/Graffiti-artist-Banksy-unmasked---public-schoolboy-middle-class-suburbia.html
33 /// **Bansky, Napalm, 2004** /// http://www.icanvasart.com/banksy-ronald-mcdonald-and-mickey-mouse-print.html

INTERVIEW: WARREN LEHRER

01 /// **Warren Lehrer** /// http://www.designingwithtype.com/purchase/index.html
02 /// **EarSay, Inc.** /// http://www.guidestar.org/organizations/31-1669271/ear-say.aspx
03 /// **Museum of Modern Art, New York NY** /// http://pulsd.com/new-york/museums/museum-of-modern-art-moma/a-free-day-at-the-moma
04 /// **The Getty Center, Los Angeles CA** /// http://www.kcrw.com/etc/programs/at/at080318art_sex_and_videotap
05 /// **The Georges Pompidou Centre, Paris** /// http://www.abroadlanguages.com/learn/french/paris/schools/know.asp
06 /// **The Tate Modern, London** /// http://www.galinsky.com/buildings/tatemodern/index.htm
07 /// **State University of New York Purchase College Panthers** /// http://www.ecac.org/membership/division_III/purchase

08 /// **Warren Lehrer, Grrrhhhh: A Study of Social Patterns, 1988** /// http://www.earsay.org/projects/books/warren-lehrer-with-dennis-bernstein-and-sandra-brownlee-ggrrrhhhh-a-study-of-social-patterns/
09 /// **Stanford University, Palo Alto CA** /// http://www.stanford.edu/group/frydman/web/
10 /// **Bruce Mau** /// http://www.entrepreneur.com/article/219487
11 /// **Rem Koolhaas and Bruce Mau, S, M, L, XL, 1996 (1376 pages)** /// http://www.chicagomag.com/Chicago-Magazine/June-2010/Photos-The-Works-of-Bruce-Mau/
12 /// **Irma Boom** /// http://en.red-dot.org/1474.html
13 /// **Irma Boom, SHV Thinkbook, 1996 (2136 pages)** /// http://universeandeverything.wordpress.com/2011/05/22/irma-boom/
14 /// **Roller Boogie, 1979 (Venice Beach)** /// http://www.film.com/movies/erics-bad-movies-roller-boogie-1979
15 /// **Warren Lehrer, Versations, 1980** /// http://www.earsay.org/projects/books/versations-a-setting-for-eight-conversations/
16 /// **AIGA** /// http://www.scholarships360.org/2012/03/03/worldstudio-aiga-scholarships/
17 /// **Judith Sloan** /// http://nyu.academia.edu/JudithSloan
18 /// **Queens NY** /// http://www.digital-topo-maps.com/county-map/new-york.shtml
19 /// **Warren Lehrer and Judith Sloan, Crossing the BLVD, 2003** /// http://www.oswegonian.com/lreview/459/queens-%E2%80%98blvd%E2%80%99-reveals-immigrants%E2%80%99-lives/
20 /// **Thank you** /// http://ourdailybread.us/?page_id=79

INTERVIEW: JOHANNA DRUCKER

01 /// **Johanna Drucker** /// http://writing.upenn.edu/pennsound/x/Drucker.php
02 /// **UCLA, Los Angeles CA** /// http://www.barewalls.com/pv-558984_Wood-Sign-UCLA-Seal.html
03 /// **Johanna Drucker, The Visible Word, 2003** /// http://www.strandbooks.com/typography/the-visible-word-experimental-typography-and-modern-art-1909-1923-0226165027
04 /// **Johanna Drucker, The Alphabetic Labyrinth, 1999** /// http://www.bythewaybooks.com/cgi-bin/btw455/15794
05 /// **Johanna Drucker and Emily McVarish, Graphic Design History: A Critical Guide, 2008** /// http://www.pearsonhighered.com/product?ISBN=0132410753
06 /// **Emily McVarish** /// http://www.artbusiness.com/1open/firstth1105.html
07 /// **Johanna Drucker, The Century of Artists' Books, 2004** /// http://www.library.illinois.edu/lsxold/books/July06/drucker.htm
08 /// **Journal of Artists' Books** /// http://www.facebook.com/pages/Journal-of-Artists-Books/279359742125922
09 /// **Brad Freeman** /// http://www2.colum.edu/sgc/Acknowledge.html
10 /// **Steve Clay** /// http://www.123people.ca/s/steve+clay
11 /// **Granary Books** /// http://www.granarybooks.com/granary.html
12 /// **First Assembling for Tony Zwicker** /// http://www.granarybooks.com/page_details/187
13 /// **Nicholas Negroponte, Being Digital, 1996** /// http://ravevisualeffects.wordpress.com/2010/11/23/being-digital-nicholas-negroponte/
14 /// **Nicholas Negroponte** /// http://one.laptop.org/about/people/negroponte
15 /// **Ubuweb** /// http://www.ubu.com/
16 /// **Pennsound** /// http://writing.upenn.edu/pennsound/
17 /// **Buffalo** /// http://www.kansastravel.org/redbuffaloranch.htm
18 /// **Electronic Poetry Center** /// http://www.facebook.com/pages/Electronic-Poetry-Center/27997573411
19 /// **Rui Torres** /// http://www.experimentalclub.com/yuxt08.htm
20 /// **Poesia Experimental** /// http://po-ex.net/
21 /// **Scott Rettberg** /// http://www.uib.no/personer/Scott.Rettberg
22 /// **ELMCIP (Electronic Literature as a Model of Creativity and Innovation in Practice)** /// http://elmcip.net/
23 /// **ELO (Electronic Literature Organization)** /// http://nickm.com/post/2011/08/
24 /// **ELO (Electric Light Orchestra), Telephone Line, 1977** /// http://eil.com/shop/moreinfo.asp?catalogid=69350
25 /// **ELO (Electric Light Orchestra), Can't Get It Out of My Head, 1974** /// http://www.jefflynnesongs.com/cgioomh/
26 /// **Thank you** /// http://vigilanteproject.com/thankyou/

CHAPTER 5
DESIGN ENTREPRENEURISM AND ECONOMY

01 /// **Company boardroom** /// http://business-ethics.com/2011/08/03/women-in-the-boardroon-should-the-us-have-quotas/
02 /// **Jessica Barness** /// http://vcd.kent.edu/about/faculty-staff
03 /// **Gourmet coffee** /// http://www.whitecloudcoffee.com/
04 /// **Spunk Design Machine** /// http://aaronpollock.com/Identity-Spunk-Design-Machine
05 /// **Jeff Johnson** /// http://blog.spkdm.com/2011/06/jeff-shapes-young-minds-in-duluth.html
06 /// **Minneapolis MN** /// http://www.burnsandwilcox.com/BranchDetail.aspx?id=199
07 /// **Davis CA** /// http://www.ars.usda.gov/main/site_main.htm?modecode=53-06-00-00
08 /// **Davis Food Co-op Flying Tomato Grocery Getter** /// http://blog.spkdm.com/2010/01/the-flying-tomato-floats-west.html
09 /// **Seward Co-op Bicycle Rack** /// http://www.thedeets.com/2008/12/15/new-seward-coop-coming-soon/
10 /// **Bricks and mortar** /// http://blog.officelinks.com/2012/bricks-and-mortar-still-have-a-place/
11 /// **Richelle Huff** /// http://mybrandforever.com/Kreechers.html
12 /// **Pre-teen boys** /// http://www.istockphoto.com/stock-photo-20364110-pre-teen-boys-at-school.php
13 /// **Sports equipment** /// http://thesportsarchivesblog.com/2013/01/01/the-sports-archives-top-7-most-popular-sports-played-in-the-world/sports-equipment-on-white/
14 /// **Pillow** /// http://goodmorningmattresscenter.com/index.php/jamison-latex-plush-pillow-soft.html
15 /// **TV** /// http://www.westofthei.com/2009/07/30/paris-fire-departmetn-dayroom-to-get-tv-upgrade/3603
16 /// **Rabbit** /// http://projects.ajc.com/gallery/view/living/pets/bunny-abandon/
17 /// **Mexico** /// http://www.virtualmex.com/map.htm
18 /// **Kidrobot.com** /// http://vimeo.com/krtv
19 /// **Bruce Mau** /// http://www.thelavinagency.com/speaker-bruce-mau.html
20 /// **Bruce Mau, Life Style, 2005** /// http://store.100hyakunen.com/products/detail.php?product_id=1024
21 /// **Bill Cahan** /// http://www.meetup.com/members/8960645/
22 /// **Bill Cahan, I Am Almost Always Hungry, 1999** /// http://www.barnesandnoble.com/w/i-am-almost-always-hungry-cahan-associates/1013772106
23 /// **Marian Bantjes** /// http://pagestopixels.com/?p=2496
24 /// **Marian Bantjes, I Wonder, 2010** /// http://designnotes.info/?p=3066
25 /// **Stefan Sagmeister** /// http://www.largeformatreview.com/superwide-printers/767-stefan-sagmeister-turns-to-hp-graphic-arts-technology
26 /// **Peter Hall** /// http://www.beijing2009.org/speakername.php?sid=33
27 /// **Stefan Sagmeister and Peter Hall, Sagmeister: Made You Look, 2001** /// http://scene360.com/articles/1186/he-will-make-you-look-an-interview-with-stefan-sagmeister/
28 /// **David Carson** /// http://ade-adebayo.blogspot.com/2012/04/david-carson.html
29 /// **Lewis Blackwell** /// http://www.visualconnections.com/blog/a-decisive-road-for-evolve-images-lewis-blackwell-3/
30 /// **David Carson and Lewis Blackwell, The End of Print: The Graphic Design of David Carson, 1995** /// http://www.congnghethongtin.org/thiet-ke-website/200-thoi-diem-dang-nho-nhat-cua-thiet-ke-p4.html
31 /// **Jonathan Barnbrook** /// http://www.flickr.com/photos/fontblog/2553634984/
32 /// **Jonathan Barnbrook, The Barnbrook Bible, 2007** /// http://112mirabela.wordpress.com/2009/04/27/barnbrook-bible/

33 /// **John Maeda** /// http://www.dustinkirk.com/2009/01/28/john-maeda-on-risd-47/
34 /// **John Maeda, Maeda On Media, 2000** /// http://www.maedastudio.com/matm/
35 /// **Jon Wozencroft** /// http://www.trafo.hu/hu-HU/program_1623
36 /// **Jon Wozencroft, The Graphic Language of Neville Brody, 2000** /// http://www.rbmodern.com/ephemera/
37 /// **Neville Brody** /// http://typotalks.com/berlin/de/blog/2011/01/25/celebrating-15-years-of-typo-berlin-moments-5/
38 /// **William Drenttel** /// http://www.flickr.com/photos/aigact/3092330535/
39 /// **Kevin Smith** /// http://www.newschool.edu/parsons/faculty_program.aspx?id=48480
40 /// **Winterhouse Editions, The National Security Strategy of the United States of America, 2003** /// http://www.winterhouse.com/editions/books/nss.html
41 /// **Simon Kavanagh** /// http://www.core77.com/blog/core77_design_awards/core77_design_awards_2013_introducing_our_first_round_of_jury_captains_24179.asp
42 /// **Danish** /// http://denmark.dk/en/quick-facts/national-flag/
43 /// **Danish** /// http://www.willisms.com/archives/2006/02/buy_danish.html
44 /// **Kaospilot** /// http://texnaes.com/about/links_co_creators/
45 /// **First Things First 2000** /// http://tpduke.wordpress.com/page/2/
46 /// **Kate Bingaman-Burt** /// http://newsroom.unl.edu/releases/2010/11/04/UNL+alumni+'Masters'+return+to+meet+with+students+Nov.+10-12
47 /// **Credit card statement** /// http://www.fasteasyaccounting.com/quickbooks-journal-entries-distort-construction-job-cost-reports/
48 /// **Etsy** /// http://www.hippiesbeautyandbooksohmy.com/2012/07/my-favorite-etsy-book-things.html
49 /// **Kate Bingham-Burt, Obsessive Consumption: What Did You Buy Today?, 2010** /// http://mocoloco.com/art/archives/015430.php
50 /// **Bruce Sterling** /// http://www.layar.com/blog/2009/08/04/bruce-sterling-to-speak-at-layar-next-event/
51 /// **Bruce Sterling, Shaping Things, 2005** /// http://www.flickr.com/photos/mike_benedetti/298078782/
52 /// **Kitten** /// http://samsykes.com/2012/05/news-for-nobodies/kitten/
53 /// **Cat litter** /// http://www.petsmart.com/product/index.jsp?productId=11164112
54 /// **Torn Curtain, 1966** /// http://www.impawards.com/1966/torn_curtain.html
55 /// **Marcel Proust, In Search of Lost Time, Volume 1: Swann's Way, 1913** /// http://www.free-download-ebooks.com/In-Search-of-Lost-Time-Vol-1-Marcel-Proust-epub-mobi-pdf_5374939.html
56 /// **Roger Martin** /// http://allangregg.tvo.org/guest/roger-martin
57 /// **Rotman School of Management, Toronto** /// http://www.feicanada.org/page/events/sme-conference-2012/sponsors
58 /// **Jon Kolko** /// http://vimeo.com/15680044
59 /// **Medea Malmö University** /// http://blog.flattr.net/2010/12/thank-you-sweden-and-thank-you-vinnova/
60 /// **Sweden** /// http://mashable.com/2011/12/16/sweden-twitter-acount/
61 /// **Frog, Project M (Project Masiluleke) website** /// http://www.frogdesign.com/work/project-m.html
62 /// **South Africa** /// http://travelblog.portfoliocollection.com/blog/did-you-know-number-11
63 /// **Frog** /// http://uncommonprojects.com/site/work/frog-design-inc
64 /// **Aricent** /// http://www.visionael.com/partners/bus_prt_aricent.html
65 /// **Salvador Zepeda** /// https://twitter.com/Salvador_Zep
66 /// **IDEO** /// http://vimeo.com/user8938528
67 /// **Brenda Laurel** /// http://lillieskoldleckstrom.com/?cat=16

DESIGNER STORIES THROUGH ENTREPRENEURIAL PUBLISHING

01 /// **Jan Tschichold** /// http://www.guardian.co.uk/artanddesign/2008/dec/05/jan-tschichold-typography
02 /// **Jan Tschichold, Die Neue Typographie, 1928** /// http://www.buechersuite.de/50486499e70c9e015/5048649a7812e6f3c/index.html
03 /// **Eric Gill** /// http://www.trendsettingdesign.com/inspiration-eric-gill/
04 /// **Eric Gill, An Essay on Typography, 1931** /// http://home.comcast.net/~eliws/portfolio/ericgillbookcover.html
05 /// **Willem Sandberg** /// http://www.design.nl/item/sandberg___graphic_designer_and_director_of_the_stedelijk_museum?relation=
06 /// **Willem Sandberg, Experimenta Typographica #11, 1931** /// hhttp://lisabedelle.wordpress.com/2011/10/05/experimenta-typografica-11-by-willem-sandberg/
07 /// **Gérard Mermoz** /// http://www.arts.ac.uk/research/cityofsigns/P3_bio.html
08 /// **Design Issues, Spring 2006** /// http://www.amazon.com/Design-Issues-Volume-22-Issue/dp/B002TDZAAQ
09 /// **Alice Twemlow** /// http://dcrit.sva.edu/intensive/
10 /// **Rick Poynor** /// http://www.blokovi.org/konferencija/rick-poynor/
11 /// **PM, No. 19, 1936** /// http://www.drleslie.com/PMADMagazines/2_7_336.shtml
12 /// **New York 1934** /// http://www.artfactory.com/man-caves-big-boy-toys-vintage-signs-genuine-americana-c-292_295.html
13 /// **Dr. Robert L. Leslie** /// http://www.lislsteiner.com/LislSteiner-Photographs-Artists.html
14 /// **Herbert Bayer** /// http://www.adcglobal.org/archive/hof/1975/?id=281
15 /// **Herbert Bayer, Alfabet, 1925** /// http://rznews.tumblr.com/post/485222655/current-issue-behind-the-type
16 /// **Gene Federico** /// http://va312aslicaglar.wordpress.com/2011/01/02/gene-federico/
17 /// **Gene Federico, She's Got to Go Out, 1954** /// http://johnsonbanks.co.uk/thoughtfortheweek/the-alphabet-that-keeps-on-giving/
18 /// **E. McKnight Kauffer** /// http://www.chess-theory.com/encpbl3007_chess_practice_blog3.php
19 /// **E. McKnight Kauffer, Soaring to Success, 1919** /// http://www.printeresting.org/2011/10/02/the-poster-king-edward-mcknight-kauffer-at-the-estorick-collection-london/
20 /// **William Golden, CBS, 1951** /// http://www.cooperhewitt.org/object-of-the-day/2013/01/24/corporate-calico-angelo-testa%E2%80%99s-fabric-ibm
21 /// **William A. Dwiggins** /// http://www.lawsonarchive.com/william-a-dwiggins-master-of-typography-and-type-design/
22 /// **W. A. Dwiggins, Layout in Advertising, 1948** /// http://www.fsgworkinprogress.com/2010/07/great-designers-of-the-past/3392076928_0d2c463b05_b/
23 /// **Cipe Pineles** /// http://arh346.blogspot.com/2010/04/cipe-pineles.html
24 /// **Cipe Pineles, Seventeen, 1949** /// http://designspiration.net/image/2077763911437/
25 /// **Herbert Matter** /// http://www.bc.edu/bc_org/avp/cas/artmuseum/exhibitions/archive/pollock-matters/index.html
26 /// **Herbert Matter, Swiss Travel Poster, 1936** /// http://www.fsgworkinprogress.com
27 /// **Erin Malone** /// http://www.flickr.com/photos/localcelebrity/4834469721/
28 /// **Steven Heller** /// http://webspace.ringling.edu/~hsieglin/Bios_2010.html
29 /// **Baseline Magazine, before and after** /// http://www.underconsideration.com/brandnew/archives/baseline_interrupted.php
30 /// **PM Magazine, August–September 1940** /// http://www.drleslie.com/PMADMagazines/6_6_8940.shtml
31 /// **Ellen Lupton** /// http://rahulgowtham.wordpress.com/2011/03/09/ellen-lupton/
32 /// **Denise Gonzales Crisp** /// http://www.flickr.com/photos/annmaryliu/4968499142/sizes/o/
33 /// **Alexey Brodovitch** /// http://www.aiga.org/medalist-alexeybrodovitch/

34 /// **Harper's Bazaar, February 1952** /// http://rorohappypills.tumblr.com/page/2
35 /// **Frank Zachary** /// http://www.aiga.org/medalist-frankzachary/
36 /// **Napoleon** /// http://frenchnapoleon.com/tag/napoleon
37 /// **Napoleon** /// http://www.tofugu.com/2012/08/04/10-japanese-movie-title-translations-that-make-no-sense/
38 /// **Napoleon** /// http://www.epicurious.com/recipes/food/photo/Caramel-Mousse-Napoleon-with-Caramel-Sauce-and-Berries-103928
39 /// **Giambattista Bodoni** /// http://www.stampcommunity.org/topic.asp?TOPIC_ID=9106&whichpage=39
40 /// **Alexander Calder** /// http://www.listal.com/viewimage/3009019
41 /// **Alexander Calder, Yellow Sail, 1950** /// http://weatherspoon.uncg.edu/blog/tag/alexander-calder/
42 /// **Jackson Pollock** /// http://yalebooks.wordpress.com/2012/01/20/the-discovery-of-an-american-icon-extract-from-jackson-pollock-by-evelyn-toynton/
43 /// **Charles & Ray Eames** /// http://press.exploratorium.edu/the-exploratorium-celebrates-the-powers-of-ten-the-work-of-charles-and-ray-eames-october-10-2010/
44 /// **Charles & Ray Eames, Eames Lounge & Ottoman, 1956** /// http://www.hermanmiller.com/products/seating/lounge-seating/eames-lounge-chair-and-ottoman.html
45 /// **Richard Avedon** /// http://luisaguirre.net/2012/09/06/inspiration-richard-avedon/
46 /// **Paul Rand** /// http://mannyjanda-blogthat.blogspot.com/2011/05/paul-rand.html
47 /// **Paul Rand, UPS, 1961** /// http://nmcad.blogspot.com/2011/07/paul-rand-1914-1996.html
48 /// **Ben Shahn** /// http://artprintz.blogspot.com/2011/03/ben-shahn.html
49 /// **Richard Hollis** /// http://file-magazine.com/mixtape/richard-hollis
50 /// **Richard Hollis, Graphic Design: A Concise History (2nd Revised Edition), 2001** /// http://shanice-connor.blogspot.com/2012/02/good-read-graphic-design-concise.html
51 /// **Seymour Chwast & Milton Glaser** /// http://blog.naver.com/PostView.nhn?blogId=janghoon531&logNo=20112802345
52 /// **Edward Sorel** /// http://www.tcj.com/the-enigmatic-edward-sorel/
53 /// **Push Pin Studio** /// http://todaysinspiration.blogspot.com/2009/05/murray-tinkelman-one-man-push-pin.html
54 /// **Paula Scher** /// http://www.core77designawards.com/2011/jury/paula-scher-2/
55 /// **Ken Robbins** /// http://us.macmillan.com/author/kenrobbins
56 /// **Push Pin Graphic 64, "Mothers", 1976** /// http://www.pushpininc.com/pushpingraphic.html
57 /// **Push Pin Graphic 67, "Your Body and You", 1977** /// http://www.pushpininc.com/pushpingraphic.html
58 /// **Push Pin Graphic 68, "New York At Night", 1977** /// http://y77w711.blog.com/2012/06/30/push-pin-graphic-number-68-august-1977-new-york-at-night-seymour-chwast/
59 /// **Jorge Luis Borges, Ficciones, 1941** /// http://www.davidicke.com/forum/showthread.php?t=11956&page=1879
60 /// **Jorge Luis Borges** /// http://www.tnr.com/book/videos?page=4
61 /// **Masque of the Red Death, 1964** /// http://filmsallthetime.blogspot.com/2012/02/brians-review-masque-of-red-death.html
62 /// **Edgar Allan Poe** /// http://seducedbyhistory.blogspot.com/2011/01/allure-of-edgar-allan-poe.html
63 /// **Seymour Chwast, The Push Pin Graphic, 2004** /// http://www.poster-books.com/music/push-pin-graphic-design-and-illustration.shtml
64 /// **The Push Pin Graphic, AIGA Exhibition, 2005** /// http://www.aiga.org/exhibit-pushpin-graphic/
65 /// **New York New York, Las Vegas NV** /// http://www.wanderfly.com/#!travel/united-states/las-vegas/new-york-new-york-hotel-and-casino
66 /// **Ralph Eckerstrom** /// http://www.ebay.com/itm/1972-Press-Photo-Ralph-Eckerstrom-founder-President-Unimark-International-/280885445215
67 /// **Massimo Vignelli** /// http://cultureby.com/anthropology-of-contemporary-culture/page/2
68 /// **Jan Conradi, Unimark: The Design of Business and the Business of Design, 2009** /// http://vi.sualize.us/unimark_lars_mueller_libri_design_selected_2010_graphic_picture_ckDe.html
69 /// **Robert Malone** /// http://www.ebay.com/itm/1982-Robert-Malone-Editor-Omni-Magazine-Press-Photo-/190699439320
70 /// **Marshall McLuhan** /// http://visualrhetoricvt.wordpress.com/practice-of-looking/chapter-6/
71 /// **Bruno Munari** /// http://share.dschola.it/sinigaglia/materna%20munari/default.aspx
72 /// **John Kenneth Galbraith** /// http://www.mun.ca/president/99-00report/honor/honorary_galbraith.html
73 /// **Jay Doblin** /// http://trex.id.iit.edu/news/idiom/050407/jaydoblin/index.html
74 /// **Umberto Eco** /// http://www.freddieomm.com/2012/03/umberto-eco-flayed-for-anti-semitism.html
75 /// **Herbert Bayer** /// http://www.aspenhalloffame.org/herbert_bayer.html
76 /// **Helvetica** /// http://breezycreativedesign.com/2010/08/24/swiss-style-minimalistic-design-and-helvetica/
77 /// **Dot Zero 1, 1966** /// http://observatory.designobserver.com/slideshow/dot-zero/11547/217/1
78 /// **Dot Zero 2, 1966** /// http://www.modernism101.com/vignelli_dot_zero_2.php
79 /// **Dot Zero 3, 1967** /// http://www.modernism101.com/vignelli_dot_zero_3.php
80 /// **Dot Zero 4, 1967** /// http://observatory.designobserver.com/slideshow/dot-zero/11547/217/19#slide
81 /// **Dot Zero 5, 1968** /// http://observatory.designobserver.com/slideshow/dot-zero/11547/217/22#slide
82 /// **Octavo 86.1, 1986** /// http://ironirvin.blogspot.com/
83 /// **Octavo 86.2, 1986** /// http://www.flickr.com/photos/insect54/916606260/
84 /// **Octavo 87.3, 1987** /// http://www.hamishmuir.com/octavo.html
85 /// **Octavo 87.4, 1987** /// http://www.modernism101.com/octavo_4.php
86 /// **Octavo 88.5, 1988** /// http://afactoryalphabet.blogspot.com/2009/05/o-is-for-octavo.htmlp
87 /// **Octavo 89.6, 1989** /// http://www.hamishmuir.com/octavo.html
88 /// **Octavo 90.7, 1990** /// http://www.hamishmuir.com/octavo.html
89 /// **Octavo 92.8, package, 1992** /// http://www.modernism101.com/octavo_8.php
90 /// **Simon Johnston** /// http://www.adcglobal.org/archive/annual/86/judges/?id=113
91 /// **Mark Holt** /// https://twitter.com/MarkHoltDesign/following
92 /// **Michael Burke** /// http://vignellicenter.rit.edu/events/event-features/michael-burke-braun-lecture/
93 /// **Hamish Muir** /// https://www.fontfont.com/designers/hamish-muir
94 /// **Student** /// http://www.istockphoto.com/stock-photo-10745619-success-student.php
95 /// **London College of Communication** /// http://www.theschoolart.co.kr/bbs/board.php?bo_table=sub4_2&wr_id=7&page=2
96 /// **Wolfgang Weingart** /// http://picasaweb.google.com/lh/photo/nG5SrPV4MWbs3ZeWviXaJQ
97 /// **CD-ROM** /// http://blog.eogn.com/eastmans_online_genealogy/2011/05/-is-your-cd-rom-data-disappearing.html
98 /// **April Greiman** /// http://www.thedetroiter.com/v3/2009/02/toyota-lecture-series-features-april-greiman/
99 /// **Zuzana Licko and Rudy Vanderlans** /// http://kingygraphicdesignhistory.blogspot.com/2010/03/rudy-vanderlans-and-zuzana-licko-emigre.html
100/// **Apple Macintosh 1984** /// http://www.infos-mobiles.com/le-mac-souffle-ses-27-bougies/
101/// **Postscript v. Bitmap** /// http://www.xaraxone.com/webxealot/workbook23/page_6.htm
102/// **Sibylle Hagmann, Cholla, 1999** /// http://www.myfonts.com/fonts/emigre/cholla/
103/// **Jonathan Barnbrook, Priori Acute, 2009** /// http://www.

emigre.com/NewMF.php
104 /// **P. Scott Makela, Dead History, 1990** /// http://papress.com/thinkingwithtype/teachers/type_lecture/history_dead_history.htm
105 /// **Barry Deck, Template Gothic, 1990** /// http://www.moma.org/collection/browse_results.php?object_id=139319
106 /// **Sibylle Hagmann** /// http://www.swisstypedesign.ch/designer/80/
107 /// **P. Scott Makela** /// http://www.lanacion.com.ar/207203-bienvenido-makela
108 /// **Barry Deck** /// http://www.meetup.com/members/21056641/
109 /// **Emigre 35, 1995** /// http://www.muamat.com/classifieds/1120/posts/5_Buy_and_Sell/46_Books/3602502__DESIGN_STUDENTS_EMIGRE_SUMMER_1995_Essays_writing_design_Emigr.html
110 /// **Emigre 36, 1995** /// http://www.moma.org/collection/browse_results.php?criteria=O%3AAD%3AE%3A30189%-7CA%3AAR%3AE%3A1&page_number=37&template_id=1&sort_order=1
111 /// **Anne Burdick** /// http://cargocollective.com/anneburdick/Anne-Burdick-Chair
112 /// **Font Shop** /// http://www.facebook.com/FontShop
113 /// **Jon Wozencroft** /// http://www.thesuffolksymphony.net/artists/
114 /// **Neville Brody** /// http://lab321design.wordpress.com/category/history-of-graphic-design/page/3/
115 /// **Floppy disk** /// http://betf.blogspot.com/2010/06/where-are-they-now-floppy-disks.html
116 /// **Matthew Carter** /// http://www.monotypeimaging.com/productsservices/typedesignershowcase/matthewcarter/Biography.aspx
117 /// **Peter Saville** /// http://showstudio.com/contributor/peter_saville
118 /// **Phil Baines** /// http://nilrey.blogspot.com/2012/03/into-fold-two-great-weeks-at-camberwell.html
119 /// **Malcolm Garret** /// http://mikedempsey.typepad.com/photos/comrades/malcolm_garrett_sq.html
120 /// **Tibor Kalman, Perverse Optimist, 2000** /// http://www.strandbooks.com/product/tibor-kalman-perverse-optimist
121 /// **Rick Valicenti** /// http://chicagoartmagazine.com/2010/05/best-midwestern-designers/
122 /// **Teal Triggs, member, WD+RU** /// http://creativeboom.co.uk/news/teal-triggs-joins-the-royal-college-of-art/
123 /// **Paul Elliman** /// http://formsofinquiry.com/exhibitions/architectural-association-school-of-architecture/events/voices-falling-through-the-air
124 /// **Runes** /// http://bardwood.com/runelore.htm
125 /// **Cuneiforms** /// http://www.theloosh.com/emily/2011/12/angle-of-angels/
126 /// **Hieroglyphics** /// http://www.ehow.com/about_5413307_history-hieroglyphics.html
127 /// **Virginia Commonwealth University, Richmond VA** /// http://www.vabookco.com/ePOS/form=robots/item.html&item_number=E66053400330&store=351&design=351
128 /// **Katie Salen** /// http://www.innovationstuntmen.com/?p=1945
129 /// **Tom Ockerse** /// http://www.visualogue.com/speakers/ockerse_e.html
130 /// **Gunnar Swanson** /// http://observatory.designobserver.com/feature/fifteen-minutes-of-fame/6547/
131 /// **Russell Bestley** /// http://www.portsmouth.co.uk/lifestyle/running-gives-me-a-sense-of-achievement-1-3131731
132 /// **Diane Gromala** /// http://taglab.utoronto.ca/people/diane-gromala/
133 /// **Queen Elizabeth II** /// http://anglicanusenews.blogspot.com/2012/04/queen-elizabeth-announces-appointment.html
134 /// **Mosquito** /// http://www.umaa.org/
135 /// **Kenneth FitzGerald** /// http://odu.academia.edu/KennethFitzGerald
136 /// **Emigre 41, 1997** /// http://www.emigre.com/EMag.php?issue=41
137 /// **Blue** /// http://davidreevesbespoke.wordpress.com/2011/04/15/international-klein-blue-suit/
138 /// **Brown** /// http://412.laxallstars.com/goodbye-brown/
139 /// **Green** /// http://tremulous.net/forum/index.php?topic=12303.0
140 /// **Purple** /// http://rateyourmusic.com/list/GilmoursAngst/deep_purple__the_art_of_purple_album_covers
141 /// **Emmet Byrne** /// http://www.facebook.com/photo.php?fbid=1957721101050&set=a.1491208478526.2069062.1183428544&type=1&theater
142 /// **Jon Sueda** /// http://www.facebook.com/photo.php?fbid=113130885371601&set=t.769752221&type=3&theater
143 /// **Alex DeArmond** /// http://www.adaagallery.com/alexdearmond
144 /// **Werkplaats Typografie** /// http://flickrhivemind.net/Tags/klarendal/Interesting
145 /// **Fred Troller** /// http://www.thinkingform.com/2011/12/12/thinking-fred-troller-12-12-1930/
146 /// **A Fred Troller cover design** /// http://kathykavan.com/fred-troller-graphic-design-swiss-typography
147 /// **Mike Figgis** /// http://londonjazz.blogspot.com/2010/09/preview-mike-figgis-at-kings-place.html
148 /// **Leaving Las Vegas, 1995, Mike Figgis, director and screenwriter** /// http://www.strandbooks.com/product/tibor-kalman-perverse-optimist
149 /// **The AA Field Guide to the Birds of Britain and Europe, 1998** /// http://www.scopesnskies.com/prod/birdwatching/books%20and%20guides/field%20guide-AA%20.html
150 /// **New York City MTA Bus** /// http://www.mta.info/nyct/bus/
151 /// **Stuart Bailey and David Reinfurt (as Dexter Sinister)** /// http://badatsports.com/2011/episode-284-dexter-sinister/
152 /// **Peter Bilák** /// http://www.sme.sk/c/709946/ani-abeceda-nemoze-byt-zadarmo.html
153 /// **Princeton Architectural Press** /// http://www.hypelondon.co.uk/12all/index.php?action=archive&mode=view_html&id=476&table=message&eid=&nl=&b=0
154 /// **Eye** /// http://www.hardformat.org/4865/eye-magazine/
155 /// **Alex Coles** /// http://www.flickr.com/photos/irisheyes/1856356/

INTERVIEW: DOUG POWELL

01 /// **Doug Powell** /// http://mergedesignblog.com/about/
02 /// **Merge** /// http://mergedesignblog.com/
03 /// **AIGA, Design For Good** /// http://www.aiga.org/design-for-good/
04 /// **The 1980s** /// http://sf.funcheap.com/rock-piano-80s-show-nopa/1980s-fashion/
05 /// **Target** /// http://www.prlog.org/11652660-connect-with-your-target-market.html
06 /// **Target** /// http://www.webdesignerdepot.com/2009/05/50-excellent-circular-logos/
07 /// **Apple** /// http://www.last.fm/music/Apple+Inc.
08 /// **Apple** /// http://www.statesymbolsusa.org/New_York/Fruit_Apple.html
09 /// **William Tell** /// http://madonagraysea.blogspot.com/2010/11/boys-and-guns-apples-and-arrows.html
10 /// **Middle Eastern oil** /// http://www.arabianbusiness.com/oman-11-month-oil-output-up-6-6-exports-up-10--373756.html
11 /// **Devil** /// http://thefirstsupper.blogspot.com/2011/05/sympathy-for-devil.html
12 /// **Thank you** /// http://kingrichardarmitage.rgcwp.com/2012/07/20/thank-you-the-search-can-begin/

INTERVIEW: RICK VALICENTI

01 /// **Rick Valicenti** /// http://blogs.suntimes.com/sweet/2011/09/michelle_obama_hosts_lunch_for.html
02 /// **Rick Valicenti, Emotion as Promotion: A Book of Thirst, 2005** /// http://www.designmeasure.com/about/awards
03 /// **Eye 6, 1992** /// http://www.eyemagazine.com/magazine/issue-6
04 /// **Rick Valicenti, Gilbert Paper promotion, 1995** /// http://www.tumblr.com/tagged/rick-valicenti
05 /// **Gilbert Paper** /// http://www.shannonrose.com/blog/

general-news/communication-arts-magazines-1985
06 /// **Lorenzo de'Medici** /// http://rosehowe.wordpress.com/
07 /// **Leonardo da Vinci** /// http://www.mamapop.com/2011/11/finally-the-leonardo-da-vinci-action-epic-weve-been-asking-for.html
08 /// **Fox River Paper** /// http://www.logopub.net/img207156.search.htm
09 /// **Neenah paper** /// http://www.neenahpaper.com/AboutNeenah/LogoUsage
10 /// **Rick Valicenti, Suburban Maul, 2003** /// http://vimeo.com/18499366
11 /// **Greg Lindy Lux Sans, 2003** /// http://vllg.com/LuxTypo/Lux_Sans#panel=usage-poster
12 /// **Cindy Ann Bader and Greg Lindy** /// http://entertainmentlawhollywood.typepad.com/photos/grammys_2009/grammy-2009-098.html
13 /// **Daisy** /// http://www.cvni.org/biodiversity/wildflowers/ox-eye-daisy/
14 /// **Orchid** /// http://www.allaboutorchidcare.com/
15 /// **Thank you** /// http://www.getkempt.com/good-idea/why-thank-you.php

CHAPTER 6

COMMUNITY DESIGN AUTHORSHIP

01 /// **Andrew Blauvelt** /// http://www.flickr.com/photos/raffaz/2957567261/
02 /// **University of Minnesota, Minneapolis MN** /// http://www.answers.com/topic/university-of-minnesota-morris-1
03 /// **Smart phones** /// http://www.joraypublications.com/gadgets/are-smart-phones-the-cigarettes-of-the-next-century.html
04 /// **Design 21** /// http://www.design21sdn.com/
05 /// **UNESCO** /// http://www.grforum.org/pages_new.php/unesco/1011/1/388/1010/
06 /// **Milton Glaser** /// http://revisionarts.com/2011/11/ten-things-i-have-learned-milton-glaser-part-of-aiga-talk-in-london/
07 /// **Art Directors Club (before)** /// http://www.metropolismag.com/pov/tag/graphic-design/page/2
08 /// **Art Directors Club (after)** /// http://www.dexigner.com/news/19161
09 /// **Mark Randall** /// http://impact.sva.edu/instructors/department/mark-randall/
10 /// **James Victore** /// http://www.yourthinkbox.com/seo-blog/james-victore-inspiration-tips/
11 /// **Elizabeth Resnick** /// http://grafikologia.blogspot.com/2009/09/desain-grafis-menurut-desainer-grafis.html
12 /// **Pieter Spinder** /// http://www.knowmads.nl/person/pieter-spinder/
13 /// **Knowmads** /// http://www.adropintheocean.dk/me/knowmad
14 /// **Moveon.org** /// http://blog.chron.com/txpotomac/2008/02/moveon-is-focusing-on-texas-will-republicans-cheer-this-time/
15 /// **Bush in 30 Seconds, best animated ad** /// http://www.bushin30seconds.org/
16 /// **George Bush** /// http://checkthafacts.blogspot.com/2009/02/why-not-blame-george-w-bush.html
17 /// **Scott Stowell** /// http://www.adcglobal.org/archive/yg/judges_06/?id=591
18 /// **Fast food** /// http://mrscampos.edublogs.org/2013/01/03/fast-food-habits/
19 /// **The world** /// http://go.hrw.com/atlas/norm_htm/world.htm
20 /// **Victorian parlor game** /// http://www.onlinequilter.com/MommyMe/19thCenturyChildrensGames/tabid/275/Default.aspx
21 /// **Exquisite corpse** /// http://rudolphjackson.com/blog/exquisite-corpse/
22 /// **San Francisco CA** /// http://www.tripadvisor.com/Tourism-g60713-San_Francisco_California-Vacations.html
23 /// **Someguy** /// http://www.sfgate.com/entertainment/article/Chronicling-the-journeys-of-1-000-wayward-journals-3275314.php
24 /// **Hostel, 2006** /// http://www.impawards.com/2006/hostel.

html
25 /// **Cafe** /// http://artscollinwood.org/cafe/
26 /// **Law office** /// http://www.krasnerlawoffice.com/
27 /// **Treasure** /// http://www.shebusiness.com/come-to-an-event/she-business-digital-treasure-hunt/
28 /// **Remote mountaintop** /// http://robpetkau.wordpress.com/2011/05/04/mountain-top/
29 /// **Airport** /// http://www.fftsecurity.com/new/fft-perimeter-security-system-performs-impressively-mcallen-airport/
30 /// **Gunpoint** /// http://atgunpointproductions.blogspot.com/
31 /// **Christmas sweater** /// http://www.sodahead.com/fun/post-some-funny-cute-nice-ugly-christmas-sweaters/question-2320641/?link=ibaf&q=&imgurl=http://thefoodinista.files.wordpress.com/2008/12/pete.jpg
32 /// **Lynne Rees** /// http://www.writingourwayhome.com/2012/01/river-be-surprised-by-lynne-rees.html
33 /// **Slow Food** /// http://www.suenosdecocina.es/empresa/en/acerca-de/slow-food/
34 /// **James Victore** /// http://www.zimbio.com/pictures/yauewjWURoo/Apple+Soho+Store+Presents+Art+Directors+-Club/1j_PDQxyMg5/James+Victore
35 /// **Brooklyn NY** /// http://www.forbes.com/sites/darrenheitner/2012/10/14/the-brooklyn-nets-are-not-found-at-nets-com-but-they-should-be/
36 /// **Dinner** /// http://www.geographypages.co.uk/08globalisation.htm
37 /// **Cash** /// http://www.tusanuncios.com/detalleanuncio?idAnuncio=8023565&tipo=5
38 /// **Margo Halverson** /// http://benjaminvandyke.com/index.php?/me/about/
39 /// **Peter Hall** /// http://www.griffith.edu.au/visual-creative-arts/queensland-college-art/staff/peter-hall
40 /// **Melle Hammer** /// http://www.myfonts.com/person/Melle_Hammer/
41 /// **Vinalhaven Island, Maine** /// http://www.epa.gov/region1/eco/drinkwater/vinalhav.html
42 /// **R2 Design (Lizá Defossez Ramalho and Artur Rebelo)** /// http://www.europeandesign.org/ed-festival/previous-events/2008-stockholm/ed-conference-2008/r2-design-studio/
43 /// **Portugal** /// http://wp.greenwichmeantime.com/time-zone/europe/european-union/portugal/flag/index.htm
44 /// **R2 Design, Vai com Deus/Go with God, Lisbon, 2008** /// http://www.r2design.pt/?id=9
45 /// **R2 Design, Vai com Deus/Go with God, Lisbon, 2008** /// http://www.r2design.pt/?id=9

CURATING DESIGN AUTHORSHIP

01 /// **American Center for Design** /// http://gallery.unt.edu/exhibitions/past?page=7&field_exhibit_location_value=4
02 /// **American Center for Design 100 show catalog, 1992** /// http://www.amazon.com/100-Show-American-Center-Design/dp/0823061760
03 /// **Katherine McCoy** /// http://agallagher.kcaigraphicdesign.com/
04 /// **Lorraine Wild** /// http://observatory.designobserver.com/entry.html?entry=8337
05 /// **Bruce Mau** /// http://greensudbury.blogspot.com/2009_11_01_archive.html
06 /// **Rick Vermeulen** /// http://www.vakbondabc.nl/2007.asp
07 /// **This author, Steven McCarthy** /// http://www.stcloudstate.edu/news/newsrelease/default.asp?storyid=35164
08 /// **Cristina de Almeida** /// courtesy of the author
09 /// **Johanna Drucker** /// http://gseis.ucla.edu/news-events/news-items/johanna-drucker-retrospective-celebrates-40-years-of-print-works
10 /// **Johanna Drucker, History of the/my World, 1990** /// http://www.artistsbooksonline.org/works/hist.xml
11 /// **Daniel Jasper** /// http://minnesota.publicradio.org/display/web/2007/01/29/design4
12 /// **Michael Bierut** /// http://typotalks.com/sanfrancisco/blog/2012/04/06/michael-bierut-learning-the-slow-way/
13 /// **Michael Bierut, Rethinking Design, 1992** /// http://www.amazon.com/Rethinking-design-ways-looking-designers/dp/B0006P2J2G

14 /// **Mohawk Paper** /// http://greenprintingpromise.com/greenlinks.html
15 /// **Maria Rogal** /// http://www.mariarogal.com/weblog/about-2/
16 /// **Martin Venezky** /// http://observermedia.designobserver.com/audio/martin-venezky/30308/
17 /// **Martin Venezky, Speak, 2001** /// http://magculture.com/blog/?p=92
18 /// **Ellen Lupton** /// http://www.cooperhewitt.org/tags/ellen-lupton
19 /// **Abbott Miller** /// http://observermedia2.designobserver.com/audio/abbott-miller/9497/
20 /// **Rudy Vanderlans** /// http://pinterest.com/designersbooks/graphic-designers/
21 /// **Katie Salen** /// http://sir.tv/profile/katie-salen
22 /// **Anne Burdick** /// http://www2.artcenter.edu/summit/archive/2007/burdick.php
23 /// **North Carolina State Wolfpack** /// http://www.sportsscienceed.com/2012/07/19/etsu-sport-scientists-gaining-valuable-experience-in-the-field/
24 /// **Kali Nikitas** /// http://www.flickr.com/photos/fontshop/6945517560/sizes/m/
25 /// **United States** /// http://www.ushistory.org/betsy/flagpics.html
26 /// **Netherlands** /// http://www.study-abroad-help.com/netherlands_stats_facts.html
27 /// **Great Britain** /// https://marketplace.secondlife.com/p/Flag-Union-Jack-The-United-Kingdom-of-Great-Britain-and-Northern-Ireland-Union-Flag-British-Flag/867891
28 /// **Malaysia** /// http://www.best-buy-flags.co.uk/Malaysia-Table-Flag-59-x-865-inch-buy-flags-10230,bestbuyflags.html
29 /// **Woman Made Gallery, Chicago IL** /// http://blogs.luc.edu/artsalive/portfolio/woman-made-gallery/
30 /// **Linda van Deursen** /// http://www.underconsideration.com/brandnew/archives/stedelijk_museum_amsterdam.php
31 /// **Sheila Levrant de Bretteville** /// http://www.princetonsda.com/directions/speakers.html?show=kw
32 /// **Lucille Tenazas** /// http://www.cranbrookart.edu/Pages/AlumniNews.html
33 /// **Irma Boom** /// http://www.adcglobal.org/archive/annual/86/judges/?id=101
34 /// **Marlene McCarty** /// http://www.timeout.com/newyork/things-to-do/marlene-mccarty-52
35 /// **Dutch post office** /// http://www.mybergenonline.com/tnt-the-post-office
36 /// **Children's book** /// http://viintage.com/gallery/the-abc-of-animals-vintage-childrens-book-free/
37 /// **Dog** /// http://www.petfinder.com/dogs/dog-problems/dog-barks-left-alone/
38 /// **Johanna Drucker, The Next Word** /// http://books.google.com/books?id=E1ZKAQAAIAAJ&source=gbs_book_similarbooks
39 /// **Neuberger Museum of Art, Purchase NY** /// http://www.karenspencerdesign.com/pages/ref_neuberger.html
40 /// **State University of New York** /// http://superstarsofscience.com/institution/state-university-of-new-york
41 /// **SUNY News Pulse** /// http://www.newpaltz.edu/newspulse/061807/whatsnew.html
42 /// **Yale, New Haven CT** /// http://symbolphotos.blogspot.com/2011_02_01_archive.html
43 /// **Zuzana Licko** /// http://www.emigre.com/Licko3.php
44 /// **Font Bureau** /// http://sndstl2011.sched.org/event/f689dcff09fac7fb78e813eae0afc303#.UJRzPWl25xk
45 /// **Pedestal** /// http://www.dei-zinz.com/knurled-fiberglass-pedestal-white-stained.html
46 /// **Perimeter** /// http://www.education.com/study-help/article/perimeter-polygons/
47 /// **Minneapolis MN** /// http://www.indoorcycleinstructor.com/icipro-community/indoor-cycling-news/minneapolis st paul-tops-for-fitness-again/
48 /// **Oslo, Norway** /// http://worldbeautifullplaces.blogspot.com/2012/05/oslo-norway.html
49 /// **Arthur Redman** /// http://csuhonors.com/id37.html
50 /// **Rob Dewey** /// http://www.meetup.com/Merge-Design-Blog/members/10689004/
51 /// **Michael Worthington** /// http://www.qualitypeoples.com/blog/page/89
52 /// **Ed Fella** /// http://www.mediabistro.com/unbeige/tag/ed-fella
53 /// **Nancy Skolos** /// http://thedesignoffice.org/2012/signing
54 /// **Grandfather** /// courtesy of the author
55 /// **Jan Jancourt** /// http://insaneoverload.com/photography/jan-jancourt-elite-falconer-elite-falcon/
56 /// **Alexei Tylevich** /// http://www.flickr.com/photos/helloflux/3316258967/
57 /// **Girlfriend, 2012** /// http://au.youth.yahoo.com/girlfriend/blog/galleries/g/-/15427166/1/december-2012-girlfriend-mag-sneak-peek/
58 /// **Pebbles, Girlfriend, 1988** /// http://www.ebay.com/itm/Pebbles-Girlfriend-Girlfriend-Inst-45-rpm-NM-/400043484172
59 /// **My Super Ex-Girlfriend, 2006** /// http://tvlistings.zap2it.com/tv/my-super-ex-girlfriend/photo-gallery-detail/MV001776850000/682130?aid=zap2it
60 /// **The Smiths, Girlfriend in a Coma, 1987** /// http://wedopix.deviantart.com/art/The-Smiths-Girlfriend-In-A-Coma-325403599
61 /// **Kenneth FitzGerald** /// http://www.blogger.com/profile/04614722268086607860
62 /// **Adversary** /// http://www.ephemeralstates.com/adversary/
63 /// **Voice2, AIGA National Conference, Washington DC, 2002** /// http://www.basenow.net/2009/10/16/interview-with-alice-twemlow-design-critic-and-chair-of-the-new-mfa-in-design-criticism-program-at-sva-pt2/
64 /// **Our nation's capital** /// http://www.ysop.org/ysopdc.htm
65 /// **Chris Thompson** /// http://www.meca.edu/bfa/art-history/faculty/chris-thompson
66 /// **Zero Station, Portland ME** /// http://www.zerostation.com/
67 /// **Elliot Earls** /// http://vimeo.com/elliottearls
68 /// **Ed Fella correspondence to Rick Valicenti** /// http://dcaiga.blogspot.com/2012/06/ed-fellacorrespondence-with-rick.html
69 /// **Gunnar Swanson, Talking Head** /// http://www.gunnarswanson.com/
70 /// **University of Minnesota Duluth Bulldogs** /// http://www.ticketmaster.com/University-of-Minnesota-Duluth-Bulldogs-Mens-Hockey-tickets/artist/838149
71 /// **Goldstein Museum of Design, Minneapolis MN** /// http://www.facebook.com/pages/Goldstein-Museum-of-Design/29682069629
72 /// **Kali Nikitas** /// http://php.unirsm.sm/designweek/web/pagina.php?valo=i_20
73 /// **Steve Sikora** /// http://artofangles.blogspot.com/
74 /// **Tim Larsen** /// http://www.aigaminnesota.org/event/portfolio-one-on-one/scholarship-opportunities/scholarship-judges/
75 /// **Maya Drozdz** /// http://theater.nytimes.com/library/tech/98/07/cyber/artsatlarge/30artsatlarge.html
76 /// **Chris Corneal** /// http://www.linkedin.com/pub/chris-corneal/a/570/98a
77 /// **Jennifer Morla** /// http://www.apartmenttherapy.com/good-quotes-jennifer-morla-85442
78 /// **Bob Aufuldish** /// http://imprint.printmag.com/graphic/why-enter-the-rda/
79 /// **Amy Franceschini** /// http://sfaiblog.org/2011/12/19/half-life-2012-season-of-programming/
80 /// **Great Britain** /// http://thegospelcoalition.org/blogs/tgc/2012/01/29/reflections-on-the-church-in-great-britain/
81 /// **Croatia** /// http://www.24h.gr/section/periballon/kroatia-65-ek-euro-gia-ilektriki-energeia-apo-biomaza
82 /// **Turkey** /// http://ishanews.com/?attachment_id=15182
83 /// **Michael Leyton** /// http://formes-symboliques.org/article.php3?id_article=231
84 /// **Zak Kyes** /// http://www.likeyou.com/en/node/9177
85 /// **Architectural Association School of Architecture, London** /// http://istanbul.aaschool.ac.uk/?page_id=22
86 /// **Mark Owens** /// http://www.flickr.com/photos/qbn/1348396032/sizes/l/in/photostream/
87 /// **Zak Kyes and Mark Owens, Forms of Inquiry: The

Architecture of Critical Graphic Design, 2009 /// http://projectprojects.com/forms-of-inquiry/?view=thumb
88 /// **Abake** /// http://www.makeithappen.org/ydlmy2.html
89 /// **Demolition of Pruitt-Igoe housing project, St. Louis, 1972** /// http://www.umsl.edu/~keelr/010/pruitt-igoe.htm
90 /// **Abake, Pruitt-Igoe, 2009** /// http://formsofinquiry.com/inquiry/pruitt-igoe
91 /// **St. Louis** /// http://www.slu.edu/x46864.xml
92 /// **David Bennewith** /// http://www.flickr.com/photos/typeshed11symposium/3371325821/
93 /// **Karel Martens** /// http://www.manystuff.org/?p=12028
94 /// **David Bennewith and Karel Martens, Notre Dame du Haut Ronchamp, 2009** /// http://formsofinquiry.com/inquiry/notre-dame-du-haut-ronchamp
95 /// **Notre Dame du Haut** /// http://home.manhattan.edu/arts/gallery/picture.php?cat=search&image_id=2142&search=-date_available:2008-04-17
96 /// **Le Corbusier** /// http://www.nickjenkins.net/house/inspiration/
97 /// **Task Newsletter #2, 2009** /// http://tasknewsletter.com/2img.html
98 /// **Bedford Press** /// https://twitter.com/bedfordpress
99 /// **Denis Crompton** /// http://www.architectmagazine.com/internet/archigramwestminsteracuk.aspx
100/// **The Archigram Archival Project** /// http://www.anyspacewhatever.com/archigram-archival-project/
101 /// **Allan Fowler, Where Land Meets Sea, 1997** /// http://www.scholastic.com/teachers/book/where-land-meets-sea
102/// **Clare Leighton, Where Land Meets Sea, 1997** /// http://premierepage.tumblr.com/post/35970985455/in-the-gloaming-where-land-meets-sea-the-tide
103 /// **Annalies Corbin and J.W. Joseph, When the Land Meets the Sea, 2011** /// http://www.springer.com/series/8370
104/// **Christiana Payne, When the Sea Meets the Land, 2007** /// http://www.angusrobertson.com.au/book/where-the-sea-meets-the-land-artists-on-the-coast-in-nineteenth-century-britain/6213102/
105 /// **Connor Garvey, Where Ocean Meets Land, 2011** /// http://www.last.fm/music/Connor+Garvey/Where+Ocean+-Meets+Land
106/// **Nancy Langston, Where Land & Water Meet, 2006** /// http://www.angusrobertson.com.au/book/where-land-and-water-meet-a-western-landscape-transformed/181135/

INTERVIEW: ARMIN VIT

01 /// **Armin Vit** /// http://www.kernandburn.com/one-hundred-days/day-34/
02 /// **Austin TX** /// http://www.abiie.com/About_Abiie.html
03 /// **Mexico** /// http://www.mega-flags.com/Mexican-Flag-image,-Mexico-Flag.html
04 /// **Atlanta GA** /// http://www.phonemanuals.com/Atlanta-Phone-Installer.htm
05 /// **Howdy from Chicago** /// http://www.chicagopostcardmuseum.org/greetings_from_chicago_LOBBY.html
06 /// **Pentagram** /// https://twitter.com/pentagramdesign
07 /// **Under Consideration** /// http://www.churchofrabbit.com/category/resources/page/13/
08 /// **Cooper Hewitt National Design Museum, New York NY** /// http://www.nycgo.com/venues/cooper-hewitt-national-design-museum
09 /// **Under Consideration at the Cooper Hewitt National Design Triennial, 2006** /// http://www.underconsideration.com/random/SU_CH_1206_03.jpg
10 /// **Armin Vit, Graphic Design Referenced, 2009** /// http://grainedit.com/2009/10/29/graphic-design-referenced/
11 /// **Bryony Gomez-Palacio** /// http://imprint.printmag.com/branding/design-entrepreneur-101-vit-and-gomez-palacio-at-how-design-live/
12 /// **Bryony Gomez-Palacio and Armin Vit, Women of Design, 2008** /// http://www.graphicbirdwatching.com/featuredbook/test-bbok/
13 /// **Walker Art Center, Minneapolis MN** /// http://www.janelletubbs.com/at5053/category/janelle-2/
14 /// **Speak Up** /// http://www.logodesignlove.com/30-logos-from-30-design-blogs
15 /// **Quipsologies** /// http://logoholic.org/gotham-logos/
16 /// **Brand New** /// http://www.logobird.com/13-must-follow-logo-and-brand-identity-design-blogs/
17 /// **Graphic Design: Now in Production, catalog, 2012** /// http://www.manystuff.org/?p=15043
18 /// **Emigre 40, "Letters to the Editor," 1996** ///
19 /// **Threadless.com** /// http://www.thequeenofswag.com/2011/12/threadless-amazing-tees-for-the-whole-family-holidaygiftguide2011-gifts.html
20 /// **Pinterest** /// http://www.ianschafer.com/2012/02/06/a-pinterest-hypothesis/
21 /// **Thank you** /// http://www.creativewriting-prompts.com/sample-thank-you-note-wording.html

INTERVIEW: MICHAEL LONGFORD

01 /// **Michael Longford** /// http://www.businessrichmondhill.ca/Symposium/speaker.asp
02 /// **York University, Toronto** /// http://en.wikipedia.org/wiki/File:York_University_Coat_of_Arms.png
03 /// **Toronto, Canada** /// http://toronto.csc-dcc.ca/
04 /// **Octopus** /// http://www.rci.rutgers.edu/~jbass/courses/425_samples/octopus2.htm
05 /// **Ontario College of Art & Design (OCAD)** /// http://www.kunstler.com/eyesore_200311.html
06 /// **Canadian Film Centre** /// http://www.torontofilm.net/2011/08/dark-knight-director-donates-to.html
07 /// **Talk To Me, Museum of Modern Art, New York NY** /// http://inhabitat.com/nyc/innovative-designs-in-momas-talk-to-me-explore-how-objects-speak-to-us/
08 /// **Digital Cities Project** /// http://www.hexanine.com/zeroside/the-future-is-fluid-inside-dynamic-logos/
09 /// **Mobile Media Lab** /// http://grainedit.com/2009/10/29/graphic-design-referenced/
10 /// **WiFi** /// http://courantblogs.com/technology/cable-wifi/
11 /// **Creative Commons** /// http://www.k12opensourceclassroom.org/?p=552
12 /// **Copyleft** /// http://www.large-icons.com/stock-icons/free-large-torrent/copyleft.htm
13 /// **Twitter feed** /// http://www.flickr.com/photos/conduitconnect/3308239556/
14 /// **Apple** /// http://www.cs.columbia.edu/~sedwards/apple2fpga/
15 /// **Google** /// http://www.forbes.com/sites/daviddisalvo/2012/01/31/google-responds-to-privacy-questions-from-congress/
16 /// **Flickr** /// http://www.bloggingpro.com/archives/2012/07/16/flickr-is-for-more-than-just-photos/
17 /// **Like** /// http://socialmouths.com/blog/2010/10/27/build-your-facebook-landing-page/
18 /// **Thank you** /// http://www.creative-expressions.uk.com/productcatalogue/detail.php?pid=RN76B

ESSAY CREDITS

Note: these sections of the book were originally published or presented in the following venues. All have been edited and updated, in varying degrees, from the originals.

TIMELINE OF DESIGN AUTHORSHIP

Design authorship's Pre-and Post-History: Framing Its Legitimacy (poster). Writing Design: Object, Process, Discourse, Translation. Design History Society Annual Conference, University of Hertfordshire. Hatfield, United Kingdom.

TYPOGRAPHIC DESIGN AUTHORSHIP

Typography's Role in Design Authorship: Product, Process or Tool? Design and Craft: a History of Convergences and Divergences, the seventh conference of the International Committee for Design History and Design Studies. Brussels, Belgium.

THE VISUAL-VERBAL TEXT

Fearless Type Writing: Self-Actualization through Design Authorship. Type Writing symposium. The Typographic Hub. Birmingham Institute of Art & Design. Birmingham, United Kingdom.

TYPOGRAPHY AND LIFE: A COMPARISON

Eric Gill and Jonathan Barnbrook: Designers as Authors at the Poles of the Twentieth Century. Mind the Map, the third international conference of the International Committee for Design History and Design Studies. Istanbul, Turkey.

DESIGNER ADVOCACY ACROSS MEDIA

In Design Advocacy Across Media, the two paragraphs beginning "Steven Johnson and Janet Murray..." were co-authored with Cristina de Almeida and published in Self-Authored Graphic Design: a Strategy for Integrative Studies. *Journal for Aesthetic Education.* Champaign-Urbana, Illinois: University of Illinois Press. Vol. 36(3).

DESIGNER AS AUTHOR ACTIVIST

Designer as Author Activist: A Model for Engagement. Design Research Society conference. Bangkok, Thailand.

CRITICAL DESIGN AND DESIGN FICTION

From Graphics to Products: Critical Design as Design Authorship. New Views 2: Conversations and Dialogs in Graphic Design. London College of Communication, London.

DESIGNER STORIES THROUGH ENTREPRENEURIAL PUBLISHING

Designer-Authored Histories: Graphic Design at the Goldstein Museum of Design. *Design Issues.* Cambridge, Massachusetts: MIT Press. © 2011 The Massachusetts Institute of Technology. Vol. 27(1).

CURATING DESIGN AUTHORSHIP

Curating as Meta Design-Authorship. *Visual:Design:Scholarship, the research journal of the Australian Graphic Design Association.* Vol. 2(2).